Valley of the Drawn Sword

The Early History
of
Burnley, Pendle and West Craven

John A Clayton

For Sylvia

© John A Clayton, 2006

ISBN (10) 0-9553821-0-6

ISBN (13) 978-0-9553821-0-9

Cover design and prepress output by

2 0 0 6

Contents

Illustrations and Plates

Illustrations (in page order):

B&W Plates (in page order):

Preface

The topographical region forming the subject of this book consists of many hills and valleys. The book title *"Valley of the Drawn Sword"* alludes to an area of three separate valleys that can be seen to combine within the sweep of a trans-county landscape known as Brogden, Middop and Admergill. This is the *'Valley'* of the book title and has been chosen to represent the subject area as a whole.

Brogden is a parish within the larger township of Barnoldswick, a parish that transcends the delineation of the pre-1974 Lancashire and Yorkshire boundary and runs hand-in-hand with its neighbour of Middop Valley. At the head of Middop we have the picturesque and historic Admergill Valley, since the Medieval period this has been included within the umbrella of the parish of Brogden Detached.

The name of Brogden is from an Old English root translating as *'moved quickly - with drawn sword.'* The suggestion here is that of trans-Pennine invaders travelling through the valley or, alternatively, the local inhabitants moving to defend their territory by cutting off this major east-west crossing point. *Brogden* is the past participle of the name, the present participle being *Bregden* - the past tense signifies that Brogden might have been named when conflict here had become a folk-memory.

The Brogden and Middop Valleys are situated between the old division of West Cravenshire and Blackburnshire, areas that were formerly united within the kingdom of the Brigantes and would later become borderlands between the Saxon kingdoms of Mercia and Northumbria. These valleys formed a virtual corridor through which ancient traders and would-be settlers passed and the number of defensive sites therein bears testimony to the fact that this human traffic did not always harbour peaceful intentions.

The *'Valley of the Drawn Sword'* is, therefore, the physical link between West Craven and the East Lancashire areas of Burnley and Pendle whose formative history will be explored within these pages.

"Know most of the rooms of thy native country before thou goest over the threshold thereof,
Especially seeing England presents thee with so many observables"

Fuller

Acknowledgements

I extend my gratitude to my long-suffering wife, Sylvia, both for her patience during the long hours that I have been locked away, frantically bashing at my computer keyboard, and also for the additional research that she has carried out.

The staff at the Local District Libraries have, as always, proved to be more than willing to help in any facet of research and, therefore, my gratitude goes to those at Colne, Nelson, Burnley and Clitheroe and also to the Lancashire Records Office at Preston for just being there!

Any form of local research must, by necessity, call upon the work of those who have gone before. The census returns, for example, have been (or are being) transcribed by groups of volunteers who carry out a sterling task, often with little recognition. Members of Local History Societies provide indexes and transcriptions of local material in order for others to have a quick and reliable method of access to the history upon our doorstep.

It is almost impossible to carry out any kind of research within the locality of the subject of this book without coming across the hand-written files of a dedicated fellow Barrowfordian by the name of Mrs. Doreen Crowther. Now sadly deceased, Doreen provided countless hand-written documents on countless subjects and without her our research would prove to be much more difficult.

My thanks also go out to historian Stanley Graham, of Barnoldswick, whose generosity in sharing his wide-ranging knowledge of the history of our locality has inspired many budding local historians, myself included.

Finally, thanks to the landowners within whose fields much of our heritage is to be found - not least amongst these are Andrew and Rachel Turner of Malkin Tower Farm, on Blacko Hillside. My particular thanks to them both for their interest in the history of the area and for allowing my pathological nosiness to be exercised over Malkin land.

Introduction

"The names, the shapes of the woodlands, the courses of the roads and rivers, the pre- historic footsteps of man still distinctly traceable up hill and down dale, the mills and the ruins, the ponds and the ferries, perhaps the standing stone or the Druidic circle on the heath; here is an inexhaustible fund of interest for any man with eyes to see, or tuppence worth of imagination to understand with!"

Robert Louis Stevenson appended the above lines to early editions of his classic novel, *Treasure Island;* I include them here as the sentiments strongly reflect my own approach to the rich legacies left to us by our distant ancestors. As an amateur local historian I hope that I approach my subject with an open mind; for over thirty years I have tramped the local moors and fields, always keeping a weather-eye open for signs of antiquity within the landscape. In fact almost any type of feature within (or upon) the land may have been, at one time or another, the subject of a prod or a poke with a big stick by yours truly!

This has led to a personal realisation that a large majority of the ancient sites within our landscape remain unrecognised. Certainly, *some* of the castles, hill forts, barrows, stone monuments, burial cairns, beacon hills, camps, defensive dykes and ancient field-systems have been officially acknowledged. For example, the hill forts at Portfield, near Whalley, and Castercliffe, on the outskirts of Colne, are reasonably well documented within official archaeological reports whilst other similar sites within the locality do not rate a mention. This does not reflect on the people who work within the local archaeological authorities, they do a professional job despite the heavy financial restraints placed upon them by lack of funding.

The hitherto unrecognised sites offered within these pages will require official recognition before they are marked upon any map; this does not detract from the fact that they are of great interest as they stand; if a site has all the hallmarks of having been created by our distant predecessors then let us say so and provisionally accept them as such, it then befalls future historians to disprove, or indeed prove the theory.

Throughout the text reference is made to the subject region as *'our area'* - this extends roughly over a *'virtuous circle'* within the part of Pennine East Lancashire and Yorkshire West Craven covering the Extwistle and Worsthorne moors above the town of Burnley, through the extended area of Pendle and onwards to the River Ribble as it flows from Settle to Gisburn. This area largely encompasses the Parish of Whalley with a *'wash-over'* into the neighbouring region of pre-1974 West Craven; in other words, the area in which the West Lancashire coastal plain routes meet with (and cross) the Pennines into the Yorkshire Dales. For over two-thousand years these inter-coastal routes, along with the north-south trans-kingdom routes, have brought the invader and the trader alike into the region. Throughout the long, dark period of the first millennium AD the influence of these diverse cultures has influenced our landscape and this, by-and-large, is the subject of this text.

The history of any particular area can never be comprehensively covered by anyone in a single lifetime, nor can it be covered by a mass of committees over numerous lifetimes; this is the nature

of the beast that any historian has to wrestle with and I hope that I have succeeded in at least some small part! Of necessity there are numerous references throughout these pages to the origins of place-names. Although it may appear that one particular suggestion is favoured over another there is no attempt here to make a definitive statement as to the correct etymology of our local places, this is certainly not a reference work within this particular field. The object of the place-name sections is to attempt to make sense of the approximate dating within which the subject nomenclature may have arisen and to stimulate an interest in the fascinating history of the local towns, villages and picturesque landscape with which we are truly blessed.

In 1953 the Oxford historian, W.G.Hoskins, described the local historian's relationship with his subject admirably; as I cannot improve upon this I am pleased to include it here:-

"One cannot understand the English landscape and enjoy it to the full, apprehend all its wonderful variety without going back to the history that lies behind it. A common place ditch may be the thousand-year-old boundary of a royal manor; a certain hedgebank may be even more ancient, the boundary of a Celtic estate; a certain deep and winding lane may be the work of twelfth-century peasants, some of whose names may be made known to us if we search diligently enough........It is not only documents that are the historian's guide - one cannot write books (on the landscape) by reading someone else's books, or even studying records in a muniment room. "

"The English landscape itself, to those who know how to read it aright, is the richest historical record we possess. There are discoveries to be made within it for which no written documents exist, or have ever existed. To write the history of the English landscape requires a combination of documentary research and of fieldwork, of laborious scrambling on foot wherever the trail may lead. The result is a new kind of history which it is hoped will appeal to all those who like to travel intelligently, to get away from the guide-book show-pieces now and then, and to know the reasons behind what they are looking at... The landscape is full of questions for those who have a sense of the past."

The observation that *"the English landscape is the richest historical record we possess"* sums up the purpose of this book admirably. The subject within the following text is, broadly speaking, the development of our particular area from its pre-history to the Norman Conquest. This period covers the first millennium AD, an era inhabited by shadows and legends, the few facts that we posses are taken from classical and later contemporary writers who often had their own axe to grind. Roman scholars and Anglo-Saxon clerics have left us with accounts of their period but these often raise more questions than they answer. The local historian, therefore, has to make an assessment of his, or her, subject from the few available facts and, of equal importance, from the story embedded within our landscape. This latter has long fascinated me and, where postulation is the only tool available, I intend to use it to the full in the hope that those who follow will find sufficient material herein on which to base further research.

John A Clayton
Barrowford
2006

Chapter One

Of Ice and Iron

Modern views of our early ancestors are in a constant state of flux, in December 2005 it was announced by the *Ancient Human Occupation of Britain Project* (AHOB) that tiny fragments of fossilised snail shells found alongside primitive flint tools in East Anglia date back about 700,000 years. Up to the close of the twentieth century it was widely believed that the earliest human occupants of Northern Europe had colonised the area around 500,000 years ago but AHOB team members from York used the newly-refined technique of amino acid analysis to verify the earlier age of the East Anglian finds. A new multi-discipline project, known as *BioArch*, is operating at York University (as at 2006), this is a joint venture between the departments of archaeology, biology and chemistry and it is envisaged that refinement of the current dating processes will enable the scientists to accurately date habitation and climate cycles to around one million years ago.

Only two years previously, in 2003, our boundaries of perception relating to early man had been reassessed; the finding of a flint axe in Norfolk, stated by experts to be around 700,000 years old, pushed the earliest known period of the Palaeolithic (Old Stone Age) back 200,000 years. *Homo heidelbergensis*, the forebears of we *homo sapiens,* made and used this superbly crafted Norfolk axe when they roamed Britain and continental Europe.

For hundreds of thousands of years our forebears very slowly evolved into the relatively sophisticated peoples of the later Stone Ages. They were able to work flint and bone to a high standard, to prepare fresh meat for food, prepare animal skins for clothing, make fishing nets and manufacture tools and weapons for hunting. By using shelters and fires they created the first artificial environments in which they could live. They were also developing an early art form and religious awareness, their use of manufactured tools proved to be the beginning of a new technological world.

The Old Stone Age culture of Britain appears to have ended quite abruptly, somewhere around 12,000 to 10,000 BC the climate changed and their way of life became untenable, the retreating ice-sheets were followed in by the warmer and dryer period known as the Boreal phase. In our area of the North West the ice-sheet finally retreated around 10,000 to 8,000 BC. The bare tundra sprouted forests of pine and birch, the massive wild ox (aurochs) and red deer took the place of reindeer. As the ice retreated a new influx of people from the Mediterranean and Middle East colonised the newly fertile lands, the people of today's modern Britain, Ireland, Germany and France are largely descended from these early tribes.

Around 6000 BC the Boreal phase gave way to a much wetter era called the Atlantic Phase, the south saw its birch and pine forests turn to damp forests of oak, elm, hazel and alder and these forests gradually spread northwards. The forests covering the east were flooded by rising sea levels and became the North Sea thus causing Britain to be separated from France when the land bridge disappeared and we assumed our present island form.

The Middle Stone Age

The Mesolithic, or Middle Stone Age, stretched from approximately 10,000 to 3500 BC (different periods for differing areas), this era saw much activity on our surrounding moors. The people of this culture were an important link between distant pre-history and man's progression towards modernity. The ice-cap had retreated and, some 8000 years ago, the landscape of our area

was very slowly beginning to take on a semblance of its present form. The glaciers left their mark in the shape of our river valleys, gritstone outcrops and undulating landscape, this led to the Romans calling our area *"the land of the breast-shaped hills"*.

There are many distinct reminders of the way in which our landscape was sculpted by the ice-cap, a good example is the melt-water overflow at Briercliffe (SD 875 353), when viewed from the valleys this feature is highly visible on the skyline. Forming a distinct deep notch in the ridge of King Cliffe, above the hamlet of Lane Bottom, the overflow was formed when the huge lake area that covered the Burnley Basin burst through the ridge and into the Walverden and Pendle Water valleys. Cliviger Gorge lies to the north of the ancient burial mounds at Everage Clough (SD 850 300), on the south-eastern rim of the Burnley Basin, and is another fine example of a glacial, or melt-water outspill.

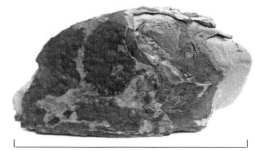

A mudstone node from Lane Bottom on the edge of the Burnley Basin. The central node is the fossilised soil in which the trees grew and eventually formed coal deposits. The outer casing is coal-bearing shale and dates from around 300 million years ago.

14cm

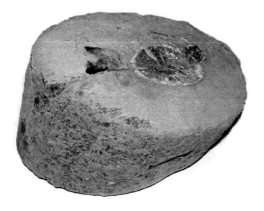

A fossilised object found at Lower Calf Hall in Barnoldswick. Measuring around 20cm across this artefact has the appearance of being a complete animal vertebra. It has been suggested that the object is the branch of a tree from a river estuary where it became encased in sandstone. Another idea is that the central section is the stalk of a sea creature known as a Crinoid, if this is indeed the case then this example would date from the Cambrian Period (around 500 million years ago).

Photograph: Nic Ashworth

Amongst the local Pennine Drift material left behind by the ice-flows are outcrops of Northern Drift which is a reddish brown, slightly calcareous, material. When found in 'sandy' patches this material is known as marl, during the Medieval period landowners in this area instructed their tenant farmers to 'marl' their fields as a means of improving the heavy soils. Many small marl pits were scattered around the countryside in the eighteenth and nineteenth centuries and became known as *'penny holes'* because this was the daily payment that a labourer received for digging the pit. A large marl pit existed in Foulridge (SD 878 423) at the eastern end of what is now the Slipper Hill reservoir at the spot called (appropriately) Sandhole. Many farms throughout the north have fields named after the fact that they were improved with the use of marl, The Marled Earth being a common field name.

The ice also left visible deposits on the landscape in the form of small hillocks of glacial till known as *drumlins*, from the Celtic meaning of *ridge*. Ranging in size these hillocks can reach five-hundred feet in height, the smaller ones are often mistaken for burial barrows. Examples of small drumlins can be found in the narrow valley (SD 855 435) behind what was the Greystones Inn on the Blacko to Gisburn Road, also a superb range of large drumlins can be seen to the north of the town of Barnoldswick. These hills run roughly east-west from approximately SD 830 490 to SD 910 495 and carry fascinating names such as Ransa, Lickber and Aynams.

The upland areas of the Pendle and Bowland Forests also have occasional outcrops of glacial erratic limestone. The largest deposits of this are to be found in the Clitheroe area where it is still extensively quarried, a smaller deposit, in the form of limestone 'pebbles' occurs at Briercliffe, to the north of Burnley. Here the local people washed the stone out of the upper ground strata by means of 'hushing' whereby streams were diverted to wash away the topsoil, exposing the limestone rocks. In the eighteenth and nineteenth centuries an area from the top of Thursden Valley (SD 905 355) down into the hamlet of Lane Bottom was heavily worked. The limestone was used in a variety of ways such as a soil improvement, for making building mortar and plaster and also for making whitewash and chemical processes. Therefore the stone had a definite value, land sales and land exchange surrenders were often subject to the retention of the hushings. Unfortunately the Thursden Scarrs, as these hushings were known, left the effected land in very rough condition, some fields in the area resemble moonscapes to this day.

In the later twentieth century a glacial erratic boulder was displayed in the grounds of Towneley Hall, Burnley. The boulder was around five feet in diameter and resembled a giant football. The stone had been 'recovered' from a field near to the village of Higham and probably originated in the Lake District. Unfortunately the removal of this boulder from its original site means that its original purpose will never be known; the stone would have been utilised by our pre-historic ancestors, possibly as a mark stone, and placed within its original position at Higham to serve a specific purpose.

The high lands above Wycoller, and in the Briercliffe and Extwistle areas, have been a rich source of evidence that Mesolithic people hunted and lived in this landscape, leaving their tools and weapons in the form of small flint blades known as pygmy flints. These artefacts were mainly used to make hunting spears and arrows and have been found on all the Pennine moorlands, fine examples coming from the Newchurch-in-Pendle area and Pendle Hill. Other evidence of these people has been destroyed in the highland areas by the highly acidic peat deposits which formed from two to three-hundred metres above sea level. These deposits of slowly decomposing organic material deepened from late prehistoric times as the climate became colder and wetter.

The upper slopes of Boulsworth Hill are blanketed in a layer of peat up to three metres in depth and beneath this layer can be found the remnants of pre-historic forests. On these slopes, between 1899 and 1902, a flint knapping 'workshop' was discovered and investigated by local archaeologist Peter Whalley.

An archaeological survey of this site took place in the 1930s leaving us with the following description:-

"Site number 20 is situated at SD93 SW6 (348) at the head of Thursden Valley, and near a ruined building marked on the map as Robin Hood's House. The overlying peat bed, eighteen inches in depth at this point, with a top two inches of overlying soil, has been washed away. This bared area is roughly 100 yards long and 7 yards wide. White and grey flints, chert flakes and small quantities of clear brown, dark-brown and reddish flints were freely scattered over the surface when first visited. There does not appear to be the mixture of cultures here, which is so

evident on many of the other sites in the district. What was found can be assigned to the Mesolithic period and shows Tardenoisian influence.............. The finds include three dark-brown flint flakes, lightly trimmed at one edge of the point: Two grey chert flakes with blunted edges: A broken flint flake trimmed to an oblique point: Three micro- barbs of white and grey flint; A triangular microlith of clean brown flint: Eleven narrow-blade microliths, most of them broken, of grey and white flint: A white flint graver; Three light flint flakes: Two flake end-scrapers of mottled yellow flint: Two brown flint cores: Three chert scrapers: A mottled grey flint scraper: Numerous flint and chert flakes and chippings were also present."

Archaeologists use the varying design of flint artefacts to date sites, chert (a type of flint) and flint tools of the Mesolithic era were very small (microliths) and the arrowheads were narrow. Gradually as the arrowheads evolved they became wider and longer, by the late Neolithic age they had become broad weapons with distinct barbs.

Three distinct, but inter-related cultures appear to have made up the peoples of the Mesolithic these were the Maglemose from Scandinavia, the Scottish Settlers and the Tardenoisians from north-east France. It is this latter group, or at least people of their general culture, who seem to have been most active in our area. Where they lived near the coast or fresh water these hunters had a preference for fishing whilst in the inland areas their hunting priorities would be red deer, wild ox, roe deer and the wild pig.

The people of this period left behind few reminders of their existence, apart from a huge number of their flint tools. In Selmeston, (Sussex) Farnham (Surrey) and Abinger (Surrey) camp sites of the Mesolithic period have been identified. These take the form of pits measuring fourteen feet by ten feet and about three feet in depth; post-holes indicate that the dwellings could have had a brushwood roof. The pits were divided into three areas, one for cooking, one for sleeping and the other for general activities, these are the oldest surviving artificial dwellings in Britain.

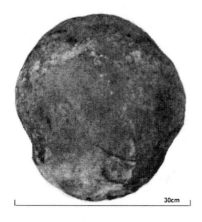

30cm

Stone implement weighing 6kg found in a pond excavation at Blacko Foot. The convex reverse face of this disk-shaped worked stone appears to have had a dual purpose of bowl quern rubbing-stone and hammer-stone

This system can be followed down through the succeeding ages. Dating from around 5000 BC other examples of these camps exist in the south of England, they always feature masses of flint microliths and are invariably sited near to springs. It is not unreasonable to assume that our local Mesolithic groups on the moors above Lothersdale, Boulsworth Hill, the Newchurch-in-Pendle ridge, Worsthorne Moor and Pendle Hill (to name but a few) lived in camps such as those described.

Starr Carr, near Scarborough in Yorkshire, is another important Mesolithic site dating from around 7400 BC, the finds from which have been spread around various museums. One of these finds was a roll of birch bark, this contained a sticky substance used by the ancient craftsmen as a type of glue – this enabled them to firmly fix their flints into wooden shafts and to form larger composite tools and weapons by fixing smaller flakes together.

No discernible examples of Mesolithic artwork have been found, unlike their Palaeolithic predecessors, leading experts to assume that they were a more practical people leaning more to craftsmanship than the arts. New tools had been developed, probably out of necessity to support the growing population; Mesolithic man had the use of fish-spears, harpoons, sledges, canoes and possibly the most important of all - the newly acquired bow and arrow.

The New Stone Age

As time passed the Neolithic (New Stone Age) period slowly dawned, the word itself implies food production based on the rearing of livestock and growing of crops without the use of metals. The Neolithic, therefore, signifies the period when the hunter-gatherer people began to settle down into stable farming units. The exact timing of this change varied enormously from area to area, as with all the 'ages' there was no distinct demarcation between periods.

The period around 3500 BC saw the new continental farming culture spreading across the south of the country but, as always, the north lagged behind this initial advancement. A date of around 3000 BC might not be far from the mark for early farming settlements within our area and 2500 BC would see the beginning of more permanent settlements. It would appear that the traditions of hunting were carried on for centuries in tandem with the new agricultural way of life to supplement a still precarious existence.

From around 3500 BC the climate again became warmer and drier, this Sub-Boreal phase lasted through to 1000 BC. The Neolithic people began to clear the forests, especially those that had covered the higher ground, in order to enclose land and grow their crops. Polished stone axes were found to be more efficient in the clearance of light woodland and so they took over from flint tools, new trade routes opened up to supply a wider area with these advanced goods. By 2000 BC hard crystalline tools were being moved into and through our area, mainly from the Langdale region of the Lake District and Cushendall in Northern Ireland.

These trade routes were the embryonic arterial ways that would come to stretch from the Ribble estuary on the east coast to the Humber estuary on the west coast and into the southern lowlands. This allowed cross-trading of goods between the north-west of England, Wales, Ireland and Scotland across to Scandinavia and the Baltic and also the importation of continental goods (such as pottery) into our north country. As the stone tool, mineral, metal and salt routes were established it became easier to trade other goods as the demand grew. The Irish gold trade would come to utilise the established routes through our area.

Excellent examples of highly-worked crystalline stone axes have been found throughout the region. In 1957 a nice example of a red quartzite hammer-stone was unearthed near Parson Lee Farm at Wycoller and in the 1980s a superb Langdale polished axe head was found near a major ancient boundary at Blacko Foot. Within a few hundred metres of this site a disk-like stone of local material has been discovered, this possibly had the dual function of a bowl quern rubbing-stone and a hammer-stone (see photograph). Other stone axes have been found at Barrowford and Beverley in Blacko. The crystalline examples could very well have had some high status purpose, or like other finds scattered across to the east coast, may have been trader's losses.

The lower grounds of the river valleys were marshy areas and therefore not easily navigated; the Pendle and Calder Valley, from Barrowford and skirting Burnley towards the Ribble, still bears many pre-Norman names in recollection of this. The number of *holme* sites (from the Old Norse *holmr* for *strip of land by a river*), and similarly, *carr* (Old Norse *kiarr - boggy land*) names along the river valleys are proof that these areas were marshy, even in relatively recent times. Barrowford, for example, had around a dozen *carr* and *holme* field names stretching from Newbridge to the Water Meetings. The Mesolithic nomads would know these areas extremely well

15

and would be able to pick their way through the valleys, across the swamps, when moving between their ridge and moorland habitations. They had no need of permanent ways, this was to change as the later cultures began to settle. Inter-ridgeways were particularly common in our area and would be utilised as a safe means of travel between the burgeoning settlements of the pre-Roman period.

The Secondary Neolithic

The later New Stone Age period is known as the Secondary Neolithic and ran from approximately 23,000 BC to 1800 BC. The people of this era were a product of the earlier Mesolithic culture through assimilation of their ways and the later migrants who brought continental influences with them. In the southern lowlands a feature of this later culture was to be the cursus formation where long avenues were created by rows of stones or earthen banks. Some of these features were massive civil engineering projects; cursus avenues could be up to six miles in length and are thought to have been used for religious purposes, a smaller example once existed near to the Long Causeway on the outskirts of Burnley.

Other impressive monuments left to us by these people are the huge earthworks of the Maiden Castle bank barrow and the Avery henge feature. The first monument at Stone Henge was started in this period, around 2200 BC henge monuments began to appear over the length of the country from Cornwall to the Orkneys.

The most impressive earthwork in Britain, to my mind at least, dates from the Secondary Neolithic and is known as Silbury Hill. Situated by the A4 near Marlborough, this giant 'steak pudding' is so big that it was thought to be a natural hill until the eighteenth century, in fact it is the largest ancient man-made earthen feature in Europe. Consisting of fourteen million cubic feet of natural material, and covering some six acres, the mound has reduced in size somewhat over the millennia, but it was originally over five-hundred and fifty feet in diameter and one-hundred and thirty feet high. Many archaeological digs on this site have shown that the hill was constructed of layers of different materials, chalk, turf and vegetable material, each layer being a constant thickness. These layers have remained undisturbed and still contain seeds, insects and flora in their original state – as for the purpose of the hill, archaeology has provided few answers.

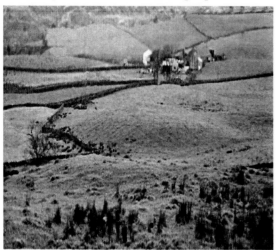

Round barrows below Knave Hill in the Shelfield area of Marsden (now Nelson)

More or less conterminous with the Secondary Neolithic peoples were the Beaker People who flourished in Britain from 2000 BC to 1600 BC. The first of these settlers came from Spain and a later wave made their way over from north-eastern Europe. Although they were still a primarily stone-using culture it is thought that the Beaker People brought a limited knowledge of metal working with them. The main source of information on this culture is from their burial remains whereby their characteristic burial urns were found at the head, or feet of the crouched skeleton. These types of burial have been found within our area, in particular on the Extwistle and Worsthorne moors. At Catlow quarry, above the town of Nelson, a number of clay pots containing cremated remains were found during the latter

16

part of the nineteenth century. The Beaker people left few settlement remains other than their round barrows, this method of burial endured for a very long period, into the Anglo-Saxon period in fact.

The Beaker Folk seem to have led nomadic lives although crops were certainly important to them and therefore they must have settled to a certain extent. Wheat had formed the staple crop throughout the Neolithic Age but the Beaker era saw barley become the main crop at around 80% of the corn total. Their situation of being placed as trading middlemen between the raw material sources, and the more wealthy southern lowlands, seems to have provided the Beaker People with a degree of influence over other local tribes. Taking advantage of the established trade routes they appear to have profited from the ever-increasing amount of goods being moved. This enabled them to coerce the available manpower of other groups into producing their trademark civil engineering structures.

The Beaker Folk were notable for the large stone circle sites such as can be found at Avebury, seventeen miles to the north of Stone Henge. This feature is very much larger than Stone Henge and consists of three stone circles within a massive circular earthwork enclosing some twenty eight acres including the village of Avesbury itself. The erection of single standing stones began in the Beaker period, the stone monolith base of Walton's Monument, on Knavehill above the town of Nelson, could very well be contemporary with this culture. Also within this area are a number of 'ringstone' sites which stretch southwards into the Extwistle and Worsthorne areas, these were possibly of the Beaker period but many of these features were cleared during the cultivation of land and dating these extant mounds can prove to be difficult.

The Bronze Age

The Beaker People straddled the period between the Neolithic and Bronze Ages, the period between 1600 to 1300 BC covers the Early Bronze Age. This whole period was characterised by a dry climate, the driest period during the past 7000 years in fact. As always, each age dawned very slowly, during the early Bronze period there was actually only a small quantity of bronze available to the people. A continued immigration of continental peoples, especially from Brittany, and the burgeoning trade routes from the Mediterranean and Southern Europe saw the Early Bronze Age peak at around 1500 BC. The southern Wessex Culture of this time was trading in goods such as Irish gold and copper, Cornish tin, Baltic amber and objects of art and luxuries from Brittany, Greece and Egypt. Our particular area did not appear to benefit greatly from this cultural advancement, raw survival would be paramount for the inhabitants of the north country.

The identified agricultural sites of this period were predominantly on the higher grounds, commonly on the slopes of river valleys. Greater areas of woodland were cleared as metal tools became more readily available. Burial customs still employed the earlier round barrows, although these developed into differing styles such as bowl barrows, disk barrows, saucer barrows, bell barrows and (more rarely) pond barrows. Where the Neolithic peoples tended to live unobtrusively *within* their landscape, the Bronze Age inhabitants made far bolder statements, especially with their burials. It became customary to site large barrows on the visible skyline of hills, not always the very top as a mound sited on the slopes was more easily seen from the surrounding lowlands. The hills of our particular area show excellent examples of this manipulation of the landscape, Monk Hall, high above the Thursden valley, is an area of burial mounds that dominate the hill above Monk Hall Farm.

The three hills of Great Hameldon, Hameldon Hill and Black Hameldon brood over the town of Burnley and are all are major features of the high grounds forming the southern edge of the Burnley basin. Below Black Hameldon, to the east of the village of Worsthorne, is Hameldon

Pasture. Here, at SD 891 325, are two examples of burial cairns both of which are constructed of stones and earth. One measures around fourteen metres in diameter and the other is larger at around thirty metres, both are around thirty centimetres in height although they would have been higher than this originally. Both these burial mounds were investigated in the nineteenth century, the smaller one revealed a stone cist (small chamber) in the centre which contained the cremated remains of an adult and child. The other had a large cist in the middle with a number of flagstones above it, unfortunately this mound was found to have been robbed of its contents at an earlier date.

Not far to the north of Hameldon Pasture is another burial barrow, around three-hundred metres to the east of the ancient Twist Hill defensive site at Extwistle (SD 889 337), this burial is a well preserved earthwork of stone and earth measuring around fourteen metres in diameter and thirty centimetres in height. In 1889 a complete ceramic food vessel was discovered here. A number of other sites are clustered around this area of Briercliffe and Extwistle including the tumulus of Ell Clough, Beadle Hill Camp and the Delph Hill stone circle.

High above the Admergill Valley, near Blacko on the Middop boundary, a pointed hill is known as Jackson Slack Hill (SD 845 434), in the Medieval period this was described as *"a pile of stones on the Pikelaw called Alainseat,"* the pikelaw description is from the Old English *'pic'* meaning *pointed* and *'law'* meaning *hill*. Alainseat was an important marker on the Middop-Brogden boundary and looking at the conical shape of the hill it becomes obvious why it came to be called a Pike Law. In late Victorian times the hill was recognised as a Bronze Age burial and an excavation shaft was sunk into the centre, unfortunately I have not seen any records of the results of this exploration. This site is on the nearest skyline relating to an impressive defensive earthwork fort or camp at Middop where the counties of Lancashire and Yorkshire meet. A large ditch, or sunken trackway, links the two sites and it would be surprising if they were not closely related.

The impressive earthwork defences at Middop. This site is of major importance within the ancient history of our area.

The mound and cairn on the summit of Pendle Hill has been ascribed to the Bronze Age, this is possibly the most visible example of manipulation of the skyline in the whole area.

Until the middle of the twentieth century it was widely believed that our area was unimportant within a nationwide trading context. An ever-increasing number of finds have rectified this, bronze axe heads and other implements, thought to be trading losses, have been uncovered on the early trackways. As time passed, and settlement sites were uncovered in greater numbers, it became more apparent that our area had a definite part to play within the wider commercial needs of Britain.

The Middle and Late Bronze Ages

Dating roughly from the period of 1300 to 700 BC the Middle and Late Bronze Ages saw a change in the hectic metal trading patterns of the Wessex Culture. Perhaps because of the massive increase in the copper mining industry of the Alpine region, the metal trade throughout Britain collapsed. Between 1300 and 1000 BC the Beaker Culture gave way to the Food Vessel culture. These people carried on the Beaker agricultural practices of herding sheep, growing barley and weaving cloth, the north being the most influenced by this culture. In the Middle Bronze Age the crescent-shaped flint sickles gave way to metal ones, this increased the amount of corn that could be harvested and also brought more marginal land into use. About a third of the grain crop was stored as seed and the remainder would be made into beer and bread, corn for the latter was ground in hollow saddle querns. In the 1950s a superb example of a saddle-quern (a hollowed-out stone of millstone grit) was found on Coombe Hill (SD 950 395) above Wycoller, a bowl-quern was also found at Barrowford in the nineteenth century. The corn was placed in the hollow of the quern and a 'rubbing' stone was used to reduce the corn to flour. Unfortunately a large amount of grit would be transferred to the flour thus causing premature wear in pre-historic teeth.

The farm animals in our area would be predominately sheep, along with pigs and oxen. Horses of the Shetland Pony type were also making an appearance on the domestic scene and short-horned oxen began to replace the earlier large, heavy-boned type. Settlers would live in huts and travellers in tents of hides stretched over a wooden framework. Farming complexes began to take shape where earthen banks and ditches formed field enclosures with trackway access, stock pens and ponds, early forms of plough (the cross-hough) and metal spades were employed. This marked the beginning of farming as we would recognise it today, it is likely that some of the modern farms are sited on, or near to these embryonic settlements.

As an example of this I would nominate Malkin Tower Farm on the southern slopes of Blacko Hill (see Figure 1a). Well served by streams, and completely surrounded by early ditches, dykes and ancient hedges this site, even today, retains a strong identity of early enclosure. The present farm appears to date from the first part of the eighteenth century although this replaced an earlier building or buildings. The original boundaries of ditch-and-walled earth bank, topped with thorn have survived and hedgerows of massive ancient holly are plentiful. When viewed from the air the boundary structure becomes clear, the farm is exactly in the centre of a surrounding master ditch designed to enclose what was, at the time, a relatively large number of acres. All other local field boundaries terminate at these master ditches, they do not cross them, this is a good indicator of a master boundary. Also on this site the ancient Black Dyke runs at a tangent to the old county boundary and forms the ancient demarcation between Blacko and Admergill. The dyke running above Malkin forms a deep clough which would be an effective defence for the settlement. It is evident that Malkin has been a self-contained enclosure for a very long period, a note of caution must be employed when dating these boundaries, however, as a long continuity of occupation means that the site could retain a Neolithic structure whilst on the other hand the British and Saxon periods would probably have seen farming activity here. Whatever the case, this area is a superb example of an early enclosure, probably having housed a great number of families during its existence.

There is evidence that the Malkin site formed part of a Norman deer park and it would go on to become even more interesting in the Early Modern period when Old Demdike, of Pendle Witch fame, took up residence here.

Yorkshire has many Food Vessel remains, the Quernhow Barrow at Ripon and the many examples of *cup-and-ring* stone carvings on the moors above Ilkley, along with other sites near to the rivers Aire and Nidd, are examples of these. *Cup-and-ring* markings are very distinctively

carved concentric rings surround a carved-out hollow. The symbolism of this is unclear; they have been ascribed to a religious purpose of birth and rebirth, a modern theory is that they denote visible sound-wave formation, as far as I am aware no examples of these stone carvings have been found in the Pendle area.

Into the Late Bronze Age the pattern of farming was settled, stock fields were normally of one or two acres and surrounded by V-shaped ditches, as opposed to the U-shaped ditches of the previous ages. As the availability of metal spread the agricultural practices also improved; the light metal plough enabled cross-ploughing of the soil and thus speeded up, and improved cultivation of the barley and wheat crops. In the south this led to a growth in the population levels although it is debatable as to how much this affected our area at this time.

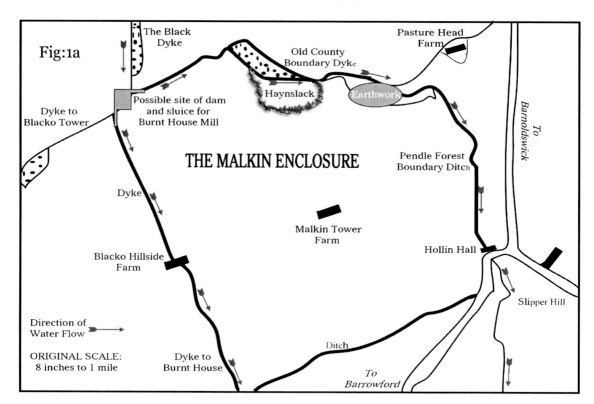

The Iron Age

As the Bronze Age drew to a close the gradual migration of metalworkers from Europe increased, a wave of immigration from the Hallstat area of West Germany was followed by another from the Swiss La Tene culture and, by 500 BC, iron objects were becoming readily available. The Early Iron Age ran from around 700 BC to 400 BC, the Middle Iron Age from 400 BC to 120 BC and the consequent Late Iron Age from 120 BC to the Roman invasion. The general Iron Age can be thought of as the end of our pre-history for there is written evidence that the people of Brittany were trading with the people of our island, referring to us as *Albion*. Within two hundred years the Greeks were calling us the *Pretanic Islands* which eventually became *Britannia* in the Roman world.

Traditionally the Iron Age people of Britain have been known as Celts, a generic term that seems to have grown to prominence amongst scholars since the eighteenth century. The reason for this is that the great influence wielded by the Celtic peoples of Gaul (France) over the Southern British cultures led to all of the inhabitants of our island being labelled as 'Celts'. As archaeology has advanced, however, it would appear that the evidence points to the British Iron Age as being a direct continuity of the local Bronze Age, rather than being a purely continental influence. In other words, our culture evolved locally with input from many generations of British settlers, a moderately steady influence within this continuation was absorbed from continental contact. Britain, then, could be seen as being part of the wider Celtic cultural world without actually being a pure Celtic nation. To further emphasise this the Roman Classical texts describe the southern Britons as being tall and fair, the Caledonians of the north were red-haired and the Silures (South Welsh) were swarthy people. This confounds the theory that the British were a single racial and cultural type.

The Iron Age inhabitants of Britain are difficult to assess with any great accuracy as skeletal burial remains are surprisingly few in number. From the exhumations that have been possible the average stature of adult males has been calculated to be five-feet six and a half inches, the maximum height within the samples was five-feet eleven inches. The average height of women was five-feet two inches (the maximum being five-feet seven inches). Few adults survived beyond the age of fifty and childbirth presented a greater risk of death than any other factor in peacetime. Generally speaking there were few actual deformities within the peoples but specific areas showed strong signs of malnutrition. Women were usually found to have been lacking in calcium, up to 50% of children and 25% of adults would have iron deficiency (anaemia), possibly due to severe lack of vitamin C (required to aid the uptake of iron within the body) during the winter months. The usual diseases such as polio were a threat, as were parasitic ailments such as roundworm. Over 25% of the population suffered from severe arthritis of the spine, this indicates the strenuous physical life of the people. These findings, however, are fragmentary and cannot be taken as firm evidence of the health of the nation as a whole. Certain communities within favoured areas could have had the advantage of better crops and a longer growing season for vegetables, fruit and berries, along with better access to fish stocks would also be an advantage.

As the use of iron became more widespread farming practices improved, iron ploughs, for example, were more effective than the previous bronze implements. Around 150 BC ox-drawn ploughs began to be used in the south and this important advancement would spread slowly northwards. New kinds of grain were introduced, emmer wheat and spelt wheat were grown in tandem, whilst barley and the newly introduced oats and rye were planted on previously untenable land. The growing season was thus extended and the new diversification of crops meant that the grain was not as susceptible to pests and disease as was previously the case. In our corner of the North Country a pastoral lifestyle was still the norm, although arable farming steadily increased. Wool appears to have been the only local fabric material (although flax could possibly have been utilised), certain families would specialise in cloth production as looms have been found within 'specialised' huts of Iron Age settlement enclosures.

Celtic field patterns were a continuation of the earlier Bronze Age system but the later method of cross-ploughing gave them their distinctive shape, field groups appearing to be clustered around a central point are known as co-axial field systems. Examples of these fields are rare today, especially in areas of intensive farming practice, but we do still have a small extant number of these groupings in our area. A close look at an aerial photograph or local map will show a small number of examples of grouped fields with ancient hedges radiating from a central point, a field system located at SD 8144 4681 on the Gisburn to Rimington lane is a case-in-point.

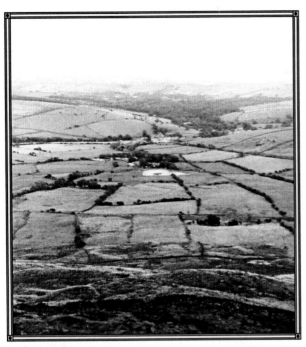

Radial field system at Barley, taken from Pendle Hill

The Saxons also adopted the existing pre-Roman and late-Roman field systems, their methods of agriculture were not much different to the indigenous British ways and some co-axial field patterns may be Saxon extensions of an earlier field pattern nucleus.

The other field pattern still to survive is still known as *Celtic terracing* whereby an area has an obvious stepped appearance. A minor example of this can be seen at Park Hill, opposite the car park where the field sweeps down to the river, no Saxon pottery has been unearthed here, however, the earliest pots found around Park Hill appear to date from the thirteenth century onwards.

The most spectacular field terracing I have seen within our area has recently come to light through a study of aerial photographs of the Middop valley where a farm named Craven Laithe lies at the foot of the pikelaw called Jackson's Slack (see illustration). An area covering a number of acres adjoining to the farm (SD 84520 43878) has been terraced, this is pasture land that has been reclaimed from the moor in a typical Saxon manner whereby the terracing forms a flat area on what was originally a fairly steep slope, there is, of course, the usual caveat in that this feature may be relatively modern but the context of the site suggests an early date. Of additional interest at this site is the fact that there appears to be two large rectangular crop-marks near to the terracing, these seem to be typical of early building patterns, the rectangles have a smaller square feature within their northern end. Also, there is the dyke (or possibly sunken roadway) running through the Bronze Age earthwork at Middop and up to the edge of the terraced feature and the nearby farm at Craven Laithe. This would seem to indicate that there was a definite link between these two (proposed) important sites.

The later fields tended to be around four-hundred feet by two-hundred and sixty feet and surrounded by earthen banks with the final plough furrows spaced fifteen inches apart. South-facing field slopes were utilised for plough-land, the bottom of the slope would be terraced, or have a large bank in order to stop the soil moving downhill. The area around village of Barley has been recognised as having some of the best visible examples of early plough land in the country (locally known as 'Roman Ploughing'). The steeply banked Lenches area of Colne Waterside is an example of the use of lynchets and this is where the name of Lenches originates.

Wood was a material of vital importance and was required in large quantities, this meant that forestry, as opposed to the simple clearing of trees to facilitate land cultivation, would be a specific skill. Carpentry was a well-advanced craft as can be seen in the archaeological finds of chariots and carts; the wheels were constructed in the three-timber manner (employing oak, ash and elm) that has been used up to the present day. Hand and treadle-powered lathes were employed for woodturning and standardised wooden components were mass-produced. Large baulks of various

types of timber were required to construct the palisade fences of the local forts and a large amount of coppiced wood was required for agricultural fencing.

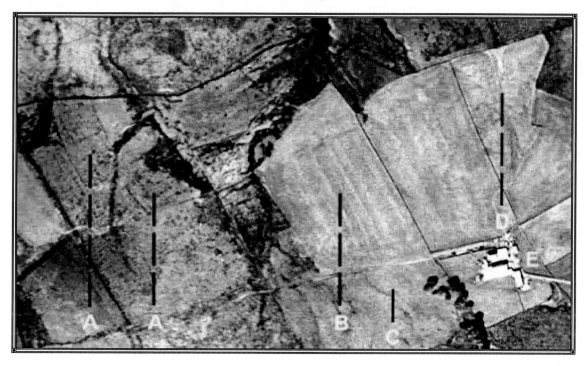

*The Craven Laithe site (Craven Laithe Farm shown **E**) at the head of the Middop Valley, shows a number of possible features.* *Photograph: External Stock*

A = *Rectilinear features could indicate an early enclosure or building.*
B = *Terracing of the land.*
C = *Possible ring-ditch enclosure.*
D = *The dyke, or roadway, leading from the Middop earthwork.*

Pots were in great demand both for kitchen and tableware and were available in large numbers. The extent of our local pottery manufacturing industries is unknown, home-grown pots were constructed of clay coils until around the first century when the kick-wheel was introduced (enabling a better quality pot to be 'thrown') although there are examples showing that the earlier method persisted in our area until the modern period, cressit pots were used as oil containers in handloom weaving and many of these were made locally using the coil- construction method Higher status pots were imported from the continent and were readily available to the wealthy.

Measuring 10cm in height this example of a coil-construction pot is made from local gritstone clay. The green glaze suggests a Medieval date .

The process of smelting iron was different to that of bronze, much higher temperatures were required in the furnace. Also iron-bloom, once smelted needed to be continually worked to drive out the impurities. The finished wrought iron did not make vastly superior tools to earlier counterparts but the availability of the metal meant that it rapidly superseded bronze. Iron ore is readily available throughout most of Britain, unlike the copper and tin required for the making of bronze. Although our particular area had limited deposits of iron the relatively local Whitehaven area (in the present county of Cumbria) was a major supplier of the metal. It is probable that the raw ore was smelted at source so as to reduce the bulk when carried. Caesar wrote that the Britons used iron bars of the specific weight grades of 1, 2, 4, 6, 8, 12 and 16 as currency, these could easily be carried around the country and traded in areas with no ore deposits of their own. Archaeological research has shown that almost all of the known Iron Age settlements have produced furnace slag, this points to large scale iron-working having been carried out throughout the country.

Gold was worked on a large scale in the Iron Age, in Gaul alone there are known to have been many hundreds of mines; the high quality of craftsmanship shown in many of the artefacts so far uncovered is staggering. The ancient trading routes that developed in the Neolithic period were now carrying gold in quantity, the Romans stated that gold was a British export but no substantial gold source has been found to prove that people used supplies from the mainland within this period. There were, however, well established supplies from Wales and Ireland. Within our area a scattering of gold artefacts have been recovered, only last year (2005) a large gold amulet was found in the Brogden area of Barnoldswick, this was on the line of the east-west trade route from Ireland through to Kildwick, the Continent and the Baltic.

The Classical texts describe Iron Age Britain as comprising many separate *civitates*, or tribes, showing a remarkable system of land-use from farms to forts. Most communities appear to have been limited to their own local areas with limited interaction amongst neighbours. Communities did come together for certain reasons, the main ones being intermarriage and trade although there must have been a strong suspicion of 'the other' between different tribes. Even in the seventeenth century we have examples of this, one being found within the folklore relating to the Lancashire witch trials of 1612. Tradition within Pendle Forest has long had it (mistakenly) that Alice Nutter *"came out of Trawden Forest to marry Richard Nutter of Roughlee"* the context implying that she was from a foreign culture. The village of Roughlee is in the Forest of Pendle area, only three miles from Trawden Forest, yet here was a distinct suspicion of 'otherness.' Further to this there is a small square earthwork to the north of Barnoldswick, this is marked on the map as Bomber Camp and archaeological research has shown that the enclosure had no external enclosures and has yielded pottery from the fourth century AD. This suggests that this is the site of a Romano-British homestead, the like of which has not been found in Lancashire, this points to the occupiers having been strongly influenced by the Roman culture east of the Pennines. If this was indeed the case then White Moor and the heights of Weets Hill, between Blacko and Barnoldswick, could very well have formed a cultural divide (along with an obvious physical barrier) between the early tribes. Even today the high ground forms a perceived barrier between east and west. It could even be said to form a cultural watershed; until the recent mass-ownership of cars the people of Barrowford tended to look to the west for their needs whilst Barnoldswick people commonly chose Skipton and Bradford to the east; this represents a tangible continuity in social practice over a period of two millennia.

In the Late Iron Age a heavy iron plough was introduced by Belgic settlers, this enabled the amount of land under cultivation to be expanded, consequently the population grew and these small farming communities must have grown closer together. Many generations of intermarriage between the tribes would lead to a larger related grouping and it would have been mutually

advantageous to share outlying lands. Communal defensive enclosures, such as hill forts, meant that the numerous groups within an area shared the responsibility of both erecting and maintaining these structures. The limited horizons of our hilly backwater would mean that our regional identity would be quite strong. To make a personal postulation at this stage I would place the local tribes of our area within a 'basin' bounded by the main hills of Pendle, Boulsworth, Black Hameldon, Great Hameldon, Wheathead Heights and down to the River Ribble at Gisburn.

This area has become a fixed ecclesiastical and civil administration district and is described by T.D. Whitaker in his *History of Whalley* (1881) as:-

"The natural districts of the great excavation between Pendle, Pinhaw, Bulswerd (Boulsworth), Hameldon, Cliviger Pike and Hameldon-in-Hapton — these are known to the British as Pinhaw, Hameldon, Calder and Colne. The modern distribution of civil and ecclesiastical lands in this area are known as Whalley with its immediately dependant townships, the chapelries of Burnley and Colne and the Forests of Pendle and Trawden."

The area within the above bounds is the one referred to as *'our area'* throughout this text and can be seen to form a 'virtuous circle' within which our forebears operated – West Craven from the Ribble 'washes over' into the above area and is included.

Towards the end of the Late Iron Age, around 75 BC, a common coinage was introduced into Britain from Gaul, these were poor copies of earlier Roman coins. The southern British began to mint their own coins and the inscriptions on these can be seen as the first stage of writing. Also at this time the 'Celtic' form of art works reached its peak, the enamelled products from around 50 BC through to 50 AD are considered to be the best of British work within the La Tene Champleve influence. The abstract method of swirling, interlocking patterns was applied to many objects and is an instantly recognisable feature of today's Celtic art, the style of book decoration known as *'illuminated lettering'* is a wonderful example of this method. This period also saw hill figures being carved into the surface of the chalk downlands. At three-hundred and sixty-five feet in length the White Horse at Uffington is the largest example of this work, the fact that the outline of the figure is cleaned regularly has ensured its survival from around 50 BC.

Before the conquest of Britain the Romans described its inhabitants as being very warlike but Diodorus, shortly after the time of Caesar, stated that inter-tribal relations were largely peaceful. Given the settled nature of the later Iron Age it is not unreasonable to see the people becoming more involved in expansive agriculture, as opposed to a high level of violence. Trouble probably ebbed and flowed, with long periods of calm. Armed violence would take the form of personal and clan feuds, small-scale wars between neighbours took the form of local skirmishes and raids. It is also possibly that personal bouts between elected warriors would generally keep the outbreak of warfare to a minimum.

* * * * * * *

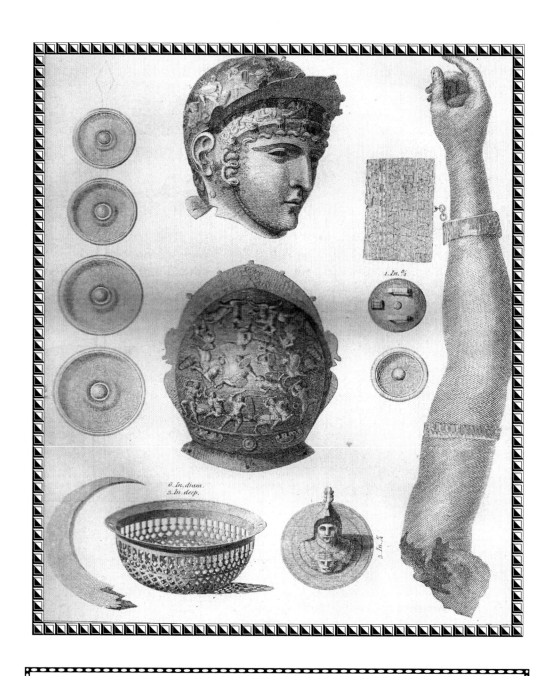

ROMAN ARTEFACTS FROM RIBCHESTER
Taken from an original lithograph - *History of Whalley*

Chapter Two

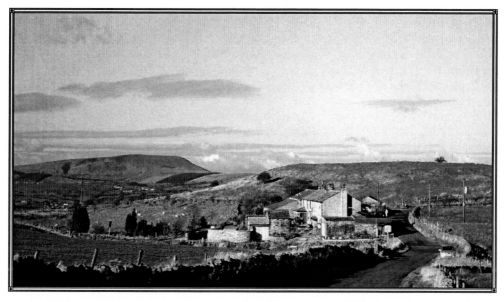

*Looking north-west: the hill fort of Castercliffe (the level area behind and above
the farm buildings) has long stood silent sentinel over the valley trade routes*

The Roman Iron Age: Hill Forts

In the final centuries before the coming of the Romans hill forts became a prominent feature upon the landscape. Varying in size, date and construction they were very often a re-working of earlier features. These forts were of a defensive nature and required a good deal of manpower, the fact that they were constructed is an indication of the response by local inhabitants to a growing threat from both the indigenous people and continental migrants. The growing levels of population meant larger areas were being settled and cultivated and therefore the scattered local communities would come together to ensure mutual security. As a result of the need to use hill forts it is possible that a specific warrior, or noble class, came to the fore and presented themselves as defenders of the community. In any case, this period saw the rise of a distinct warrior class, hierarchical societies began to grow in both size and number.

The method of construction is reasonably standard across the known hill fort sites. Initially a shallow ditch would be created to set the outline of the fort then gangs of diggers would start at different points. As the main ditch was being dug the excavated material was thrown inwards to form a rampart, the outer ditches were then created in the same manner. Depending upon the availability of local materials, either wood or stone would be used to shore up the steep earthen banks and form palisade fencing around the main enclosure. The palisade would take the form of a solid, high wooden fence with, perhaps, a stone shoring or base and a massive double gateway

would control access into the main part of the site. Although these hill forts have now been weathered into soft contours in their prime they would make an impressively dominant feature upon the skyline.

The design and size of hill forts varied to some degree upon the particular part of the country in which they were situated, how many people from within the strategic area were to be accommodated and, presumably, the level of perceived threat.

Caesar wrote a description of the fighting methods of the people who defended the forts; horses were harnessed in pairs and used for drawing chariots in offensive warfare, these chariots were two-wheeled vehicles with a light wicker platform to carry the charioteer and a warrior. The warrior was armed with two throwing spears, a dagger and a sword. The charioteer would drive across the battlefield whilst his passenger hurled his spears, the warrior then dismounted whilst the chariot withdrew a short distance. If the warriors were struggling against the enemy then they could fall back and be whisked away by the vehicles. This method of attack combined the fighting power of infantry with the mobility of cavalry.

It is generally thought that there are a number of hill forts yet to be discovered in the territories inland from the western coast. Taking our particular Pennine region, the major hill fort at Ingleborough can be thought of as dominating the eastern limits. Situated at SD741 746 the defences sit on the heights of the mountain at over 2200 feet. The fort is marked by ancient stone walls enclosing around fifteen acres within which were at least nineteen hut circles. The site dominates the headwaters of the rivers Ribble, Greta and Wenning and therefore control of these strategic routes was afforded to the builders and occupiers of the defences.

On our western flanks sits the hill fort of Portfield, near Whalley (SD746 355), a site occupying a position between the coastal lowlands towards the Ribble estuary and our Pennine uplands. Portfield is a hill fort of the promontory type, covers around three acres and rises three-hundred feet above the nearby river Calder. A twenty-feet wide rampart had been constructed to the north side, along with an outer ditch and counterscarp bank. To the southern side of the defence another rampart probably carried an internal palisade. Finds from as early as the Neolithic have been found at Portfield, the site appears to have been of a high status indicated by finds of the rare Grimston type of pottery. Unfortunately four large water pipelines cross the site and these have damaged much of the archaeology, also twentieth century farming work has flattened some of the ramparts. In 1966 workmen digging on the site uncovered a hoard of artefacts dating to the seventh century BC amongst which were a gold tress-ring and a bracelet along with a number of bronze items thought to have belonged to a bronze smith.

Around eight or nine miles to the west of Portfield, in the heart of our area, is the hill fort at Castercliffe (SD884 388). The site was situated on a ridge adjacent to the Roman high road between Colne and Burnley and the panoramic views from here show that the site would have been carefully chosen so as to enable control over the movements of people and troops. It is no coincidence that the valley directly below the hill fort was chosen to take the Leeds and Liverpool Canal from the western lowlands over the Pennines by way of the Aire Gap. The importance of this route is highlighted by the siting along its course of the Roman fort at Elslack, the Roman villa at Gargrave and Skipton Castle.

Known locally as *Tum Hills*, possibly from the Celtic word *tun* meaning enclosure, or from *tumulus* describing the mounds of the site, Castercliffe is thought to have been a site of higher status than other Lancashire hill forts, at least for a period of time. The defensive enclosure of the fort occupied around four and a half acres (1.69 hectares) but the site as a whole is much larger than this when the related defensive features of the surrounding area are taken into consideration.

Portfield is of the bivallate promontory type of construction whereby the fort of Castercliffe is a contour site, the fort being formed along the top of a natural ridge. The argument has raged for

centuries as to whether this site was actually ever occupied by the Romans, and furthermore, did the area of Colne ever serve as a Roman outpost? In *The Annals of Colne* James Carr dedicates a number of pages to the issue, he reports the contents of a letter written in 1696 by Reverend Hargreave in favour of the pro-Roman argument:-

"I have often, from the name Coln, conjectured that the place was of more ancient Original than the Tradition current among the Inhabitants made it; and I was further confirmed in this by the great number of Roman Coins, which have been frequently dug up nigh it, as in Wheatley Lane, which are generally copper; and those Silver Ones cast up by a Plough, three or four years agoe, nigh Emmet, enclosed in a great Silver Cup, some of which I have seen; one of Gordianus (AD 236- 8), was very legible, and another not so. I have seen parts of others, whose remains shew they were one of the Antonines. But that which most confirmed my conjecture of this Town's being a Roman Station, was a conversation I was honoured with the last summer by our reverend Dean of York, Dr. Gale, who was pleased to show me a Book, written in about the seventh Century, by a nameless Author of Ravenna, which is, so far as I know of it, nothing but an Itinerary wherein many ancient names of Towns through the Roman Empire are remembered, which others have omitted, especially in Britain. The Author comes from Camolodunium to Colunium, and thence to Gallunium, which by the usual transmutation of the Roman G into our W, that learned person concludes to be Walley, and thence, I think, I may safely, from the distance of Coln from Almondbury, and its lying to the Road between that and Walley, conclude that Coln was a Roman Station.........The respect that I bear to the place of my Birth, has perchance tempted me to decide too peremptorily in favour of it, which I wholly submit to your very judicious censure; and if what I have written so hastily be in any way serviceable to your Chapter of Antiquities, I shall be extremely proud to have been in the last measure, Your Humble Servant."

To counter this argument Dr. Leigh, in the middle of the nineteenth century, wrote in *The History of Cheshire and Lancashire*:-

"With all deference to that learned gentleman (Mr.Hargreave) it is my opinion Coln was NOT a Roman Station, and that for these following reasons; First, because where the Roman Stations were there are usually fosses and fortifications, of which this Learned Gentleman gives no account, and tho' the Coins found might induce him to think so, yet that Instance is not convincing, since they are frequently found in several other parts which in probability were never ROMAN Stations, as at Bury and Standish in Lancashire. Besides, it is frequently observed that, where the Roman Stations were, there are usually found Roman Altars, dedicated to the Genius of the Place, Paterae and Fibulae (goblets and brass rings). It is likely, therefore, that where those Coins are found, and not the other Antiquities, they were only buried there by the Romans in their marches when they quitted their stations, who rather chose to hide them in the Earth than let them fall into their Enemies hands. Secondly, it is probable it was not a Roman Station from the account that is given of the Boundaries belonging to them; for, as Siculus Flaccus informs us, the Fields that lay near the Colonies were determined by several sorts of bounds; in the Limits that were placed for Marks, sometimes one thing and sometimes another; in some a little statue of Mercury, in others a Wine Vessel; in others a Spatula, in others a Rhombus, or a Figure in shape like a Lozenge; and in some, according to Vitalis and Arcadius, a Flaggon or Jarr. Now, none of these as ever I heard of having been dug up at Coln, I cannot conclude it a Roman Station, but that the Coins found there were lodged by the Romans in their Itineries (marches)."

A Roman altar found in Lancashire and now used as a church altar

A letter of reply in the Preston Guardian further stoked the fires of debate:-

"In reply to Leigh's objection two things may be urged. First, that it is absurd to assume that no ancient remains "exist" at a given spot, because, at a given time, none have been discovered. And, secondly, that it is an error to imagine that all Roman Stations in Britain were of equal importance, equally populous, equally imposing and equally permanent. In respect of the former consideration, fresh traces of Roman occupation have been met with here since Leigh's days, and others yet may be forthcoming in process of time. And, as to the latter suggestion, it is quite possible that Colne was a minor station, held by a small garrison at intervals during periods of disturbance, and abandoned on account of its remoteness from the sea and from great military roads in time of tranquillity. Leigh urges that altars and similar structures are commonly found at the Roman Stations, and that no such relics have been heard of at Colne. This would apply with equal force to Walton, and many other places accepted by antiquaries as sites of stations in various parts of the country, where no altars, inscribed stones, or vestige of Roman architecture have been exposed to view. Nor is it possible for Leigh to dispose thus summarily of the fact that the rampart and ditch of a large military earthwork, most apparently Roman, are still visible on the adjacent summit. This may have been the only fortification of the Romans at this spot, but it is more likely that it was but the "summer camp," and that another fortress, available for winter quarters, was nigh at hand in some less exposed situation."

To reinforce the argument for the existence of a Roman Station at Colne Whitaker stated that the monk Richard, a scribe in Roman times, noted the details of Roman stations along the east-west route (or *iter*) from Manchester to York. Richard wrote that there was a missing station *ad Alpes Penninos* (beyond the Pennines) and between Rigodunum on our side of the hills and Olicana (Ilkley) on the Yorkshire side. He then went on to postulate a site for the station at an even distance along the iter so as to accommodate the standard daily Roman marching distance.

Whitaker takes this up and placed the missing station at Greenfield in Colne. He stated that:-

"It seems probable that the exact spot occupied by this station was in some of the low grounds beneath the present town (of Colne) and on the banks of the river where all remains of it have been effaced by cultivation. Perhaps the real site is now irretrievable , but there are two lingulae of land betwixt Colne and Barrowford on the north side of Colne Water and formed by the influx of two inconsiderable brooks, which have equal pretensions. The modern town of Colne has certainly none. It is much too elevated and too far from the water..... the environs of Colne appear to have been populous in Roman times, as great numbers of their coins have been discovered in the neighbourhood, particularly at Wheatley Lane and near Emmet where a large silver cup filled with them was turned up by the plough in the latter end of the 17th century."

30

Richard's stations were noted as being:-

MANTIO ALUNNA CALUNIO GALLUNIO MODIBOGDO CAMULODUNO

Whitaker places *Mantio* at Manchester, *Camuloduno* at Slack, *Alunna* at either Littleborough or Castleshaw, *Modibogdo* was a corruption of *Rigodunum* and was therefore Ribchester and *Gallunio* was a corruption of *Calunio* and therefore Colne. Another view of the site at Castercliffe was provided by the historian T.T. Wilkinson, of Burnley, in a nineteenth century paper entitled *'The Battle of Brunanburgh:'*

"The entrenchments on Castor Cliff form a parallelogram measuring about 550ft. by 520ft. broad; but the walls appear to have enclosed an area of about 380ft. in length by 340ft. in breadth. The camp has been protected on the south- west front by a deep gulley, and also by a double vallum (rampart) and fosse (ditch), which are still entire about the whole crest of the mound. We are informed that many hundreds of tons of stones have been carted away from the walls within the last 30 or 40 years, all of which appear to have been subjected to intense heat. Large quantities still remain half- buried in the soil, many of them completely vitrified, and others presenting a singularly mottled appearance, from only having been half burnt through. The burnt sandstone and lime form excellent manure, and at the time of our visit a luxuriant crop of corn and cabbages had just been gathered from the ditches of the camp."

"A less elevated plateau of considerable extent bounds the north-eastern slope, which is again protected by a steep cliff down to the Calder, near Waterside. This would afford a convenient space for the exercise of large bodies of troops, or for the protection of the cattle belonging to the garrison, and it has probably been used for such purposes by the respective masters of the fortifications. Being almost inaccessible on all sides except the east, where they are skirted by the Roman road, these defences when complete, must have constituted one of the strongholds of the north, since they overlook the whole of the Forest of Trawden, Emmott Moor, a great portion of Craven, with the valley of the Calder, and terminate the eastern limit of the ridge on which Saxifield is situated. Castor Cliff has evidently been the key of this portion of Lancashire in the hands of the Romans, and its importance would undoubtedly not be overlooked by the Saxons and Danes."

The argument has still not been settled, opinion falls into two camps (no pun intended), the timber and stone palisades show strong evidence of having been destroyed by fire but this could have occurred a number of times within different periods throughout the site's history. One thing is certain, Castercliffe was the product of a huge amount of effort by organised labour, probably over a number of years. The amount of earth that had to be moved, the ditches and ramps, the stone walls and the heavy timber palisade; all of these required a deal of effort and dedication from the local tribes.

Roman Influence

Information regarding the occupation of the Castercliffe area during the Roman period is sketchy to say the least. The nearby Roman Station at Ribchester is the only one to have been mentioned in the *'Notitia Imperii'* of AD 432, the first document available following the *'Antonine Itinery'* and the writings of Ptolomy in AD 140. It is thought that the Sixth York Legion were stationed at Ribchester and would, therefore, control the other local Pennine areas. Claudius

Gothicus led the Legions from their stronghold at York in the years AD 268-270 and his only daughter married Eutropius, a Roman noble. Their son, Constantius, succeeded to the Empire both in Britain and Rome, he was appointed Augustus at York in AD 306. Constantius married Helena, the daughter of Coel, a tributary king of the British Iceni tribe. He was descended from Praesatagus, the king of the Iceni, by his queen, Boudica. The alliance of Roman and British families created confidence amongst the people who were more easily persuaded to adopt the Christian religion of Constantius who was better known to us as Constantine the Great.

Constantine's wife, Helena, was a Christian (probably a late convert) and is said to have discovered the remains of the True Cross when she led a pilgrimage to Jerusalem in either AD 323 or the spring of AD 327. Having removed many tons of rubble from their excavation site Helena's team were said to have uncovered three crosses, still with their nails attached, and a written tablet attached to one. She founded a number of basilica churches amongst which were the Church of the Holy Sepulchre in Jerusalem and the Church of the Nativity at Bethlehem. Helen was to become a saint of the Eastern Orthodoxy and Roman Catholic Churches.

Because of her eagerness to spread Christianity throughout the country Saint Helen is credited with being a great road builder, many sites are named after her. We have two of these within our area; St. Helen's well at Colne Waterside and St. Helena, now part of the municipal golf course on Kings Causeway, Nelson. It is possible that these sites reflect in their names a memory of very early Christianity within the area, care must be taken here, though as some schools of thought believe that the Helen dedications actually refer to an earlier British deity, either way we have here references concerning early settlements within the bounds of Colne and Nelson. It is interesting to note that there are few St. Helen sites in Lancashire, (amongst which the well sites are themselves rare), they are concentrated mostly in the Lincolnshire and South Yorkshire areas. This makes the two local sites all the more interesting. It is thought that Helen died in the year AD 329 at the age of eighty.

Many artefacts of the Roman occupational period have been unearthed throughout our area, far more will have been found than are actually recorded. The Medieval ploughing and coal mining operations, especially on concentrated early sites such as Castercliffe, must have turned up a huge amount of ancient artefacts, probably because they were not recognised at the time as being ancient they would be dismissed as mere curiosities and thrown into the nearest midden. Coins tended to be kept because of their intrinsic value, especially those made of precious metal, although a great number would have been scrapped and sold at the going base rate. A large number of ancient coin finds have survived, both in private hands and under the auspices of various museums. The following are known to have been found in the area:-

- *A 'large number' of Roman coins in Wheatley Lane:*
- *A 'large number' of Roman coins in the Greenfield area of Colne:*
- *Coins of one of the Roman Antonines and Gordanius in a silver cup at Emmott:*
- *A 'large number' of Roman coins of the Emperor Hadrian and Pius at Downham:*
- *A 'considerable' number of Roman coins at Ribchester:*
- *1000 coins dating from AD 252- 282 at Heywood:*
- *A fine collection of medals at Mereclough in 1695:*
- *Coins both Consular and Imperial at Cliviger in 1698:*
- *A glass vessel full of brass coins of Constantine and Lecinius near Barcroft in 1764:*
- *'Numerous' coins of the Roman period at Castercliffe on a regular basis:*
- *Three Roman coins at the Holme (Water Meetings), Barrowford in the 1980s.*

Although the reported number of coins is often vague the pattern of finds, and the type of coin,

can provide a *general* picture of the movement of people across regions but, as the coinage of immigrants was used by the native population, care must be taken in the assignment of settlements around coin finds. As an example of this, in 1921 Peter Walsh found a coin on his allotment on the north side of Castercliffe, this turned out to be of Greek origin, dating from before the Roman occupation. The probability here being that either the Romans had used the coinage of a suppressed nation or a Roman Legionary, perhaps of Greek origin, had brought it with him to another part of the Empire. Apart from the many coins of Constantine the Great found in our immediate area large numbers have also been unearthed at Manchester, Stretford, Fleetwood, Preston and Burnley. This is thought to show that Constantine had a definite presence hereabouts and this could also bolster the argument for the early naming of the Saint Helen (Helena) wells.

Castercliffe

Considering its impressive nature, and highly strategic siting within the local topography, the hill fort site of Castercliffe has undergone surprisingly little archaeological exploration. The Reverend J. A. Plummer carried out a limited survey of the fort enclosure between 1958 and 1960, unfortunately Plummer died before he could publish his results. The site was further excavated by Forde-Johnston in 1961 when he concentrated mainly on the surface evidence. He published his findings as *The Iron Age Hill Forts of Lancashire and Cheshire* in the transactions of *The Lancashire and Cheshire Antiquarian Society, volume 72, 1962.*

Over a three-year period, from 1970 to 1972, Manchester University organised an excavation at Castercliffe in the form of a training exercise for their archaeology course students. These digs were led by David Coombs who managed to obtain some of the notes that Plummer made in his earlier excavation, these show that he had been of the opinion that Castercliffe would have been abandoned sometime between the years AD 60-90. In 1982 Coombs published a full report his 1970-71-72 excavations in the transactions of *The Lancashire and Cheshire Antiquarian Society, volume 81.*

A short description from Coombs' report is that the occupational area within the defensive enclosure forms an oval of ninety metres by sixty metres, the defensive enclosure in total, including the outer workings, measures 1.69 hectares (4½ acres). The inner rampart took the form of a stone and timber revetment, or palisade but due to the robbing of the stone in the nineteenth century the only remnant of this rampart is a low bank feature. The outer rampart is better preserved, this rises to 1.6 metres above the level interior and 2.8 metres above the bottom of its associated ditch, in some places, however, this rampart has been totally robbed-out.

The inner side of the outer rampart was found to be a banking of loose stones, these were mixed with burnt earth, smaller stones, charcoal and lumps of vitrified material and the stones of the inner rampart were found to have been robbed-out down to the natural earth level. This level of clay was extensively burnt and was covered in a layer of charcoal, in this layer the remains of burnt timbers were found, analysis of these timbers showed them to have been of oak. The excavations carried out by Coombs covered a reasonably large area within the interior of the fort but he recorded no finds signifying occupation, or disturbance, within the enclosure. It has been postulated that the enclosure was used as a pen in which the animals were kept whilst the humans inhabited another part of the extensive site. The limited evidence from the available records shows that only a tiny part of the whole site has been excavated, and these were limited digs in any case.

Carbon-dating has been used to approximate the date of the construction of Castercliffe, the results show the timbers from the vitrified inner rampart date to 510 ± 70 BC and those of the rear revetment date to 510 ± 60 BC. It is possible that the two ramparts were not built by the same people as they are of different construction, the inner is of timber and revetted stone whilst the

outer is timber revetment with a clay core. The inner rampart is almost certainly the earlier construction of the two, it is likely that the outer rampart was built as an additional strengthening of the defences. It is thought that the fort would have finally have been abandoned following the burning of the ramparts. A calculation of the number of timber posts used in the palisades has allowed an estimate of the time it took to build the defences :-

Inner Rampart

Lacing posts	1240
Cladding posts	775
Large posts	620
Total no. of timbers	**2635**

Outer Rampart

Large posts	3650
Lacing posts	2760
Cladding posts	1380
Chavaux-de-frise posts	2200
Total no. of timbers	**9990**

Given the number of posts in the construction of the inner rampart it is suggested that one-hundred people, with eighty of them actually employed on the immediate work and twenty supporting workers, would take one month to complete the work. Accounting for poor weather, illness etc, this is extended to three months, or a summer season, using the same criteria, the outer rampart would have taken six months to complete. If the community were to be under threat then it is possible that these times would contract to around four months in all. These figures are purely educated guesswork and provide us with a very rough idea only. Apart from the rampart construction, the theory does not take in to account the thousands of tons of heavy clay and shale that it was necessary to shift by hand during the construction of the outer ditches and mounds of the extended site. It would appear that this was an ongoing communal task, the extent of which would be counted in years of labour.

A series of timber posts excavated near to the centre of the inner enclosure appear to have been structured so as to elevate a building above ground level. This was possibly a grain store, or other building of a specialised nature. Using evidence found at other excavated Iron Age sites the inner enclosure would have contained a number of round-houses. The very centre of the enclosure would be of higher status and therefore the ordinary people would have lived around the inner edge of the palisade. Aerial photographs show evidence of hut circles, with their openings facing east, outside of the enclosure. It has been suggested that the main entrance would be on the opposite side to the prevailing winds, predominately from the west.

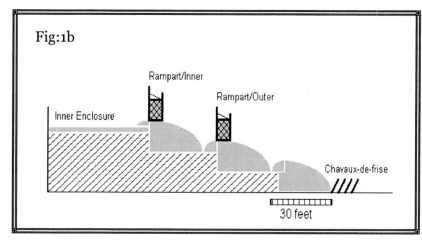

Fig:1b

Inner Enclosure

Rampart/Inner

Rampart/Outer

Chavaux-de-frise

30 feet

Section through the enclosure bank of Castercliffe

By the year AD 350 Britain had been Roman for three-hundred years and was part of the common economy within the empire as a whole. Public events were determined by Imperial politics and administration was controlled by men appointed in Italy. The lasting peace of *Pax Romana* meant that wars were confined to the borders and coastal raids, the people of our area would have been left largely as they were before the invasion. The British were now Roman subjects and considered themselves to be equal to the other nationalities who fell within the Roman hegemony, the enemies within our northern area were the Picts, north of the Clyde, and the Scots in Ireland.

Over the centuries in which the Romans successfully dominated an increasing slice of the world they had learned to employ a valuable resource - the fighting men of their conquered former enemies. Total subjugation of an enemy leads to resentment and discord which in turn often leads to uprising, having long recognised this the Romans assimilated their new subjects into their own ways and this meant that diverse nationalities made up the fighting legions. The none-Roman soldiers were paid, clothed and fed and promises of promotion (and eventual retirement within the Roman sphere) meant that discipline could be maintained amongst these diverse 'mercenaries.'

The Romans perceived their real enemy to be the Celtic peoples, this was largely as a result of successful early military campaigns by the Celts against them. The Roman leaders had a definite bias against the Celtic races whom they considered to be wild, cruel and akin to animals, the fact that the Classical scholars were issuing written propaganda against the Celts has largely led to our modern ideas of the race being crude and uncultured. The Roman description of their enemy as 'Barbarians' has endured throughout the intervening years. We know now, of course, that this was utter nonsense and that the Celtic races lived by sophisticated laws, practised scientific disciplines and were advanced in their knowledge of the arts.

End of an Empire

Eventually the ethnic diversity within the Roman Empire would prove to be its downfall, as the armies became ever more stretched the homeland was suffering from disintegration within its society. Large numbers of Goths and Vandals had been given lands in Italy and this was indicative of the problem facing the crumbling Senate, you cannot please all of the people all of the time and the various ethnic elements were placing ever increasing demands on the infrastructure of Rome, the dwindling resources became overstretched. Added to this were a number of uprisings within the Empire, particularly from the Vandals, by the early fifth century the writing was on the forum wall! Continental incursions into the south of England were becoming more frequent and in AD 367 the forts of the Saxon Shore were failing to keep out the intruders. The bulk of the Legions were occupied in those southern areas and therefore the Picts, Irish and Attacotti were able to

freely plunder the north and west. In AD 368 the Irish and Picts again attacked here and this led to the Irish setting up colonies in Wales. Fighting the Vandals and Goths had drained the Roman resources and, by AD 403, Stilicho found it necessary to take the Twentieth British Legion from Chester to fight this war. These troops had been the front-line in defence of the Scottish borders, and the eastern coast, and through their withdrawal the Picts and Irish were allowed virtual free reign. No regular Roman troops were ever again stationed in Britain after AD 406.

In AD 409 invaders from northern and western Germany made a concerted effort to invade the British mainland, the Irish also made renewed incursions, the British had been left to their own accord and appear to have mounted a stout defence. The emperor Honorius instructed the British cities in AD 410 that they were officially on their own, he refused to send either troops or money to aid the British and therefore the island effectively became an *independent* part of the Roman Empire.

For another two-hundred years Britain operated without an effective central government but the Roman system of towns, villas, trade and agriculture appears to have carried on. During the Roman occupation the population of Britain was as high as it was at the peak of the Middle Ages but, surprisingly, we are left with few Roman place-names (around three-hundred). It would appear that the invaders tended to use the original Celtic names, amongst the Latin name elements left to us are *castra* (camp/town/fort), as in Castercliffe, Caster Clough and Chester, and *strat* (street) as in Wattling Street.

Writing on this situation the early English historian, William of Samlesbury, stated that:-

"Britain...despoiled of its youthful (military) population, who had gone with the Roman Legions, was for a long time exposed to the ambition of neighbouring nations. By an excursion of the Picts and Scots numbers of the people were slain, villages burnt, towns destroyed and everything would perish by sword and fire."

The limited archaeological investigations at Castercliffe *appear* to show that it was destroyed by fire and never rebuilt. Strong evidence has also been found that parts of the Ribchester Camp were also burned. In 1899 Mr. John Garstang B.A. excavated near to the church at Ribchester and found a great quantity of burnt barley and wheat, this was mixed in with rotten, charred timbers. A space measuring thirty feet by twenty feet contained compressed grains of charcoaled grains to a depth of two feet. T. D. Whittaker also excavated at Ribchester and reported finding a number of skeletons amongst large amounts of broken pottery.

There appears, then, to be an argument for the timing of the destruction of our local Romano-British sites (at Ribchester and Castercliffe) as being within the early period following the Roman withdrawal from our shores when the Picts and Scots regularly raided the area. As the Dark Ages approached it is tempting to picture the surviving natives of our area settling down within their small clusters of farmsteads around Waterside and Marsden hoping that the worst enemy they would be likely to face in the future would be the elements.

As usual, however, there is a caveat; in the presumption of the dating of the destruction of vitrified sites a strong debate rages amongst archaeologists. To fuse stones together by fire requires a high temperature, much higher than is thought to be possible merely by the firing of timber palisades. Experiments have shown that the only way that the stones within a revetment can be vitrified is by piling large amounts of wood around the walls, enclosing this with turf to make a furnace, throw in copious amounts of sea salt (to act as a catalyst), light the lot and stand well back! Even this did not produce the burnt effect on the stones found at vitrified sites. The methods used in the fusing of the fort walls remains unclear, even more unclear is the actual

reason that drove the people to do this. A *scorched earth* policy may have operated whereby the fort occupants, sensing defeat, set fire to their structure before legging it; this, however, would not destroy the defences sufficiently to prevent re-use as it would not be a massive undertaking for an invader to replace the burnt palisades.

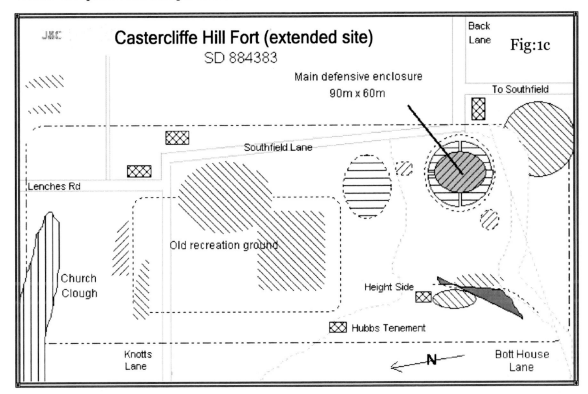

It would not be feasible for an invader to lay siege to an occupied fort and burn the palisades with the defenders still inside. With arrows, missiles and goodness-knows-what piling down upon their heads it would have been highly dangerous for the invaders to even approach the defences, let alone piling wood against the walls in enough quantity to destroy them. It has been suggested recently that the occupiers of the forts deliberately vitrified their own structures for some obscure reason unknown to us. By fusing the stone walls no apparent advantage in strength was gained so it was probably not a standard part of the construction method, besides which, vitrified sites are rare in comparison to their none-vitrified contemporaries.

Another school of thought is that the forts were fired in order to pacify the relevant British Gods, to ensure a successful structure in times of conflict. The use of ritual fire appears to have been of extreme importance to mankind the world over, both to pacify the deities and to cleanse or purify.

A Europe-wide survey of the vitrified fort phenomenon shows that the majority of these sites are to be found in Scotland, with just a few in England. It has been suggested that the frequent Pictish raiders from north of the border may have brought their methods with them. Possibly they defeated the occupants of Castercliffe and applied their own cultural methods to the fort, alternatively economic immigrants may have passed on their knowledge to the local inhabitants. The upshot of the none-invasive firing theory is that we are not necessarily looking for a period of conflict to date the final occupation of Castercliffe. It is possible that the site was finally

abandoned in a time of protracted peace, surrendering meekly to the growing of crops and the winning of coal from its massive mounds and ditches.

Elslack

On first sight there is little to see of the Roman fort at Elslack (SD9249 Fig:1d) except for an area of disturbed ground around the stream that runs through the site. The fort is situated on the main east- west route through our area, from the fort at Ribchester onwards to the small fort at Ilkley. As with most other Roman sites throughout our region these forts were the product of the Roman need for stations along communication corridors in order to rest their troops and to protect the routes.

The north of England was the subject of Roman Military Rule, as opposed to the Civil Rule applied to the more subjugated south and this meant that the Legions would, by-and-large, pass through the area rather than have need of a permanent defensive system. In the late first century AD Roman engineers had established the Elslack fort, possibly making use of an earlier Bronze or Iron Age defensive enclosure, and the site would have been used to rest marching troops and to supply them with provisions from the surrounding countryside.

The Elslack site is a fort of the Flavian period covering some 1.3 hectares and was occupied until around 120 AD, it is thought that the fort was then reoccupied sometime around 150 AD. The original fort was square in plan with sides measuring three-hundred and forty-five feet inside the ramparts, these were of clay construction, eighteen feet in width and erected upon a stone base. Around the outside of the ramparts ran a double ditch over which ran two entrances via gateways on either side of the enclosure. It appears that the fort would house around five-hundred men at the most, this was the equivalent of one cohort of infantry.

In the fourth century the fort was demolished and rebuilt to almost twice its original size at 2.2 hectares, the clay rampart of this new structure was faced with a stone revetment.

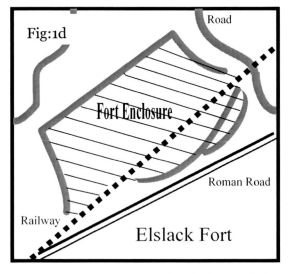

Fig:1d — Road — Fort Enclosure — Roman Road — Railway — Elslack Fort

Before we leave Elslack it is worth noting that the ancient beacon system that had served the communities within the extended area for millennia were still being employed as late as the nineteenth century. On the heights above the village of Elslack the moorland stretches out to Carlton and Lothersdale and the highest point of the moor is the ancient beacon site known as Pinhaw.

Near to the beacon lies a half-buried memorial stone with the inscription:-

"Here was found dead the body of Robert Wilson,
one of the beacon guards, who died Jan 29th 1805 aged 69 years."

The story behind this is that during the Napoleonic wars it was deemed necessary to man the old beacon system in order to provide an early warning of any intended invasion by the French.

Coastal fires would be lit and these would be relayed inland via the beacons on Pendle and Pinhaw and onwards through Yorkshire. The Pinhaw beacon guards would serve in shifts, living in a hut on the beacon site, they had ample provisions for their standard shift but, unfortunately, they had not allowed for extreme weather.

Robert Wilson was assisted by two aides and, in the winter of 1804/5 they were overwhelmed by a severe snow storm and trapped in their hut. When their food was almost exhausted Robert decided to seek help at the nearest farm. Armed with a milk can and bag he set out, against the advice of his colleagues, on his fateful quest. As the two remaining guards had feared, Robert did not return to the hut. As soon as the storm began to die down the two men made their way down the moor and raised the alarm at Elslack. A search party was quickly out on the moors and it was not long before they found the body just four-hundred yards from the hut. It is probable that Robert, not being able to see any landmarks in the falling snow, had wandered in a circle and, exhausted, had succumbed to his icy fate. As a mark of respect for his bravery Robert's friends erected the moorland memorial which is still marked on the OS map.

Coal in the Castercliffe area

At the August 1515 assembly of the local halmote court it was ordered that the coal mines at *Castell Cliffe* be filled in for the safety of the king's subjects. The hill fort site is littered with old coal pits, the circular, pond-like depressions having formed where the original infill has settled. The rights to mine coal in the area are well documented in the Clitheroe Court Rolls, the Towneleys, Listers, Parkers, Waltons, Tempests and Hargreaves families were all involved in the industry. It is recorded as early as 1296, and again in 1304, that *sea coals* were won and sold within the Forest of Trawden. Coal was also recorded as being mined above Colne Waterside, Church Clough and towards Southfield in the thirteenth century, the Castercliffe pits are thought to have provided coal for Bolton Abbey in 1328. In 1295 the lord's coal pits around Church Clough, where colliers were employed by manorial stewards, provided coals to a value of ten shillings over the year and in 1305 this had risen to sixteen shillings.

Henry Emot was fined four pence in 1531 for *winning carbunculae* (small coals) in Cathole Clough, near Beardshaw (between Trawden and Marsden), without a licence. The illicit taking of coal was widespread throughout the whole area, much of the problem was that the people who took the coals were selling it on an industrial scale and this did not go down well with the owners of the mining rights! In 1443 the rents payable to the lords of Clitheroe for coal mines in Colne and Trawden amounted to thirty shillings and in 1459 Lawrence Lister paid six shillings and eight pence per year for the rights to mine all of the coal in Colne, Marsden and Trawden. In 1621 James Folds of Lee complained against Margaret Hartley, of Gisburn, because she had leased him the coal rights above Colne but the seams had run out. In their original agreement Margaret Hartley should have reimbursed Folds in this situation and returned their bond. She refused to do this, however, much to the annoyance of Folds who stated that this would bankrupt him and that Hartley was *"a very covetous and hard-dealing woman."*

Lark Hill Colliery was opened around 1874, this used the old workings in Fox Clough Colliery as drainage. Eventually the Lark Hill workings broke through into the old Cathole Clough workings where ancient mining implements were found some forty feet below ground. The final coal pit in the Casterciffe area was Colonel Hargreaves' Broughton Colliery, this was on the northern slopes of the hill fort site and was reached via the lane now called Wackersall Road.

A surface coal pit within the Castercliffe fort enclosure. Settlement of the original infill has caused these depressions to form.The last pit in the area was at Lark Hill and this closed in 1890.

In the fifteenth century there was much dispute between those claiming rights to mine coal, the Crown had seen fit to re-grant the rights on short-term leases, this meant that those miners of the old lease-hold were at variance with the new lease-holders. The Castercliffe area was designated as *shallow-winning* and therefore only surface pits were allowed. This being the case the larger land holders were not particularly interested in these pits and the town tenants were able to carry on with their small operations here. The sixteenth and seventeenth centuries saw a large increase in demand for coal, largely because of a national timber shortage, this led to market-forces causing an increase in the number of mines, especially on the previously un-worked moors and wastes. The landed families of Towneley, Lister etc, also became more involved in the increasingly lucrative trade, sometimes to the annoyance of the small miner because the new pits were often sunk on the common lands. There are numerous recorded incidents in the sixteenth and seventeenth centuries where the miners banded together in order to threaten, or actually damage, the pits owned by the gentry.

The Ganister coal seam runs South of Colne Water from Trawden to the northern edge of the Burnley district. This seam is of the low-level type, the lowest part of it being found at Cottontree and Winewall. The problem with this seam is that it contains a large amount of stone, known as *farewell rock* to the old miners. This seam can be followed by the remaining depressions of the old surface pits through Trawden, Castercliffe, Southfield, Catlow, King Cliffe at Lane Bottom and Black Hill over into Nelson. There is a particular cluster of these pit depressions around the Castercliffe hill fort site in the north-western corner of which were a number owned by John Robinson of Grindlestonehurst. He is recorded as owning the rights to the mines at the Nook (the top of Knotts Lane), Birchenlee and Fox Clough. Coal seams carry many other minerals, iron pyrites (fool's gold) must have been evident locally as in 1731 John Tempest, of Broughton, wrote that *"the Colne seam had in it, to all intents and purposes, veins of gold and silver."*

The pits at Lark Hill and Fox Clough were partly responsible for the growth of the cotton industry in the Colne area, the hard-won coal was hauled into the town on small railway trucks. As the mining industry became more advanced more coal from greater depths could be won. This gave the deeper and much more extensive coal fields a distinct advantage over the smaller, poorer quality sites. The new Burnley Basin coalfield was a large, *middle-level* operation and was therefore able to produce fuel at a much more competitive rate than the Colne and Marsden mines. As the cotton industry expanded, so the road network improved: in 1828 it was reported that *"a new road from Grindlestone Hirst in Marsden to Waterside in Colne"* was to be built. Methods of transportation improved accordingly, the opening of the Leeds and Liverpool Canal set the ball rolling but the coming of the railway to Marsden and Colne meant the death-knell for the local collieries, it was far more economical to bring coal in bulk from Burnley.

Place-Names around Castercliffe

The use of place-names has been shown to provide positive, if inconclusive, evidence for the settlements of particular cultures. Place-nomenclature, applied to both main sites (such as towns and villages) and minor sites (field names etc,) provides a strong indication of the use of a particular language at a particular time. Care has to be exercised, however, as the dominant culture within an area often assimilated the nomenclature of their predecessors, the names applied to people and places within an area can, in some cases, be traced to our early British culture.

The Scandinavian word *wapentake* largely replaced the English word *hundred*, the Old Norse personal name of *Swain* became descriptive of a farm worker and the Old Norse *búð* and Old Danish *bóþ* became *booth* (as in Barrowford Booth) under the later Norman feudal system.

Because of our rich heritage we are able to draw on naming patterns from the early British Celtic languages through Roman Latin, Anglo-Saxon and Scandinavian to the later Norman French. As a general rule the Saxons named the areas in which they settled after themselves whilst the Normans generally took the names of their settlements. To gain a rough idea of the evolution of the Marsden and Colne settlements around the Castercliffe site it may be worthwhile to consider the etymology of the names within this area. The area concerning us at the moment stretches from Trawden Forest in the north, to the Burnley boundary in the south and from Colne Water to the higher slopes of Boulsworth Hill. Castercliffe itself lies in the centre of an area bounded by Southfield, Wackersall, Lenches and Shelfield. In Saxon times there would have been a limited number of scattered farmsteads where the people eked-out a rough living from their woodland clearings, it is reasonable to assume that some of the present farms in the area have evolved from these settlements. The whole area was officially described as *'waste'* following the Norman Conquest, over the ensuing centuries these areas were slowly won over to pasture and farms became more numerous. Following the grant of copyholds in the later Medieval period the wastes took on the appearance that we are familiar with today. It is certain that the areas of waste contained large numbers of small areas of woodland, the old names for these are common today. Amongst these are *holt, shaw, hirst/hurst, og, hough, dene, sab, wold* and *wood*. Pollen samples have been analysed from the Briercliffe and Extwistle areas and these show that the early mass clearance of woodland, common in many areas, did not apply here, a significant amount of tree-cover survived well into the Early Medieval period.

The area of **Southfield** (*field* being the term used to describe an area of common land) was former waste land used by the people to the south of the settlement of Marsden. The Southfield area was variously in the ownership of a number of prominent local families, namely the Marsdens, Mancknowles, Towneleys, Listers and Waltons. A deed of c.1240 shows Robert de Merclesden (Marsden) living at Heirs House, Colne, he granted lands at Heasandford, Burnley, to Robert de Swillington that had been held by the parson of Burnley. In 1407 William de Marsden of Swindon left to his son, Henry de Marsden:- *"A messuage (farm buildings) and land in the vill of Suthfield called le sec-acres."*

In 1447 Geoffrey Osbaldeston delivered to Richard Towneley, by letters of attorney:- *"All his lands called Sowthfield in Great Marsden."*

The Mancknowles family, of **Townhouse**, were one of the main land owners here, the name signifies *The House in the Town Fields* because of its position on the town common. A deed of covenant, dating to 1641, shows Henry Mancknowles, of Townhouse, yeoman, conveying to Issabell Payley, spinster of Great Marsden, the following:

"A messuage of 10 acres: 1 rood: 2 furlongs in Great Marsden; 23 acres: 30 furlongs late part of the moors (former waste) in Great Marsden; 18 acres of wastes between Crawley Sike and Shelfield; 1 acre: 2 roods: 16 furlongs at the same place: 3 acres: 12 furlongs on Catlawedge: 4 acres: 2 roods on Ringstonehill; 1 rood: 20 furlongs at Catlaw Delfs: 2 acres between Swaynsplatte and Hordomosse: 6 acres between Crawshaysike and the highway from Colne to Catlaw for the payment of His Majestie's debts."

- *Crawley Sike* refers to the area of **Crawshaw Hill** to the north of the Shooters Inn, this shows that the land between the Shooters Inn and Walton Spire was still regarded as waste.

- *Catlawedge* would be the land running from the Shooters Inn southwards to the Catlow Quarry (*Catlaw Delfs*); the name of **Catlow** is usually referred to as *The Hill of the Cats* but there is an argument for the name originating in the Old English *cata* meaning *sheep pen*. I have also seen the name described as having the meaning of *the hill path*.

- *Swaynsplatte* refers to **Swains Plat Clough** on Will Moor, near to the Upper Coldwell reservoir. As we have seen, the word *swain/swein* was used by the Saxons as a personal name, this was then borrowed by the Normans and applied to a worker on a feudal farm, by the sixteenth century it had come to mean *farm labourer* or *shepherd*. This is interesting as the clough is adjacent to the ancient Will 'O Moor Road, this droving and packhorse route skirted around the base of Boulsworth Hill and linked our area with the trade centres in the Halifax area. The *plat* part of the name possibly originates in the Middle English meaning of *small piece of ground*. It is not unreasonable, then, to link the *swain* or *shepherd* with a person who ran a fold, or holding site, for the drover's livestock at this particular spot. It also entirely possible that this was a piece of ground belonging to a Saxon named Swain or applied to an area in which pigs were found.

- *Hordomosse* is not apparent on the nineteenth and twentieth century maps although there is a **Moss** area (Little Moss farm and Moss Barn) on the edge of Shelfield, around a mile to the north of Swains Plat Clough, this area was known as Oaken Bank. If this is indeed the Hordomosse referred to in the Mancknowles deed then this puts the area of two acres *"in between"* at Deerstone Moor. The name of *Hordo* could originate in the French *hourd* meaning *palisade* - this could refer to an agricultural enclosure of the moss, a defensive site or it could even relate to the nearby Castercliffe defences. The word *moss* is Old Norse with the meaning of *swampy area*. As a matter of interest, there is an exact match for the name of *hordo* in as much as the Norse word *hórdó* means *adultery* but I am unable to relate the description in this particular context.

A grant, dated at Merclesden in 1442 was made by Henry Merlond, the Vicar of Rochdale. He made the grant to James, the son of James Walton and his wife, Alice who was the daughter of Walter de Merclesden. The grant concerned lands:- *"At Polwode, Hormanhill and Wackersall in Marclesden Magna which he held jointly with the said James Walton."*

- *Polwode,* from the Old English *pal* meaning *stake* probably refers to a coppice from where fencing posts were obtained.

- *Hormanhill* can be seen to have a number of origins, the most obvious in this context being either *hoar* where the Old English meaning is *old, venerable, grey* and usually refers in place-

names to a boundary stone - thus giving the meaning of *'the hill of the old-established people'* or *'dwellers by the stones on the hill' (Ring Stones Hill?)*. Alternatively we could have the High German *hor* for *marshy* giving *'the marsh dwellers'* or the Modern English *Northman Hill*.

- *Wackersall* is the area at the base of the northern slopes of Castercliffe, shown in early documents as *Wakershal*. It has been suggested that the name originates in *walk* from the *walk-mill* description of the early, man-powered process of the fulling of cloth. An equally pertinent description, however, is the Saxon word borrowed from the Old High German *wacke* meaning *sandstone* or *gravel*. This was related to an old Germanic miner's word and, coupled with *hole,* gives the description of a *quarry*, or *mine*. This is interesting in as much as the largest coal mine on Castercliffe was at the top of **Wackersall Road**.

The **Knotts** area is situated between Castercliffe and Waterside, the steep lane from the Nook (the word meaning *corner*) down to Colne Water taking its name from the area. There was a Knotts Farm half-way up the lane (near to the Knotts quarry and brick works) and, more recently, the farm of Higher Knotts on the Castercliffe slope. The name of *Knotts* can be seen as a description of the two prominent features of the Castercliffe fort enclosure whereby the Old English term *cnotta* signifies a *protuberance* or *lump*.

Burwains, on the town hill to the west of Colne Lane, shares its name with three other sites - one at Foulridge - another ancient circular earthwork near to Coldwell and a farm at Briercliffe. Alfred Watkins, in *The Old Straight Track*, stated that:-

"The topographical student and the language student are both necessary to get at a prehistoric word meaning. To give an example: In the early epic 'Beowulf' occur the two similar words 'beorh' and 'burh,' the first is used only for a tumulus or barrow, which was a burying place; the second a fortified or protected dwelling or enclosure; and the two meanings are not confused. Philologists adopt these meanings, and extend 'burh' to include the hill-top camps, and also later to enclosed settlements or towns which now are called - bury. And on this evidence they decide that -bury in a place-name is derived from 'burh' and not from 'beorh'."

"But I find that the earthwork enclosures called 'burh' (camps or castles) in most cases originated from the nucleus of an older tumulus or 'beorh' to which they are akin in fact as well as name. Moreover, I find that farmers wishing to protect their roots call the earth-mound which they use for the purpose a 'bury,' but that the same heap of roots protected in a barn is not a 'bury,' the earth covering being the essential point in the word. Moreover, our modern verb 'to bury' has the earth covering (and the mound still persists) as an essential, for cremated remains are not buried if enclosed and protected in an urn, and placed in a shelf in a chapel."

"Can there be a doubt that the instinctive use of 'bury' shows that the word originated in the tumulus or barrow, and that the philologist has not gone far back enough in its history, but commences where it had already split into two branches? "

If we accept Watkins' postulation on this we have the origin of Burwains within the old Norse *beorh* for a mound. It is interesting to note that the same root of the word appears to have applied to the halo ring (known as a *burr)* that the moon sometimes acquires in certain weather conditions. The word *burr* also applies to something *thrown up* or *around an edge* as in the raised material on a newly-sharpened metal blade. Burwains Farm, at Briercliffe, is situated near to a

large mound, of uncertain pedigree (possibly a relict of quarrying operations), and the Burwains earthwork, to the south of this site, is an ancient defensive feature. The Burwains area upon the southern slopes of the Colne hill (adjacent to Colne Lane) is probably also of ancient lineage and could have acquired its name from either an ancient burial site, or some other circular feature now lost to antiquity.

The *bury* name crops up to the south of Castercliffe (on Southfield Lane) in the property known as **Sansbury**. This site was evident in the medieval period and an explanation for the name can be that *sans* is the Old French for *outside* which provides us with *the place outside the mounds*. Alternatively, if Watkins was not entirely correct, *bury* can be seen as a *camp* or *enclosure*, this would accurately describe the site of Sansbury as it is on the very outside edge of the Castercliffe site.

A short distance to the south of Sansbury is the property of **Hill End**, this is mentioned in 1569 when John Holgate, also known as *Block,* buys the rights to the farm from William Lister of Thornton-in-Craven. The property then became known as Block Tenement and consisted of:- *"A messuage, a laithe, two carthinges and two closes containing 8 acres in Great Marsden and within the halmote of Colne."*

A proviso in the agreement was that an existing deed on the property, giving the rights to dig coal to William, son of William Lister, was to stand as a covenant on the understanding that Lister paid two shillings per year to Holgate. By 1728 the property had become Hill End as Joshua Crabtree of Stanroyd, yeoman, sold his share in the freehold of Hill End, formerly called Block Tenement, to William Harrison, a miner of Colne, providing Harrison paid £14 due to Thomas Towneley of Royle.

Church Clough, at the northern-end of the extended Castercliffe site, was shown as *'"Kerkcloughe at Foxecloughe"'* when Helen (widow of Henry Farrer) surrendered the messuage to her cousin, Leonard Blakey, in 1612. The messuage was:- *"Abutting onto Colne Moore or Marsden Moore on the west and south and on the rundell called Colesyke on the north and on Trawden Pasture on the east."* The term *Kerkcloughe,* used to describe what is now Church Clough, originates in the name *kirk*, this can be formally ascribed to both the Old English and Scandinavian languages.

Coal Syke is mentioned again in 1784 when Mathew Wilson of Otley sells to:- *"Ambrose Greenwood, of Coal Sike in Marsden, a messuage in Little Marsden called Walverden."*

The *rundell* description within the deed of surrender probably originates in the Middle English *rund* and was applied to round or circular features (i.e; a round hill) and as a nickname for fat people. *Syke* is of Scandinavian origin where *sik* meant *stream*. In *1873* part of Coal Syke Farm land was occupied by Long Swinden Farm. A 1766 survey by James Foulds shows this land as being: The Great Meadow at 3 acres: 12 perches - The Acre at 1 acre: 2 roods: 33 perches - Clough at 2 roods: 49 perches - Clough Head at 1 acre: 2 perches - Hammon Fields at 2 acres: 3 roods: 31 perches. At the time of the survey Coal Syke was:- *"Formerly in the occupation of John Prescott and James Foulds then Richard Elliott and John Cook then John Kippax, James Greenwood and Ambrose Greenwood."*

Bott House Lane (known locally as Cow lane) was the main north-south trackway from

Castercliffe and onwards through Hagg Gate, Swinden and Barrowford. Adam le Botte probably lived at Bott House in the fourteenth century, there were a number of early farmsteads along the lane including Hole House, Gib Hill and Gib Field. The *Bott* name is probably taken from the Norman meaning of *bottom* or *butt* and can be seen as an accurate description for the area at the bottom of the slopes of Castercliffe and Gib Hill. Bott House Lane is today interrupted by the railway line and a modern housing estate although it can be picked up higher up the hill where it shows itself as an obvious, sunken road. In the middle years of the twentieth century this lane was a popular walking route for the townspeople, a farm house on the slopes of the hill was known as The Pink House and served teas up to the 1960s. In 1726 Thomas Whitaker, gent. of Simonstone was:- *"At the manor of Colne, admitted to lands at Bothouse by the surrender of Richard Holt, yeoman of Bothouse in Marsden for the sum of £240."*

The **Lenches** area of Colne Waterside runs from the river up towards the former wastes of Trawden and Marsden, the name is descriptive of the medieval farming practice of terracing the hillside slopes. In 1682 James Smith of Edge (Colne) bequeathed to his son and heir Christopher Smith:- *"Half of one messuage and half of one rood of improved waste land in Marsden called Leanches."*

Birchenlee and **Kiln Hill** are farms at the head of an ancient track that once carried traffic from Waterside to Halifax, this was virtually a south-easterly extension of Knotts Lane. The track leaves Lenches Road at the properties now known as Reed Row, this was formerly Woolpack Row, the name indicating the type of traffic that once passed this way. In 1569 William Lister of Thornton-in-Craven, esquire, sold:- *"To Robert Hartley a messuage and all its lands called Birchingley, and a barn and 2 closes of which one is called Fawgheade, in Great Marsden, for the term of his life."*

The property was leased to William Rotheman and Jenet, his wife, for the term of their lives. As we saw earlier, William Lister entered a codicil conveying the coal rights to his son, William, for permanent access to the coal pits they paid two shillings annually to Robert Hartley. The sale proceeds amounted to £50:13s:4d. It is shown in the above record that a field at Birchenlee was called *Fawgheade*, the Old English term for money, cattle or property was *feoh* thus providing us with *cattle head*, or the furthest extent of the reclaimed land at that particular time. Another explanation for the name of *Fawgheade* could possibly be that the French word *faux* means *false* providing the description *false head* or *small hill below a larger hill*. The name of Birchenlee is one of the many names throughout the area that refer to woodland. Where *ley* is a clearing and *lee/lea* were both used to describe meadows we have either the *clearing amongst the birches* or the *meadow amongst the birches*. Either of these descriptions can be taken to show that this area was named when it was initially taken from the wooded waste land.

Kiln Hill is self-descriptive, within our area the word kiln almost invariably refers to lime-burning or malting operations but in coal areas, such as Castercliffe, ovens were also used to produce coke. Henry Spencer of Birchenlee surrendered his rights to win coal in the area to Thomas Towneley of Royle in 1721. Spencer retained his right to work a piece of ground called the *Clock of Hillend*. Part of this agreement was that Spencer was not to sell more than three-hundredweight of coal in each year besides which he was to be allowed the standard amount of coal for home use, this was usually enough to supply one fire per household.

Gib Hill is the name applied to the northern slopes of Castercliffe hillside, Little Gib Hill Farm and Gib Hill Farm are on the hillside whilst Gib Clough Head is situated besides the hill fort

enclosure; most of this area came under the auspices of the Marsden Hall estate. In 1352 Henry, duke of Lancaster, rewarded Richard Walton for his role as vaccary keeper in the Pendle Forest by granting him lands in Colne and Marsden; these included *Northman Hill* (Gib Hill). It has been suggested that the word *gib* originates in the name of Gilbert but this is unclear. An explanation that appears to fit the bill is that *gibbus* describes a *hump*, or *hunch*, in Latin and this was adopted in Early French to *gib*. We have here another example of a very apt name for the two Castercliffe hills, *hump*, or *hunched* provide a nice topographical description. To further this argument the word *gib* is also used, within our context, as a reference to an ancient cairn elsewhere. In Derbyshire lies the fascinating feature of Arbor Low stone circle and henge, measuring some two-hundred and fifty-feet in diameter, the henge of Arbor Low contains a circle of forty two recumbent stones and is dated to somewhere between 2500 BC and 1700 BC. A number of Bronze Age barrows are scattered about the site and the largest one, in the shape of a massive cairn, is called *Gib Hill* - this was excavated by Thomas Bateman junior in 1848, his party narrowly escaped with their lives when their tunnel collapsed.

Hole House was the name of a farm that stood near the lower end of Bott Lane, opposite Bott House. The name of Hole could originate in the Old English *hol* meaning *orifice, hollow place* giving the modern description of *hollow*. Alternatively, the Welsh word *heol* means road, if this is the origin of the *Hole House* name then this would show a very early settlement date for the site, the fact that it was situated by an ancient road tends to lend some weight to this. *Deeds numbered 147:* Show that the Corporation purchased Hole House, on the 21st May 1920, from Mrs. Annie Hartley and Mrs. Annie Barber and demolished the property. They also sold a plot of land to Thomas Leaver, builder, of 61 Halifax Road, Brierfield in order for him to build Sheridan Street. In 1696 land deeds show that the property of Hole House was part of the Towneley Estate. Other, later, deeds give an impression of the life of the place over its final century:-

- *1st December 1815:* Hole House was purchased by Robert Hartley of Seed Hill, Little Marsden, yeoman, for the sum of £2,305.

- *19th July 1816:* An indenture from Robert Towneley Parker esq, of Royle and Cuerden, surrendered to Robert Hartley:- All that freehold messuage, farm and tenement called Hole House, with cottages, barns, stables, outbuildings and land of 27 acres: 36 perches, then in the occupation of William Sagar, on a nine year lease.

- *23rd January 1918:* Luke Hartley, Frederick Barber and others let Hole House Farm to the Nelson Co-Operative Society.

- *21st May 1920:* A conveyance from Mr. John Hartley and Mrs. Annie Hartley and others, lets Hole House to Nelson Corporation for the sum of £1,675.

- *5th August 1924:* Land at Hole House was conveyed by the Nelson Corporation to Lancashire County Council. This was 11 acres; 3 roods; 6 perches for the building of Nelson Grammar School - price £1,414: 10s.

- *10th November 1939:* Deeds show that Nelson Corporation purchased Marsden Hall Farm and a small portion of Gib Hill Farm and Hole House from the personal representative of James Charles Waddington, he was a solicitor of Burnley and owned a number of farms, including Hill Farm at Lane Bottom.

- *28th February 1974:* Land of the former Hole House, on the north side of Hollins Road, Nelson (at 5.08 acres) was conveyed by Nelson Corporation to Alfred Robinson Estates Ltd;

Boulsworth, the name of the second highest hill within our area, is often said to have its name origin in *bull* (the hill being shaped like a bull's neck), there is, however, a reasonable explanation for the name in the Old English words of *byl* and *byle* meaning *swelling* - the Old English *bul* and *bher* mean *to swell*. The *worth* name is suffix commonly applied throughout this area, amongst many examples of this are Wadsworth, Boulsworth, Oakworth and Haworth, the word is from the Old English *worp* for *enclosed place* or *homestead*. The traditional name for Boulsworth is Lad Low showing an earlier etymology whereby *llad* is the Old Norse for *heap* or *pile* and *hlaw* means *hill*. A large mound on White Moor is also called Lad Low.

Cock Leach Farm viewed from the enclosure of Castercliffe

Cock Leach Farm is to the south-east of Castercliffe, the etymology here is somewhat difficult; the obvious meaning of the word *cock* is for a hen where the German *hahn* shares a root with *cock*. In the Middle English we have the word *cocken* meaning to *fight* and in the Middle Ages the term *cock* was applied to scullions, servants and apprentices whilst there is also the Old English meaning of *side* (on the hill side).

In the Old English *cocc* and the Old Norse *kokkr* there is a common word, commonly used up to the fifteenth century, as a pet diminutive in Christian names such as Wilcox and Hitchcock. The term *cocker* is still in use within the area today when an older person addresses a youngster. Leach originates in the Old English *leccan* meaning *to moisten*. There is the possibility that the name describes a hillside spring or the beginning of a watercourse.

Knave Hill shares a name element with the Bronze Age burial mound, known as Jeppe Knave Grave, on the slopes of Pendle Hill. The Knave meaning is usually taken as a reference to a *wrong doer* or *rascal*. In the case of Knave Hill, the name of the hill upon which the ancient monolith of Walton's Spire stands, there could be alternative explanations. In the Old English *cnafa* there is an element shared with the Old High German *knabo,* the German *knabe*, the Old Norse *knapi*, and the Dutch word *knaap* all with the same meaning of *boy, youth, servant*. In the Middle High German *knappe* means a *young squire or shield-bearer* and, curiously, the origin of this may have been in the meaning of *stick, piece of wood*.

There is also the consideration that in Old English the word *nave* meant the *hub of a wheel* whereby *nafu* had evolved from the early German *nabo* which appears to have been connected with *navel* on the notion of centrality. We have here a possible description of the Knave Hill site having been a central, important place to the local tribes of the wider area. The erection of the huge monolith on the crest of the hill here could very well reinforce this argument. The Stanleys

are commemorated in certain street names within Colne town ie, Lord Street, Derby Street, Earl Street and Stanley Street.

Doughty Farm is situated a field's distance from the Castercliffe enclosure, the unusual name can be assigned to the local land owner of Colne Hall, Henry Doughty esquire. Many of the later nineteenth century houses in Colne were built upon land belonging to the Earl of Derby; these lands were held within the Stanley family and were acquired upon the marriage of Mary, the daughter and heiress of Henry Doughty, to one Thomas Patten esquire.

In 1425 James Walton of Colne was allowed to enclose three acres between Haggate Gate and Grindlestonehurst with the proviso that he kept the road open for the use of others. This family later enclosed more land by the name of **Langshaw** at Waterside the name of which would relate to the *long/extended wood*.

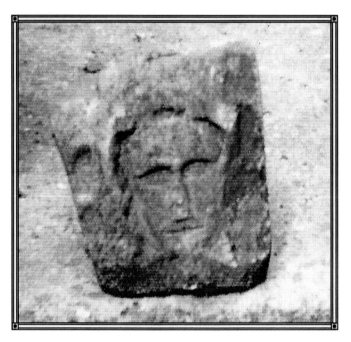

Carved stone found at Lane Bottom, Briercliffe: These are generically known as 'Celtic Heads' and this example had been used as a door-stop for many years.

The term 'Celtic' is somewhat misleading as this type of carving can date from an extended period. This particular example suggests a late Saxon style

Chapter Three

Grindlestonehurst and Walton's Spire

Although we do not have ancient structures to compare with the hugely impressive giant stone monoliths of the Devil's Arrows at Boroughbridge (adjacent to the A1 road near Harrogate) we do have a particularly fine example of a true monolith now known as Walton's Spire (or Walton's Monument). A landmark that few travellers in the area can have failed to see the Spire stands some eight metres in height upon a hill at Shelfield, between Nelson and Trawden. Originally this monolith (SD 894 373) stood higher and broader than it does now. The Reverend Richard Thomas Wroe-Walton (1773-1845) of nearby Marsden Hall, had his stone masons trim down the impressive structure and place a dressed-stone cross on the top. This act was reminiscent of the centuries of the Early Medieval period where pagan sites were Christianised, many wayside stones and boundary stones were carved with Christian symbols at this time.

Knave Hill upon which the Spire stands overlooks the Iron Age fort of Castercliffe and is of great intrinsic interest, viewed from the opposite side of the valley to the north the hill appears to be part of the natural sweeping contour of the western end of the long ridge upon which it stands. The hill sits perfectly within its environment, a gentle brow leads to a level platform from which the stone projects. However, seen from Shelfield, on the Boulsworth side of the hill, only the tip of the spire can be seen as another large mound obscures it from view, the level area here has all the hallmarks of a pre-historic settlement or camp. A close inspection, from all angles, shows that the hill upon which Walton Spire stands could very well have been artificially formed, this was a common feature within the landscapes of the Neolithic culture.

It has been suggested that the stone base of the spire at Shelfield is actually a *Battle Stone* erected to commemorate the burial of a great number of dead from some Saxon battle (possibly the Battle of Brunanburh, see Chapters Thirteen and Fourteen). In the Worsthorne and Extwistle areas, to the north of the site, there is a legend that a massive battle took place somewhere in the region and that *"five Kings lay dead"*. Personally I think that this monolith-pierced hill blends too well with the landscape and, therefore, suggests a Neolithic/Bronze Age feature. Also, on the Shelfield slopes of Knave Hill are many apparent barrow mounds and artefacts of the Neolithic, Bronze and Iron Ages have been uncovered here.

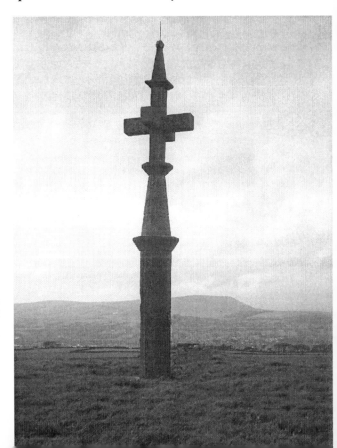

Walton's Spire dominates the Pendle area and the monolith base has possibly done so for over two millennia

The imposing monument of Walton's Spire stands 1.5 kilometres to the south-west of Castercliffe and could very well have served as an

important (possibly religious) site for the tribes within the area. It is very possible that, whatever its function may have been, the monolith is situated in a roughly central position within a number of (postulated) local settlements.

The hill upon which the Spire stands affords a superb 360 degree view and, conversely, can be seen from all points within the area. The high plateau areas of Castercliffe, Cowfield, Ringstone Hill, King Cliffe and Slack Laith all lie within a half-hour's walking distance. The flattened hilltops of these sites would have been ideal for early settlers.

Fig:2

Possible settlements relating to Knave Hill

Aerial photographs show that Cowfield has ditch features and the deep Fox Clough (where ancient stone implements have been found) would have protected the western side of any settlement here. A trackway still runs from the Spire hill, past Dry Clough farm and on to the Cowfield Hill. It is likely that different families within a tribe would settle these high grounds (Fig:2), the defensive site at Castercliffe would provide communal safety in times of trouble and the monolith site would have been a focal point.

The origin of the name of Shelfield could have its root in a number of Old and Middle English words. The *field* part is simple enough as this signified a common area, whereas *shel* could have its origin in the early British word *seol* meaning *show, point out, direct or guide* - this could be a description of the purpose of the Knave Hill site. Another British word *siol* has the meaning of *descendants or clan,* possibly reference to the tribe who occupied the Shelfield area. It is also possible that the Shelfield name originates from the Old Norse word *skali* meaning *summer pasture,* there is another northern British word, *shiel,* with much the same meaning. It would be no surprise if the hilly areas mentioned above were used as summer pasture by the early settlers from the areas now covered by Colne, Trawden, Marsden and Briercliffe. During the cold and wet winter months these lower slopes of Boulsworth Hill would have been boggy and uninviting, therefore the livestock would be driven from the moors in late autumn to be closer to the farmsteads and smallholdings.

The area of Grindlestonehurst straddles the Nelson and Colne boundary and it has been suggested that a stone bearing the carved impression of a cross in the Colne Waterside area is the actual *'Grindle Stone'* from which the area took its name. It strikes me, however, that as this area is dominated by the Spire, one of the most impressive ancient stones to be found in the north of England, then the Spire could well have been the Grindle Stone.

The town of Nelson, in which the Spire now stands, was known as Marchesdene in 1177, Merkedenne and Merclesdene in 1180, Merklesdene in 1246, Marchdene and Merchesden in 1258, Merclesden in 1311 and had become Marsden (sometimes Aske Marsden or Rough Marsden) by the sixteenth century. Known for a long period as Great and Little Marsden the area eventually lost the area of Little Marsden to Brierfield and the expanding community of Great Marsden took the name of the inn at the new turnpike cross-roads, the Lord Nelson. The term *Merclesden* can be

taken as being a description of *The Valley of the Marker,* if it were to be accepted that this related to the Spire monolith then this would serve to illustrate the importance accorded to the monument when, in its former, untouched state, it would preside majestically over the whole area.

We have seen that the stone stands in the centre of a flat, circular area some two- hundred metres in diameter on the highest point of a long ridge. The culture responsible for the erection of the monolith clearly intended it to be seen for many miles to the north and west, in fact it is visible from the Whernside Ridge, in the Yorkshire Dales, some fifty miles distant.

The prospect of the monument from the south, however, is totally different – it can hardly be seen at all. I am convinced that the hill upon which the Spire stands was created in its present form by the people who first erected the monolith, this would demonstrate a high degree of civil-engineering skill on their part. To further illustrate this the stone is placed *exactly* in alignment with the highest points on both Pendle and Boulsworth Hills. This apparent manipulation of the Shelfield ridge is a fine example of a subtle shaping of the landscape and illustrates the capabilities of our forebears within this art; the Spire, and its surroundings, were meant to fulfil their (unknown) purpose as a dominant but integral part of the natural topography of the area.

That the area around Walton's Spire was a major pre-historic settlement there can be no doubt. The extensive Iron Age earthworks at Castercliffe, the round barrows at Knave Hill, a long barrow at Ringstone Hill and many examples of cairns, stone circles and artefacts found within the area can be taken as evidence that this area was of great importance to the inhabitants, probably from at least the Neolithic period.

The 'Anvil Stone': This stone is large enough to be visible on aerial photographs of the area

To add another feature to the equation, there is a group of stones some two-hundred metres to the south of the Spire, the largest of which I have named the *Anvil Stone* for the sake of descriptive simplicity, this is the only one of the group left in its original position, no doubt because its sheer weight would prevent it from being removed. The other stones have been cleared from the field and lie in a large depression in the earth (possibly an abandoned coal pit), these may have been part of a larger stone arrangement, such as a circle. The Anvil Stone is of particular interest, not only because it has been heavily worked to attain its shape, it also weighs about one and a half tons and is on an exact alignment with the other ancient features of Black Hameldon, the tumulus at Ell Clough, Ringstone Hill and the Spire monolith (Fig:3).

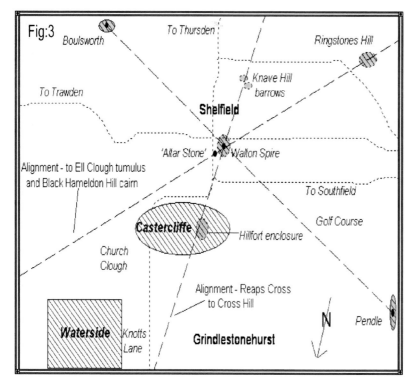

Fig:3

Boulsworth
To Thursden
Ringstones Hill
To Trawden
Knave Hill
barrows
Shelfield
'Altar Stone' Walton Spire
Alignment - to Ell Clough tumulus
and Black Hameldon Hill cairn
To Southfield
Golf Course
Castercliffe
Hillfort enclosure
Church
Clough
Alignment - Reaps Cross
to Cross Hill
N
Pendle
Waterside Knotts
Lane
Grindlestonehurst

Example of alignments relating to Walton's Spire

To return to the *Grindle Stone*, it strikes me that either the monolith of Walton's Spire, or even the *Anvil Stone*, could actually be the *Grindle Stone*, mainly because their sheer size and position within the landscape suggests them as leading candidates. *Hurst is an Old English description for a wooded area* and the word *grindle,* or *grindel,* can be seen as having a High German route describing *someone who lived by a swamp or moor,* this is a possibility as Grindlestonehurst was part of the common wastes around Colne. Another possibility of the origin of *grindle* is the Middle English meaning of *green valley* but another viable origin of the word is where *grindle* is the Old English for *bolt* or *bar (door).* This raises the possibility that, in this context, *grindle* is a metonymic name for the occupation of *guard of the door* or *gatekeeper.* Therefore we could have in *Grindlestonehurst* a description of *the stone of the gatekeeper,* or *the guard-stone by the woods.*

To the north of this area is the village of Grindleton and the fact that this provides us with two examples of this rare name could be significant. The village is situated on the ancient border between Northumbria and Mercia and was recorded in Domesday as having been the manor of Earl Tostig, this extended to some thirty two carucates of land. The manor was granted to Roger de Poitou by William 1st following the Norman Conquest. If the *grindle* element within Grindleton had the *door keeper* connotation then the second element of the Old English *tun* will give the meaning of *the guard's settlement,* perhaps this was a reference to the border situation between the two kingdoms. This raises the possibility that the name of Grindlestonehurst was actually *Grindle-ton-hurst,* or the *guard's settlement by the woods.*

Further to this we have seen that the Shelfield area of Knave Hill may have originated in the early British word *seol* meaning *guide, show, point out or direct,* this may have been related to the function of the monolith and related stones whereby they would fulfil an important role within inter-tribal migration and the general movement of people and goods through the area. We have already seen the possibility that this area could have fulfilled a role as that of a *central tribal authority,* given its topographical situation overlooking the major inter-coastal trading routes. Furthermore, there can be no doubt that the heavily fortified site of nearby Castercliffe would have been connected to the Knave Hill monuments. The position of Castercliffe upon the main north-south and east-west highways would suggest that it may have acted as a kind of ancient *passport-*

control or *border check-point* and to this end the description of *gatekeeper* would fit the site admirably.

The area of Shelfield was common land during the Medieval period, the present Shelfield Farm was formerly known as Green Middens which means *the central common*. This was not to say that everyone could use the land as they pleased, however, the Court Roll records show many instances of the common rights being abused, most often the problem was that people from outside the area had no rights to the commons of other parishes but this did not stop them from trying it on! The Colne Halmote records for the 27th May 1570 were taken before John Towneley, Chief Steward, and show the following amercements (fines) being levied on a number of trespassers:

- *John Higgyn fined two pence: "because he dug and got two cartloads of turfs upon the common pasture of Shelfield. John Parker (2d), Henry Boithe (2d) and Henry Bawden (2d) did likewise."*

- *Henry Manknoles fined four pence: "because he trespassed upon the common pasture of Sholfield with 40 of his sheep."*

- *Henry Bawden of Wethead (Roughlee), Christopher Bawden of the same, senior, and Nicholas Bawden all fined two pence: "because they kept about 12 sheep upon the common pasture aforesaid."*

- *Edward Hartley of Trawden fined four pence: "because he trespassed upon the common pasture aforesaid with a horse."*

- *Nicholas Robinson, alias Thurnyholme, fine four pence: "because he ~~overstocked~~ trespassed upon the aforesaid common pasture with 20 sheep."*

- *John Wilson fined two pence: "because he kept strangers' geese upon the common pasture aforesaid."*

In 1533 an Inquisition was taken into:

'The obstruction of the Lones between Gryndilstonchy rat and Agotthole in Colne, beginning at the Greneloyne Heyde to the Prestfeld, Pulforth Loyne, and Kynewode Heyd, and from Grene Lone to the Heyrerhowse and the waste.'

This affords another description of Grindlestonehurst whereby *hurst* is replaced by *chy,* this is most probably a form of *shaw* which has a similar *woodland site* meaning to *hurst*. A particularly interesting part of this inquisition is that we have the description of a *rat* at Grindlestonehurst. The term *rat* was used to describe a defensive wall upon a banking or mound, commonly applied to the pre-Norman earthwork defences and the small earthen castles of the early Norman period. This being the case we surely have a reference in *Grindlestonchy rat* to the Castercliffe hill fort defences as we know that much of the wall system was extant at this time. To further this argument, twenty-one years on from the above inquisition Robert Blakey, of Colne, made a deposition to a royal commission. He reported that: *"The King's Majesty had a certain waste ground called The Castle Town Field at Grindiltownhurst, of which 60 acres might well be improved, leaving sufficient commons for the inhabitants."*

Local traditions and folk-memories of the area are a fascinating mix of fact and fiction offering glimpses into our history that are often difficult to substantiate. There is often a germ of truth within these stories, although verbatim history tends to provide evidence that is patchy at best it would be a mistake to dismiss them out of hand. In the following examples it would appear that the common local memory is an acknowledgement of the importance of the area as a defensive site:-

- *"A large castle once stood in the Castercliffe area, the wooden gates of this structure were so massive that when they were closed the thunderous noise could be heard echoing throughout the whole of the Forest of Pendle.... until Cromwell destroyed it."*

- *"Julius Caesar sailed his legions up the River Calder and they landed at Colne Waterside."*

- *"Retired Legionaries from the Roman army were granted lands at Greenfield, Colne, where they and their families settled permanently."*

- *"Fairies and kings sleep beneath the massive bulk of Boulsworth Hill and will emerge if the area is ever under threat."*

In 1425 the Parker families of Foulridge and Alkincoats were shown as owning most of the farms around the area of Grindlestonehurst , eventually these properties would pass to the Bannister family through marriage settlements between the two families. The Bannisters could then boast that they owned almost all of the lands and farms within the area. Eventually the Bannister estates would pass, again through marriage settlements, to the Towneleys of Royle and their successors the Towneley-Parkers of Extwistle and Cuerden. By the late 1500s there were three main copyholders shown, these were the Robinsons of Grindlestonehurst at 2½ acres, the Waltons of Grindlestonehurst at 6 acres and Gib Hill at 4 acres and the Bannisters of Greenfield had Botthouse at 24 acres, Hole House at 27 acres, Lones at 10 acres and Whackersall at 7 acres. In 1507 John Robinson erected a farmstead at Grindlestonehurst and added three illegal cottages to the property.

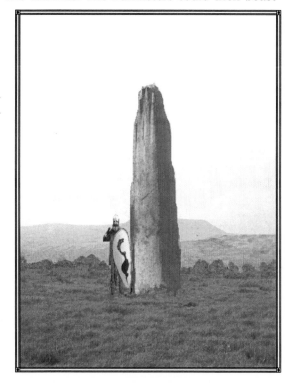

Reconstruction of the original Walton's Spire monolith as it would probably have appeared in the Saxon period

Chapter Four

Brigantia

"Capering ninnies covered in woad" – such was the description famously applied to the northern tribes of Britain by an eminent nineteenth century archaeologist. The intervening decades, however, have provided a more flattering picture of our predecessors.

Within our north-western area the pre-Roman tribes occupied a large tract of land stretching from the Mersey in the south into the present Scottish borders. This area was known as Brigantia and its inhabitants were described by the first century historian, Tacitus, as being the most populous of all the native British tribes. Writing in the second century the geographer, Ptolemy, noted that the land of the Brigantes stretched from sea to sea bounding the lands of the Cornovii tribe (the modern Chester area) and the Corieltauvi, to the east of the Pennines. As was the case with the Druids, we have to rely in the main upon the descriptions of classical writers to get a picture of the Brigantes.

The name Brigantes, or *'dwellers in a high place,'* was used to describe all of the inhabitants of our north country although, within this generic whole, were separate tribal groups. Among these were the Lopocares and Tectoverdi who inhabited the areas east of the Pennines, the Carvetii of the Eden Valley and Setantii to the west of the Pennines. Ptolomy described the latter as having a specific seaport, which he named *Portus Setantiorum* - this is largely accepted as being a Romano-British port in the Wyre estuary. I have recently read an account whereby Ptolomy's surveys have been extrapolated by modern methods to place the port *exactly* on the old stone jetty at Morecambe although it is uncertain as to exactly how accurate this is! The account goes on to postulate that the port supplied the centre of the Setantii at what is now the nearby city of Lancaster. It is unclear as to the extent of the Setantii tribal boundaries; Whitaker thought that they occupied all of our area to the Ribble, other historians state that they possibly occupied lands to the west of Pendle Hill.

Our particular area of interest, the Pennine area of Lancashire and West Craven, appears to have maintained a Bronze Age culture long after more southerly areas of the country had absorbed Continental ideas. This insularity, mainly for geographical reasons, has been a feature of the Pendle and Bowland Forest areas right up to the Early Modern period. For around five centuries, to the coming of the Romans, the Western Pennine people appear to have been strongly influenced by a tribe known as the Parisi. At this time local hill forts began to be abandoned as the representatives of the Arras culture of East Yorkshire spread their control, eventually ruling territories stretching from the North Sea to the Irish Sea.

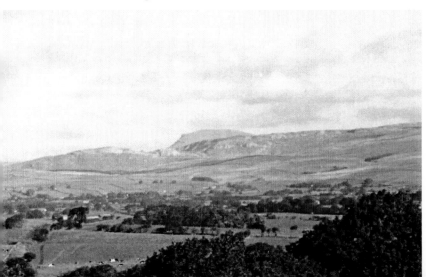

Ingleborough viewed from Barnoldswick showing the close proximity of this Brigantian centre to our area

Around the time that the Romans arrived in our area the Parisi seem to have lost much of their influence to the Brigantes proper. The power base connected to our area at this time was possibly the Brigantian centre of Ingleborough where many farmsteads of both the pre and post-Roman periods have been identified. These farms were arable in the main but livestock was a portable form of wealth and must have figured in their system. It has been suggested that the decline in the local power wielded by the smaller tribes, and the expansion of the Brigante influence around this time, can be attributed to the need for a 'united front' to counter the Roman threat.

It would appear that the Brigantes developed a specifically north country culture over the period of the first millennium BC, certainly by AD 51 there are records showing that Cartimandua ruled the Brigantes, at this time she surrendered Caractacus to the Romans. Historians are divided on the subject of Cartimandua's leadership, some say that she was the daughter of the first true leader and others say that she was the first (and last) ruler. Tacitus stated that she was of *'noble lineage'* which tends to support the theory that she could have taken the leadership of the tribes when a male heir died as was the case when Boudicca ruled the Iceni following the death of her husband.

Cartimandua took Venutius, of the Carvetii tribe, as her consort but this proved to be ill-fated, she was pro-Roman in her policies but Venutius became the leader of the anti-Roman coalition. This led to the Romans having to shore up Cartimandua's rule by sending in their troops during the middle period of the first century AD, this isolated Ventutius and his forces within the East Pennine region.

By the middle of the second century AD the most southerly Roman garrisons were stationed along the Ribble/Aire Gap, many other stations had been decommissioned, this is possibly because of the Roman push into Scotland, equally it may be due to the fact that the Brigantian power base had been split. According to the Roman scribe, Pausanius, the Brigantes had lost their power because Antoninus Pius had put down an uprising by the Genounii tribe. It is not known who these tribes people were but, if true, this would be a good excuse for the Romans to hammer the Brigantes.

Because large areas of Brigantia had been broken up into smaller territories the Romans no longer required a large force to oversee their interests. Eventually the Brigantes consolidated in a small area around their civitas capital of Isurium (Aldborough near Bainbridge). Eventually Britain was divided into two provinces by Severus in the early third century AD. *Britannia Superior* covered the southern territories and *Britannia Inferior* was based upon York; Lancashire formed the south-west quarter of this province.

Within the context of territories (both strategic and resource led) Lancashire and Yorkshire was slowly beginning to take shape. Communication was the key to the later development of our area, political and defensive considerations being as important to later polities as they were to those in pre-history. Eventually the Saxons would hone our civic and ecclesiastic boundaries and the Normans would finalise them.

The Dark Ages (or Early Medieval period) approached and so the last of the true Iron Age people of the British mainland adapted to a slowly changing lifestyle. It appears that the inhabitants of our particular area would not have seen a massive change during the Roman occupation, our Pennine micro-culture would probably be largely untouched by the invaders although, as we have seen, we do have the odd residual Latin name in places like Caster (*caester*) Clough at Blacko Foot and Castercliffe.

* * * * * * *

The Celtic Language

The Celtic languages of the British continued to be used up to the coming of the Northern German peoples whose numbers were made up largely of Jutes, Angles and Southern Danes. The early Indo-European culture spread across Europe and with it came the beginnings of a variety of modern languages. The Germanic language of the Saxons had its roots in the Elbe River region around 3000 years ago, apart from a distant common origin the Celtic and Germanic languages share very little else. The Old English language of the Saxons is ascribed roughly to the period between AD 410 and the Norman Conquest, this language did not assimilate the Celtic language other than the incorporation of a few place-names. This is possibly because of a racial/ethnic arrogance by the Saxons or perhaps the native Britons were more adept at learning English than the Anglo-Saxons were at learning the indigenous Celtic language. The Old English language gave way to Middle English at the end of the eleventh century and Modern English took centre-stage around AD 1500.

The series of post-Iron Age invasions, from the Romans to the Anglo-Saxons, pushed the majority (but by no means all) of the Celtic speaking peoples out of what is now England into Scotland, Wales, Cornwall and Ireland, the only one of these regions not to have an extant Celtic language today is Cornwall (the last native speaker here died in 1777). This gradual cut-off in the use of Celtic descriptions for our landscape provides a useful tool in the use of etymology for dating purposes.

Although the majority of place, and topographical names have been left to us by the Saxons, the Scandinavians left a definite legacy, as did the Normans, we also have a small number of Celtic names that can be ascribed to the older Welsh language. This method of dating is certainly not foolproof, however, care must be taken when assigning a Gaelic word to an early British settlement. In the later ninth century, and throughout the tenth century, Scandinavian raiders settled within parts of our area, these people came mainly from Ireland and their numbers included native Irish speakers who may have left us with Celtic descriptions for the topography around their settlements. The etymology of our native languages is complex although the adoption of known languages within a specific time-frame does allow room for the 'educated guess.' Where there is a viable alternative in the ubiquitous Old English I have included it in order to illustrate the difficulties encountered within early place-name research.

The geography of our area can be seen as a good reason for our local population to remain insular, the local inhabitants were still largely of an Iron Age culture when the Anglo-Saxons arrived and would therefore retain the traditional British descriptions of their environment. A few apparent examples of extant Celtic names in our area are:-

Noggarth on the ridgeway above Barrowford originates in *gart,* meaning *enclosed corn-land, garth* being a Norse adoption of the earlier Celtic word for *enclosure, promontory* or *hill* (an exact description of the site) and *nog* is the Saxon word for *abundant/plenty* leaving us with *the enclosure of plenty,* presumably because the land was fertile (it is certainly well drained). Noggarth Hill was traditionally used as a communal gathering ground from at least the later Medieval period (this may have been a continuation of much earlier 'moot' gatherings) - it became a favourite place for the local militia captains to hold their recruitment drives. On more than one occasion local ruffians invaded the meetings, assaulted the militia and drove their would-be recruits away. The Noggarth hillside became a quarry in the nineteenth century, supplying stone for the burgeoning streets of terraced houses being built for the new, and ever expanding influx of mill workers within the district.

Ogden is a deep clough on the slopes of Pendle Hill created when underground waters burst from the side of the hill. This is an example of a Celtic prefix to a Norse word *Og* is the Celtic for *young oak* whilst *den* is the Saxon word for *valley*.

The name **Pendle Hill** is commonly shown to comprise of the Celtic *Pen,* meaning *hill*, this later became a prefix when the Old English *hyll* was added and even later still the Modern English word *hill* was appended to give us the actual translation of *Hill Hill Hill*. If this is indeed the origin of the name we have a nice example of the continuity in our three main languages where the previous cultural description was taken up along with the relevant one of the period. However, there is another consideration and that is the possibility of the name originating in Penda, the pagan king of Mercia, this is discussed in the place-name section of Chapter Nine.

Lawnd; seen in both **New Laund** and **Old Laund** at Fence and Wheatley Lane, is the Celtic for *'open space within woodland.'* The Saxons used the word *laund* to describe the same feature whilst the Normans adopted it to describe a deer park. The village of **Fence** takes its name from the fact that it was a fenced area for the control of deer within the Forest of Pendle following the Norman Conquest. Old Laund, to the south of this area, shows a continuation of the name, this would appear to show that this was a cleared (and probably settled) area of land long before the Normans appeared.

Colne has been described as having its origins in the Roman *Colluna* or *Colunio*. This has not been substantiated, many etymologists agree that the name is Celtic.

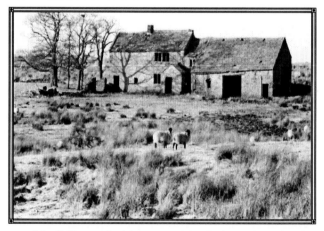

Firber House (SD 835 432) is a fascinating site, it stands as testament to the hard life led by its many occupants from at least the sixteenth century to the middle of the twentieth century. This farm has always been an extremely marginal holding, the sixteenth century Clitheroe Court Rolls show it changing hands on a regular basis, the steep slopes of nearby Rimington Moor still bear the evidence of ridge-and-furrow ploughing, the fact that the farmers of this land had need to, and actually managed to plough these precipitous slopes beggars belief, it is difficult enough to even walk them! The farmstead buildings of Firber stood in their entirety in the 1980s (photograph right), except for doors and windows (see photograph above); I last visited this site in the winter of 2005 and found that the building had seriously decayed.

The meaning of the name Firber has a number of possibilities: the Gaelic word *fir* means *men* and, if this were the origin of the first element then we would have a hybrid Celtic/Saxon name as *ber* is the old English for *(defensive) enclosure*. In the Old English Saxon language the word *fir* is *fyr* meaning *fire*, but the similar word *fyr* means remote or distant, this is an apt description of the place, located as it is on a flat, open plain at the head of the Middop Valley under the shadow of Pendle Hill. *Fére* has the meaning of *able to go* ie, *'fit for military service'* and would provide a description of a military camp at the Firber site which would offer an excellent control point for

the movement of goods and people. Ancient trackways running both north-south and east-west converge on Firber, this highlights the fact that this now isolated, lonely place hidden within the moorlands of Pendleside could well have been of former strategic importance.

Bale Plantation and **Bell Flat Hill** are situated to the north of the town of Barnoldswick, and there is a *Bell Wood* at Caster Clough below Blacko. *Bale Hill* is a patch of high ground on Rimington Moor as it sweeps through Middop Valley, down to Gisburn, from the heights of Wheathead. The word *bell* has the Old English meaning of '*at the head of,*' this term was sometimes applied to the external area of mine workings (the pit-head) but there can be an origin in the earlier *baile* which is Gaelic for a *farm* or *village*. The Old English word *belle* had the meaning of *a sharp ridge* and is possibly reflected in the name of the village of Barley where Pendle Hill forms the back-drop of the area. *Baal* is a Celtic word often denoting a fire-related site, for complex reasons this is one of a number of Celtic words owing their foundation to the Hebrew language. On this theme the Old English word *bǽl* became *bale* and means *bonfire* whilst *bǽlcan* means '*to cry out'* – all of these possibilities have a strong suggestion of a look- out post or early warning site. It has been noted by researchers of '*baal*' sites that they are commonly located near to megalithic remains (stone circles etc,).

Middop is often said to be a Saxon description of *the valley between* or *middle valley*, whereby *midd* means *middle* or *in the midst of,* the word *hop,* however, when used as a second name element gave the meaning of *moor*. This describes Middop perfectly as '*in the middle of the moor.'* It is here that we find the large (postulated) Bronze Age earthwork, which must have been a settlement, or occasional defensive camp, at SD 834 453.

Within a very short distance of the Middop earthwork is the deep valley known as **Tory Log Clough** (SD 833 444) which runs from the northern edge of the Middop earthwork to the higher ground of Craven Laithe, Rimington Moor, Admergill and Wheathead Height. The word *tory* was,

in 1566, *an outlaw*, specifically *a robber* from the Irish *toruighe* for *plunderer,* originally *pursuer, searcher,* from Old Irish *toirighim* for '*I pursue,'* related to *toracht* meaning *pursuit, log* can have the meaning of *great*.

Tory Log Clough

As we have seen, incursions into the area took place when Norsemen from Ireland spread from the Ribble estuary during the tenth century, these newcomers brought with them a number of Irish natives who may well have influenced certain place-names during their stay. It is not impossible that the Middop Valley was employed by these people as a route back-and-forth to the west coast in their constant travels throughout our area. Alternatively we have the Old English *toryne* meaning *together/concourse* and *torr* meaning *watch tower*. *Toren* is *tear apart* or *cleave, logian* means *divide* or *portion out* and another derivation of *log* is from *léan* meaning *reward, gift* or *retribution;* the general assumption here could be that of the

area having been apportioned out. It is interesting to note that at the very head of the Tory Log Clough is **Bale Hill**, we have already seen that this could have been a look-out and beacon site which would fit nicely with the *torr* meaning of watch tower. If this were to be the case than it would be no surprise to see such a use being made of such a strategic area situated on the east-west Pennine crossing point. To stretch a point a little it may also be suggested that *tory* is the shortened Gaelic element of *torradh* meaning *heaping up* or *burial*. Coupled with *log* this would give the meaning of either a *'man-made mound on which sat a tower'* or a *'mound of reward or retribution'*, this latter possibly having been a post-battle burial place.

Another farm settlement on the edge of the Middop earthwork carries the unusual name of **Whytha**, a word whose etymology can reasonably be assigned to the Celtic *wy* for *water* and *thar* for *over/beyond*. This gives us a description of the settlement in as much as it lies beyond the stream which skirts the earthwork. The Old English word of *wyrht* means *work* or *service* and the word *wyrhta* is *worker,* this suggests that the farm at Whytha could have been the home of a Saxon worker who laboured on the estate of a local manor. It is also possible that we have a number of Gaelic/Celtic names concentrated within a very small area of the untouched moorland around Brogden and Middop. If this is the case then it suggests either an early British origin, and a continuation in British place-names, or a later settlement naming, possibly at the time of Hiberno-Norse raids during the tenth century. These raids could have left their mark in the naming of certain topographical features and the Middop area, therefore, could have been either a Celtic speaking stronghold within the Iron Age, possibly centred on the earthwork camp, or a temporary settlement of later Celtic invaders. It is interesting to note that the areas to the east and west of Middop (in common with the rest of modern England) have predominately Anglo-Saxon names with a scattering of Scandinavian names thus creating a Celtic 'sandwich' within the valley. It has to be said, however, that it does not seem probable that a transient invader would have stayed in the area long enough to have sufficient influence to actually name a site, the inference being that where there is a choice in the etymology between the Germanic languages and the Celtic the former is likely to prevail.

Castercliffe, as we have seen, is the Iron Age hill fort on the ridgeway above Nelson, the name is likely to derive from the Roman Latin *caester* for camp giving the meaning *camp on the ridge*. There is the consideration, however, of the fact that the Celtic word *cas* means *castle*, this could be a description applied to the hill fort - Medieval documents show Castercliffe as *Castel Cliff*.

Marl is the Celtic name for chalky clay, the word marl is used to this day in certain field-names.

Canto has the Celtic meaning of *'rim or border'* – this fits very well with the area known as **Cant Clough** on Worsthorne Moor, the water forming the Cant Clough springs is on the Lancashire and Yorkshire boundary at Black Hameldon.

Burn Moor adjoins Wheathead Heights above the Admergill valley. **Burnt House** is a farm at the back of the Cross gates Inn, Blacko, the building is situated directly over the stream running down Blacko Hillside from the Black Dyke and has a waterwheel pit beneath the farmhouse floor. This suggests that the property was a rare example of a mill in the Blacko area, possibly a fulling mill as the farms on Blacko Hillside housed a proportionately large number of handloom weavers in the eighteenth and nineteenth centuries. Nearby Blakey Hall was another example of a water driven woollen processing operation. *Burna* is the Old English for *brook* or *small stream* (an exact description for this stream) but the word has its roots in the Celtic word for *fresh water*. Nearby

Burnley also has the *burn* element but this was known as Brun-ley in the Middle Ages and probably derives from either the Saxon *brun*, meaning *brown-ley*, or the Germanic *brunnen* also meaning the same as *burn* but often appended through failure to recognise the original meaning of the name *burn* (also see later chapters on the Battle of Brunanburh).

The road on **Tubber Hill** climbs from Barnoldswick over White Moor and on towards Barrowford, the hill could have its origins in the anglicised Celtic name of *tiobar* meaning a *well*, it has also been used to describe *cascading,* or *boiling water*. This is interesting as there is a gushing stream on Tubber Hill that runs down towards the town.

Langroyd is a settlement within the town of Colne, The Long Royde is a field name on the ridge of Admergill Pasture in Blacko, there are Monkroyd place-names at Laneshawbridge and Barnoldswick. The word *'royd'* was the Saxon description for a clearing. It is likely that the term, in the context of Langroyd at least, has its roots within the Celtic *'Roid'* for *'a place where the bog myrtle grows'* ie; land denuded of trees or a clearing. There is also the later Old English word *rid* which has much the same meaning.

The **Calder River** is the combination of the Pendle Water, Colne Water and Wanless Water rivers, it carries the run-off from both Pendle Hill and Boulsworth Hill. The Calder ambles through its valley, to the west of Burnley and along to its confluence with the river Ribble near to the ancient Hacking Hall. *Calder* is the Celtic name *cwl-dwr* meaning *'rough water.'*

The Gisburn Old Track, which becomes Coal Pit Lane on the Gisburn side of Weets Hill, is a metalled road following the way from Colne and Foulridge to a point where it enters the Ridge of Weets Moor, it then becomes a rough moorland track. Whilst still climbing the western slopes of Weets Hill the track crosses a stream at a spot known as Sandyford. In the sixteenth century Clitheroe Court Rolls the disturbed ground area above Sandyford was referred to as *Star Bank,* the farm at this point is called **Star Hall** and stands upon an ancient road from Admergill over to Barnoldswick, the Greystones Cross stood by this track just above the hall. The possible antiquity of this area becomes apparent when it is realised that the Old Irish word *Staer* (a Latin derivation) means *history.* If this is indeed the root of the name then this site appears to have been called *'old or historic'* even in Saxon times!

We have a number of **White** place-names in the area, two examples are Whitemoor between Barnoldswick and Blacko, and Whitehough near the Pendleside village of Barley. It is possible that (in some cases) the *white* etymology has its roots within the Celtic language as the classical writer Pliny used the word *wight* and in later times Bede used *wiht*. In this context the words describe *'that which has been raised'* thus giving us the description of high ground, an apt name for White Moor. The hamlet of Whitehough has the *white* name coupled with the Anglo Saxon *hough* meaning *'a wooded valley by the side of a river'*. As Whitehough fits this description exactly, and it climbs out of the valley to the heights of Stang Moor above, the *high* connotation appears to be accurate. We also have Weets Hill overlooking White Moor and the Middop Valley, *weets* could have the same root where *white* describes high land. In many other cases, however, the name element of *white* appears to have a number of derivations in that it is said to relate to the white cotton grass of moorland, sites by salt trade routes, wheat growing areas and lime-spread field improvements. The number of White Walls sites in the area could very well originate in the latter.

The name of **Malkin Tower** is known throughout the English speaking world for its association

with the Pendle Witch Trials of 1612. The etymology of the word *Malkin* is difficult to say the least, it can be ascribed to a number of periods within our history; in Shakespeare's time, for example, the word came to be used as a derogatory term for a female servant. *Grimalkin* had the meaning of *cat* or *grey cat*. Searching further into the recesses of our culture the *Malkin* name takes on a different hue as *maw* was a Celtic word originally and was assimilated into the Old English where it replaced the Saxon word *mag*, this meant *stomach* or *open mouth* which exactly describes the large, deep gully at Malkin known as *Haynslack* (a Norse description for *a hillside hollow on a boundary*). A field adjacent to the Haynslack feature is called *Mawkin Hole Field*, this may be the colloquial name for Haynslack or it could refer to the ancient trackway (now merely a footpath) running through the site. The word *hole* is Old English and in local useage has the same meaning as the Norse word *slack* ie, *a hollow* or (more rarely) *a road*.

The Celtic relationship with the *maw* name continues with the Welsh word *mawr*, this means great and is usually associated with hills, an example of which is Bryn Mawr. The word *maelecan* bears a strong resemblance to *Malkin* and was a Celtic double diminutive describing the *shaven one*, this commonly applied to monks. In the Medieval period a popular card game was introduced to England from Ireland, this was called *maw*. It would appear that there was a Welsh Prince named *A'dd Mawr* who controlled certain British lands sometime in the Early Medieval period, it is very possible that this name has been shortened over time to *Maw (- kin)* but, equally, it could apply to the nearby settlement of **Admergill** whereby we would have the Celtic name of *A'dd Mawr* with the Norse suffix of *gill* for *steep valley* or *stream* thus giving *A'dd Mawr's Gill*. There is, however, a strong argument for the Admergill name having originated within the Old English meaning of '*boundary mound in the steep valley.*'

The list of *Maw* derivations goes on, in the year AD 1200 Irish records show examples of the Old Irish given name of *Maelchon*, the singular gender is variously given as *Malcanrehou*, *Melcanerhou*, *Melkanerhou* and *Melkenerhou*. It can be seen within the word *Maelchon* that it would easily become *Malkin* in a later period. There are many more possibilities for the meaning of the Malkin name - Malkin was church glebe land overseen by the steward of the honor of Clitheroe and attached to the living of the Colne incumbent, the records show the site as *Malken Yard* and *Mawkin Yerde*, a yard being an enclosure.

The nearby former estate of Alkincoats also carries a similar name to Malkin in *alkin,* this is said to refer to a '*site upon a hillside.*' Returning to the possibility of a Celtic origin for the Malkin name the Annals of Ulster named a leader of the Ardri tribe, in the year AD 844, as being *Maelsechlainn,* it would not take a huge leap of faith to imagine this being shortened in the English to Malkin. During the later Medieval period Malkin was a common given name within our area, probably signifying an early root within the Celtic. Another common name, both given and Christian, was that of Maude and this was commonly changed colloquially to Malkin, it would be no surprise, therefore, if someone named Maude farmed at Malkin Tower Farm in the post-Norman period. Whatever the truth of the matter, we have in Malkin a nice example of the complexity encountered within place-name etymology.

Chapter Five

Ridgeways

The embryonic trading routes evolved into a pattern that we can recognise today, many of our known 'Roman' roads were actually extant ancient routes utilised by the invaders. Our area became important within the hinterland track network, sited as it is near to the low-level crossing of the Pennines at Kildwick, much of this network still exists as tracks, pathways and even major roads. These were the main arterial trackways serving the west-coastal traders enroute to the Humber estuary and onwards to Scandinavia and the Baltic. A good example of this is the minor road that has served the area well for millennia, this route, known locally as Back Lane, runs from the once-navigable Ribble at Ribchester, through the Portfield area near Whalley, and picks up the Pendleside Ridge (Fig4).

The route then follows the ridge-brow (keeping the traveller safely above the valley bottoms) onwards past Padiham Heights above Sabden and along by Hoarstones in Fence, following the 'Roman' road along Spen and Noggarth Top the trackway heads through the field gate by Noggarth Top Cottage and straight through the field; at points along this route the agger, or ditch and bank, construction can be clearly seen (see photograph). This feature can be followed along on to the farm track above Ridgaling Farm and across the area known as Greystones overlooking Roughlee. The long straight way then enters the field gate above Spitalfield Head at the top of Pasture Lane where the agger is again apparent, along the grass track directly above Roughlee, straight past Higher Ridge Farm, on to Utherstone Wood and so down from the very end of the ridge into the valley of the Water Meetings at Barrowford.

The agger bank on the ridgeway route from Noggarth Top to Ridgaling and the Water Meetings

At this point the Blacko Hill (SD 860 422), sweeps from the Water Meetings valley to its full height of one-thousand feet (it was once considerably higher but quarrying operations have removed its conical top), and forms a 'stopper' at the northern end of the Roughlee and Barrowford valleys. The Water Meetings, or colloquially Watter Gait, is situated at the confluence of the three boundaries separating the parishes of Blacko, Barrowford and Roughlee and would have been an ideal spot for early settlers; apart from being extremely picturesque the area has a number of highly defensible areas at the confluence of two waterways. Its position at the end of two valleys, and at the base of the Utherstone Ridge and Blacko Hill, was on a trade route and must surely have been attractive to the Neolithic people. Aerial photography substantiates this view, on close study two areas of higher ground show strong indication of having been enclosed by ditches and a field here was named Ringstone Hill in the sixteenth century.

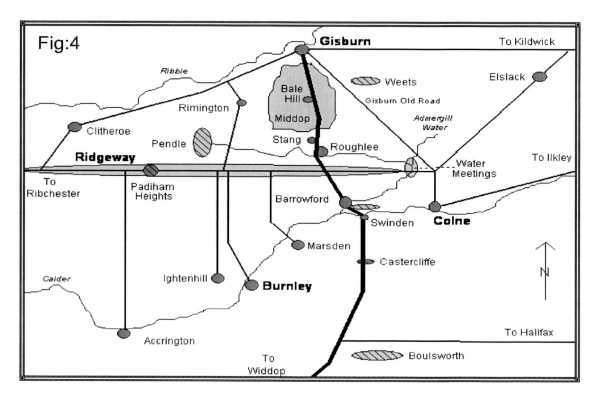

Fig:4

The main north-south arterial route ran from the Ribble, through our area and on to Halifax. The east-west ridgeway ran from Ribchester and terminated at the Barrowford Water Meetings. Branches of this route then led through the Pennines and connected locally to Colne and Gisburn. Figure 4 shows that the ridgeway acted as a form of conduit to carry the north-south traffic to all the major settlements of our area.

The track from the ridgeway divides at the Water Meetings and heads along Blacko Water, across the bridge at Blacko Foot, through Caster Clough (SD 850 412) and across the 1914 bridge on Wheathead Lane before following Admergill Water along to Lower Admergill. This was an important route from the ridgeway and Roughlee areas as the hamlet of Admergill was situated on a strategic east-west route at the head of the Middop Valley.

Another road, from the point where the ridgeway descends into the Water Meetings, traversed Blacko Hillside from where it headed south to Colne and eastwards into Barnoldswick where it joined Blue Pot Lane and onwards to Kildwick. This trade route through the town of Barnoldswick can be seen today as the minor roads of Brogden Lane and on past the Middop earthwork to join the Roman road system in the Rimington area. This ancient way is thought to have been a 'gold route' whereby precious metals were transported from Ireland through to the Baltic.

From the very spot where Admergill Water (here having become Blacko Water) and Pendle Waters join, a track ran past the vestige of a circle of large stones, placed within a high semi-circular bank forming a large amphitheatre. This particular type of feature also occurs at other points within the area - higher upstream at Caster Clough and below the long, heavily-wooded hill of Rye Bank which forms a backdrop to Barrowford Park. This latter feature is another example of a high ridge with steep, defensive slopes and the present site of the cemetery would probably have

been utilised for early settlement. The 'amphitheatre' here overlooks the park lake and in the sixteenth century was known as Coney Garth, this was a rabbit warren used to supply meat for the Park Hill estate. The name of Rye Bank was taken from the type of cereal grain grown in the area, the high ground being more suitable for this particular crop than the lower riverside holmes. The Rye Bank ridge forms a barrier between the village of Barrowford and the area of Swinden and in all probability was the reason for the element of 'Barrow' in Barrowford being adopted.

The Cross Gates (where the Inn now stands), along with the rest of the modern parish of Blacko, was formerly a part of the administrative area of Over Barrowford, the site now forms a fork in the Barnoldswick Road whereas it was once a point where at least six ancient routes converged. One of these ancient tracks is still a footpath and heads down from the Cross Gates Inn to Wanless Farm on the north bank of the Leeds and Liverpool Canal. The canalside house here was formerly an Inn known as The Grinning Rat, this served the many bargees and carriers who used the nearby Wanless Wharf to offload raw cotton and stone for the burgeoning local towns. From here the old route joined Red Lane and could be taken to the Alkincoats estate or Blakey Hall, Heirs House, Greenfield and Colne. From the Cross Gates northwards the roads ran to Gisburn, Pendleside and Clitheroe. Many of these ways are now are only to be traced with difficulty and field-work is the best way to prove their existence. Banked, ditched and hollowed ground, along with ancient hedgerows, stone markers and extant lengths of dirt track can still be found along these ancient byways.

Inter-Ridgeways

The Neolithic and later Metal Ages saw a steady increase in trade across Europe and therefore the need for established routes increased. More areas of higher ground were utilised as settlements to accommodate the population increase, this necessitated higher levels of communication between these settlements. The ridgeways became permanent tracks and the wet valley bottoms were crossed, when necessary, by more permanent means than the previous narrow paths. Fords were used wherever possible but large areas of morass were crossed by means of timbered causeways or raised stone walkways.

A good example of a trans-ridgeway is Pasture Lane (SD 848 402), running from the ridgeway above Roughlee to the high land of Castercliffe and beyond. The road descending down into Barrowford now avoids the former Haighton's Mill lodge by means of a sharp S- bend along to Pasture Gate Farm (known locally as Piece House) but formerly it carried straight on down into the village. West Hill (at the western end of the Conservative Club row on Gisburn Road in Barrowford) carried the road straight to the old ford at the bottom of Church Street and across to the ancient Park Mill (sadly long since demolished). Having gained the opposite bank of Pendle Water the road ran through the present park and passed behind Park Hill (now the Pendle Heritage Centre) and onwards to Colne, it also branched here up Rye Bank towards the cemetery and across the fields, past the now lost Swinden Hall, up Bott Lane through Castercliffe and onwards towards Widdop. The same Pendle Water crossing carried the road from Old Laund, Rishton Thornes (the area where the Old Sparrow Hawk Inn is situated in Wheatley Lane) down through Clough and Back Lane (now Church Street in Barrowford)) and across towards Park Hill.

The remains of yet another ford in this area could still be seen before the great Barrowford flood of 1967, this crossed near to the end of Harry Street where the original Berry's Mill stood (before making way for Berry's number one shed), this site is now occupied by new town-houses. In his *Annals of Barrowford* Jesse Blakey noted that when Berry's Mill was being constructed the remains of a house were uncovered, this was found to contain a large amount of deer antlers – it was postulated at the time that the house would have been used by a gamekeeper of the Pendle

Forest during the times when the area was a Medieval hunting ground. The riverside lands of Barrowford were favoured territories for the hunters, as late as the eighteenth century the Extwistle Hunting Song states that Squire Parker of Extwistle Hall chased a stag for most of a day, finally hunting it down by the river at Barrowford. The close proximity of these three early fords may be explained by the presence, and importance, of the old mill in the park. Other fords at Reedyford, Park Hill and Higherford show that it is no coincidence that the village carries the name of Barrow-*ford*.

Another good example of a way between two ridges is Sandy Lane (SD 840 390). This is a continuation of the road from Barley up the hill at Happy Valley to Noggarth Top where it continues towards Nelson as a dirt track. At Wheatley Lane the road forms Carr Hall Road and drops down past the site of the old Carr Hall and Carr Mill through what was once a large swampy area at Seedhill, this was once a noted newt breeding ground – the route of this road is now lost as it passes through the town of Nelson.

The trackway of Gisburn Old Road SD 864 435), running from Pasture Head at the end of Standing Stone Lane below White Moor, is the old route to Gisburn from Colne and Foulridge. Exactly how old this route is, however, is unclear. It appears to me that the ancient boundary ditch of the Black Dyke (SD 864 430) running roughly parallel with the Old Road, could originally have been the original trackway for this particular route. The Black Dyke is an impressive civil engineering operation, carried out to form a major boundary and/or a defensive line in ancient times. In the Medieval period the lower end of the Dyke, from Peel's House southwards, was used to carry water from Whitemoor, Admergill Pasture and the top of Blacko Hill down to Hollin Hall, Malkin Tower Farm, Blacko Hillside Farm, Burnt House Farm, Beverley, Blakey Old Hall and Wanless Farm.

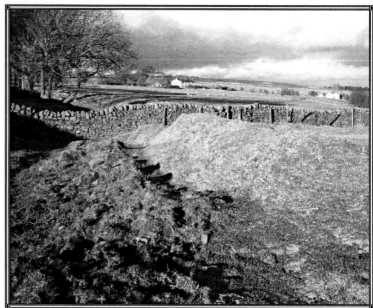

Photograph taken from within the Black Dyke looking north

The wall crossing at right-angles runs over the ridge of Blacko Hill to the left of picture and was the old Lancashire-Yorkshire county boundary

The structure of the Black Dyke (otherwise known as Hanson's Dyke or Admergill Dyke) is reminiscent of the major works of Offa's Dyke on the Welsh borders. The fact that the Black Dyke end is the confluence of a number of ancient tracks leads me to believe that it was used as a route northwards. The dyke converges with the Gisburn Old Road at Sandyford (Star Hall), then dives down Greystone Moor and along to the Level of Weets Hill before rejoining the old road to pass the Ridge of Weets, Newfield Edge and down to the old road at Lane Side. A left turn here takes the route straight to the impressive earthworks at Middop and on to Howgill Manor.

Carrying straight on at Laneside (instead of the above left turn) the ancient hollow road continues with its heavily tree-lined banks down to Coverdale where it meets with the equally ancient Howgill Lane. A couple of hundred yards along the way it passes a point where the Roman road, from Brogden Lane on its route to Rimington, crosses (SD 844 468). Carrying along its route the way passes the ancient earthwork at Bomber, then on to Whin Hill and beyond. For most of its length over the moor this route forms the Brogden/Middop boundary and is marked by a number of Medieval boundary stones.

The stretch of Howgill Lane that runs from Coverdale Farm (SD 847 466) to the Gisburn-Blacko Road is a fascinating length of road. It takes the form of two deep gulleys, or ditches, both banked on either side with the road running on the centre ridge. Where the lane now bends down to meet the main road it formerly carried straight on to Middop, the ditch and bank can easily be seen marking out its former course across the fields. The end of the lane at the main road junction does not line up with the continuation of Howgill Lane (the 'Roman' road) down to Rimington. This suggests that this length of Howgill Lane was not originally a track but formed an important boundary or defensive ditch along the lower western slopes of Weets Hill. The large variety of tree and shrub species on either bank of this lane is another indicator of its antiquity.

As the Neolithic Age progressed a specific group of people became established as traders and would have made good use of these tracks. The Peterborough culture retained a strong Mesolithic influence, even in the later Neolithic they were still using large, heavy pottery instead of the more refined pottery of the later period. The Peterborough can be thought of as the Gypsies of their age, camping wherever they could, trading implements across the length and breadth of the country. These people lived very closely with nature and were survivors, other cultures had not really effected them. They knew the trackways, the countryside, the trade centres and they would be part poacher and part hawker, storytellers and bringers of news, mostly operating on the periphery of the mainstream contemporary cultures.

These people would probably have know the Pendleside to Middop track well, this formed part of the main north-south arterial route illustrated in Figure 4. One of my favourites for walking, this section of the track led from Roughlee, up the minor road past Offa Hill, skirted the high ground of Stang Top and Brown Hill and traversed Wheathead Height (SD 840 429). Running above the ruined Firber House Farm the track crossed the county boundary at Firber Gate, then ran across Rimington Moor (near to the ruins of a supposed ancient tower there), over Bale Hill and joined the ancient 'gold' route at Whytha (SD 827 449). Turning right here the track passed the major earthwork feature at Middop and carried on over the county boundary as Brogden Lane. Alternatively the route could be taken straight down into Gisburn, a keen eye can still spot this ancient way as it cut over the wild moorland, sections of hollow roadway have survived on the higher ground.

The hamlet of Haggate is on the cross-roads from Nelson to Worsthorne and Burnley to Colne, the route through the nearby hamlet of Lane Bottom follows the Thursden Valley to the lower slopes of Boulsworth Hill. At the head of this climb through the valley is an Iron Age earthwork known as Burwains Camp (SD903 353). At this point the present road turns sharply left and heads over the moor towards Colne, originally this track headed straight up the slopes of Red Spa Moor via Burwains camp (see chapters on the Battle of Brunanburh), the hollow road here can still be made out. Leaving the modern road the ancient track known locally as the *Scotch Road* takes a direct route towards the ruins of Robin Hood's House (this took its name from the nearby Robin Hood's Well). Situated at SD 920348 the ruins of this cottage lie in splendid isolation near to the ridge of the weather-beaten Boulsworth Hill. Local legend has it, perhaps inevitably, that this house was the hideout of a gang of highwaymen. There is, however, the consideration that these isolated dwellings are now seen out of their original context - Robin Hood's House was on a trade

route between the expanding textile areas of Burnley and Marsden and their main woollen marketplace of Heptonstall and Halifax. The ancient Will 'O Moor trackway skirts around the western slopes of Boulsworth Hill and then carried on over the moors to Oakworth, Haworth and the Bronte's Yorkshire Moors.

To end this section on the ancient links between our higher ridgeways we have the route from Blacko Hill. This extends south, from Brogden, along the line of the Black Dyke, past the Cross Gates Inn and down Barnoldswick Road. It then carried on down to Red Lane and, where the present lane bends sharply left to the canal, carried straight on over Wanless Water, by Barrowford Canal Lochs and so on to Greenfield and Colne, a branch also headed up the hill at Bott Lane to the settlements at Castercliffe. The hill fort here has been firmly assigned to the Iron Age but it is highly likely that this area was also of great importance during the earlier Neolithic and Bronze Age periods, most of these sites show a continuity of occupation. As mentioned previously, this route from Blacko Hill, taken in the opposite direction, becomes Coal Pit Lane and skirts Weets Hill on to the Bomber earthworks (SD 842 478). In his *History of Whalley* Whitaker postulates that, because of artefact finds, the first settlement of Colne would have been in the Greenfield area on the higher points of the plain of Colne Water. The Blacko/Castercliffe route would pass through this area and could have been one of the earliest, and most important, inter-settlement routes in our local pre-history.

Other Reminders

The Neolithic peoples left reminders other than trackways, flints and stone tools, chief amongst these are their burial sites, territorial markers, stone structures, and causewayed enclosures. Quality stone tools were replacing flint during this period but even these, and the later bronze tools, were hardly capable of cultivating the heavy clay soils in the valleys, this meant that cultivation was largely confined to the slopes where the soil was thinner. Although these more acidic soils were less fertile they tended to yield larger crops of the early types of wheat and barley. Many examples of the terracing methods, used on hill slopes in this period for crop growing, can still be seen, they have always been known locally as *Roman Ploughing* although many of them were ancient even in that era.

Standing stones, or monoliths, are a firm reminder of our ancient forebears, these are often difficult to date as stones of all shapes and sizes were employed for different purposes right up to the Middle Ages. The exact purpose of the large monoliths, and stone circles left to us by the Neolithic culture is unclear. It has been postulated that some sites had an astrological use whilst others were for religious or fertility rites. The amount of variation in design between the different structures, and the differences in topographical siting, strongly suggests that the stone features had different purposes. Whatever these purposes might have been it is quite obvious that someone within the ancient communities took a great deal of time and trouble to construct them.

The country areas around us have their share of standing stones although care must be taken in ascribing these to a particular culture as many of these stones were used for other purposes through to the Middle Ages at least. They were used for marking tribal, family, parish and county boundaries and many are now incorporated into the enclosure stone walls. Marker stones, in the form of boulders both large and small, delineate footpaths (especially where two or more paths cross), trackways and boundaries. Some of these markers were very large, examples can be seen at Narrowgates Mill, Prospect at Barnoldswick, Slipper Hill near Colne Edge, Admergill Water and Sabden Heights to name but a few.

It can prove difficult to show that a large stone, or multi-ton boulder, has ever been used for a specific purpose in antiquity. Many stone circles, standing stones and mark stones have either

been totally destroyed or moved in the later agricultural process, extant stones at field edges and in ditches could have been moved from their nearby locations so as to facilitate the growing of crops. One thing is sure, these large stones will never have moved very far from their original location. When a three-ton boulder is seen in a field on the moorland slopes it is possible that it would have been a glacial deposit, left by the final glaciers as they crept across our land. The glaciers covering the higher hills of our area retreated some 20,000 to 16,000 years ago leaving deposits of Pennine Drift material above two to three-hundred feet. It strikes me, however, that few of these boulders remained untouched by our forebears, they were often placed in a specific position within the landscape - this only becomes apparent when they were either placed to act as boundary markers, in alignment with other contemporary features or in specific groupings. In the Welsh culture of the pre-Roman era it is recorded that the act of destroying or moving a mark stone was punishable by death, as late as the sixteenth century the Clitheroe Court Rolls show local people being amerced (fined) for moving *merestanes*.

The moors around Pendle have many hidden stones that only the solitary walker, and the sheep farmer, know exist. In an article written in 1992 a local field archaeologist, John H Hope, made some interesting observations regarding Neolithic stones; Mr. Hope studied the area around his home of Newchurch-in-Pendle (SD 823 394) and found a number of standing stones. In the field behind the Witches Galore shop are a couple of large stones, one taking the form of a stellae, (an upright stone bearing ancient inscriptions or figures). If this is a genuinely early example then it is a very rare find within this area. The author also relates a story of the shop owner attempting to drive fence posts into the ground behind the shop, when driven the posts disappeared into a void beneath the ground, this occurred over a wide enough area for him to postulate the presence of a chambered tomb beneath the field. Given the hillside site, the large amount of extant Neolithic remains in the immediate vicinity and the fact that the local millstone grit does not tend to form large chambers, this theory must hold some water. Around 2700 BC people of a similar culture to the Windmill Hill people of Wiltshire began to arrive in Britain, they brought with them the continental practise of erecting large megalithic structures and chambered tombs. It is pure conjecture, however, to assume that the Newchurch feature could be a consequence of the spread of the Windmill Hill people.

Black Bank stands to the right of the Newchurch-in-Pendle ridge

The remains of a double-ring stone circle still exist near to St. Mary's church, this can best be seen from the vantage point of nearby Green Hill on Saddlers Height. Mr. Hope also identified probable examples of the burial practises of Neolithic culture. Seven earthen long barrows appear to be located at Black Bank, behind the woods above the former Lamb Inn. At the time of writing the article Mr. Hope had not excavated these mounds but extant parallel ditches, and patches of

burnt material brought to the surface by moles from within the earth, strongly suggest barrow burials. Burial mounds of this culture, and the later pre-Roman cultures, litter our landscape and I would say that it is no exaggeration to state that well over 99% of these features remain undiscovered.

The Neolithic people settled into their pastoral-come-nomadic way of life and slowly began to create more permanent settlements and enclosures. An excellent example of this is Windmill Hill in Wiltshire, this takes the form of a causewayed camp of three ditches, roughly concentric, enclosing around twenty three acres. The construction was by means of a ditch around ten feet in depth the soil from which was thrown up to form a bank. It would appear that this enclosure was used as safe shelter for housing both the cattle herds and the people's dwellings and dates to around 2500 BC, having been formed on the site of an earlier feature.

The history books do not afford much scope for ancient civilisation within East Lancashire and West Craven (the numerous tumuli of Briercliffe and Worsthorne apart), there is always a mention for Portfield and Castercliffe Iron Age hill forts and the bronze implements found here and there, otherwise we appear to be considered as having been a wasteland. Local historians, of course, know better than this, one of the main problems we have here is the lack of funding available to the official archaeological departments, this shortage of money equates to lack of manpower and therefore few official sites.

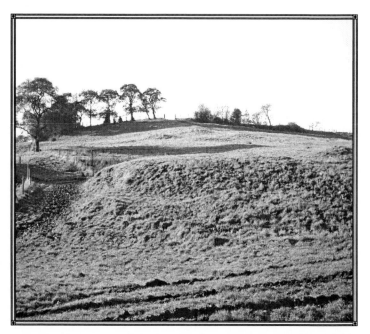

Looking towards the top of the Water Meeting site. Beyond the ridge is the level enclosure area. The feature is washed on two sides by rivers and forms an ideal defensive area

Many of our local ancient sites have yet to be discovered, the access to aerial photography now afforded to us, amateur and professional alike, is helping to address this situation. A site found by this method is located at the Water Meetings, below the village of Blacko, (SD 858 410), where the trade route passed from the Utherstone ridge to Blacko Hillside. This apparently defensive site covers around six acres, the level enclosure is surrounded on three sides by ditches and banks. The site makes use of the natural topography of high ground that slopes sharply into the rivers on both of its flanks (see photograph). Whether this site was a permanent settlement within the Bronze and Iron Ages, or simply a refuge in times of trouble is not clear because there has been no official research within the area. For whatever reason the feature may have been created it is certain that it is located at a strategic point on a main ridgeway route.

The Druids

The Druids were a shadowy people, described by contemporary scribes as a Celtic 'priest' class. Unfortunately the available evidence is so scanty that history has assigned their works to being stuff of legend. Almost at the very end of the Late Iron Age the Classical author Strabo wrote in his Geographica;-

"Among all the Gallic peoples, generally speaking, there are three sets of men who are held in exceptional honour: the Bards, the Vates and the Druids. The Bards are singers and poets; the Vates, diviners and natural philosophers; while the Druids, in addition to natural philosophy, study also moral philosophy............ The Druids are considered the most just of men, and on this account they are entrusted with the decision, not only of the private disputes, but of the public disputes as well; so that, in former times, they even arbitrated cases of war and made the opponents stop when they were about to line up for battle, and the murder cases in particular were turned over to them for decision."

The Romans had much to say on the British Druids (this being the generic term used to describe the culture as a whole), the validity of much of these descriptions is difficult to quantify. Some Classical writers appeared to be in awe of the perceived high status of the Druids within society whilst many writers denigrated the culture, describing Druidic practices as barbaric and based largely upon the making of human sacrifices. Towards the time when the Romans would finally invade Britain their descriptions took the form of pure propaganda, if their information on the Druids was reliable then they would not tolerate a strong extant leadership when attempting to assimilate a conquered nation into their own empire.

Within the general Druidic classes are three specific groups; these are Bards, Ovates and Druids. It is widely accepted that Druids were genetically Celtic, research carried out in the late twentieth century suggested that the European Celts have their roots within an Indo- European culture. Around 6000 BC eastern Anatolian people were speaking a language that was the origin of all Indo- European languages and by about 4000 BC the speakers of these languages had reached Europe and could be seen as the start of a Celtic people proper. These cultures eventually reached, and settled into eastern Britain (Cornwall and Wales) Scotland and Ireland, Sanskrit literature shows that Indian rituals can be traced within the Irish Celtic traditions, Hindu deities and Celtic gods have a certain similarities. Some schools of thought state that they can show that Indo- European religious practices provide a parallel with Druidic practices suggesting a possible foundation dating back to before 6000 BC. This theory postulates that similarities in tradition can be seen in the contemporary descriptions of sacrifices, the sanctity of water, the importance of weapons within religion, the abstract style of Celtic art, the use of fire to sanctify religious ceremonies, astrological knowledge, use of a calendar and the sacred importance of numbers (especially the number three).

Another theory on the origins of the Druidic Celts argues that they originated within the Beaker People, as a proto-Celtic culture, within specific areas of Britain. Whatever the truth of the Druid origins, not all historians are convinced that their tradition has a truly ancient lineage. The Druids also state that they have a strong relationship within the Megalithic cultures of Britain whereby they built, or adopted, the inter-linked stone structures (circles, monoliths etc,) to develop and practice their advanced knowledge of mathematics, astronomy, philosophy, engineering and spiritual enlightenment. A complex structure of the Druidic tradition is described in the manuscripts of *The Welsh Triads* where their importance within the ancient landscape was made possible, and maintained, through a powerful hierarchy of Bards, Ovates and Druids. Epigraphic

evidence of the Druid culture has been found by archaeologists in the form of fifth and sixth century AD memorial stones in Wales and Ireland. These Ogham stones contain many dedicatory inscriptions relating to the time of the Roman occupation but not earlier. The study of language, archaeology, texts and comparative mythology is suggested by pro-Druid culturalists as proof that they had a continuous tradition from at least the Neolithic period.

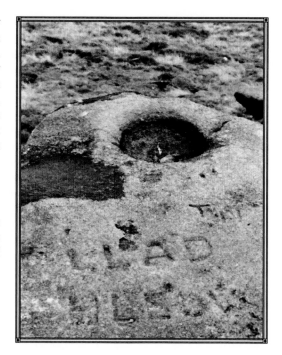

The so-called Druidic 'Slaughter Stone' on the summit of Boulsworth Hill. The bowl-like depression is said to have held human sacrificial blood

The Last Throes

As the winds of change blew over the Late Iron Age, the might of the Roman Empire assembled on the continent. Caesar actually made tactical incursions into Britain in the years 55 BC and 54 BC but was sent packing by British armies. The following century saw the Romans develop a bridgehead on the French shores of the English Channel before the final invasion of these islands by the emperor Claudius in AD 43.

The final years before the Roman Iron Age saw definite changes within Britain, especially southern Britain, whereby a 'kingship minority' began to wield power over larger territories and the populations within them. Contacts with the continent meant greater available wealth for the elite, the beginnings of a new 'state' could be seen. More exotic imports were to be had, such as wine in vast quantities, and the hill forts were abandoned.

Many thousands of British settlements from this period have been identified, this suggests that the advances in agriculture, and a more organised labour force, led to a population that could now be counted in millions.

This expansion enabled more goods to be traded over longer distances, items from Gaul and the classical world were now more readily available than ever before. This meant that Britain was ripe for the picking as far as the Romans were concerned, the south at least was able to produce a surplus of grain in order to provide for the insatiable Legions.

The centralised southern polities were capable of being quickly adapted to the Roman methods of government but this did not particularly apply within our area – the Northern Britons did not wish to join in the Roman fun and therefore became the inhabitants of a new military frontier.

Chapter Six

Legacies In The Landscape

Of standing stones and mound-cased bones,
Of dykes that scar the land,
Long ages past, in landscapes cast
With scythe and sword in hand

JAC

In an article written for *The Listener* in 1971 Dr. Colin Renfrew stated that:

"The rejection of the diffusionist model leaves something of a void in the European prehistoric studies. In consequence our profession is in a state of flux...we have to adjust our thinking to the realisation that our barbarian predecessors and ancestors were just as creative as we ourselves... The next decade's work in prehistory promises to be very exiting"

This proved to be the beginning of a reassessment of the nature and capabilities of our forebears, modern archaeology no longer typifies Stone Age man as a Barbarian.

There are numerous examples of standing stones, stone circles, stone avenues, dolmens and stone tombs throughout the world. The French example of a stone avenue at Carnac is most impressive, it takes the form of a double row of standing stones forming an avenue that runs for miles across the countryside before entering the sea. These types of structure are common in many countries, including Britain. The time-frame within which the stone structures of our ancestors were created is being constantly pushed backwards. Rather than having to wait until the new culture spread from abroad our native people have proved to be as advanced as other megalithic cultures. Unfortunately the vast majority of 'Stone Age' structures have disappeared, most have been destroyed within relatively recent history.

During the early Medieval period the need for new agricultural land grew in direct proportion to the expanding populations, this meant that areas of higher ground were utilised and any large stones, or monuments, would become a nuisance; if standing stones could not be incorporated into a hedgerow or wall they would often have been broken up, mark stones were often rolled into the nearest ditch.

It is largely for this reason, along with the fact that Bronze and Iron Age burial evidence is scant, that our area appears to be lacking in archaeological evidence for the existence of our pre-historic forebears. Over thirty years of walking the landscape, and close study of maps and aerial photographs have convinced me that our area, and probably the rest of the country, was far more densely populated than is generally thought. Obviously there were far less people within our landscape than is the case today, the population numbers ebbed and flowed in response to a number of factors such as wars, plague and famine. At any given time, however, (from the Neolithic period at least) it appears that there were sufficient numbers of a settled population to improve large tracts of land and to manipulate the landscape to suit their requirements.

Stand on the higher grounds, perhaps on the ridgeways of Noggarth or Castercliffe, and take a look around at the skyline formed by the surrounding high hills and the outline appears to resemble a sack of spanners! High points, low points, sharply pointed hills and deep notches - it is natural to assume that the skyline has always been that way. The general formation of the hills is indeed a natural product of the last ice-sheet, as the glaciers retreated they scoured out the profile of our hills and valleys. It might not seem to be obvious at first sight but I would suggest that there is hardly a square yard of our skyline that has not been manipulated by our ancestors. Native American tribes used their skyline as a type of calendar; by sighting over a particular feature on the distant hills (often a mound or notch) from a given spot on the ground, they were able to ascertain their position in the yearly growing cycle. The marking of the sunrise over a sighting-point enabled them to sow, or harvest their corn at the appropriate time. Whether our ancient forebears used their skyline in this manner is not known although there is no physical reason why this would not be the case.

Landscape Alignments

In 1922 a book called *Early British Trackways* was published by Alfred Watkins, a representative for his father's brewery in Hereford; Watkins followed up on this book by publishing *The Old Straight Track* in 1925. The author had ridden on horseback, on a daily basis, through the countryside of Hereford whilst visiting his customers - having always had a keen interest in the landscape he realised (at the age of sixty five) that certain landscape features were placed in alignment with each other. Mounds, moats, beacons, standing stones and mark stones could all be plotted on a map to show that some of them lay in alignment. He speculated that this alignment of man-made features was due to ancient trackways running straight through the landscape, sometimes for many miles. Watkins named his alignments *'leys'* as in 'lay-of-the-land,' some forty years later a young generation, hungry for an alternative to the traditional teachings of subjects such as history and archaeology, latched onto Watkins' leys and a cult grew around the perceived phenomena. By the middle years of the 1960s the notion of straight lines within the landscape had escalated into *'ley lines,'* these were said to represent anything from linear pathways of earth-energy to landing guides for flying saucers.

When Watkins first mooted his ideas the professional archaeological world gave him the cold-shoulder, his ideas were automatically dismissed as utter nonsense. These ideas became even more entrenched in later decades when the *ley line* adepts put out their ever-more fanciful theories. The hunt for the secrets behind the mysterious *ley lines* settled down to some extent although there is still a large following for the related subject of 'earth mysteries.'

There has been a change in archaeological thinking, however, the past decade has seen what appears to be a quiet acceptance of 'landscape alignment,' (the term *ley lines* having become totally obsolete within these circles), the television programme, Time Team, now has a Landscape Surveyor who seeks out site alignments within the area of an excavation. English Heritage also recognise the importance of the alignment phenomenon and employ their own field surveyors. This gradual acceptance of alignment by the authorities is analogous with the slow take-up of metal detectors as a useful tool within archaeological research and the reluctance to recognise the long-proven skills of the water-diviner.

Having been interested in the subject of landscape alignment for over thirty years I find that I have to accept that the deliberate alignment of early man-made features does, in fact, exist; however, there is one major caveat! With regard to Watkins' early work, bearing in mind that he pioneered the subject and did not have the benefit of hindsight, he eventually realised that his notion of straight trackways had been wrong and that his alignments, whilst being a proven

phenomenon, were of no apparent practical use. My personal approach here is to dismiss the terms *ley* and *line* as irrelevant; the alignment may exist but the physical space, or line between sites, has yet to be proven to have any practical purpose. Where a number of features, such as burial mounds, standing stones and proven pre-Roman sites do fall on a drawn line on the map then investigation is required. Watkins postulated that pre-reformation churches were often built on mark stone sites and so he included them in his accepted sites along with cross-roads and cross-paths as they were usually marked by some feature. He also accepted moorland ponds, solitary trees, wells and hill notches – I do not count any of these as qualifying as bona-fide ancient *straight* site alignments. I accept only tumuli, standing stones (not boundary stones), ancient crosses (usually converted early mark stones) and trig. points on hills as these were usually beacon sites, or in the case of Pendle Hill, a Bronze Age cairn.

The following is an example of a local alignment (see Fig:5):-

Near to the village of Gisburn (SD 827 468) is the Cross Hill and on the rim of the Burnley Basin at Heptonstall Moor (SD 943 302) stands the Reaps Cross, this is an example of a later upright column placed within a much earlier mark stone base. An alignment plotted between these two points on a 1:50,000 OS map shows a number of intermediate points. Working north to south from Cross Hill the alignment passes through the massive Bronze/Iron Age earthworks at Middop; this is marked on the map as a quarry because a small portion of the bank has been worked to obtain building stone, the earthwork lies slightly to the south east of Middop Hall.

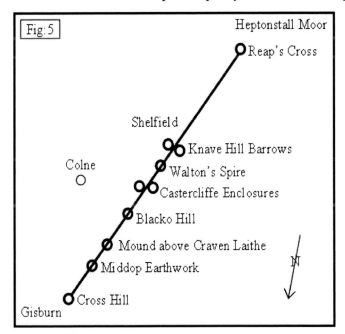

An example of landscape alignment

The alignment then passes through a ridge-top mound above Craven Laithe Farm on the old county boundary. It follows on through the apex of Blacko Hill, where the tower now stands, and continues through the hill fort of Castercliffe. The hatched marking on the OS map shows the enclosure area of the hill fort only, the earthworks actually cover a much larger area of which the alignment slices right through the true centre. Passing through the Spire monument the alignment bisects the Knave Hill barrows and reaches its apparent termination at Reaps Cross on Heptonstall Moor. It does not appear that this alignment carries on any further than the terminals of the two Cross sites.

Here we have an alignment with a minimum of eight points, all of which signify a postulated date of the Bronze Age to the Iron Age. If this type of alignment is to be accepted then the obvious question is 'what was its purpose?' My own thoughts on this are that these individual sites were incorporated into a *'sphere of influence'* within the ancient tribal world. When sites are placed in a

line they assume a relationship with each other – within a given area each site would have had a different purpose such as burial, defence, religious worship, boundary demarcation, a place for meeting and law-giving, beacon cairns for early warning and so forth.

Whilst the sites upon the alignment in Fig:5 appear at first glance to be entirely unconnected even a cursory glance at the map will soon make it clear that there is a degree of interrelation between them. A tumulus may have been used to mark a burial but it could also be positioned so as to be a prominent feature on the skyline along with being one of a series of linear landscape features. The best theory I have to offer on the reasons for doing this, (leaving aside the manifold arguments for these sites having served various religious purposes), is that the two extreme points of an alignment appear to fall on the outer edge of what could be seen as a tribal area, or minor kingdom. The people responsible for the erection of ancient sites would be of high status within the community, they would know their area down to the final square yard and might use the perceived linear relationships between sites to exactly correlate their topography; in other words their important tribal sites were connected by an invisible latticework and only the wise- man, priest or tribal elder might have had this knowledge.

Even down to the present day it has been customary, where land boundary disputes occur, for the elders of the community to state before a jury (usually a group of their fellow villagers) where the boundaries of an area have traditionally fallen. In the days before land deeds were written down the detailed knowledge of local boundaries, and their specific markers, was vital if the status-quo were to be maintained. I have no doubt that these people were capable of accurately surveying and placing their monuments at precisely laid out points, the image of our ancestors

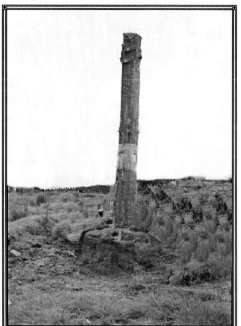

running around naked, painted bright-blue and dragging their womenfolk by the hair must surely now be an obsolete one! The incredible achievements in art and civil engineering perfected by pre-Roman peoples across the globe speak for themselves.

Reaps Cross following restoration of the shaft

Watkins was aware of the fact that alignments can fall along a line by chance and went to great pains to qualify his theory, he experimented with maps of differing scale and alignments of different lengths. He came to the conclusion that a three-point alignment, over a distance of twelve miles, was not beyond chance so to be sure he accepted a four-point alignment as being beyond chance. Later work carried out on this by mathematicians employed a formulae whereby the map area, scale, width of the area of a pencil line on a given map, ancient site distribution and length of an alignment are all included in the equation. The results of these calculations are that over an area of 625 square miles, and over a maximum alignment distance of thirty miles, a three-point alignment could be expected to occur 1,570 times. An alignment of five points might occur twice, six points 0.05 times and a seven point alignment 0.001 times.

Of course, the acceptance of a specific chance is somewhat subjective, it means different things to different people. My postulated alignment (Fig.5) of eight 'filtered' points (where the type of

acceptable site has been much reduced), over less than half of the distance of thirty miles allowed in the above equation, shows that it would occur by chance far less than 0.001 times. I am willing, therefore, to accept this alignment on the present evidence of six specific points falling over a distance of some 12.62 miles. I am also willing to discount the notion of deliberate alignment should a more viable explanation be forthcoming!

The alignment in Fig:5 possibly 'tied in' specific features within an authoritative area, it is not unreasonable to suggest that an early British kingdom, or tribal territory, encompassed the area within which the alignment falls ie, from the high ridges of the Hameldon Hills, where the Reaps Cross stands, to the boundary formed by the River Ribble at Gisburn.

Having stated that I do not accept certain features, such as wells, springs, cross-paths, roads and pre-reformation churches when plotting a straight landscape alignment, I will now throw caution to the wind and bring another type of alignment into the equation and that is the *circular* alignment. A wider type of marker is acceptable here because of the increased probability that points falling on a circle are less likely to occur by chance than those on a straight line. I came across this phenomenon when trying to make sense of a feature in the Admergill area (which I am unable to relate the exact location of in deference to the landowner). Whilst pouring over the map, I noticed that this feature appeared to be in the exact centre of a number of concentric circles where boundary-related features, and farmsteads, fell upon radiating lines. The most interesting of these circular alignments, to my mind at least, is the one illustrated in Fig:6, this appears to encompass what could have been the natural, and original bounds of a given area, such as a tribal territory or estate.

Ten features fall upon this outer circular alignment and the likelihood of these falling exactly upon a circular alignment by chance must be very small; it is conceivable that a ten-point alignment of this type of feature will occur randomly but the fact that two other circles on this radii also show around twelve points on average somewhat negates this. The radius of the particular alignment in Fig:6 is approximately 1.6 miles.

The obvious question in relation to this apparent example of early surveying is whether earlier cultures had the means to accurately set out complicated geometric features within the landscape, the official answer is a resounding NO! To accept the principal of the European peoples wandering around with scientific instruments is anathema to modern surveying, acceptance of this would mean that the history of the subject would need to be re-written. There is a consideration, however, in that at least one instrument was in use in the later years of the first millennium AD and that was the *astrolabe*, this is an instrument usually made of brass and accurately set out with marked degrees. There were many uses for the astrolabe, particularly in maritime navigation, but the design also allowed for relatively accurate measurement of angles on both the horizontal and vertical plains. The history of the astrolabe begins more than two thousand years ago, the principles of its projection were known before 150 BC, and true astrolabes were made before AD 400. The astrolabe was highly developed in the Islamic world by AD 800 and was introduced (officially) to Europe from Islamic Spain (Andalusia) in the early twelfth century. It was the most popular astronomical instrument until about 1650, when it was replaced by more specialised and accurate instruments. Astrolabes are still appreciated for their unique capabilities and their value within astronomy education. A recent experiment with the instrument took place whereby the angles of hills and church steeples were measured by both an astrolabe and a modern theodolite, the astrolabe measured the angles to the nearest degree and the theodolite confirmed this, the latter measuring the given angles to a fraction of a second. It was not until the sixteenth century that measurements could be taken to the precision of one-hundredth of one degree. The relative accuracy of the astrolabe suggests that it was perfectly capable of setting out the proposed geometry to be found in our landscape.

The question remains as to the possibility of ancient man having had instruments of this calibre enabling him to create his masterpieces, Stone Henge being the obvious example. The Romans are known to have been capable of surprising accuracy in the laying out of their towns and roads and the ancient Egyptians worked to an astonishing level of measurement. It is probable that the ancients had an elite of trained surveyors who would be expert in the use of their available technology; the recent find in Ireland of an extremely complex brass instrument, the purpose of which appears to have been as a sophisticated computer for astronomical prediction and dating to the late Iron Age, shows that the Celts, (previously thought to have been largely ignorant in their knowledge of science) were actually capable of a degree of advanced technology.

Taking these observations into account it does not appear that the creation of linear alignments, and basic geometry by our forebears would have been beyond their level of knowledge. Furthermore, given the scant written records available to us before the second millennium AD, it may be possible that the astrolabe, in its most basic form, had been introduced into Europe much earlier than is now thought.

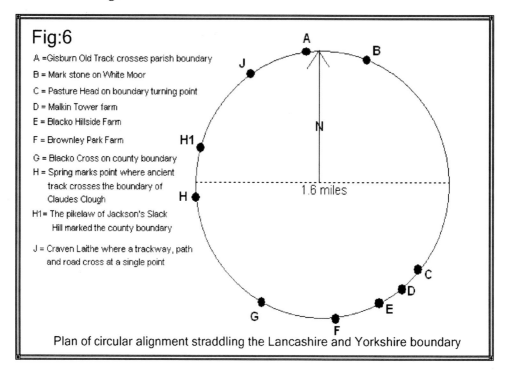

Fig:6

A =Gisburn Old Track crosses parish boundary

B = Mark stone on White Moor

C = Pasture Head on boundary turning point

D = Malkin Tower farm

E = Blacko Hillside Farm

F = Brownley Park Farm

G = Blacko Cross on county boundary

H = Spring marks point where ancient
 track crosses the boundary of
 Claudes Clough

H1= The pikelaw of Jackson's Slack
 Hill marked the county boundary

J = Craven Laithe where a trackway, path
 and road cross at a single point

1.6 miles

Plan of circular alignment straddling the Lancashire and Yorkshire boundary

Alignments relating to Figure 6:

- From the centre the northern most point **A** falls where the Old Gisburn Road enters Weets Moor by crossing over the parish boundary. This was the now lost continuation of the ancient track known as Folly Lane which runs from Barnoldswick, over Whitemoor into Middop. Two ancient tracks cross at a single point upon a boundary.

- Working clockwise, point **B** is not marked on any map, only by walking the moor did I realise that a mark stone stands by another ancient trackway on the moor, this falls on the circle.

- Point *C* is Pasture Head Farm at SD 869 424 situated at the very beginning of Gisburn Old Road. In 1580 on this site stood an ancient thorn tree and stone marker, these marked the point where the Foulridge, White Moor and Pendle Forest boundaries met before changing direction.

- Point *D* is Malkin Tower Farm on the old track from Pasture Head traversing Blacko Hill. Malkin is situated in the north- eastern corner of Pendle Forest

- Point *E* is Blacko Hillside Farm, further along the track around Blacko Hill. This farm straddles a large ancient dyke that was the Malkin boundary and also carried water from the end of the Black Dyke.

- Point *F* is Brownley Park Farm (formerly known as Bramley Park), I can find no obvious boundary connection here other than 'park' signifies an area that would be enclosed by a ditch. There is a probable Medieval date for the name of this site (not the building), although the settlement is likely to be much older.

- Point *G* is the exact spot where the Blacko Cross stood, at the bottom of the dyke over Blacko Hill ridge. At this point the dyke, and an old track, crossed the old road down to Admergill. This dyke formed the old county boundary.

- Point *H* is where a spring (marked on the map) marks the crossing at Burn Moor End of a track over Claude's Clough (shown as Cloudes Clough on early maps), this forms the boundary between the parishes of Brogden (detached) and Wheatley.

- Point *HI* is the centre of the pikelaw known as Jackson's Slack Hill, this appears to have been an example of a tumulus built upon the skyline to serve as an important marker, it served this purpose right up to the changing of the county boundary in 1974. Formerly known as Alainseat the hill is now named after a family of Jacksons who farmed the nearby Jackson House farm.

- Point *J* is where the track from the (Saxon?) settlement at Craven Laithe, at the head of the Middop valley, crosses the Gisburn Road and on to Coldweather House; it would originally have carried on over the moor. At this crossing point a footpath from the Middop direction also crosses the Gisburn Road. Also the boundary wall that runs up Crag Clough from Middop ends at this point.

Looking at this circular alignment it is interesting to note that the only buildings to fall on the line are all clustered next to each other on the southern quadrant. What are the chances of these four farmsteads, and the mark stone, being located exactly on a circle around Blacko Hillside by chance alone? The reasons why these features appear to fall within a mathematically defined area is obscure to say the least. If the planning of this area was carried out in Saxon times (or earlier) it is possible that the present farm settlements did not exist. There was every possibility, however, that these sites were strategically marked by features such as wells, they all have their own well to this day. If the farms are indeed on early Saxon settlement sites, as I suggest, then there would be a continuity of occupation of the sites.

Building in stone did not begin in earnest until the later sixteenth century, the timber constructions of the earlier periods were gradually replaced as the yeoman class grew in wealth and confidence. Most of the standard farm houses of our Pennine area were built in the period

between 1610 to 1710. Malkin appears to have been rebuilt by Richard Towneley around 1720; it replaces an earlier building and was then extended at least twice, the barn being added in the early 19th century. The new buildings were almost all built on the exact spot where the earlier timber building stood and often employed timbers from the earlier structure. We have, therefore, the strong possibility that Pasture, Malkin, Blacko Hillside and Brownley Park Farms all occupy contemporary sites and that they would be related within a planned landscape. Further to this I will attempt to show that this relationship forms only a tiny part within the macrocosm of surveyed sites littered around our countryside.

We have seen in Fig:5 a single example of the many site alignments running through the Pendle area, this example is directly related to the circular alignment in Fig:6 and, in turn, both of these alignments are included within the series of interconnected alignments illustrated in Fig:7. The criterion of three points falling on a given line also applies to the points of a triangle – this means that they are possibly there due to chance alone. However, when the three points form known angles, and the distance between two of the points forms an accurately measured base-line, then the relationship between the points, and the areas within the triangle, can be measured with an amazing degree of accuracy. This method of triangulation has, of course, been employed by map-makers over the centuries.

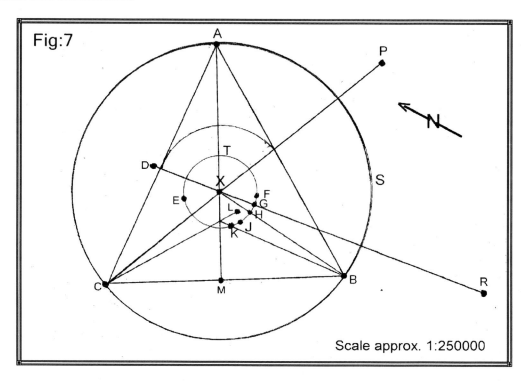

Geometry created by local alignments

The point **A** at the apex of Fig:7 is the earthwork at Bracewell, near Barnoldswick (SD 876 483); **B** is Castercliffe Hillfort; **C** is the trig. point on Pendle Hill; **D** is the camp/earthwork at Middop; **E** is the pikelaw of Jackson Slack Hill; **F** is Pasture Head Farm; **G** is Malkin Tower farm; **H** is Blacko Hillside Farm; **J** is Brownley Park Farm; **K** is the site of the mark stone of Blacko Cross; **L** is

Blacko Tower, exactly equidistant from **C** with the site at **X**; **M** is the ancient (former) cross- roads at the apex of Pasture Lane - the tip of a mark stone can be seen within the road surface; **P** is the tumulus on Bleara Moor and **R** is the Reaps Cross. The points **D- R** represent the alignment shown in Fig:5.

It is worth mentioning the correlation of alignments that these features create: given in modern inches, at a scale of 1:50,000 line **A** to **B** is 7 and 8/10ths as is **A** to **C**, the base- line of this triangle is 6 and 8/10ths. The outer circle **S** has a diameter of 8 and 8/10ths. The line connecting sites **R** and **D** passes through the central site **X** and bisects the base- line **A** to **C** at exactly halfway along its length - this is also the case where line **A** to **M** bisects the base- line **C** to **B**. **X** and **L** are exactly equidistant from **C**. The important site represented by **L** is 8/10ths of an inch from centre **X**. I have no idea if the distance of 8/10 of a modern inch is significant, given in megalithic inches this distance is .9795. Some schools of thought have it that there is a mathematical magic in the distances between ancient sites but, to my mind. there is magic enough in the fact that the landscape appears to have been accurately surveyed, and manipulated by our ancestors, people who, not long ago were often portrayed as club-wielding savages!

It strikes me that those sites of a known date correlate in a way that others outside of that period do not. For example, point **A** is officially denoted as a Romano-British site. Pottery from the Yorkshire area has been found there but none from the Lancashire area. As a result of this archaeologists have postulated that this site was occupied by the British within the Roman period, these people being influenced by the tribes around the Ingleborough area. However, as this site is a major 'primary' indicator within the system shown in Fig:7 it may be possible that it can be date-linked to its fellows where they fall within that survey indicator. In this instance, the other points in the system are thought to have originated within the Bronze Age and so it could be that the Romano-British site was actually in continual use for many centuries before the Romans arrived.

The same principal can be applied to Iron Age and Neolithic sites although there is one major caveat in that sites were used and re-used by subsequent settlers, the Saxons re-used Iron Age burial mounds for example. It appears that we may have the bones of a system beginning, perhaps in the late Mesolithic. Once the basis of the system was founded, and marked permanently by cairns, mounds etc, later generations (and later cultures) would use their own surveying techniques to expand on the older system and to create their own sites.

The reason for my stating earlier that the circular alignments in Fig:6 are closely allied to those of Fig:7 is that the centre **X** is common in both figures. Time spent perusing local maps, whether they are eighteenth century or modern, often pays dividends; I find that the Pathfinder series is the best for this purpose. For the above alignment I used the Pathfinder 670 (SD 84 to 94) at 2½ inches to the mile (4cm to 1km). To my mind the most satisfying part of this map-work is the field work that, by necessity, follows. I have lost count of the number of times that I have noticed a pattern on the map and have set out to walk a part of it only to find a feature of some kind to prove the theory. A case-in-point is when I first noticed the circular alignments, unwilling to believe that our forebears would have found it necessary to go to all the trouble of placing their markers in such a meticulous manner, I set off to check my first circle. After a difficult tramp over Rimington Moor I eventually found a five-foot boundary stone where two ancient tracks crossed the county boundary (SD 838 433). There is nothing unusual here as the moors contain many boundary markers, this one, however, was found to be exactly upon the circle plotted. Another example is the Anvil Stone below Walton's Spire; this is overlooked by people because the Spire overshadows it. When sorting the photo stock for this piece I plotted the stone on the map, needless to say it falls exactly on the alignment **R-D.** Although the Anvil Stone and the neighbouring Walton's Spire are on private property they can both be seen from the nearby road.

That a few genuine multi-point ancient alignments exist within our present topography I have no doubt, I also do not doubt the importance of these sites to the ancient communities; they were maintained, re-used and incorporated into later alignments over a long continuity of inhabitation within our islands. The actual purpose for these alignments can only be speculated upon, I have stated my theory, for what it is worth; one thing is for certain - if interest in our ancient heritage is lost then so will any chance that we may have of understanding it both now and in the future. By seeking out moorland standing stones and field mounds and recording their existence where they have not been officially noted we all play our part in the preservation of these sites for future generations. However unlikely a theory may be, if it maintains the knowledge and awareness of our landscape heritage then it performs an indispensable function - it certainly does no harm!

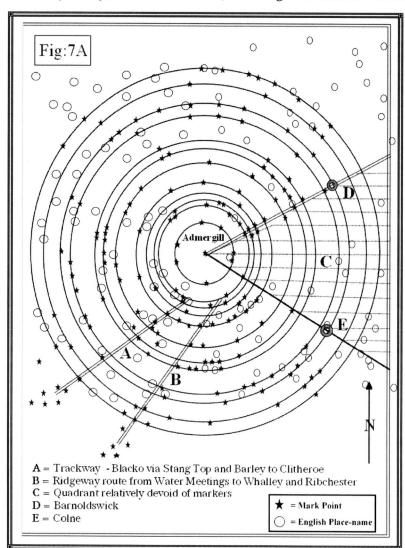

Fig:7A

A = Trackway - Blacko via Stang Top and Barley to Clitheroe
B = Ridgeway route from Water Meetings to Whalley and Ribchester
C = Quadrant relatively devoid of markers
D = Barnoldswick
E = Colne

★ = Mark Point
◯ = English Place-name

Fig:7A shows the distribution of certain mark points within a radius of nine miles from the Admergill area taken directly from the 1:25000 OS map. The points are springs, stone-markers, trackway markers, early cross-roads, cross-paths, ancient mounds and tumuli. As we have seen, a high incidence of these points falling along concentric circles appears to be beyond chance. It is interesting to note that the marked place-names (the majority of which are settlements) do not conform to any pattern of alignment, this would appear to bolster the argument for the aligned markers to have been deliberately sited. The quadrant **C** can be clearly seen to contain few mark points although the English place-name average in this sector is as high as corresponding quadrants. It can be seen that the marker points are not found to be adjacent (in most cases) to the settlements – this suggests that the majority of extant markers were placed in outlying areas of the communities. This is not surprising as many

types of marker relate to boundaries and trackways and therefore the pattern shown in Fig:7A is a distribution within outlying areas of settlement. If these markers were to be proven to be older than the English (Anglo-Saxon) settlements then the distribution of earlier British settlement would appear to have been far more dense than is presently thought. The features **A**, **B** and **D** are major routes through the area and *are* represented by the numerous common trackway markers and settlements clustered along their path.

Summary

A common theme running throughout this text is that of the *'marker'* – throughout the ages man has left his mark upon the landscape in one form or another. Our ancestors, in the form of *homo sapiens* arrived some 40,000 years ago and slowly, but surely evolved physically and culturally into our present form. The early markers left by early man have disappeared beneath the sporadic ice-sheets that ground and shaped our lands. Only since the last ice-age have the vestiges of the lives of our predecessors been available to us; fossilised remains of early man *have* been found but their living, physical presence within the landscape eludes us. Firm historical records of the English people only began in the post-Norman period; Classical writers, scribes of the Saxon times and Norse folk-lorists have left us records but they tend to be somewhat esoteric in their detail.

The stone monoliths, circles, dolmens and chambers, the earthen burial mounds and massive earthworks, the stone, flint, bone and metal tools, the enclosure ditches, dykes, causeways and henges - all these things are irrefutable evidence of a history beyond written record. They do not tell us their exact purpose, we can only guess at the ceremonies and rites carried out when they were part of living history. This does not negate their fascination to we modern people however, if anything the mystery surrounding these ancient sites heightens our interest.

We are lucky in that the area surrounding Pendle Hill and West Craven has many square- miles of unspoilt moorland to explore. The truly ancient relics of our ancestors lie too far beneath the peat layers to be found, except in exceptional circumstances where they have been washed out by nature. The lower moors have been improved continually over the millennia, Neolithic man had the same basic requirements from their acreage (albeit on a smaller scale) as we ourselves have. Over time the heights have eroded and the valleys have levelled, but where man tended his fields of heavy soil, where he created boundaries and tilled the surface, where he marked the paths and trackways passing over his land, where he placed his pre-Roman roundhouse or his Medieval manor house – these things we can see.

The single ditch-and-hedged banking, the double-ditched boundary, the wide dyke, the U-shaped ditch and the V-shaped ditch are all readily apparent should we care to leave the metalled roadway and look around. A wider knowledge of the area is often necessary to put certain features within their true context. This should not stop us from looking, taking photographs, speaking to local people who will have knowledge of the area, checking the map for marked boundaries, checking written records at the library and local records office. In this way it is often possible to ascertain the period in which an obviously early settlement, or feature, was occupied.

I have attempted to show within this text that the boundaries of our first local settlers, perhaps 3000 to 4500 years ago, were being fixed, these boundaries were of no less importance to the later cultures than they were to the Mesolithic people. It is no surprise, therefore, to see that the many extant footpaths and trackways forming a spider's web across our open landscapes have been recognised, and maintained throughout the ages.

The period of the main Enclosures Act of the eighteenth century saw many of our outlying moorland areas being enclosed by the ubiquitous stone walls, the White Moor and Boulsworth

Moor were enclosed in the early nineteenth century. A flurry of moorland improvements also took place following the official deforestation of Pendle Forest in 1507, much of the outlying area of Burnley was enclosed in the seventeenth century. The ancient footpaths and tracks were encompassed within this 'new boundary age,' the original markers (trees, springs, wells, stones, etc,) were incorporated into the new walls, far from being destroyed many of these early markers were respected. The moorland wall, where it snakes around a spring before resuming its straight course, is making the same statement that a Neolithic ditch made where it stopped at a thorn tree then turned abruptly. Where the Black Dyke, upon the heights of Blacko Hill, slices deeply across the landscape we have an extremely clear example of ancient landowners, be they British, Saxon, Norse or Norman, making a statement to the world:- *"We are here, this is ours and so it will remain."*

An ancient sunken road (left foreground) descends into the Admergill Valley from the Gisburn Old Road. On the horizon (centre) is the pikelaw hill of Jackson Slack or Alainseat

Chapter Seven

Boundaries

"The hedge abideth, that acres divideth"

In most of the preceding observations boundaries have figured prominently. Their importance throughout history cannot be overestimated; from the lord's manor and the worker's cottage to large and small settlements, kingdoms and countries - all required definitive boundaries that would be obvious within the landscape, this made the statement to outsiders *"thus far and no further!"* Back into the mists of time the elders of a community or settlement would define and oversee the construction of their ditches, dykes, hedgerows, walls, mark stones and fences, land that may have been hard fought-for needed to be retained, new settlements needed to be bounded.

When a settlement had been occupied for a number of years its boundaries would have been fixed, it was then necessary to maintain these features, ditches had to be kept clear, hedgerows laid, stream courses managed and mark stones monitored for any signs of interference. It was vital that future generations of the community were aware of the history and extent of their settlement boundaries, this necessity gave rise to the ancient tradition known as *'beating the bounds.'* This is where the village elders would take the villagers, including the youngsters, on a tour of the settlement limits. The head-man would carry a gaily decorated staff and tap on the boundary mark stones with it, the use of this staff would later evolve into the village Maypole.

The annual bounds outing was carried out on a certain day of each year and would ensure that the limits of the community-owned land were known to each following generation. Larger areas, such as the edges of the extended territory of a particular tribe, would have used natural features as far as was practicable, for demarcation purposes; ridges, watersheds, rivers, valleys, cloughs, streams and rocky outcrops were all known as *'God's Boundaries'*. Ditches and dykes were sometimes edged with wooden palisades known as *'Pale-Dykes,'* these sites sometimes came to carry the name of *Palace*, an example of which can be found at Palace House in Burnley.

As later cultures took control of the ownership of land it passed more into the hands of the individual as opposed to the community as a whole. Settlement boundaries were still perambulated in the *beating the bounds* tradition but land appropriation also needed to be fixed and this was done by a formal procession of local worthies around the land in question. Where land had changed hands within the community local people of a high status would accompany the new landowner and vendor around the boundary in question and a narrative analogue would be used. This took the form of a spoken deed which became a form of property charter, henceforth an annual procession around the land established a right of tenure. The final words of the deed were *"...... and by performing this service we hold our lands."* Remnants of this formality could be seen even in the nineteenth century where written deeds contained the phrase *"..... and by a rod out of court was sworn......."* Where the rod was a staff upon which a testament was sworn, hailing back to the origin of the staff used in the boundary procession.

Many myths have grown from the form of oral deed-making, they usually take the form of a large landowner granting lands to the underprivileged. An example of this relates to the Royal Forest of Knaresborough in Yorkshire; John of Gaunt granted land to a cripple named Havera by quoting the following:-

"I, John o' Gaunt ~ Do give and do grant ~ To thee Havera ~ As much of my ground ~ As thou canst hop round ~ In a long summer's day."

Havera selected St. Barnaby Day (June 11th) and began to hop around the land at sunrise. As the sun vanished at the end of the day he had almost made a complete circuit, he threw his crutch in the air and it landed on his starting point. Havera was therefore awarded the land, this led to that part of the forest becoming known as Havera Park.

A similar story relates to West Witton in Yorkshire; on St. Bartholomew's Day an effigy is made by the young people and this is carried, or rather dragged up and down the village. The youngsters shout a piece of doggerel whilst they go along and this suggests a procession around places along the local boundaries:-

In Penhill crags He broke his rags
At Hunter's thorn He blew his horn
At Capplebank Stee He broke his knee
At Briskill beck He broke his neck
At Wadham's end He could not fend
At Briskill end He made his end

Other cultures employed the tradition of encircling their land or property, the Egyptian Pharaohs walked around a fortified city as part of their coronation ceremony. Indian Rajputs would circumambulate a temple during its consecration; also Thai and African kings made the circuit of their palaces on their enthronement. Hittite and Malaysian rulers had to travel around their dominions in order to establish a right to them.

Roads are an important element within the ancient boundary systems, they have a strong tendency to endure within the landscape and can be seen to be a strong anthropogenic feature, both in the indication of settlement, and in the continuity of land occupation. Boundary roads resemble other boundary features in as much as they provide a linear limit of the extents of an area but they differ in that they also provide movement into, through and out of that area.

Throughout our history five main boundary types were employed, these are political, defensive, estate, parish and farm; within these main categories were less important divisions such as field boundaries. The purpose of the latter was two-fold; firstly a ditch around the perimeter of a field would carry water and therefore act as useful drainage. Secondly the banking thrown up from the excavated soil was reinforced with stones and then a hedge (frequently thorn) was planted on the top, this provided a highly visible boundary that was also stock-proof.

Many of our national tribal boundaries have been identified by the finds of Celtic coinage and also by the written evidence of Roman historians. The actual boundary ditch, or dyke, did not always form the definitive tribal extent as there could be a zone of no-man's land up to twenty miles in width. Late Iron Age boundary zones were commonly used to make ritual deposits. These zones were usually river valleys or areas of wetland and have produced important concentrations of flint tools, metalwork and single coins, numerous finds of this type have been uncovered over the ages from the River Ribble

Iron Age tribal boundaries survived into the Saxon period and, in some cases, form the present county boundaries, most of our parish boundaries were established by the eleventh century AD when many tribal frontiers were incorporated into local administrative boundaries. The Romans

kept many tribal boundaries to mark their *civitates,* these formed the main units of Roman local government. Following the collapse of Roman rule in the early fifth century AD many earlier Celtic territories in the north and west reasserted their independence, this ensured a strong continuity of boundaries from the Iron Age and Early Medieval kingdoms.

Most ecclesiastical parishes were established during the tenth and eleventh centuries AD. Late Saxon ecclesiastical parishes very often follow boundaries of Roman and pre-Roman times but these are difficult to prove due to the lack of written evidence during the Early Medieval period. In some areas Roman villas have been found next to the parish church and manor house within settlements. Anglo-Saxon land and ecclesiastical charters detail estate boundaries from the seventh century, many hundreds were translated into English and show grants of land from the king to individuals or monastic establishments.

Saxon Medieval estate boundaries were marked by a two-fold ditch, this was a hollow way formed by a double ditch several feet in width and several feet below the modern surface with high banks. These ditches were very often back-filled at a later date and incorporated into the field, this means that a parish boundary may run along the line of a single hedgerow. Very often this hedgerow will run across country for miles with other hedges running up to it, but never across it. Such hedgerows invariably comprise massive earthen banks which support a number of different tree species, the number of certain species within a given distance can be used in a formula to ascertain the age of a boundary.

Saxon estates formed the basis of later ecclesiastical parishes and often share a considerable length of common boundary with them, these were prominent natural, or man- made features. Where later parish boundaries appear to be out of context it is advisable to employ the use of a tithe map, rather than accept present day civil parish boundaries as these are often later political limits. Admergill is a case in point here, the civil parish boundary does not appear to fit the estate and forest boundaries.

Identifying Saxon and Norman farms can be done only where they are a single unit working a clearly defined block of land; on open field systems, around ancient nucleated villages, the lord's plough strips were generally on the best land but were often intermixed with those of the local villagers. Demesne land can be identified as this was the farm owned by the lord of the manor and was commonly the largest, richest, most fertile and best drained farm within the parish. The demesne farm was usually located near to the parish church and manor house, the farm house often (but not always) contains remains of Medieval structure and can carry a specific name such as *Great...., Barton....,Barton, Church...., Manor...., Hall....,Hall, Court....,Court.*

The tithe maps of our area commonly date from around 1843 and show boundaries as they existed at this time. Although some boundaries will have changed over time, Saxon and Norman boundaries can be traced with a little detective work. Where a boundary on the tithe map follows a man-made, or natural feature, such as a stream, hedge or lane and they coincide with the parish boundary then this would be the original farm boundary.

Demesne farms on larger manors frequently included deer parks for the provision of sport and meat. Most of these were oval in shape but the local topography would dictate the final layout. The park would be around thirty to two-hundred acres in extent and contained woodland and pasture surrounded by an earthwork bank. The ditch was on the inside and would be topped by a palisade fence, wall or hedge with occasional 'leaps' to allow for the movement of deer. Most Medieval deer parks were broken up in the sixteenth and seventeenth centuries and incorporated into farms, the boundaries of these frequently include parts of the original park boundary and can signify a boundary area, as in the village of *Rim*-ington.

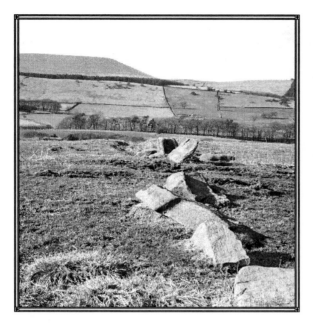

This ancient boundary of large stones above Dole House, Roughlee, has the appearance of a fourteenth century vaccary (dairy farm) wall. However, this boundary continues as a deep ditch running into the valley near Thorneyholme and aligns with the Barrowford and Old Laund boundary running down to Pendle Water.

This wall could have formed the old boundary between Roughlee and Goldshaw and possibly signified a farm boundary of the Saxon/ Scandinavian period.

Markers

Of the various methods of boundary construction the most visible ones left to us are mark stones, ditches, banks, walled-banks, mounds and ancient hedgerows. Mark stones vary in size from pudding stones measuring one foot in height to massive boulders. Care needs to be exercised in dating markers as many standing stones are actually Medieval boundary stones as opposed to the monoliths of the Neolithic Period. These boundary stones are commonly found on moorland and are often incorporated into the modern stone walls, or stand adjacent to the walls.

Genuine marker stones have been employed as boundary markers since time immemorial. Large boulders in the middle of fields or moorland are commonly dismissed as glacial erratics and given no more thought. Some of these large stones are indeed glacial deposits, some have broken away from nearby rock outcrops whilst others have been brought into the area for reasons known only to the people who placed them. Given the fact that man has walked amongst these stones, scattered around the landscape, since the retreat of the last ice-cap it is likely that few large stones remained untouched.

Many stones were cleared from prospective cropland whilst the most favoured were used as markers, the purpose for this, in many cases, has being lost within the mists of time. No doubt these stones were used as way-markers to guide the ramblings of Palaeolithic Man, as trackway markers to aid the movement of traded copper, tin, flint tools, stone axes and salt within the Neolithic and Iron Age periods. The Romans used mark stones, some of these *mila* stones are still to be found - an example that appears to be consistent with a Roman *mila* stone is situated on the ancient ridgeway track above Utherstone Woods at SD 853 408, this marks the spot where a footpath crosses the trackway.

As settlement progressed boundaries were constructed and enforced but the movement of people across settled land was still necessary, trade routes, inter-tribal tracks and footpaths could not be closed. Of the smaller mark stones I have come across by far the greatest number mark the spot where two footpaths cross or where a footpath crosses a boundary (usually now a wall style).

A nice example of a path/track mark stone stands on Slipper Hill, half way along the path from the Leeds and Liverpool canal up to Colne Edge (SD 876 415). An impressive stone of the large boulder variety stands in the corner of a field at Prospect, off Lister Well Road (SD 869 448). Another stone of this type can be found behind Narrowgates Mill near the village of Barley (SD 824 403) – this is a huge limestone boulder almost identical in size to the Lakeland boulder found at Higham and moved to Towneley Hall.

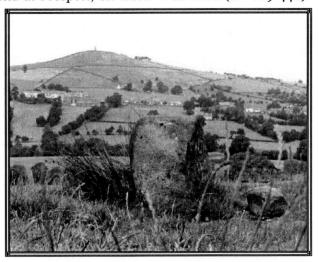

Possible mila stone on the ridgeway

Blacko Hill in the background

Medieval records make many references to *merc stones, marchstans* etc, the town of Nelson was formerly known as Great and Little Marsden, the name Marsden grew out of the earlier Merclesden. It is possible that this description, applied to valley below the large monolith now known as Walton's Spire. It is interesting to note how close are the words mark, *merch* and *march* to the words *market, mercet* and *merchant*, especially as Medieval markets were centred around the market stone, these commonly had a later shaft added to become the market cross. There is also a relevance in the fact that the god, *Merc*-ury, had the emblem of a standing stone.

The use of stones for bargaining is well documented, they often had holes in them through which traders would shake hands to formalise a deal. A *bargain stone* stands near to Ball House at Foulridge. During the outbreaks of the Black Death villagers would pay traders for their goods by placing coins in a pool of vinegar held in a hollow in *plague stones,* these are probably of the same origin as bargain stones and market stones.

Owen's *Ancient Laws of Wales* states that: " *there are three other stones, for which an action of theft shall lie against such as shall remove them: maen tervyn (meer stone); maen gwyn gorsedd (white stone of session); maen gobaith (a guide stone); and his life shall be forfeited whoever shall do so."*

The Saxon word *haran* was used in description of stones, later being refined to *hoar stones* and then *grey stones,* we have a number of examples of these in the Grey Stones at the top of Pasture Lane, Barrowford, Greystones Moor below Weets Hill and Hoarstones in the village of Fence. Saxon moots, or communal meetings overseen by the local leader, were held in the open air, usually at the site of some distinguishing landscape feature such as an ancient thorn tree or large stone. An Anglo-Saxon Gospel account for the Herefordshire area records:-

"Note of a Shire-Mote held at Aeglenoth's Stone in the reign of King Cnut, at which were present the Bishop Athelstan and Sheriff Bruning........ and all the Thanes in Herefordshire."

Every sovereign of England (except for Queen Mary) has been crowned on the ancient stone beneath the coronation chair at Westminster Abbey. Tradition relates that this stone dates back to at least 503 AD where it was used in its role as a sacred mark stone.

The old stone crosses dotting our countryside were, in the main, wayside mark stones until they were adopted by the clergy and Christianised, usually by grafting a shaft with a cross on the top into the original stone base. Walton's Monument must be one of the most blatant examples of this practise in the country.

The stone at the cross-roads has always been a rich source of myth for the folklorist, Annel Cross (SD 816 426) stood on the cross-roads below Pendle Hill by the old road known as Colne Gate. Funerals would pass this spot and the coffin bearers would lay down the coffin and say a prayer at the stone, this was the spot where the local gibbet would display the decomposing bodies of executed criminals for many years. The cross has now been moved from the cross-roads for some

reason, it is difficult to find as it now lies on the nearby moor. This, of course, is the fate of most early mark stones; although some farmers have always held these stones in great respect many others have simply destroyed or moved them.

Stone marking the old road from Blacko to Colne at Slipper Hill

We have seen that it is not uncommon to find large boulders in stream beds where they were rolled by a farmer intent on reclaiming the ground upon which it once stood. This is a relatively late phenomenon, sixteenth century Court Rolls show that the halmote courts were fining people heavily for moving *merkstans*. Of course, where a large stone stood in the way of a prospective field, and was not part of an obvious boundary, then no one would object to it being moved or broken up. The *'frog stone'* by the Admergill Beck (SD 856 426) is another example of a large surviving boulder, this lay on an ancient track traversing along the slopes of the valley up to the Moorcock area, however, the stone is now perched on the very edge of the encroaching stream and will soon be lost.

The planting of trees would have been an important method of marking a boundary, especially where a high visibility of the boundary would be required. Holly and hawthorn (*haw* is the Old English for hedge) were an obvious choice of tree where cattle and sheep needed to be contained, many ancient holly hedges still exist in our more rural areas, some of the massive old holly hedgerows within the Malkin area are a case-in-point. I have seen it suggested that the presence of Scots Pine trees is a good indicator of an ancient site, I do not know how accurate this is although I have noticed that this tree commonly occurs in deep, isolated gulleys and other remote sites. At Haynslack, near Malkin, a deep gulley carries the Black Dyke stream and forms the Pendle Forest and old county boundary, within this gulley are a number of Scots Pines. The deep gully carrying Admergill Beck, on the road bend near the Moorcock Inn (on the Blacko to Gisburn Road), has many Scots Pines. There are also a number of these trees on the old road banking at the brow of Wheat Head Lane, this is the ancient route past Stang Top and over Rimington Moor to Middop. Scots Pine trees seed themselves vertically, this leads to their remaining extant in one particular area for a very long time, this method of reproduction is also aided where the tree grows in a sheltered situation.

In 1580 a local court heard an oral testimony from a local man who described the boundaries between Admergill and Barnoldswick, he stated that the boundary ran up to *"the thorn by John Hartley's house to Hanson's Dike Newk then over Blackomownt."* By cross-checking the modern boundaries with a 1581 map of Foulridge and Whitemoor the thorn can be placed at the corner of what is now Pasture Head Farm, the building that once stood on the site of the present Pasture Head, or within the vicinity, was obviously occupied by a John Hartley at the time of the above deposition. The map shows this tree as *'the thorn at Haynslack,'* which corroborates the importance of the tree as a boundary marker. Slightly to the east of this thorn the map shows a peculiar horse-shoe shaped feature with the description of *'the stone at Slipper Hill'* which can be taken as a reference to an extant upright standing stone that has been incorporated into the boundary wall and is now thoroughly hidden by holly trees. This shows the importance of individual markers, few buildings are named on the map but certain boundary stones and trees are given definite importance. The thorn and stone at Pasture Head marked the spot where the boundary of Pendle Forest and Foulridge (north-south) met the boundary of Barnoldswick and Foulridge along Standing Stone Lane (east-west).

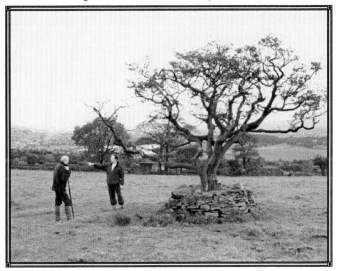

The author (pointing) and Andrew Turner, of Malkin Tower Farm, discussing the Malkin thorn tree (photograph: Stanley Graham).

In a field behind Malkin Tower Farm is an unusual feature, a very old thorn tree growing in isolation on a walled plinth (see photograph), the stones have been deliberately formed into a protective wall around the base of the tree which now stands around one metre above the ground level. I have puzzled over the reason for this until very recently when I saw an RAF surveillance photograph from the Second World War, this shows that there was a full hedgerow of hawthorn trees in nearby Haynslack bottom but only a single specimen now remains. It is possible that the 'walled' tree could have been the sole survivor of a full hedgerow, possibly having been saved as a sop to superstition. If the tree had been atop a walled ditch-banking then its present height is easily explained as it would have been in this position originally, a wall being built around it would ensure its survival. It has to be remembered that thorn trees were highly respected by our forebears, it was considered to be extremely bad luck to damage a thorn tree, let alone actually cut one down. A number of folk-tales are related to *'the fairy tree,'* as the thorn is known in Ireland, where a thorn was situated near to a spring then it was thought to be a gateway to the water spirit. It would not be surprising, therefore, if a farmer thought it prudent to leave at least one tree in situ when removing a hedge. Neither would it surprise me if this solitary tree was alive in the Medieval period, in that case the probability is that the Malkin Tower Witch brood would have known this tree very well.

The importance accorded to the depositions from the elders of a community is nicely illustrated in the following short account: In 1592 the Queen ordered Sir Richard Shireburn, and others, to

survey the boundaries of Colne and the adjoining manors. The survey committee heard the deposition of one Robert Hargreaves, an old tenant of Colne (living at the Towneley family seat of Barnside) and a tenant of Edmund Towneley of Royle:-

"He has heard from very aged men that a 'Whikin' or mountain ash, and a thorn grew in the upper end of Hayneslack above and below the dyke called Lancashire Dyke and that this dyke was the boundary between Colne and Ickornshaw as far as it went. Then the marks were a grey stone in the Bawsedge and Wolfstones."

Another witness said that:

"The boundaries began at Tom Cross, led straight to a stone on Surgill End, then south to south-east into Skipton Clough, down to a stone in the lower end of this clough, thence to a stone on Grindlestone Edge and directly over the grey stone on Bawsedge. Then to a dyke called Sandyforth, running on the east end of Redeshaw, down into Ickornshaw and so to Hunter Law."* *The name of Tom Cross was commonly used as a boundary stone appellation, other given names were also used to donate features upon a boundary.

Yet another witness stated that:- *"The known bounds were a grey stone in Aynslack Head, Stone Benkes, round the hill at Barnside Knarr end to Sandyford bridge and Lancashire Water. Tenants of Monkroyd had always repaired the west end of the stone bridge over Sandyford Dyke and the tenants of Ickornshaw repaired the east end of it."*

A further survey was made in 1605 to set the bounds between Colne and Ickornshaw, this boundary defined the eastern limits of the parish of Whalley; Ickornshaw was in the Yorkshire parish of Kildwick. The topographical features in these boundary descriptions can still be recognised on the modern map and the Lancashire Dyke is still clearly visible near to the Black Lane Ends cross-roads on the outskirts of Colne.

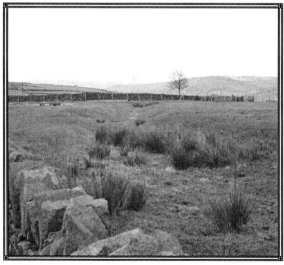

Lancashire Dyke at Black Lane Ends, Colne *Large stone at Prospect above Barnoldswick*

Chapter Eight

The Anglo-Saxons

The Anglo-Saxon period covered almost seven centuries (AD 410-1066) and forms a period of proto-history whereby archaeology and written records combine for the first time. The Venerable Bede, a monk from the north-east of England, was the first real Anglo-Saxon historian, his *Ecclesiastical History of the English Peoples* was written in the first third of the eighth century and is still a major source of information to the historian. The *Anglo-Saxon Chronicle* of the ninth century largely deals with the royal ancestry of Alfred The Great and, although extremely valuable, tends to embroider the facts in favour of Alfred's family. These histories prove that the Anglo-Saxon nobles took to the early English Christian teachings with fervour, from the seventh century onwards churchmen held great sway with the rulers.

There is a certain amount of controversy amongst historians as to exactly how many of the peoples of northern Germany and southern Scandinavia were actually involved in the Anglo-Saxon 'invasion' of Britain. On the one hand it is suggested that a small number of armed bands joined with mercenaries from their homelands who were already here, took over regional British kingdoms, married into British tribes and spread their culture from their newly held bases. On the other hand it has been pointed out that Gildas described Saxon reinforcements as *"ravaging Britain from sea to sea"* and that *"Britain had come under the control of the Saxons."* Bede may not have been far wrong when he described the original Anglia, from whence many of the invaders originated, as being deserted as a result of the fifth century migration to Britain. Burial finds from the period also show that the Saxon warriors, or at least a reasonably large percentage of them, brought their wives and families with them; it is now thought that the Saxon people actually practised a system of apartheid in Britain whereby they did not actively assimilate into the native culture other than marriages of convenience into high-status British families. This is born out by the fact that genetic testing has shown that the vast majority of native English people are of direct Anglo-Saxon descent.

Although the Saxons appear to have rapidly settled the eastern and southern parts of the country through the fifth century they do not appear to have ventured into our area until a much later period, perhaps around AD 680. Their methods of farming were not much different to the peoples of the late Roman Iron Age, scattered farmsteads reared livestock and grew crops wherever they could. By the middle of the eleventh century the open-field method of agriculture had become firmly established over much of England. Two or more common fields would be divided into strips and crops were rotated between them. This Saxon way of life was actually little different to the later post-Conquest rule of the Normans, Angevins and Plantagenets.

Archaeology provides us with an insight into the Saxon farm; on average they kept cattle as 43.3% of overall stock; sheep and goats 23.7%; horses 12.7%; pigs 11.1% and dogs at 4.2%. Of the crops barley and oats made up 40% of the total whilst beans and flax made up 25% each. In our part of the world it is probable that the Saxons grew more spelt wheat and oats; rye was grown in particularly heavy clay soils such as the lands above Park Hill in Barrowford, still known today as Rye Bank.

The spread of the Anglo-Saxon culture throughout the land saw the emergence of individual kingdoms. Kings were basically military leaders and the extent of their success was dependant upon the amount of land they could obtain from other groups; the more land they controlled and the more money and goods they could extract from the vanquished people. Often two or more

kings would rule a particular kingdom, usually there would be a family relationship between them and there would be a senior partner with ultimate authority. Bede called the Saxon kingdoms *Provinces* and it is apparent that they varied in size, often a king who was successful in the conquest of his neighbours would amalgamate that neighbour's kingdom into his own. By the seventh century this had culminated in the creation of four *super kingdoms* of which Northumbria was one; this was a large Anglian area of the north-east and was formerly the two separate kingdoms of Bernicia and Deira which, upon amalgamation, took over many other provinces, amongst these were the British kingdoms of Reghed and Elmet which covered our area and over to the east of the Pennines.

In the earlier Saxon period our own area was, to all intents and purposes, a 'floating' province in as much as it was on the very edge of the Cumbrian and Northumbrian kingdoms and had at least some political influence from the more northerly kingdom of Strathclyde, the Northumbrian border *eventually* became settled along the River Ribble.

The growing strength of the Northumbrian rulers brought the two large Anglo-Saxon kingdoms of Northumbria and Mercia into bitter conflict until the Battle of Trent, in 678, brought things to a head. A peace treaty was forged and the boundaries of Northumbria were set, the southern limit within our area being the Mersey. The British kingdoms of north-west England were now firmly under the control of the rulers of the kingdom of Northumbria. Within this period society began to change, kingship was no longer seen purely as a military force but more as a provider of lands and lordships under royal patronage. Besides nobles and loyal retainers, the Northumbrian church became bestowed of much land within Lancashire, Cartmel and the lands *iuxta Rippel* (near the Ribble) were granted in the 670s and it is thought that Samlesbury, near Preston, was granted out and became part of the Ripon diocese. Small sub-kingdoms, or lordships, within Lancashire probably came into being at this time, amongst these could be numbered the Lune Valley, Fylde, Manchester along with the Yorkshire Craven area.

From about AD 800 waves of Viking assaults on the coastlines of the British Isles were gradually followed by a succession of settlers. These enclaves rapidly expanded, and soon the Viking warriors were establishing areas of control of such a large extent that they might reasonably be described as kingdoms. The reasons for these waves of immigration are complex as they were bound to the political situation in Scandinavia at that time; moreover, they occurred at a time when the Viking forces were also establishing their presence in the Hebrides, in the Orkneys, the Faroe Islands, in Iceland and Russia.

The Danelaw, whereby the Danish invaders were paid-off and allowed to settle in the north was formally established as a result of the Treaty of Wedmore in the late ninth century following Alfred the Great's defeat of the Viking, Guthrum, at the Battle of Edington. The subsequent conversion of Guthrum to Christianity underlines the ideological significance of a shift in the balance of power. The English in the south defended their territory against the Danelaw, this exclusively southern/midland English kingdom extended as far north as the River Mersey (the name Mersey meaning *the marker* or *boundary river)* and the descendants of Alfred built a series of *burh* fortifications along the Danelaw boundaries at Runcorn and Manchester.

Supremacy was finally gained over the Danes when Alfred's grandson, Athelstan, routed a coalition of his enemies at the great Battle of Brunanburh in AD 937 (see Chapters Thirteen and Fourteen) and was recognised as the ruler of all England. At this time the River Ribble became the southern Northumbrian border instead of the Mersey.

From the eighth century the previous patterns of small scattered farmsteads began to expand across the country. The population levels responded to improvements in both the climate and trading patterns, there was improved stability within society and the need for an increasing amount of agricultural land, and related dwellings, grew apace. A former hamlet would often turn

into a larger nucleated village and coinage began to circulate again after a long absence.

By the turn of the tenth century the importance of our area along the east-west communication corridor had seen the formation of the two large parishes of Blackburn and Whalley, both of which formed the hundred of Blackburn. The hundreds are thought, in many cases, to have been multi-settlement estates (relics of earlier British occupation) where a combination of territories and lordships saw growth throughout the later Anglo-Saxon period, the hundredal system rose in importance to the extent that the Norman authorities readily encompassed them within their shires.

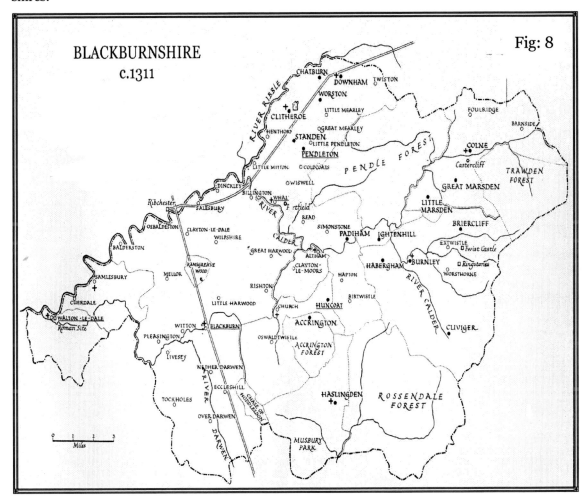

Fig: 8

BLACKBURNSHIRE
c.1311

Whitaker provided a description of the Saxon encroachment into Lancashire in his *History Of Whalley*: Whitaker's somewhat jaundiced views of the native British peoples strongly echoed the views of the venerable Bede who saw the coming of the Saxons as God-sent. He considered that the past British rulers has been a bit naughty and the newcomers would assert a strict morality upon the kingdom:- *"The Saxon Memorials of Whalley parish are more considerable than might have been expected from the obscure situation of the place and the meagre accounts which have been transmitted to us of that barbarous and uninteresting period. The deplorable state of weakness*

95

of barbarism, into which the Britons lapsed after the final desertion of their country by the Romans, is true cause of that total revolution in language, laws, manners and property, which took place after the Saxon conquest. Unlike the operation of those irruptions which rude but vigorous tribes sometimes make upon their more polished and feeble neighbours - in which though property for the most part changes hands - the conquerors themselves are gradually subdued to the habits, arts and language of their captives - these invasions found the miserable remnant of the native inhabitants, unable to solicit their subduers by the blandishments of Roman luxury, to refine them by the cultivation of Roman arts, or to enlighten them in the institution of Roman laws."

"All these themselves had successively learned and lost and with them they had nearly lost a greater treasure, which is never found to ensure a state of second barbarism, namely Christianity itself, so that from the middle of the fifth to that of the sixth century, they are accused by Gildas and Bede of having lost not only the power of religion, but the external form, of having abolished, excepting in a few instances, the order of priesthood and distinctions of civil society."

"The Saxons were therefore at full liberty to institute an order of things altogether original, they parcelled out the country upon their own plan, called the lands by their own names and transmitted to their posterity, a local nomenclature and a fundamental system of legal usages which sustained the shock of the Norman conquest and even subsist at present. Above the rest of Britain, the name of Deira which marked the whole tract of country interposed between the Tine and the Mersey and the Humber, leads to the idea of depopulation and decay, from which the Saxons themselves never completely reclaimed it, for while the map of their other kingdoms in this island is thickly strewn with towns and cities, Bericia and Deira together supply not more than twenty names, amongst which stands distinguished, on the south western confines of Deira, the Palalaes of Simeon of Durham, the Whallaes of the Saxon Chronicles and the modern Whalley."

"......of the great Saxon battle at Whalley I have the low hill by the village of Billinge, although there is now no trace unless a large tumulus near Hacking Hall and in the immediate vicinity of Langho be supposed to cover the remains of Alric or some other chieftain slain there...Wadhow four miles up the Ribble from Whalley may be the hill of Wadda, perhaps the site of his camp before the battle. Waddington in the Domesday book is Wadeton the town of Wada... Edisforth is the Nobleman's Ford and Wiswall which is much nearer to the field of battle Pisarpaella or the Hero's Well."*

"Considered as an obscure village in a remote province this testimony is honourable to Whalley. Few even of our large provincial towns, which have no claim to Roman antiquity, but are content to find themselves first recorded in the great register of Domesday, but our story reaches nearly three centuries backward into the Saxon era, is connected in its origin with an important national event and attested by no private record but by the annals of the Northumbrian kingdom." *Elsewhere in his book Whitaker states that the Anglo- Saxon Battle of *Hwaelleage* (AD798) took place at Whalley but this has recently been challenged on etymological grounds.

* * * * * * *

Two Anglo-Saxon Sites

A careful look into the history of a specific area can uncover a number of small pieces of evidence that, in some cases, add up to a viable argument for the area having been a probable Anglo-Saxon settlement. One example of this can be seen in the hamlet of Lane Bottom (Fig:9). This lies in Briercliffe, to the north-east of Burnley and adjacent to the area of Harle Syke, this latter name translates from the Anglo-Saxon as *the ditch of Herle/Harle*, presumably describing a boundary dyke around the lands belonging to a Saxon noble named Herle. On the southern edge of Harle Syke is the long ridge of land known as Saxifield, this stretches from Burnley towards Southfield above Nelson, the name of Saxifield is often said to have originated in *Saxon Field* but this is not proven (see later chapters relating to the Battle of Brunanburh). In Lane Bottom, below Haggate, the fields show a number of features; linear earth mounds and a prominent boundary ditch run from Haggate into the small glacial overspill valley of Banks Farm and then upwards and along the prominent ridge of King Cliffe from where the fields run down into the village of Lane Bottom, these are named on the 1843 tithe map as Dodgefield, Town Fields and Eight lands.

The name *Dodge* is Old English and has the meaning of *the nose-like hill* which describes the King Cliffe exactly, this acquired its nose-shape when the melting ice-cap overflowed the Burnley basin leaving a rounded protuberance at its northern end. A small group of crofts above the Dodgefield are known as Eight Lands and these, including the King Cliffe, belonged to Hill Farm which stands towards the top end of the village of Lane Bottom. A sixteenth century Clitheroe Court Roll record refers to this land:-

1565: *Nicholas Hargher and Richard Woodruff, Queen's tenants, surrender 1 house, 1 parcel of a barn with garden now in the tenure of Alice Smith of Hill, widow: and a close of land called Dodgefield, another field called Headlands adjacent to Dodgefield, and also 8 ridges, or seliones, of land abutting upon the said headland, which ridges, called "landes", be in Le Townefield of Burnley containing 5 acres of land: which the said Alice Smith delivered to Nicholas and Richard, to the use of William Halstead of Ridehalgh and his assigns during her life, in consideration of a marriage to be solomised between the said William Halstead and Margaret Smith daughter of the said Alice Smith. Admittance granted at 20d.*

This shows that Dodgefield has been known by that name for a long time, the King Cliffe was known as the Headlands and Eight Lands was called the *Eight Seliones,* or *Landes,* within *Le Townfield.* The modern name of Eight Lands, therefore, has its roots in the Norman word *selion* which here describes a ploughed strip of land. The Townfield is the common area where local people would cultivate their own strip of land, evidently there were eight such strips here. This area of land now runs to four acres so the sixteenth century common plough-strips would appear to have been a half-acre in extent.

The field walls enclosing the eight lands date to the seventeenth and nineteenth centuries, the Eight Lands incorporates gateposts, or stoops, of apparently much earlier date. The walling stone is sandstone taken from local delphs but it would appear that stoops from an earlier period were taken from the gritstone outcrops in the hills; the extant examples are smaller than modern stoops, extremely worn and have the early hole-and-groove where wooden rails were inserted to act as gates.

An area to the south of Harle Syke is known as Walshaw, this is likely to have come from one of two Anglo-Saxon words; *wealas* literally translates as *The Welshmen,* therefore meaning *foreigner,* and suggests that the Saxons were describing a local settlement of British speakers within a larger area of English speakers who would have been in residence here long before the

arrival of the newcomers. Alternatively, the word *wael* has the meaning of *battle* and was commonly applied as a prefix ie, *wael-stan* (battle stone), *wael-stede* (battle field) and in our case possibly *wael-shaw* for battle wood (see Chapter Fourteen). *Walh* place-names often occur within close proximity to Roman settlements in other parts of Lancashire but within our Pennine region they usually relate to nearby places carrying British, or borrowed British names. There is an interesting postulation that the related Scandinavian word of *bretar (+ clife = high-land of the British)* could be the origin of the name Briercliffe although it is commonly taken to have originated in the Old English *brer + clif = the hill of the briers*.

Looking from Haggate over Dodge Field and the King Cliffe towards Boulsworth in the far distance

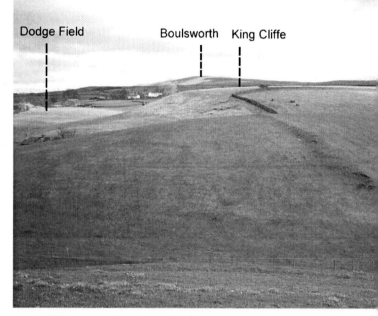

The road from Haggate now runs down into Lane Bottom where it takes a ninety-degree turn around the Dodgefield. The road through the village does not follow its original course, however, as the route from Thursden ran down past Hill Farm and then straight up the hill past Hill End and onwards to Marsden, this meant that there would have been a cross-roads on the corner of Dodge Field, where the Lane Bottom cotton mill stood.

Aerial photographs show the Dodge Field to contain at least two pronounced mounds, although the nearest of these to the King Cliffe appears to be a natural drumlin (this is where the Ice Age waters from the Burnley Basin burst into the Walverden Valley). There is also a single standing stone of about 1.5 metres in height, almost on the crest of a small, flattened hillock within the Dodge Field. This stone has been described as a rubbing-post for cattle, this is often applied to standing stones and the idea possibly arose in the seventeenth century when numerous references were made to *bull-rubbing stanes,* maybe the possibility that these were ancient stones was not considered at that time. The stone has also been said to be an extant gatepost and it is a fact that it has two carved hollows resembling rail holes. On the other hand there is no record, or other evidence, of there ever having been a wall or fence at this point. Furthermore, the stone relates by alignment to known ancient features throughout our area.

The last farmer to farm this land at Hill Farm, in the 1960s, was a character called George Proctor who always said that this stone was 'Cromwell's Stone,' he would lean on the stone and paint a verbal picture of the Parliamentarian army marching up the valley from Walverden and Colne below. There is an element of fact here as there was a Civil War skirmish in this locality, in 1644, when five local farmers were killed in a fight with Royalists. It has been suggested that the stone marks the spot where the skirmish took place.

In June, 2006, a new water pipeline was laid through the Dodge Field, this necessitated the removal of a twenty-metre swathe of topsoil which revealed a paved stone platform on the side of

the King Cliffe, the original purpose of this is unclear due to time constraints curtailing the excavation. A lime-burning operation was also evident, the lime was probably taken from surface pits at the top of the King Cliffe, this would then have been used in the construction of the late eighteenth/early nineteenth century cottages on the Banks. This was formerly the ancient Saxifield to Walverden track via Higher Cockden and Banks Farm.

The utility work also uncovered two almost identical mark stones, one at the base of the King Cliffe hill and the other besides an old dyke running from Hill Farm barn towards Hanson's Tenement.

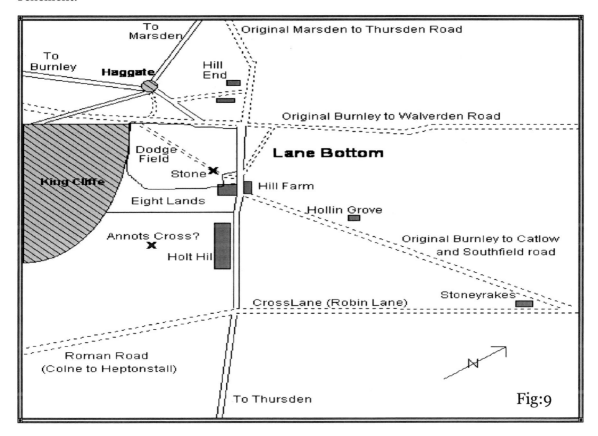

Early routes through Lane Bottom

Somewhere within this vicinity was a stone that had probably stood sentinel on its spot for many centuries. As the road to the Thursden Valley leaves Lane Bottom there is an area called Holt Hill and, in the year 1313, a local landowner named Robert Briercliffe was recorded in a land transaction which referred to *'the intacks (land improvements) in Holts as it lay by Annot Cross on the south side.'* Burnley historian Roger Frost states that a nearby field is called Meanstone Hill and rightly says that this would have been the site of a mark stone although there is now no evidence for exactly where the Annot Cross stood. The local Robin House Lane was known in the nineteenth century as Cross Lane – a possible reference to the Cross site.

Robin House Lane was part of the main Roman route passing from Colne, skirting Castercliffe,

through Southfield and on to Roggerham and Worsthorne. The soil removal works for the water pipeline passed around one-hundred metres behind the houses on Holt Hill and here, besides a demolished wall, a heap of large stones was apparent. A number of these were obviously not related to the original enclosure wall as they were too boulder-like, two large uprights lay side-by-side, one was a standard millstone-grit gatepost, of the early pattern whereby grooves had been carved to take the wooden rails of a gate. Next to this was a stone of equal length (around two metres) but of sandstone (bottom of photograph, broken into three fragments), this was of greater bulk than its neighbour, of different shape and had no carved grooves to facilitate the use of gate-poles. The fact that this latter stone was lying next to the gatepost does not associate it with having been part of the wall as it showed clear signs of having been moved during the recent excavations and dumped in its present position on the edge of the soil clearance. I was unable to find the workman who carried this out and, therefore, could not find the exact original location of the stone - suffice it to say that it would not have been moved any further than the immediate locality and, when in situ, would have stood *"on the south side of Holts."*

Gritstone gatepost (top) and sandstone upright below

This begs the obvious question; is this the lost Annots Cross? Given that the this stone has a massive base, is made of sandstone, has no carved recesses to take wooden poles and is located to the south of Holt Hill suggests that this was possible; on the other hand there is no firm evidence and so it must be filed away as 'unknown.' There is always the possibility that the stone in the Dodgefield, only a couple of hundred yards from Holt Hill, could be the long lost Annots Cross but again there is no hard evidence for this.

The description of Annots *"laying to the south side of Holts"* may refer to the fields above Hill Farm House, the field directly above the property is known as Coppice Field and contains a massive cistern-like well, constructed of stone and now capped over. This feature only came to light in the 1990s when the farmer almost lost his muck-spreader down the hole when the massive cap-stone flags collapsed.

The word *holt* has the meaning of *wood* and therefore the stone opposite Hill Farm would lay to the south of the wood, whether or not this was actually the case, it is apparent that this area was settled in early times. The King Cliffe is a level-topped area of around five acres with a steep defensive escarpment to the north, it lies on the same ridgeway as Catlow, Southfield and Castercliffe, all of which were ancient settlements. It would be surprising, therefore, if the Lane Bottom site did not form a part of this line of defensive Bronze/Iron Age ridgeway settlements.

Swinden

On the boundary of Nelson and Colne, running down to Colne Water where the river separates the village of Barrowford from the town of Nelson is the area of Swinden – this site has all the hallmarks of having been a settlement within the Anglo-Saxon period prior to its development as a farmstead estate after the Norman Conquest. The area was certainly being cultivated as farmland in the twelfth century, between the years 1213 and 1232 John de Lacy granted by charter to one Adam de Swinden sixteen acres to be held freehold. Some years later de Lacy made a further grant to Adam of twelve acres at Higgin Grove near Swinden Bent. The descendants of Adam de Swinden took upon themselves the name of Marsden and continued to occupy Swinden along with many other land acquisitions along the way. In 1427 John de Marsden sold his Swinden estate to John Bannister of Wakefield on the condition that he could occupy the house and lands for the rest of his life. John was the last Marsden to occupy Swinden.

Long Swinden Farm in the 19th century

As was often the case with land and property the whole estate moved into the ownership of another family when the Listers appeared on the scene. William Lister of Middop inherited much of the Swinden area through marriage settlements with the Bannisters. An earlier copyhold and freeholder's list shows that the Bannister lands at Swinden included an unnamed farm at 11 acres freehold, Higgin Grove at 12 acres freehold (established in the early thirteenth century), Swinden Hall at 35½ acres copyhold and Swinden Farm at 16 acres freehold (also established in the early thirteenth century). These were the four farms making up the Swinden estate.

At the centre of this small group of farmsteads stood Swinden Hall, long since demolished this building occupied the site of a much earlier (and probably high status) structure. The Hall, rated on five hearths, was built upon an elevation of land overlooking Swinden Clough and nearby, across the Clough, stood Long Swinden Farm. Both these properties had adjacent farm buildings and within a short distance were the other farmsteads of Hodge House, Hole House, Rakes House, Hagg Gate and Further Lee, many of which might later be seen to be part of a single former estate settlement.

Around the middle of the sixteenth century the freehold of Swinden Farm was sold to John Halstead of Rowley and around one-hundred years later this farm was to be raided by the Royalist Garrison stationed at Skipton Castle during the Civil War. Swinden was one of many farmsteads to be looted in this manner during that unsettled period.

The area of Nelson now known as Swinden covers the site of the Whitewalls Industrial Estate and the Swinden Playing Fields. In the Medieval period this area, from Reedyford to the 'King's Wastes' at Greenfield, was part of *Great Merclesden* and known as The Lee. *Swindon* was the site

of Swinden Clough and the present highway from Burnley to Colne was just a short length of track running along the end of the Swinden Hall Farm track (at the bottom of the present Bott House Lane, then known as Mitton Lane) along to Colne Waterside. This track was known as *Small Pack* and the narrowness and difficulty of passage along this track would account for the name. This road was in such a poor state of repair, in fact, that in 1469 Richard Bannister *'removed the mud road there and redirected it into the Lee Common over one half of one rood of his land.'*

The main highway from the Colne area to Great Marsden was the route from Waterside, via Castercliffe and Southfield from where it diverted down to the settlement of Marsden Chapel or onwards to Briercliffe and Burnley. As we saw in Chapter Two, Swinden is located at a major crossing point of Colne Water where the inter-ridgeway routes from Barrowford and Wheatley Lane pass through the valley on their way to Colne and Castercliffe. Long Swinden was once known as *Gillriding Ford,* the *gill* element of the name is Norse with the meaning of *steep- sided stream valley* whilst the Old English word *gil* has much the same meaning.

Riding is a word of many possibilities, one common root originates in the Old Norse and originally meaning *third part*, usually this applied to a political area and is evident in the Ridings of Yorkshire. The word also came to mean *proceeding north, west or east.* In the name of Gillriding we have an exact description of the Swinden site where the buildings were erected in Swinden Clough and the three parishes of Marsden, Barrowford and Colne all met thus providing us with *'the third part.'*

Whitaker argued that *riding* had its routes in the word *royde,* becoming *rode* and thus denoting a clearing of agricultural land and the land area measurement of a rod. However, *royde* is relatively common in our area, as are *ridding* and *rhydding,* and all commonly describe a clearing but *riding* is rare and is likely to have applied to a very specific site-use. There is also a consideration in that the word *gille* is Gaelic and is thought to have been borrowed from the Anglo-Saxon *gild* meaning *payment* whilst the *Saxon ridan* means *to ride or ride over,* and so the two together provide *gille-ridan-ford,* the connotation of a charge being made for crossing the ford being apparent. A Swinden Farm deed of 1877 mentions:

"The farm house, outhouses, barns and gardens at, or near, the ford of Gillriding 2 roods 3 perches - The Horse Pasture 3 roods - Rye Bank Meadow 1 acre 2 roods 29 perches - Great Holme 3 acres 2 roods 14 perches - Great Holme Top 1 acre 1 rood 16 perches - Little Rye Bank 1 acre 3 roods 16 perches - Tup Holme 1 acre 2 roods 32 perches - Square Holme 1 acre 1 rood 26 perches - Great Rye Bank 4 acres 1 rood."

The farm buildings are shown to have been close to the ford, maps show that a track crossed Swinden Clough and connected Swinden Hall with Long Swinden Farm, this would almost certainly have been the site of the Gillriding Ford. This suggests that the *riding* name-element could have been the clearing in Swinden Clough upon which the farms stood thus giving us *the ford in the valley clearing.*

We have seen that the general area around the Swinden Hall and Farm was known as The Lee and one of the number of farms forming a ring around the Hall was called Further Lee, this was located just to the west of the present Boundary Mill and the name indicates that it stood at the edge of the Lee, or Swinden, estate. The name Lee is the Old English word *leah* and is commonly taken to have the modern meaning of *cleared woodland.* In 1991 Denise Kenyon wrote, in relation to the word *leah,* that there are limited numbers of places with this name within Lancashire when compared to our neighbours. This is possibly because much of the area of Lancashire, west of Blackburn, was covered by low marsh land and would have had fewer trees to be cleared.

Our particular area, however, had many areas of woodland and this would mean that *leah* would

be applied within our Pennine area to settlements in woodland clearings or to settlements within a generally woody area. It is not difficult to imagine that woodland would have spread into the Swinden valley from the higher lands. The English word *leah* can also be seen in the villages running along the Pendle valley bottom of Bar-ley and Rough-lee, in nearby White-lee, in Whal-ley and also in Brad-ley within Great Marsden.

Whitaker states that:

"In the 8th of Edward 111 (1335) I find (from Towneley MSS.G. 26) that John de Haslingden and Adam de Swyne, chaplains, as I conjecture, of Colne, for chaplains of the place were the usual trustees upon these occasions, granted certain lands and tenements in Blakey in conformity to the will of Richard de Merclesden, deceased, to one John de Merclesden for the term of his life, and after his decease, to find one chaplain who should celebrate, for the soul of the said Richard and Avice his wife, their children, ancestors, and all the faithful, deceased in the church of Colne or Broughton, or in the chapel of the manor house of Richard de Broughton, or at Swynden."

Other early records suggest that Swinden was a relatively high status site. The name itself is usually taken to have the Old English meaning of the *Valley of the Swines,* possibly there were numbers of wild boar in the woods here when the Anglian settlers first arrived. I have mentioned previously that the Anglo-Saxons used the term *Swaine/Swein* as a personal name and it also came to mean a *farm-based worker.* The *long* in Long Swinden probably has its roots in the Old English *lange* for *extended* - this possibly applied to the farm buildings where they would be seen as an extension to the Swinden Hall.

On the Medieval track called Small Pack, on the southern edge of the former Swinden Estate, is the former farm site variously shown on early maps as Agot Yate, Agothole, Haggott Yate and Hag Yate. The name *hag* in this context possibly signifies *low lying meadows between two hills,* an apt description of the site; coupled with the Norse word *gate* for *track* or *way* we have a name for the thoroughfare from Castercliffe to Barrowford, and beyond, and the Marsden to Waterside track. Alternatively Walter Bennet, in his *History of Marsden and Nelson,* suggests that Hagg Gate was originally shown as *Algotholmeyate* and that this originated in '*the road to the holme of Algautr.*'

The Swinden area is no different to other English districts in carrying many Anglo-Saxon place-names, along with a smaller number of Scandinavian names. Further to this, an Anglian stone cross, of the type known as *Celtic,* was found in the river at Swinden when the new Colne sewage works was being constructed.

This would suggest that the area was settled by the Christian Angles and was an important site as far back as the eighth century. A fragment of another Anglian cross has been found in the gardens of Alkincoats Hall although it is not clear if this was of the free-standing type (see illustration), or part of another type of sculpture. The carved stonework of these crosses is taken as evidence that they were related to the Christian church, perhaps they were sited at convenient locations where numbers of people could be brought together to hear a priest give his sermon. They may also have marked a previously holy site of the British, and were assimilated by the new Christian culture. The few examples (around one-hundred) of this type of cross to be found in Lancashire have usually been moved from their original positions, they were often broken up and dumped, as may be seen with the Swinden cross.

Perhaps worth a mention here, further to the *riding* name element mentioned above, is the fact that *rood* was the Saxon word for *cross* and had the same root as *rode;* this raises the possibility of Gillriding having the meaning of *the cross in the stream valley,* if this were to have been the case then the lost location of the Swinden Cross may be placed within Swinden Clough, moreover, the

most likely site here would be the point where the Clough empties into Colne Water at the precise spot where the three boundaries of Colne, Marsden and Barrowford meet. This very spot was shown as being marked by a boundary marker on the first OS map of the area.

To the west of Swinden Hall were the settlements of Rakes House and Hodge House. The former possibly takes its name from the fact that it was on the road from Swinden to Whitefield, *rake* meaning *go* or *proceed,* and later, *slope.* Hodge House was demolished sometime around the late 1960s, the name *Hodge* was a nickname given to those with the Norman name *Rogeri* and could also have connotations of *carrier* from the original meaning of the word *hod,* possibly this was a reference to the site being upon the valley trade route. The surviving Court Rolls and deeds for the Swinden properties show that it was still considered to be an estate into the nineteenth century when a number of local farms were jointly owned.

Swinden Cross

Three parish boundaries meet here at the point where Swinden Clough meets Colne Water. The end of the wall (left of picture) is the possible site of Swinden Cross

Swinden Estate Deeds

❑ *1569: John Hartley of Swinden surrendered, by Robert Hartley of Great Marsden, a tenant of the Queen, one messuage, other buildings, and 20½ acres of arable land and meadow, being a parcel of the demesne land of Swyndon aforesaid in Greate Marsdene, in the tenure of the said John Hartley, and his assigns, to John Talior of Cloughhead, Roger Hartley, son and heir apparent of James Hartley of Wynewall and their heirs as feoffes according to the intent. Admittance sought and granted. Fine 6s 10d by pledge of John Swayne..........*

❑ *1569: John Swane surrendered one messuage and one close of land called Bent Heigh containing 2 acres of land in Great Marsden, in the tenure of the said John Swaine, to Lawrence Leche and his assigns for life. Admittance sought and granted. Annual rent of 2d was payable to John Swane and his heirs. Fine 8d by the pledge of John Tailior of Clougheade.*

- *1570: Gilbert Harteley of Great Marsdene surrendered certain buildings, a part of the buildings of Swynden, and 8 acres: 23 falls* of land in Great Marsedene, now or lately in the tenure of the said Gilbert Harteleye, to Geoffrey Shawe of Colne and John Foldes of Carrie Bridge and their heirs as feoffes according to the intent. Admittance sought and granted. Fine 2s 8d by the pledge of Robert Hartleye. *A fall of land equalled a square rod, pole or perch.*

- *1570: Henry Barcrofte of Lodge, gent. surrendered by James Foldes of Trawdene, a tenant of the Queen, one messuage, other buildings, lands, tenements, meadows, pastures and grazing lands in Great Marsdene containing 12 acres, now or lately in the tenure of James Foldes of Lee, to John Hyggyne of Little Marsdene and Robert Bawdwyn of Great Marsdene and their heirs as feoffes according to the intent. Admittance sought and granted. Fine 8s by the pledge of James Foldes of Trawedene.*

- *1766: A survey by James Foulds shows Long Swinden to be: Great Meadow 3 acres: 12 perches - The Acre 1 acre: 2 roods: 33 perches - Clough 2 roods: 49 perches - Clough Head 1 acre: 2 perches - Hammon Fields 2 acres: 3 roods: 31 perches. The Long Swinden Farm was formerly in the occupation of John Prescott and James Foulds then Richard Elliott and John Cook then John Kippax, James Greenwood and Ambrose Greenwood.*

- *December 1766: A survey of James Foulds esq, shows the Swinden Hall Estate to comprise of: The House - Outhouses - Bays - Fold - Garden and Lane at 1 acre 1 rood 12 perches - Leath Holme 2 acres: 17 perches - Wastes 1 acre: 3 roods: 31 perches - Nearer, Middle and Further Bank respectively 3 acres: 10 roods: 2 perches, 2 acres: 1 rood: 32 perches, 1 acre: 2 roods: 28 perches - Stoney Holme 2 acres: 3 roods: 28 perches - Little Holme 3 acres: 3 roods - Little Over The Water Holme 19 perches - Little Field 3 roods: 6 perches - Little Marled Field 1 acre: 39 perches - Great Marled Field 2 acres: 1 rood: 32 perches- Total area 29 acres: 3 roods: 3 perches - all formerly in the occupation of John Prescott and James Foulds and afterwards of Richard Elliott and John Cook then of John Kippax, James Greenwood and Ambrose Greenwood and since of James Rushton, late of James Crabtree and now of Richard Blackburn.*

- *1860: Indenture between William Pilling of Trawden House, Colne, gent - Christopher Grimshaw - James Foulds esq - Thomas Mason Johnson esq - William Nicholson Alcock - Henry Alcock - Thomas Birkbeck - John Birkbeck - William Robinson the elder - George Stansfield - William Robinson the younger - Joseph Birkbeck - William Smith - Henry Alcock - Robert Shaw by which the Swinden hereditaments were conveyed to Robert Shaw in trust for William Pilling.*

- *1866: William Pilling devised by his will: Swinden in Great Marsden containing in the Lord's measure 26 acres: 1 rood: and 28 perches and then in the occupation of John Elliott..............*

- *1873 part of Coal Syke Farm land was occupied by Long Swinden Farm:- All that messuage or tenement formerly called Gill Riding and now known as Swinden Farm late in the occupation of John Elliot, now of Richard Elliot, being: Great Holme - Long Holme - Tup Holme - Farther and Nearer Rye Bank and Baxter Butts about 16 acres.*

All those closes formerly belonging and occupied with a farm or tenement called Coal Syke being Great Meadow - Acre - Black Earth - Clay Earth and Clough.

❑ *1875:* All that capital messuage and tenement called Swinden Hall in Great Marsden containing 29 acres: 3 roods: 3 perches in the Lord's measures, then in the occupation of James Crabtree charged with payment of £30 to the testator's wife Mary and containing *Barns - Buildings - Gardens - Orchards - Backsides and Closes called: Great Lands - Less Lands - Little Ing - Great Marled and Lesser Marled Fields - Great, Middle and Further North Bank - The Leys - The Horse Holme Ing and the Laithe Holme:-* Some of this land was sold by Mary Fould's estate to the proprietors of the canal navigation from Leeds to Liverpool.

❑ *1883:* John Pilling sells land at Swinden to the Local Board for the purposes of the erection of a sewage works. William Henry Hartley receives £800 and John Pilling receives £4,093. The land in question was:- *all of The Square - Small and Great Holme - parts of Great and Little Rye Bank - Lower Meadow and all parts of Swinden Farm being 16 acres 3 roods 10 perches and late in occupation of Robert Jackson.*

❑ *21st December 1883:* Thomas Chadwick purchases, for £3,500:- *All that capital messuage and tenements known as Swinden Hall with the land now occupied by Richard Blackburn and now described as: Farm House - Stable - Buildings - Fold 1 rood: 27 perches - part of Little Holme and Wastes (in one close) 5 acres: 32 perches - Nearer, Middle and Further Bank - Stoney, Little and Lower Holme (in one close) 16 acres: 1 rood: 3 perches - Further and Middle Bank - Little Field - Little and Great Marled Field (in one close) 10 acres: 2 roods: 33 perches - Nearer Bank 3 acres: 1 rood: 37 perches - Land - Nearer and Farther Meadow (in one) 5 acres: 2 roods: 2 perches.*

❑ *6th September 1912:* William Arthur Pilling sells:- *all that part of two acres at Swinden Hall Farm, near to Swinden Bridge, to the Leeds and Liverpool Canal Company for the sum of £320.* The purpose of the sale was for the Company to pile the canal banking at that point so as to avoid further erosion.

❑ *1917:* Swinden Farm and Hall sold to Alfred Parker and William Sagar, tanner, they resold to Corporation 23rd Aug 1935. The property was listed as:- *The Great Meadow 5 acres: 0 roods: 2 perches - The Acre at 2 acres: 3 roods: 26 perches - Clough or Wood 1 acre: 2 roods: 26 perches - Lee Field (formerly two closes called Clough Head and Hammon Fields) 6 acres: 3 roods: 15 perches - A parcel partly in Colne and partly in Nelson bounded on the north-west & west by a portion of Swinden Hall Farm and south by a close called Clough or Wood 0 acres: 1 rood: 13 perches - A strip formerly part of Swinden Hall Farm and forming the road from the highway from Colne to Burnley.*

❑ *20th August 1928:* William Pilling and his wife Mary convey to Alfred Parker Sagar and William Sagar: *all that plot of land formerly a portion of the Lee, or Nearer Lee Farm, at Colne bounded on the north-west by Swinden Hall and Swinden Farm, on the south-east by Burnley Road, Colne and by a back street, on the north-east by a plot now, or formerly, belonging to John Kenyon Ltd; on the south-west side by Swinden Lane and on the south by the dwelling house of number 362 Burnley Road, Colne, containing some 2,255 square yards.*

❑ *23rd August 1935: Harry Oates Sagar and Thomas Preston Sagar sell all of the Estate of Swinden Hall and Swinden Farm and all of the land at Lee to Nelson Corporation for the sum of £7,000.*

The Swinden Estate was broken up and demolished over the first half of the twentieth century. The buildings of Swinden Hall, Long Swinden, Hodge House, Rakes House and Hole House were amongst the many old local buildings to be unceremoniously wiped from the face of the earth in this 'enlightened' period. Looking around the area now there is little left to see of the history that the people of Swinden created, perhaps over a period of twelve-hundred years or more.

The disused ford on Colne Water connected Swinden with Barrowford

A study of early maps and aerial photographs strongly suggests that the main Colne Water crossing was situated between the bottom of Rye Bank, on the Barrowford side, and the present Swinden playing fields. The Barrowford bank of the river still show two trackways converging on the river at this point (Fig:10). The parish boundary running along Colne Water, between Barrowford and Nelson, changes abruptly and veers inland when it reaches Swinden playing fields (Fig:10). It then describes an arc through the playing fields, is bisected by the canal and rejoins the river at the point where Swinden Clough empties.

The Canal Company found that their original site for the aqueduct to carry the canal over Colne Water did not provide for sufficient height over the river bed. Their solution to this problem was to divert the river to its present course and move their structure around eighty metres north to the spot where it now stands. The construction of the Swinden playing fields, in the inter-war period, saw the old river channel filled in and levelled - the only reminder of the original river course is now the kink in the parish boundary.

The situation of the Swinden Estate as an important valley crossing at the junction of three boundaries, plus the evidence of the Anglian cross that once stood here, point to this area between Marsden and Colne having once been of some importance. This certainly appears to have been the case within the Medieval period and may well have applied within the earlier British occupation of the neighbouring Castercliffe and Shelfield areas.

107

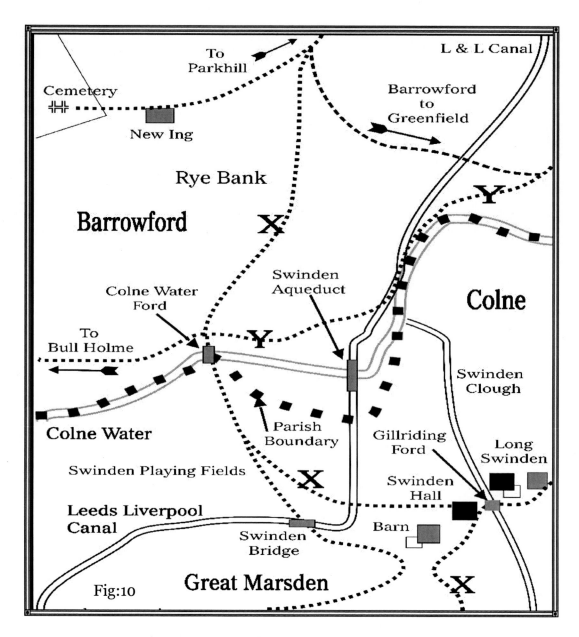

Swinden and Gillriding Ford: *SD 392 867*

*The north-south inter-ridgeway route from Castercliffe is shown at **X** heading up Rye Bank to Park Hill. The east-west route **Y** connected Little Marsden, Newbridge and Wheatley to Greenfield and Colne.*

The Barrowford/Marsden boundary is marked ■ ■ ■ ■ ■ ■ ■ *and the deviation from Colne Water, at the old Colne Water Ford, can be clearly seen.*

Chapter Nine

Anglo-Saxon Place-names

The physical location of Anglo-Saxon settlements by archaeological methods is notoriously difficult, more often than not any new site follows the accidental unearthing of relevant artefacts such as grave-goods, pottery and jewellery. Excavation might then uncover the timber post-holes, cemeteries and pits associated with this period. We as an area have little archaeological information to go on and so the main weapon in our armoury for identifying Anglo-Saxon settlement is the use of place-names, carved stonework and documentary evidence. We have a number of extant examples of Anglian stonework from the region although these are often found to have been moved and have no particular context. The written evidence for the Anglo-Saxon period within Lancashire is somewhat scant, as is the Domesday Survey of the eleventh century. This leaves us with the method of place-name etymology in our search for the location of Anglo-Saxon settlements.

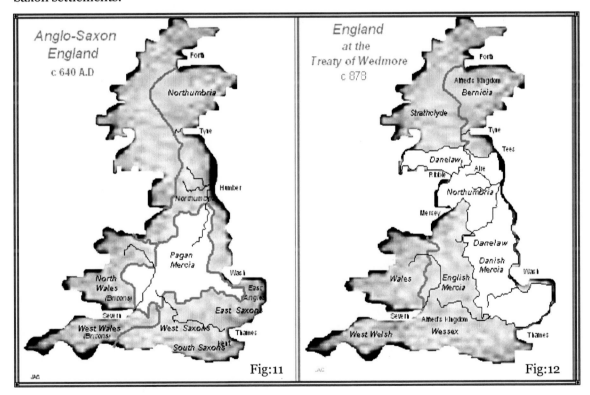

Fig:11

Fig:12

As always in the use of place-names to locate and date a particular site there is a caveat because names of the Anglo-Saxons can sometimes be the same as those used by the later Scandinavian settlers. The people of both these cultures spoke a variety of cognate Germanic dialects, these dialects are the root of Modern English and share many common features of vocabulary, grammar and syntax, a number of words are virtually the same in both languages. The fact that English

became the dominant language of lowland Britain (and eventually throughout the mainland) replacing the earlier Celtic language, is taken by many historians to be proof that the initial number of Anglo-Saxon invaders was considerable.

A very rough guide when it comes to differentiating between earlier English settlement and the later Scandinavian incursions is to take the topographical location into account. The later settlers usually found that the more productive lands had already been taken and therefore each successive culture tended to settle the remaining marginal lands. It would appear that the Scandinavians were, in some cases, content with lands that the already-settled English had rejected whilst it has been shown that the earliest Anglian settlers within Lancashire preferred to farm the rising ground between one-hundred and five-hundred feet above sea-level, they deliberately avoided the marshy coastlands.

The Scandinavians appear to have been willing to take over low-lying vacant lands towards the east coast whilst within our Pennine area it can be argued that they were happy to make use of both the higher moors and the valley mosses. Thus a few scattered farmsteads carrying evidently Norse names, and located some eight hundred or nine-hundred feet above sea-level, might be assumed to be of Scandinavian origin as opposed to having originated within the earlier Anglo-Saxon period. This is a simplification, however, as the later Anglo-Saxon estate patterns tended to incorporate all grades of land from the better arable lands to the common grazing lands of outlying moors.

It is now recognised that much of the landscape is named in the Old English of the Saxon peoples although we have seen that the later Scandinavian settlers also spoke Germanic dialects. To further confuse matters, many Scandinavian words have survived within our area, following the Norman Conquest minor names, such as field names, were still being applied to newly adopted lands – both *carr* and *holme* are examples of this and many others, such as *snicket, sneck, ginnel, clout* and *beck* are in regular use today. Scandinavian names were also applied before the Norman Conquest to earlier English settlements which in turn may have been earlier British settlements. This means that an obviously Scandinavian name applied to a cluster of farmsteads, or a hamlet, does not necessarily confine the dating of that site to the initial period of the Scandinavian incursions.

The dating of Anglo-Saxon settlement by name was previously heavily reliant on certain test-words, one of these words, *ingas,* was used as evidence for tribal or kinship groups known as *xingas* who were thought to have given their name to settlements such as Cowling. Dating of earlier Anglo-Saxon names now uses the *ing* element, where it forms part of a topographical description, as evidence of settlement. Our area has a small number of the *ing* elements, an example that springs to mind is that of Ridgaling on the ridgeway route above Roughlee. However, when the *ing* element is coupled with modern names it can be taken to have the later meaning of *meadow,* there are numerous examples of this around Pendle Hill such as Ing Wood, Ing Barn and Ing Head.

Another element accepted as an Anglo-Saxon test word is *ham,* this means an *estate* or *village* and is often combined, as in the name *Ingham,* the root of the *ham* word means *safe dwelling.* Nationwide the ham-named settlements often seem to be located near to Romano-British settlements, this contradicts the older acceptance that the Anglo-Saxons avoided the already existing population sites. The early Saxons often built their houses within the ruins of Roman cities in the southern lowlands, one reason for their spread away from these once densely populated areas is that the Romans left a poor legacy of agriculture. They had farmed the land so intensively (in order to feed their troops both here and abroad) that it was in very poor condition when the bulk of the Anglo-Saxons arrived, this is one reason for the steady incursion of the English into our sparsely-populated area.

Thus the early English names in the north-west of England were being applied to our particular area by the new settlers sometime around AD 650 to AD 850. Names of interest include *Kirkham, Penwortham, Whittingham, Altham, Higham, Hameldon, Coolham, Habergham* and *Padiham*. A study of the **ham** names shows that a great percentage are related to river and coastal locations, this reflects both the siting of settlement near to clean water and good land but also along communications routes. We saw earlier that the ridgeway from Ribchester passed through our area along Padiham heights and above Barrowford. The villages of *Altham, Padiham, Habergham* and *Higham* are all situated along this route and *Downham* is placed on the Roman road skirting around the Clitheroe side of Pendle Hill.

An indicator of the relative lateness of Anglo-Saxon settlement in our part of the north-west is the lack of places carrying the name **feld.** This was commonly applied to higher moorland boundary areas in the very early years of Saxon settlement and can be seen in the names Huddersfield, Macclesfield etc. The local names of this type that we do have are thought to have acquired the suffix in post-Norman times when the term *field* came to mean *an area of enclosed common land*, examples here are Brierfield and Threshfield.

The name **tun** was a generic word with the meaning of *settlement* or *farmstead*. The name was in use by the later seventh century as a descriptive of estate components ie, Waddington was *the tun of Wadda* and Bolton *the tun of the hall*. It is possible that the **tun** element was applied as a wholesale convenience wherever the Saxons took over an existing British settlement, or as a standard name for previously unnamed sites. Examples of the name are; *Mitton, Billington, Accrington, Clayton, Rishton, Hapton, Rimington, Thornton, Grindleton, Twiston, Worston, Pendleton, Bolton-by-Bowland, Horton, Marton, Long Preston, Carleton* and *Skipton*.

Worth names, from **worσ,** can be found along a corridor of high land to the south of our area, *Boulsworth, Wadsworth, Haworth* and *Oakworth* being examples. **Cot** can be found within the names of Alkincoats at Colne and Coates in Barnoldswick. **Wic** is an element of Barnoldswick, thought to originate in the personal name of Barnulf's-*wic*. **Stock** (from **stoc**) is the name of a deserted Medieval village to the north of Barnoldswick. All four of these words have been shown to apply to sites forming a small part of a larger estate. The **worth** areas would form a fenced border area of marginal moss and moor lands, as they do today. Alkincoats is tucked away within the north-west corner of Colne and was formerly an important element within that manor. In the Medieval period this site was described as a village and included nearby farms such as Holt House. Barnoldswick expanded from its original foundations within the Calf Hall, Old Town and Wapping districts, the village was part of an ecclesiastical grange estate under the auspices of Kirkstall Abbey – the Coates area of Barnoldswick was an outlying estate farm, or grange, connected to Sawley Abbey to whom the area belonged.

The former arrangement of Anglo-Saxon estate holding began to break down in the later Saxon period and this was exacerbated following the Norman Conquest, the small settlements carrying the **stoc, cot** and **wic** elements went on to form independent units. Alkincoats, Stock and Barnoldswick illustrate this as they all became vills, the latter in particular took advantage of the eighteenth century textile boom and evolved into a small town whilst Stock and Alkincoats gradually declined to become a scatter of farmsteads. **Cot** was often applied to a small dwelling during the later Medieval period - such was the case with *Proctor Cote* (Proctor's Cottage) in Extwistle.

Throughout this book I have consulted the works of scholars in order to make sense of our rich variety of place-names and one thing above all others has become apparent - the more that the subject is studied the more complex it becomes. We have seen that our landscape is named in a multi-layered fashion, each successive culture influencing the last up to modern times. An example is the name of Castercliffe where we have the Old English element of *clif* and the Old Norse *klif*,

both with the same meaning of *raised ground,* and the Old English *ceaster* whose origins can be seen in the Roman Latin *castrum* meaning *army camp,* this word itself was borrowed from the Indo-European language word *kez* or *kas 'to cut off.'* The study of linguistics appears to move so rapidly that I would think that even a scholar of the subject would hesitate to define many place-names as an absolute given. Within the broader framework of alternative place-names we can, however, glean a reasonable history of the places that our forebears named.

Local place-names

- **OE** = *Old English (Anglo- Saxon)*
- **OF** = *Old French*
- **N** = *Norse (Scandinavian)*
- **ON** = *Old Norse*
- **ME** = *MIddle English (post- Norman)*
- **C** = *Celtic (British)*
- **G** = *Gaelic*
- **L** = *Latin*
- **OD** = *Old Danish*

✳ **Accrington** is probably *the settlement where acorns are found,* from the OE *aecern* + *tun.* From its position on the edge of the Rossendale Forest this etymology is likely although this makes it the only major English place-name to contain the word *aecern.* In the early Medieval period Accrington was depopulated by the monks of Kirkstall Abbey who turned the vill into a grange

✳ **Altham,** the name of this village near to the River Calder comes from the **OE** *aelfet* + *hamm* meaning *the water meadow of the swans.* The name was shown as Elvetham in c.1150

✳ The small village of **Barley** is tucked into a hollow below the brooding bulk of Pendle Hill, the name carries the suffix of *leah* and the prefix could possibly be represented by the **G** *baile* or *belle* for *a narrow promontory.* There is also the consideration here, highlighting the difficulty of name-continuity, that the **OE** *beorh-leah* had the meaning of *a clearing near to a projecting height;* or *bere-leah* for *clearing where barley is grown;* or *bere-leah* for *glade where boars are found or kept.* The Clitheroe overlords had established the village as a vaccary by the year 1260.

✳ **Barnoldswick** appears to have a personal name element in *Bernulph* (Bernulph's-wic) and the **OE** *wic* - the usual form of this in Lancashire is given as *-wick.* The Germanic word *wic* was borrowed from the **L** *vicus* meaning *row of houses, street, city district.* It appears to have the meaning of *dwelling* and is used in the sense of a building for a particular purpose or occupation - in particular a *dairy farm* which is commonly thought to be the case in the name of Barnoldswick (for more on this see Chapter Ten).

✳ **Barnside,** near Laneshawbridge, was the seat of a branch of the Towneley family for generations and was originally known as **Bernesete** from the **ON** *Biorn* + *saetr* meaning *Biorn's mountain pasture.* The name developed into Barneside when the **OE** *side* was added giving the *long hill slope,* a suitable description of the topography.

* **Barrowford** has always been commonly assumed to have originated in the *ford by the barrow* but the **OE** word *bearu* has the meaning of *grove or wooded hillside*. The term *grove* could very well be a description of the Rye Bank which forms the backdrop to Barrowford park, this area would have been heavily wooded. The *ford* was probably the one at the bottom of Church Street, this took the traffic from Wheatley Lane, Marsden and Pendleside (via Roughlee down Pasture Lane to West Hill) across to Park Hill and Colne or straight up Rye Bank and down to Swinden. Barrowford probably had a pre-Norman settlement around the Park Hill area and began to exist as an area of scattered farms, as opposed to merely a valley crossing-point, when it was granted out as vaccary in the thirteenth century.

* **Blacko** is taken to be *the black hill* from the **OE** *blaec* + **OE** *hoh* or **ON** *haugr*. The colour black is appropriate here owing to the peat soil on the higher slopes of Blacko Hillside. The black element within place- names is not always clear, however, as the **G** *(a)blaecan* is the root of our **ME** *bleach* and means *to whiten.*

* Another *leah* name occurs, as we have seen, in **Bradley.** This was an area of Great Marsden and is now a political ward within Nelson. The name has the **OE** meaning the *broad lee,* this area became a cluster of farmsteads in the post-Norman period, Sir Richard Towneley set up an illegal corn mill here in the fifteenth century in order to poach the lucrative corn- grinding trade from his competitors.

* **Burnley** is, of course, another example of the *leah* suffix, this time coupled with the ubiquitous *burn*. The most likely source of the name is within the **OE** words *brun* meaning *brown - burna* meaning *stream - burn* meaning *stream or well*. Burnley was probably settled by the Anglo-Saxons within the later eighth century and grew, under the Normans, to be one of the more wealthy parishes within the area. The *burn* name can be seen running throughout our area, roughly in a line along the east-west valley route from Yorkshire to the Ribble at Samlesbury. This corridor of *burn* place-names, seen in **Eastburn** and **Glusburn** (both in the Aire Gap near Keighley), **Gisburn, Chatburn, Burn Moor, Burnley, Hindburn** and **Blackburn**, may have represented a particular period of naming. The east- west nature of the boundaries of these places suggest that they were named by people who commonly used the inter-coastal route through our Pennine area.

* **Chatburn:** the photograph right shows the church steeple at Chatburn following a lightening strike in the nineteenth century. In the name we have the **OE** *Ceatta* + *burna* which possibly show the Saxon personal name of *Ceatta's stream* (the small brook upon which the village stands) although the **OE** *ceat* means *piece of wet ground* and could equally well show *the wet ground by the stream.*

* The town of **Clitheroe** is a town of the early Medieval period

planted around the castle and became the local seat of the Norman lords, the honor of Clitheroe covered a large area from Accrington to Foulridge and from Chatburn to Cliviger. It has been suggested that one Robert de Lacy built the stone castle at Clitheroe in 1186, probably as a replacement for an earlier earthen structure of the Saxon/Scandinavian period. The name of Clitheroe has the **OE** element of *clyder* and the **ON** *haugr* giving the meaning of *the hill of loose stones*. It is also possible that the second element is the **OE** *hoh,* meaning *spur*. There is also the possibility that the first element represents the personal name of *Klidda* giving *Klidda's Hill*.

* **Colne** was known as *Calna* in 1123, *Kaun* in 1242, *Calne* in 1246, *Caune* in 1251, *Caln* in 1255 and *Coune* in 1292 - by 1296 the modern name seems to have been adopted. It has been suggested that the town was founded in 79 AD when the Roman governor of Britain, Agricola, gained power over the people of Lancashire. Folklore has it that many battles were fought at Colne between Anglo-Saxon princes from Trawden and Marsden. It is probable that the once-separate community of Waterside was an Anglo-Saxon settlement. This area had a fulling mill and corn mill by the year 1290 and Colne had a manor house by 1200.

* **Downham** was mentioned in the Domesday Book where it was: *"to be taxed in three carucates and may be two ploughs. Gospatric had a manor there, he now has it of the earl and its waste the whole one mile long and one mile broad were in King Edward's time 10 shillings."* The name of Downham has the OE elements of *dun-* and the dative plural *-m*, giving the meaning of *at the hills* - the village was shown as *Dunum* in 1188 and does not have the *ham* element as might be supposed. Downham was the settlement of Aufray, or Alfred the Saxon who granted it to Ilbert de Lacy following the Norman Conquest. In 1353 the Duke of Lancaster granted the manor of Downham to the Dyneley family who held it until 1558 when Roger Assheton obtained it, the area has been in the ownership of this family ever since.

Parts of the village church of St. Leonard's date back at least to Norman times, although excavations carried out in 1910 show that the church has Saxon, or early Norman origins - the fact that there is a field in Downham parish known as *Kirkacre* (pure **OE**) lends weight to the argument for there having been a pre-Conquest church here. Downham now comprises the townships of Downham and Twiston, an area of over 3,000 acres. Owing to its natural setting, and unspoilt character, the village of Downham has been the setting for a number of period film and television dramas - the most recent being the television series *Born and Bred*.

* **Extwistle** can be shown to mean the *meeting of rivers where oxen graze* from the **OE** *oxa,* in the plural form of *exen + twisla*. It has been suggested that the name could also mean the *oak trees near the river confluence*. The rivers here are the Don (possibly from the **C** *dana*) and the Swinden. There is no nucleus to the Extwistle township although it was to become the manor of Extwistle by 1193, probably as a sub-manor of Ightenhill. The area around Extwistle Hall can be said to be the populated 'centre' of the region.

* **The Eyes**, an example of this name can be found at Greenfield, Colne, where the land between Wanless Water and Colne Water form 'an island' as it runs towards Swinden. Eyes is from the **OE** *eg* or **ON** *ey* meaning *land partly surrounded by water* - the Colne example is shown on Medieval maps as *Colne Eey*.

* The river running through Colne originates on the hills to the east. The area known as

Emmott is where the two hill streams of Wycoller Brook and Laneshaw River meet and this is exactly what the place-name means, the **OE** *Ea(ge)motu* signifies either *a meeting of streams* or *the mouth of the stream*. Emmott Hall stood on the site of a holy well, reputed to be where early Christians of the locality were baptised in the ninth century. The Anglo- Saxon chronicle recorded that *"King Athelstan ruled all the kings in the island and at a place called **Eamot** they renounced idolatry."* It is interesting to note that the new king of all England may have respected the site of Emmott enough to have chosen the site to assert his authority. There is also the tantalising possibility that the Battle of Brunanburh, often said to have decided the fate of our islands, may have been fought in close proximity to Emmott (see Chapter Thirteen).

* The name of **Fence** refers to the fact that the village had been fenced to retain the deer of Pendle Forest when the former hunting grounds were being granted out to vaccary - the name is apparently late in date. The **OF** *defence* became the **ME** *fence*, the village was shown as Fence in 1425.

* **Foulridge** is situated on the eastern-most boundary of the parish of Whalley. The name is commonly taken to have its origin in **OE** *fola + hrycg* giving *the ridge where the foals graze,* possibly a reference to nearby Slipper Hill but the hill name now refers to the settlement name. On the other hand there is the suggestion that the prefix comes from the **OF** word *fouler* means *trample*; this originated in the **L** *fullare* meaning *to clean cloth* and *fullo* for *one who cleans cloth, a fuller.* We know that a corn mill existed at Foulridge by the year 1540, it is possible that a much earlier fulling mill also existed here, or at least the area could have specialised in the fulling process, thus providing the village with its name. In 1311 Colne was shown to have a *Mol. Folreticum,* or fulling mill, valued at six shillings and eight pence and the *folre* element here has a definite pronuncial relationship to the *foul* in Foulridge.

* Between Padiham and Burnley is the area of **Gawthorpe**, mainly known for its magnificent hall on the south bank of the River Calder. Gawthorpe was originally a hamlet founded upon the banks of the Calder, the name may have a Celtic first element but appears to originate in the **ON** *Gaukr* meaning *cuckoo* and the **N** *thorpe* is *a settlement* - hence we have *the village where the cuckoo is found.* The area of Gawthorpe has long been associated with the Shuttleworth family, a very early document, written in English, was recently discovered in the estate office showing the name as Schotilworth. Shuttleworth is an **OE** name for *gated enclosure* where *scyt(t)els* and *worth*

come together. By the year 1333 the hamlet had become known by its present name as a William of Gawthorpe gave up nine and a half acres which he had previously farmed. It has been suggested that Gawthorpe name has been taken from another site of that name in Yorkshire.

* **Gisburn** lies along the ancient route from Clitheroe to Ilkley and from Blackburnshire into the Forest of Bowland, the prefix possibly

originates in the origin of the **OF** *guis(e),* thus having the connotation of *the wise river* or *well.* An early document showing details of the Percy lands in Ribblesdale has the name as *Ghiseburne* (this is also the name given in Domesday) – fitting the strategic siting of the village would be the **OE** word *gis(can)* meaning *to close, bolt* or *bar.*

To illustrate the strategic importance that has long been assigned to the area we have, on the edge of the village on the banks of the Ribble, the remnant of a defensive earthwork known as Castle Haugh (see Chapter Ten) or colloquially *Cromwell's Basin.* This occupies the north-western end of a spit of high ground overlooking the Ribble and, in estate-agent parlance, 'affords extensive views to the north-east and south-east'. The castle takes the form of a six metre high earthen mound surrounded by a two metre deep ditch. A breastwork of earth runs around the summit with an open edge facing to the west. There is every likelihood that the Norman mound was erected upon the site of an earlier mound. Also to be found near to this site are the remains of an early barrow burial, this was found to contain a crude earthen urn. The village church of St. Mary the Virgin, at Gisburn, was dedicated around 1135 when Norman de Rimington gave a carucate of land to the *Blessed Church of St. Mary the Virgin, Gisleburne.* A charter makes mention of a priest, by the name of Renulf, at Gisburn between 1140 and 1146. In 1147 there is a reference to the priest of Gisburn being present at the laying of the foundation stone at nearby Sawley Abbey. It is possible that there was a Saxon kirk at Gisburn but no records of this have been found. Names relating to Gisburn in the Domesday Book were: *Arnketil; Beornwulf; Ber; Ealdraed; Everard the man of William de Percy; Gamal; Gamal Barn; Godfrey; Grim; Hrosskell and Leodwine.*

* **Goldshaw** is a complex place-name thought to have its origins in the **OE** personal name of *Goldgeofu.* Originally it was a woman's name but the *-g* would become vocalised to an *i* with the result of *di* sounding like 'judge'. Therefore the second element of the name would be replaced by *shaw* (**OE** *sceaga - small wood*) as a description of the area. Eventually the **OD** *both* was added to give the early spelling of *Goldiauebothis* - now **Goldshaw Booth.**

* **Habergham Eaves** is thought to have been an example of *ingaham* indicating an early settlement. The elements appear to be the **OE** *heah + beorg + ing + ham* - (the **OE** *efes* for *eaves* or *hillside* being a later addition) and therefore the name would mean *the settlement associated with the high hill.* The hill in question would most likely be nearby Horelaw Hill shown in early records as *Heahbeorg.* In 1861 Habergham Eaves, at 4,217 acres, covered a larger area than the 1,996 acres of its close neighbour, Burnley. In the later nineteenth century, and the early twentieth century, a series of Acts saw a steady transference of Habergham Eaves land into Burnley Borough. Habergham Eaves is now a distinct area, not to be confused with Habergham which is located around All Saint's Church between Burnley and Padiham.

The old Habergham Hall was long the residence of the Habergham family, in 1201 Alina and Selina Habergham were in mitigation with their sister, Eugenia, over four bovates of land. Roger de Lacy was on good terms with the family and, in 1204, gave to Mathew de Hambringham two bovates of land within Hambringham. The last male heir was John Habergham esq, who was born in 1650 and died without legitimate issue in the early eighteenth century. He married Fleetwood, a daughter of Nicholas Towneley esq, of Royle Hall, but the union was not a happy one. It is not known where John Habergham died, or where he was buried because he became a vagabond and was deserted by the 'friends' who had helped him to waste his estates. A song called *Love's Evil Choice* was written by Fleetwood and this went to the top of the Medieval hit parade!

* **Hameldon Hills** are the two hills to the south of Burnley, Hameldon Hill at 1,305 feet and Great Hameldon at 1,343 feet. They take their names from the **OE** *hamol + dun* giving the possible meaning of *scarred hill* - *hamol* is uncertain, it could also mean *treeless, bare* or *flat-topped*. Great Hameldon is the third highest hill within our area and was the scene of a mass 'pilgrimage' to its summit by local people on the first Sunday in May of each year. This is similar to the Pagan pace- egging traditions of Pendle Hill on Good Fridays.

* **Hapton,** in the valley of the Hameldon Hills, has the **OE** elements *heap + tun* meaning the village by the hill.

* **Higham** would have been a settlement long before the Normans came, the name appears to signify a settlement higher up the valley sides and has the **OE** elements *heah + ham (high-village)*. The village is situated at a level of around 650-700 feet on the east-west ridgeway track leading from Whalley over to Barnoldswick. The village would have been strategically placed on this route so as to take advantage of its proximity to the outlying settlements and farmsteads around Pendle. Following the Norman Conquest the area of Higham, under the Clitheroe lordship, was effectively cleared of people to make way for the deer of the new Pendle Chase (hunting area). This slowly changed as the lords confined their hunting operations to specific areas of parkland and let extended lands out to farming. By the sixteenth century Higham had become a hamlet and, because of its proximity to Pendleside and Ightenhill, a halmote court was established here.

* **Ightenhill** (the photograph right shows Ightenhill Old Hall Farm, once part of the large Ightenhill estate) is a parish within the Burnley area and was an important manor within the Medieval period. The main halmote court for the area was held here and there was a horse-breeding stud for the use of the Clitheroe lords. The name is a hybrid of the two elements of **C** *eithin* + **OE** *hyll* giving the meaning of *furze (gorse) hill*, a nice description of the 530 foot hill upon which the manor house stood.

* The village of **Laneshawbridge** is the last one in Lancashire before the border with Yorkshire is crossed and has an Anglo-Saxon origin where *sceaga* means a *small wood*, or *copse*, hence *lane-copse-bridge*.

* **Laund (Old and New)** were created by the Norman lords of Clitheroe as open pasture, or deer parks, within the Forest of Pendle. These areas would have held scattered Saxon farmsteads around Higham and Wheatley but the name elements reflect their later use ie. **OF** *launde* and the **ME** *new/old*.

* **Marsden:** the vills of Great and Little Marsden are now known as Nelson and Brierfield. The original settlement probably dated from the eighth century and was called Merclesden (see Chapter Two). The name is the **OE** *mercels + denu* giving *the valley of the marker* or *monument*. The earliest recorded inhabitants of the area are Peter, Richard, Osbert and Uvieth of Marsden. By the thirteenth century a chapel had been established, the central area of the vill of Great Marsden was located around the St. Paul's and Edge End district.

* **Padiham** shows another early example of the Saxon name of *ingaham* where we have the **OE** personal name of *Padd(a) + ingaham* or *the village of Padda.*

* **Pendle Hill** stands at over 1,800 feet and dominates the landscape for hundreds of square miles. We saw earlier that, on the face of it at least, the name itself is an excellent example of earlier names being assimilated by later cultures – the elements are **C** *penno* + **OE** *hyll* and **ME** *hill* (Pennhyll Hill). The British name of *penno* means *hill* but, if this is indeed the origin of the name, then it is apparent that the Anglo-Saxons did not understand this and added their own *hyll* following which the modern name of *hill* was appended just to make sure! The name was shown as *Pennul* in 1258 and *Pennehille* in 1296.

There is another possibility in the name of Pendle (photograph left) and that is that it may have been named after Penda who was the Pagan king of Mercia (of which our area formed the northern limit) within the Dark Ages. His main hobby was fighting his Christian neighbours, Northumbria being his favourite enemy. Given his many battles in the north Penda would possibly encamp within the Pendle district - failing this it is not unreasonable to suggest that he would probably have known our area well. His ultimate encounter was at the Battle of Winwaed (AD655) where he lost his life, following this England could be seen to have become thoroughly Christianised.

The **OE** name-element of *dael* is *valley (dale)*, *dÆl* means *division* or *separation* and *dÄel* is *region* or *district*. Given this we may have a description of the hill in *'The Hill of Penda's Valley' - 'The Hill of Penda's Boundary' - 'The Hill within Penda's District.'* It is interesting to note that Pendle is thought to have formed the boundary of a British kingdom Furthermore we have the local boundary names of Rimington and Twiston. The water draining from Ogden Clough on the flanks of Pendle Hill was known as Barley Beck, Roughlee Water and Pendle Water in the lower valleys, this was shown as *The Piddle* on a 1577 map.

* **Read** has an early forest connotation whereby we have the **OE** *raege + heafod* meaning the *headland of the roe.* The headland is the ridge between Sabden Brook and the River Calder

upon which the village stands. In the later Medieval period the area became an important cattle-breeding site for the Parish of Whalley.

* **Ribchester** has the **OE** element of *ribble* and the **L** *ceaster,* early records show it as *Ribelcastre.* The Roman fort here, known as *Bremetennacum,* was built in wood during the first century AD and rebuilt in stone during the second century. The site was renamed after the River Ribble by the Anglo- Saxons following the abandonment of the fort during the fourth century. The pronunciation in *Chester,* and *Ribchester* is suggested by Ekwall to separate the northern Mercian dialect of our area, where we pronounce the word as *caster,* from the other regions within Mercia. Ribchester, therefore, was possibly on the western boundary of Northumbrian influence.

* **Ridgaling,** *from the OE lhrycg + ing* and meaning *the people* or *settlement on the ridge,* does exactly what it says on the tin! The present farm of that name sits almost astride of the ancient ridgeway between Barrowford and Roughlee from whence a number of tracks diverge. The nearby farms of **Fulshaw Head** and Higher and Lower Fulshaw could well take their name from the same root as we saw in Foulridge, alternatively the name might mean *a densely wooded area.* A number of other farmsteads are clustered around this area, these include Pasture Gate, Pasture and West Pasture Farms (probably named when the new land holdings came into being in the sixteenth century), Higher and Lower Ridge Farms, Dole House and Spittlefield Head.

* **Rimington,** as we have seen, is an example of a village on the boundary *(rim-ing-tun),* the village covers a relatively large area and includes the small hamlets of **Newby, Middop, Martin Top** and **Howgill.** Newby and Howgill in particular have retained their hamlet status, the latter had a cornmill the revenue from which went to the Lister family for a number of years. The name of How-gill could well originate in the **N** *how* for *hill* and the **OE** *gile* or **N** *gille* therefore meaning *the ravine on the hillside* but there is also the consideration that the **OE** word *hæwen* means *purple* and might have described the heather-covered moorland of the area. Whitaker leaves us with the description: *"Midhope is a township of 1,161 acres, the manor is one of the most extensive and valuable grazing farms in Craven, the name is from Med- hope meaning the meadow on the hill"* The people of Middop who rated a mention in Domesday were: *Arnketil; Beornwulf; Ber; Ealdraed; Everard the man of William de Percy; Gamal; Gamal Barn; Godfrey; Grim; Hrosskell; Leodwine; Ramkel; Thorbiorn; Thorkil; Ulf; Ulfkil; Wigbeorht; William, knight and Wulfwine.* The original property of **Middop Hall** (right) was

owned by the Listers and dates from c.1600, the adjacent farm buildings date from around the middle of the nineteenth century and the fabric of the buildings contain stones from Sawley Abbey.

* Also in this area is **Gazegill** on which subject Whitaker said: *"Gasegill is a village where the hospitallers of Saint John of Jerusalem once held lands at an early period as they did in many other parts of Craven."* The name of Gazegill probably originates in the **OE** *gaesne* which describes barren or sterile land.

* **Roughlee** has the **OE** *ruh + leah, ruh* gives the same meaning as the modern description of *rough* and therefore we have *the rough clearing*. The addition of Booth (**ON** *buð*) suggests a clearing within the Forest of Pendle. Given as Rughley in 1296 the village stands on the river variously known here as Ogden Brook and Roughlee Water. The village probably shares its name-origin with the old settlement of Rowley on the outskirts of Burnley.

* **Sabden** has the **OE** elements *saeppa + denu* meaning *the valley where the fir trees grow*. Given as Sapeden in 1140 the village stands in the valley of Sabden Brook.

* **Samlesbury** is somewhat difficult but appears to contain the **OE** *sceamol + es + burh* giving *settlement* or *enclosure on a shelf of land*. On our western flanks, the lands beyond Samlesbury would have been influenced by the kingdom of Cumbria whilst the lands to the east of the Pennines were influenced by the Yorkshire kingdoms, later to become Northumbria within the *Danelaw*. The areas of Burnley, Pendle and West Craven would, therefore, possibly have formed a strip of land between these two, both east-west and north-south, which would fall within the control of a minor Northumbrian king or prince.

* **Salterforth** was probably named for being on the east-west salt trading route and comes from the OE *salt* + the **ON** *erg + forth* possibly giving the meaning of a *salt storage building by the ford*.

* **Simonstone** can mean *the stone building belonging to Sigemund* from **OE** *Sigemund + - es* (possessive) + *stan* or alternatively we may have *Sigemund's stone*, perhaps a boundary marker.

* The nearby settlement of **Twiston** is located in the centre of a tongue of land between Ings Beck and a tributary stream. The name has the **OE** *twist (twixt) + tun* giving *boundary settlement*. Alternatively the **OE** word *twisla* means *on the river fork* and the **OE** *twisehtan* means *disagreement,* this latter meaning having a definite boundary connotation. Twiston was the most northerly township within the hundred of Blackburnshire and in the later Medieval period the village had both a water corn mill and a manor house.

* **West Close Booth** is the area around Higham, the name means *western enclosure* from the **OE** *west* + **OF** / **ME** *clos* to which the **ON** *buð* or *both* has been added, this latter element shows in the earliest form of the name as a vaccary.

* We have seen that the village of **Whalley,** (from *hwaell + leah* giving *clearing by the hill)* was thought to have been the site of a number of battles within the Saxon period. Unfortunately these do not seem to have been substantiated because of the difficulty in the modern

interpretation of the early chronicles in this area. It is safe to say that the church at Whalley was long established by the coming of the Normans, it is said that Paulinus set up a cross in the seventh century upon the site now occupied by the Whalley Church and the Cistercian Abbey ruins.

The Abbey at Whalley, established in the fourteenth century when the Abbey of Stanlaw was transferred here, would become the seat of ecclesiastical power within our area - the powerful Abbots of Whalley had charge of the vast areas of forest and villages that would become the parish of Whalley. Through their network of parish churches, and the priests who ran them, the Abbey expanded, this meant that the number of vaccary glebe farms increased and therefore the tithes due to the Abbey increased. Running parallel with this expansion was the growing wealth amongst certain people, clothiers and farmers for example, who were happy to donate lands to the churches and the Abbey in exchange for a guarantee on the safe repose of their souls.

* The name of **Winewall is** commonly thought to be from the **OE** *Wina* + *wella* meaning *Wina's stream* and could have referred to Trawden Water running through the site - the name of **Trawden** is usually given the meaning of *trough valley* and could be later than Winewall. David Mills, a professional philologist, has suggested that the first element in the name of Winewall would be pronounced *win*, rather than *wine*, and therefore the **C** word *winn* (*white, fair, holy*) would be appropriate, this would provide us with the equivalent name to *Whitewalls* - this occurs in sites at Swinden (near Colne) and on the Boulsworth moors.

It is of interest that nearby Emmott was also known for its holy well. Yet again we see in Winewall an alternative in the etymology whereby the **OE** wine means *friend* or *protector* and *wall* is from the **OE** *weall* meaning *wall, dyke, earthwork, rampart* or *enclosure* providing a description of *'the protected enclosure.'* In a mid-nineteenth century paper on the Battle of Brunanburh the Burnley historian, T. T. Wilkinson, stated that Winewall meant *'the place of contention,'* presumably he based this finding on the derivation of *winn* from the **OE** *wine*, *winn* meaning *hardship, conflict* or *war*. We have seen that the Mercian king, Penda, fought a great battle at a place called Winwaed in AD655 and it is tempting to compare this name with that of Winewall. However, the second element within the name of *winwaed* does not resemble the second element in Winewall - *waed* means *shallows* (of a river) or *ford*.

* **Wiswell,** a small village near Whalley, means *the marshy stream* from the **OE** *wise* + *wella*. Given as Wisewell in 1207, the later form of Wiswall has the *a* instead of *e* in the second element, this probably denotes Mercian, or southern Saxon, influence.

* **Wycoller** also appears to be an **OE** compound word where *wic* has been conjoined with *alr* giving a rough meaning of *the dairy farm by the alder trees*.

Figure 13 illustrates the distribution of a small percentage of the pre-Norman place-names within our area. From Pendle Hill at the centre the radius to the outside is approximately 9.5 miles, the area as a whole covers some 289 square miles. Taking only the Anglo-Saxon names of *tun, ham, worth* and *ing* it is interesting to note that twice the number of sites fall within the inner area of 132 square miles than in the larger, outer areas. This inner area, at a radius of 6½ miles from Pendle Hill, contains a similar number of each of the *ing, tun, den* and *ham* names, the close pattern of settlement here suggests that the lands around Pendle were particularly favoured by the English.

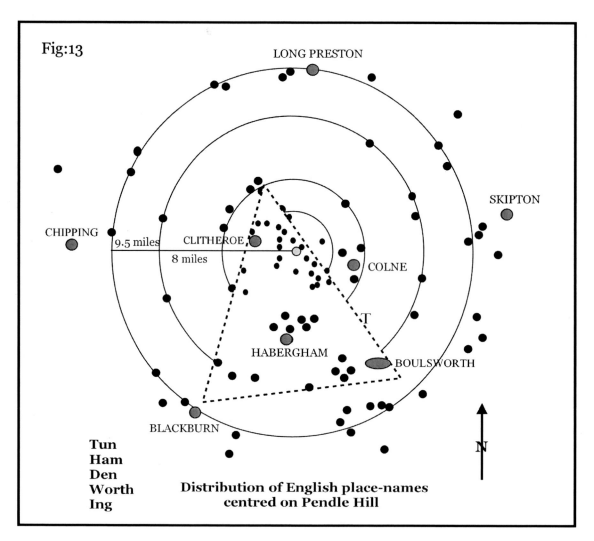

Fig:13

LONG PRESTON

SKIPTON

CHIPPING

9.5 miles
CLITHEROE
8 miles

COLNE

T

HABERGHAM

BOULSWORTH

BLACKBURN

Tun
Ham
Den
Worth **Distribution of English place-names**
Ing **centred on Pendle Hill**

N

All of the place-names can be seen to form clusters to some degree, the area within the triangle **T** can be seen to contain a particularly high number of all the name examples, excepting *worth,* the few examples of this name are scattered around the moorland periphery of the area. It is also of interest to note that a high percentage of the places shown tend to fall at a regular distance from the centre, in this case at 5, 6½, 8 and 9½ miles distant from Pendle Hill. It must be said that some of the place-names shown in Fig:13 are related to minor names and not those of the major townships; this does, however, illustrate a settlement pattern of sorts. Field and river names etc, show an extended landscape usage whereby a field carrying a Saxon name can lie at some distance to the village with which it was once associated. At a later period that field might have become part of the lands connected to another village with a Norse (or modern) name but kept the original Saxon nomenclature, identification of this type of site provides evidence for an earlier settlement at an apparently later site.

In his *History of Burnley (Volume 1)* W. Bennett has this to say on the subject: *"The English settlers, being essentially farmers, naturally took over the most fertile land that was available; this is to be found in the valleys of the rivers and the lower parts of the tributary streams. Walton, Samlesbury, Balderston, Osbalderstone, Clayton- le- Dale, Salesbury and Billington are, therefore, probably amongst the earliest English settlements in the Ribble Valley; possibly Altham and Padiham ought to be included among them. Later settlers necessarily had to take over land which was less fertile and situated in the more elevated parts on the upper reaches of the rivers and streams. One may, therefore, assume that Burnley, Marsden, Briercliffe, Extwistle, Worsthorne and Cliviger were taken over by the English many years after the first conquest of the Lancashire Britons 617-633 AD."*

"Place-names give the same impression. It is the present-day view that places with names ending in tun, ham *or* bury *are amongst the earliest colonised by the English, though there are many exceptions. Now in 1332, out of nineteen townships that existed in the Parish of Blackburn (south of the Ribble and on both sides of Darwen), nine, or almost half of them, ended in* ton; *at the same date in the Parish of Whalley (mostly fell country on the upper Ribble and Calder) only six out of twenty- seven townships, less than a quarter, had names ending in* ton. *On this evidence it is probable that townships in the Parish of Whalley, which include Burnley and district, are much later in origin than those in Blackburn Parish. Moreover, it was common, though not an invariable custom, for the earliest villages to be named after a chieftain or head of a family, while later names usually reflected some natural feature. Almost every place in the Burnley area has a name which explains its position and natural character; ravine, hill, marsh, rough land etc."*

Other elements used within the dating of Anglo-Saxon place-names are *burh, halh* and *hyrst*. The element of *burh* is commonly given as *burgh* or *borough* and *byrig* which is the modern *bury*. There is the root of the modern *borough* here as the Germanic *burgs* are *shelters, areas of protection. Burh* has the connotation of *'fortified place.'*

Halh takes two forms, firstly *haulgh* which can be seen in the *hal* of *Halsall* or the *haugh* in *Haughton*. Secondly it is seen as a second element in -*all* as in *Little Ethersall* (Marsden) or *halgh* as in *Mustyhalgh* (Briercliffe). The -*all* suffix is taken to mean *a piece of low-lying land by a river* in Lancashire, such as *Wackersall* on the outskirts of Colne. The OE word *hyrst* is the Germanic *hurst* and possibly relates to the Welsh *prys* for *brushwood*. The name appears to have a variance of meanings within a strict woodland sense, *copse* or *wooded hill* being amongst the most common. We have examples in Grindlestonehurst, Stoneyhurst and Hurst Green. We do not have a great number of any of these place-name elements within our area so for the sake of clarity they are not included any of them on the plan of Fig:13.

Chapter Ten

The New Saxon Border

By the early tenth century the coalition of Danes and Hiberno-Norwegians had been established across the northern lands from Dublin to York, this posed an obvious threat to the southern kingdom of Wessex. In response to this the north-western borders of the kingdom of Mercia, initially along the Mersey, were fortified by a number of places known as *burhs*. These were often earthwork mounds with fortified areas within the mound enclosure and some would eventually form the focus of the *burghs*, or boroughs.

The *burghs* of Mercia were formalised in the period 917 to 937 under Edward and Athelstan. The reason for this organisation becomes clear when one considers that the Danes were a constant threat and that each of the one-hundred and twenty hides of a borough could potentially supply one armed man for defence of the kingdom. The *Burghal Hidage* was a Saxon document listing the allocations of rural hides to each of the defended *burghs* in England, outside of the Danelaw, and from this we see the calculation that it took four armed men to defend a pole (5.5 yards) of *burgh* (i.e. town or city) wall.

It was the duty of each estate owner to ensure that his vassals fulfilled their obligation to the *burgh*. The supply of armed men by the estate owners could be commuted to supply of labour or materials for the building or maintenance of *burgh* defences or bridges, the latter of which were constructed to prevent longships from penetrating up the rivers and to provide crossing places. In addition to formalising the supply of men to defend the *burgh*, the county system also assisted in the administration of tax gathering.

Eventually, by the year 919, the main line of *burghs* ran from Rhuddlan and Chester along the Mersey and inland to the area described as 'Manchester in Northumbria.' The next part of the Saxon plan was to gain control of the Norse bases around the Ribble estuary, it is apparent that a number of small defensive sites were situated along the length of the Ribble (Fig:13). The later Norman motte-and-bailey castles within the north-west were often built to take advantage of pre-existing mounds as these tended to be placed at strategic points, the castle at Clitheroe could be an example of this.

Surprisingly few minor castle sites have been properly excavated, some of these will undoubtedly be discovered to have been masonry castles if they ever were to be investigated whilst others will be found to never have been castles at all. Equally many earthworks now considered to be tumuli and mill mounds could be discovered to have been castles. Many prehistoric tumuli were re-used as mottes and watch towers, by no means all of these will have been identified as such. Many smaller mottes were quite low mounds and could have readily been converted and modified into fashionable square, moated manor houses in the thirteenth and fourteenth centuries. How many such moated manors started out as mottes may never been known.

The area of south Lancashire became annexed to the Wessex kingdom, most probably by either Edward the Elder or his son, Athelstan. A charter of York stated that the lordship of Amounderness (this would eventually become 'Lancashire over the sands') was actually purchased from the Norsemen *"at no little cost"* and reinstated to the English kingdom.

Around 920 Edward the Elder came north on a royal progression, he received the submissions of the king of Strathclyde, the Scottish king and the Northumbrian rulers *"both English and Danish, Norsemen and others."* Having taken the northern kingdoms into English control the House of Wessex was careful not to alienate these strongly independent areas, leaders were chosen

who would retain both political respect and the confidence of the established church; arranged marriages between daughters of the royal family and the established northern noblemen showed a high level of diplomacy on the part of the English ruler. At this time the area that would become Lancashire was made up of multi-centre estates, hundreds (an area of one hundred hides) and lordships. The hundred system was an internal division of the larger shire and, by the tenth century, the hundreds had become a standardised administration unit.

The name *shire* would eventually apply to most of the counties within England but it had a very specific use within Saxon times. The word originates in the OE *scîr* and, in the tenth and eleventh centuries, was applied to territorial units dependent upon a *burh* and also for the administrative hundreds. In earlier periods of English rule shire appears to have been used in relation to smaller units of administration such as Cravenshire. In our area there are few (surviving) examples of shire place-names: Denise Kenyon (*The Origins of Lancashire*) suggests that Wilpshire, at the centre of the parish of Blackburn, may have been an Anglo-British name ie, Celtic *Wilp* and OE *scîr,* and therefore may have been a pre-Saxon estate which passed into Saxon hands and was renamed.

Our particular area became the hundred of Blackburnshire and was described in the Domesday Book as a hundred within the region "*inter Ripam et Mersham*" (between the Ribble and Mersey). The *wapentake* of Blackburnshire, which appears in the royal records of the fourteenth century, was larger than the Domesday hundred, for while the latter was wholly south of the Ribble, the former included an additional group of townships north of the river. These vills had been counted as part of Amounderness in the Domesday Book, but by about 1100 they were granted to the lord of the honor of Clitheroe, who added them to the Domesday hundred of Blackburn which he already held – according to the *Lancashire Pipe Rolls and Early Charters* (W.Farrer) the vills added to the hundred were: Ribchester, Thornley, Wheatley, Dutton, Aighton, Bailey and Chaigley. It was this larger unit, or private hundred, which the Medieval kings accepted later as the *wapentake* of Blackburn when making their assessments for *scutage* (taxation).

Blackburnshire is actually a hundred comprised of two large parishes ie, the forty-five townships within the parish of Whalley and the twenty-four within the parish of Blackburn. Generally speaking the lands within Whalley parish lie between the Ribble and Calder and form upland areas whereas the Blackburn lands tend to be located more within the valley bottoms. Combined, these two parishes form an area encompassing a large chunk of the east-west Ribble/Aire corridor, the importance of this throughout history cannot be understated as the existence of the hill forts at Castercliffe and Portfield (and the postulated defensive camps at Middop and Barrowford Water Meetings) bear witness.

Colne was shown in the tenth century as having been assessed, along with the vill of *Altencotes*, as having two carucates of land and the nearby village of Foulridge was assessed on one carucate. Land measure vary from area to area and period to period but a rough estimate as to the extent of a carucate of land would be one hundred and twenty acres. Following the Norman Conquest almost the entire area of the hundred of Blackburnshire was granted to the Norman lord, Roger de Poitou and our area, the honor of Clitheroe, stretched from Foulridge to Accrington and from Cliviger to Chatburn.

* * * * * * *

Fortifications

The accepted modern reference work for the study of castles in Britain is D. J. C. King's *Castellarium Anglicanum* (1983) in which he lists seven extant earthwork castles within Lancashire, most of which fell between the Kent and the Lune – these are Arkholme, Castle Haugh (Gisburn), Halton, Hornby (Castlestede), Melling, Penwortham and Whittington. He also lists two vanished examples at Preston (Tulketh) and Mourhall (Warton) plus a possible one at Borwick. Some consideration must be made here, however, as King's sites are assessed largely on their military capability, those sites thought to have fulfilled a purely administration role tend not to be listed. In a 1991 paper, M. C. Higham made a strong case for a castle site at Borwick and also lists three more sites in Dolphinholme, Ellenthorpe (Gisburn) and Whitewell. He also favours the argument that the masonry castles at Clitheroe and Lancaster were based upon earlier (pre-Norman) earthwork defences.

The first earthwork castles are generally said to be of Norman origin but the lack of written evidence for the early part of this period leaves this open to speculation; as we have seen above, the existence of a Saxon *burh* mound at a strategically important spot would have seen it being incorporated into the later Norman defences. From the middle of the twelfth century the earthwork castles were being abandoned, only the few on important sites were converted to masonry structures, these were prestige sites to be used for the administration of a specific area. Examples here are Lancaster Castle, possibly initiated by David 1st of Scotland, and Clitheroe Castle, built by the de Lacy family and attested in 1186, although earlier records of 1102 and 1123-1124 suggest an earlier earthwork on the site.

Castle Haugh on the outskirts of Gisburn is an excellent example of an early castle site

A group of earthwork castles can be found on the lower regions of the River Lune whilst the Ribble has a small grouping around Preston and others are distributed towards its upper reaches at Clitheroe, Gisburn and Settle. Along with the important motte defences there are also a number of minor defended sites such as moated manor houses, fortified manors and pele towers. Whilst it is not suggested that these were actually built to counter the Norse threat along the Northumbrian border, these sites commonly occupy older strategic/defended sites and therefore show a continuity of purpose.

It has been suggested that all of these sites were the military answer to incursions by the Irish

126

and Scots and Higham noted that the mottes on the Lune *"Might well indicate the real frontier zone at the time of Domesday"*. A counter argument has it that these sites were more likely to have been placed so as to exercise an administrative role within feudal secular societies. This latter explanation holds true for the later post-Norman period as the overlords placed mottes in strategic positions so as to oversee the running of their estates, however, this does not explain the fact that many motte sites are related to archaeological sites found to have a much earlier context.

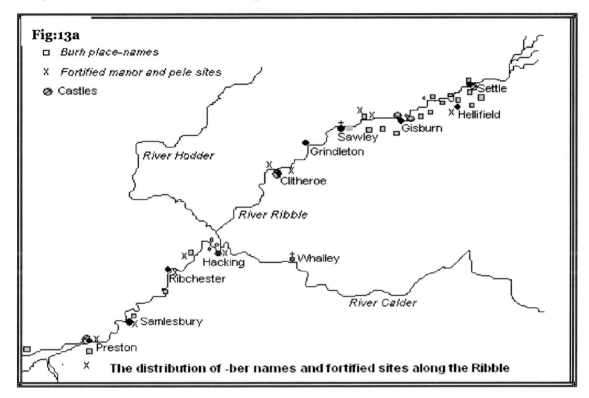

Fig:13a

☐ *Burh place-names*

✗ *Fortified manor and pele sites*

⊘ Castles

The distribution of -ber names and fortified sites along the Ribble

Further to this, it may be of value to look at related types of the *burh* name in sites located along the length of the Ribble – the boundary that would become the northern and western edge of the kingdom of Mercia. Taking names ending in the element *-ber* it is interesting to note that a number of these are distributed along the Ribble (Fig:13a) but the vast majority appear to be located within a specific area of Craven (Fig:14). Most of these minor sites will probably relate to the possessive *-ber/-berg* name, usually applied to hills and hill enclosures and will never have been related to formal fortifications. Examples of this name-element fall into two categories, the minor sites within a village or township (fields or other small features in the landscape) that do not appear on any OS maps and the slightly more important sites that are shown on the map, these are largely major features such as hills and streams. Taking note of the *-ber* names scattered along the Ribble shows that they could be a consequence of English settlers taking over the river valley lands as they spread along the waterway. It can be seen, however, that as these names are also heavily distributed along certain lines within the old shire of Craven they are not limited to lowland areas alone.

The Ribble

Where Ribble from her springs,
An alien known to be,
And, from the mountains rude
Of Yorkshire getting strength,
Here boldly dares intrude

The inter-County rivalry between Yorkshire and Lancashire is evident within the above lines but the Ribble is a shared entity whether we like it or not! The River Ribble springs to life (appropriately enough) at Ribble Head in the wapentake of Ewcross, an area to the north of Settle, between the Dales villages of Ingleton and Hawes. A number of small tributary streams drain the Langstrothdale moors here and feed into the waterway that, by the time it tumbles beneath the bridge at Horton-in-Ribblesdale, is changing from a tumbling moorland beck to the more serious waterway it will soon become. The river then crashes over the limestone bed of Stainforth Foss, passes the old papermill at Langcliffe and flows by the site of the old snuff mill into the town of Settle. It is here at Settle that we meet with the first of the *ber* related names. Castleburgh Hill is an impressive limestone crag that dominates the town and would have had an obvious purpose of fortification and control over the area. Nearby the splendidly Arthurian name of Scaleber applies to a stream running to the west of the town and draining into the Ribble via Long Preston Beck.

Carrying along its south-westerly heading the Ribble passes the village of Long Preston (*'the further settlement of the priests'*) and here are two minor *ber* names in the areas known as Thornber and Cowber. The river then passes to the west of Goosemere Height which is a short stroll from the ruin of the Hellifield Pele Tower, this in turn is near to an ancient earthwork at Kelber, by the A65 road. A short distance to the south there is an ancient earthwork on Swinden Moor and a tumulus overlooks the river below the small settlement of Halton West. Nearby we find other *ber* names in Hayber, Cobers Laithe and Greenbers Plantation, these are within the area known as Nappa which possibly has its origin in the Norwegian word *nappe = to catch* relating to fishing the river or alternatively the OE word *cnæpp* means *top* or *summit*. Nappa was the site of an important ford over the Ribble where three river islands were connected by stepping stones.

The next site of interest is slightly to the north of Gisburn where a fascinating example of a motte mound can be found at Castle Haugh (SD 830507). The six metre high mound has a ditch around two metres in depth and a raised ring-work bank around the top, the western edge of this bank has collapsed down the forty metre sheer drop into the Ribble below. A large unworked upright stone stands on the eastern outer bank of the castle ditch and appears to have formed part of the entrance-way, the outer edge of the ditch has been heavily reinforced with large stones at some time, this length of boundary forms part of an early ditch-and-walled bank boundary still to be seen in the field.

Whitaker says on the subject: *"Castle Haugh is generally, and I think rightly, understood to be of Danish origin - Giants Hill in Leeds was another specimen of the same kind, with steep banks down into the River Aire."*

An extant bridleway runs by the castle, this is the remnant of an ancient trackway that served the site and runs south towards Gisburn where it took a course straight through the tumulus mound of nearby Little Painley, descended to cross the Stock Beck and then headed due south to meet with Coal Pit Lane at Bomber Camp, on the lower slopes of Weets Hill – we saw in an earlier

chapter that this was a main route into Lancashire. From the castle site the bridleway also runs north-east down into the valley where it once crossed the Ribble at Paythorne Bridge, at this point the name of the road, as it crosses the modern bridge, is Neps Lane and this can be seen to have been the route of the ancient track. *Neps* is a Medieval name for the herb *catnip* which might describe the prominent vegetation that grew here at that time.

Before the river leaves Gisburn behind there is a site on the north bank known as Ellenthorpe. Here there is an 'abraded' motte mound situated above the river crossing, it is thought that this was originally a castle of timber construction. The name of Ellenthorpe is open to interpretation (as indeed most place-names are), suggestions are that it means the *hamlet of Aelfwynn* or the *hamlet of Ayling*. It is interesting to note that a noblewoman named Aethelflaed was responsible for the governing of Mercia before 911, she was the daughter of Alfred the Great and Ealhswith and sister of Edward the Elder, she went on to marry ealdorman Aethelred of the Mercians and this led to her becoming known as *Moinas Myrcna Hlaford* or *'Lady of the Mercians.'* Aethelflaed joined Edward in the construction of the line of forts, or *burhs,* stretching from the Mersey to Essex and the Mersey to Manchester and beyond. She built the forts at Chester in 907, Eddisbury in 914 and Runcorn in 915 and went on to rule Mercia for seven years following the death of her husband. She dominated the political scene in the Midlands and the North, her military operations are recorded in a surviving fragment of a lost Mercian Chronicle known as *The Mercian Register.* Aethelflaed had a daughter by the name of Aelfwyn who, through marriage, came to rule our area of northern Mercia for some eighteen months until Edgar removed her to Wessex.

Shown in Domesday as *Elwinetorp* and *Halwidetorp* the hamlet of Ellenthorpe was associated with the following people: *Arnketil; Beornwulf; Ber; Ealdraed; Everard the man of William de Percy; Gamal; Gamal Barn; Godfrey; Grim; Hrosskell and Leodwine.*

In 1086 the settlements of Gisburn, Barnoldswick, Horton and Ellenthorpe are all related to a man known as Earnwine and also a priest called Earnwine – did Earnwine become corrupted to Ellen? There is a suggestion of royalty within the name of *ayling* as the name originates in the OE *aedeling = prince* which derives from OE *aedel = noble,* although the possible origin of Ellenthorpe within *Aelfwyn–thorpe* appears to be more plausible than that of *Ayling–thorpe.* The fact that Aelfwyn and her family were so closely connected with the erection of *burhs* raises the question as to whether the Ellenthorpe site may have been related.

An extended area to the north and west of Gisburn shows a number of *Ellin* minor names but the *thorpe* element is particularly interesting. Medieval records show an Ellenthorpe within the manor of Barnoldswick although the location of this has now been lost, as were two more examples of the name in the west-coastal areas of Melling and Bretherton. Where the *thorpe* place-name is compounded (as in Ellen–thorpe) we might be seeing an example of the OE *þorp, þrop* and therefore Ellenthorpe would be an English settlement. The west-coast examples of the *thorpe* name are uncompounded and here we should look rather to the ON *þorp* or ODan *thorp.* The Scandinavian *thorpe* cannot be regarded as a safe Danish test-word, but it is true that in England it was commonly used by the Danes and seldom used by the Norwegians. The rarity of *thorpe* in north-west of England, indeed, is usually considered to be a sign that Danish influence here was slight. The compounded *thorpe* was often used to describe a secondary settlement site and, in the case of Ellenthorpe, it can be seen that the small settlement of Ellenthorpe Grange, and the castle motte here, fall on the edge of the vill of Gisburn. If the element of *thorpe* does indeed have a root in the OE then the secondary element of *ellen* may also be English. This leaves us with the OE prefixes of *ele,* meaning *foreign* or *strange,* the OE *ean* is *'bring forth (young)'* or

alternatively *ellen* meaning *strength* or *courage* - the conclusion here would be that a Saxon *Ellenthorpe* meant either *Ellenthorpe* = 'settlement of the strong' or *Ele–ean-thorpe* = 'settlement of the foreigners.' Both of these descriptions can be seen to be particularly apt in the case of a fortified site where troops from outside the area would have manned the defences.

Having left Gisburn behind, the Ribble flows by the site of the fortified manor house of Bolton Hall, the former home of the Pudsey family of Bolton-by-Bowland. On the river bank here is Rainsber Wood, this is shown on early maps as *Rainsborough,* again we have the *burgh* element of an administrative area, in this case centred on a manor site. Here also, on a tributary stream below the old Bolton Mill, is the Bolton Pele. A little further along is the village of Sawley where we find a farm site once related to Sawley Abbey called Dockber, this is from the OE meaning of *hut enclosure*. It is known that the Percy family erected huts for the monks to live in when they arrived to build Sawley Abbey, perhaps Dockber is where the huts were situated.

The Ribble winds its way around Sawley village, with its Abbey now in ruins, before skirting the village of Grindleton, this was once the manor of earl Tostig before becoming the centre of a multi-settlement estate within the Craven land holding of Roger de Poitou. Heading towards Clitheroe the river passes Tower Hill and the extant masonry castle keep in the town centre.

A short distance to the north-west of Whalley is the ancient site of Hacking Hall, here can be found an extant Saxon building that is one of the oldest structures within Lancashire. On the opposite bank of the river, within an exaggerated loop, are three ancient mounds, the early OS maps show these as a *tumulus* and two *lowes,* also shown nearby is an ancient stone cross. The fact that this spot is where the Rivers Hodder and Calder flow into the Ribble would have marked it out as an important site to our ancient forebears. A short distance downstream, at Hurst Green, is a site shown on modern maps as Lambing Clough but marked on the early OS maps as Lamburgh Clough, this small settlement also has a moated site by the name of Bailey Farm. Further down river we reach Samlesbury, the second element of *bury* suggests a defensive nature, this could relate to the superb extant ancient manor house of Samlesbury Hall. The Ribble then reaches Preston and Penwortham with its remains of a motte mound, this is the final port-of-call for the Ribble before flowing into the Irish Sea at Hesketh Sands.

Examples within Craven

By the eighth century the country had been largely divided into large estates, or lordships, within which were smaller settlements, each of them having a specific role to play within the wider context of the estate. These smaller estate elements might have been hamlets bonded to the overlord, free hamlets, hamlets under the control of the church and the king or outlying hamlets placed so as to exploit moorland and lowland areas. Small groups of estate workers would live near to valuable resources such as lead deposits, stone quarries and woodland and each would serve as a cog in the larger wheel of the central manor.

As we saw in a previous chapter, the word name element of *tun* was being used by the English to signify the status of a place within the larger estate, examples are Barton = *barley- tun*, Eccleston = *church- un* and Plumpton = *plum-tree (orchard) tun*. Regions with these types of place-name are likely to have been British estates taken over in their entirety by the Anglo-Saxons and are, therefore, a clue to the age of a particular settlement. In time these estates prospered and more specialised hamlets appeared, we have seen that the name element of *wic* is an example of this, Ekwall suggested a range of meanings for the name including trading, industry and dairy farming. *Cot* and *stoc* names also signified a type of small inter-estate settlement ie, the smallest possible division.

The eleventh century saw the breaking down of the prominent Saxon estates, this was to

accelerate following the Norman Conquest although the small estate elements aforementioned did, by-and-large, survive as independent social units.

Using the *burh* names within a small area of Craven as a framework (Fig:14) it should be possible to provide a rough illustration of social/estate unity. Bordering upon Northumbria, and bounded by the Ribble to the east, this area may or may not have been an independent region, however, there is much of interest here within the place-names. We have seen that *ber* sites are spread along the Ribble as if they had a definite relationship to boundary demarcation, the lesser distribution of this name element within other areas is noteworthy and might serve to confirm this.

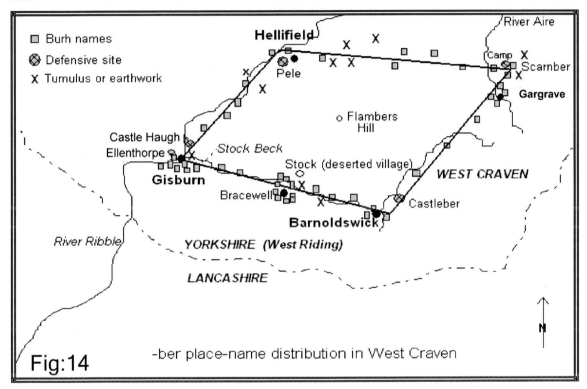

Fig:14 *The apparent boundary created by the incidence of ber names could be synonymous with the lands held by the Percy family within the Medieval period. Whitaker stated that: "The Percy fee in Craven stretched for at least twenty-five miles north to south embracing the whole of Ribblesdale and much of the valleys of the Aire and Wharf."*

From the tumulus at Little Painley in Gisburn, the easterly course of Stock Beck runs below the high ground of Rosber and Lickber hills and along to the ancient earthwork of Hawber before passing the deserted Medieval village of Stock and the nearby areas of Heber and Grazenber. Next comes the ancient earthwork site of Gilbeber Hill, then the Greenberfield and Loughber Hill areas of Barnoldswick. Heading northwards here, along Gill Syke to Carr Beck, we come to Castleber Hill and Langber. Still heading northwards the next *ber* name is that of Cobber Hill and, as we saw at Settle, an example of the Scaleber name. North of this we cross the River Aire at Gargrave, with its nearby Ingber site, then Ellinber (related to Ellenthorpe?) and Sourber on to the moors of

Scarnber. Heading east from here a rough alignment of names is apparent in Bonber, Kelber Wenningber, Enber, Linber and at Hellifield, Gallaber and Cowber.

Heading south, back to our starting point of Gisburn, we have already seen the distribution of sites associated with this stretch of the river. The Gisburn area is particularly rich in *ber* sites, marked on the modern map are Todber, Bomber and Gawber. Not marked on any map other than those applying to the Ribblesdale Estate are the field names of Millnber, Kirkber, Thornber, Withber, Gallegheber, Skeatber, Wyber and Moorber. Most of the meanings of the first elements here are clear excepting, perhaps, that of Skeatber and Gallegheber - the former is likely to relate to the Norse word *skeat* meaning *to shoot,* there was a butts field in Gisburn, possibly set aside for the compulsory practise of archery although this name can also signify a place *'at the end of.'* The *skeatber* or *skeat-enclosure* could be on the same site as butts whilst Gallegheber, in the Westby area to the south of Gisburn, has the Celtic element *galeg.* The surname Gallagher means *'the foreign helper'* and *heber* is from *hæf* meaning *sea/ocean* suggesting that Gallagheber could be a reference to *'the foreign helpers from overseas.'* Exactly who these foreigners might have been is anyone's guess, the Celts would regard the Anglo-Saxons as being foreigners from overseas as would the Saxons view the Scandinavians.

Taking the apparent boundary formed by the *ber* sites above, the resultant 'enclosed' area covers roughly sixty square miles of mixed lowland and moorland. Using the principal of estate association where the *tun, cot* and *wic* name elements occur it is possible to form an idea of the structure of this area. In this context the *tun* element is taken to be a farmstead, small settlement or (more rarely) manor, as opposed to the major *tun* names within *-town.*

- Beginning along the northern bounds of the region we find the names **Hellifield** = OE *hel, helle* for *'burial place area,'* significantly a number of burial mounds dot this area within the north-eastern corner of the region.

- **Coniston** = OE Cyning's tun for the king's manor, or possibly from ME/OF *conis* for *rabbit.* **Scarnber** = OE *dung hill* or perhaps some derivative like *brown.* Passing swiftly on from this we come to **Eshton** = OE *'the ash tree tun,'* possibly referring to the management of woodland - alternatively the Danish word *aeske (ash/esh/axe)* means *enquiry.* The term *"axe a question"* is still used today in country areas.

- **Gargrave** = *Gara's grove* or OE *goare for scarred/damaged grove.* The River Aire passing through the village has a Celtic name in *strong river.*

- **Winterley** = OE *aentre-ley* or *winter clearing,* this may refer to an area of land to be used for stock in the winter months, the Anglo-Saxons passed or measured their years in winters hence the name for a two-year old cow would be a *twinter* (two-winters old).

- **Stainton Cotes** = OE *stane, stan tun* for *stone getting* or *'stoney area within the manor.'* The cotes element could signify an outlying estate unit dedicated to winning stone for the manor.

- **Horton** and Horton Hall = OE *hoare- ton* meaning *'old, long established settlement.'* Domesday shows the folowing at Horton: *Alcolm; Almund; Arnbrandr; Arnketil; Beornwulf; Berengar de Tosny; Bo; Clibert; Earl Tosti; Earnwine; Earnwine the priest; Erneis de ...Ealdraed; Everard the man of William de Percy; Gamal; Gamal Barn; Godfrey; Grim; Hrosskell and Leodwine.*

- **East and West Marton**, within the larger area of Martons Both, fall on the eastern boundary of the 'enclosed' region and the name of Marton can be seen in either the OE *merran-tun* for *waste area* or OE *maerc, merc, mere-tun* meaning '*settlement on the boundary*' or '*settlement of the boundary marker*' or OE *mere- tun* for *settlement by the pool.*

- Close by Marton the village of **Thornton-in-Craven** also lies on the boundary area and the name probably relates to the '*thorn-tree settlement,*' again we have a boundary reference as the thorn, particularly a solitary thorn, has been an important method of boundary marking throughout the ages.

- **Gledstone** = OE *glaed-tun* meaning *bright* and often referring to *a clearing within woodland* - also the name could possibly relate to *the bright stone.*

- **Stainton Hall** could also have the OE *stane* for stone whilst the *cotes* element would place the site as a specific unit within the larger manor estate.

- In **Newton** we have the description of a later settlement whilst at Gargrave there is the **Milton** name, this would show a mill area and **Brighton** is the bridge area.

- On the outskirts of Gisburn, to the west of the Long Preston road, can be found the name of **Ebor,** this may be the British word *eburos* meaning *yew tree* or '*the sacred yew grove,*' the OE word *eofor* meaning *wild boar* could just as easily apply.

Craven

The boundaries of Cravenshire have been in a continual state of flux, ebbing backward and forward since the first colonists arrived in the area. The name of Craven shows the old British roots of the area, probably from when the Brigantians inhabited this part of the world. The Welsh word *craf* means *wild garlic* and this plant still grows freely here, an excellent example is where the road from Gisburn to Bolton-by-Bowland drops down to the Ribble at Mill Bridge, the smell from the mass of wild garlic growing here in summer is quite overpowering. The present Craven boundary does not actually include the village of Gisburn or the town of Barnoldswick, the West Craven boundary having moved northwards within recent times. For the purpose of this exercise, however, both of these settlements will be regarded as being within the old south-west limits of Cravenshire.

Following the Norman invasion of 1066 William the First appointed Gospatric as Earl of Northumberland, Gospatric led the northern nobles in a revolt against King William and as a result of this, in1069, the King laid waste to the north-east of England. Gospatric was ousted as earl of Northumberland in 1072 and was given the Scottish lands of Dunbar by the king of Scotland. The '*Harrying of the North,*' as William's revenge became known, was singularly unpleasant, whole regions had their villages, cattle and crops destroyed, it is not known how far this violence spread into the Lancashire area but the consequences were felt within the Craven district. More trouble was in store following the death of King Henry of England in 1135. In the year 1138 William Fitz Duncan, the Great Great Grandson of Gospatric, earl of Northumberland, fighting on behalf of his uncle, David (king of Scotland), was at the head of an expedition which marched through the inherited Cumbrian lands of both himself and his wife. The march led to Craven in Yorkshire, then in possession of the English and was described by a contemporary scribe, Richard of Hexham:

"They ravaged Craven with sword and fire, sparing no rank, no age, no condition, and neither sex. They first slew children and kindred in the sight of their relations, lords in the sight of their serfs and the opposite, and husbands in the sight of their wives; then oh, most shameful! They led away noble matrons, chaste virgins, mixed alike with other women, and the booty, driving before them naked, in troops, tied and coupled with ropes and thongs, tormenting them with their lances and pikes. This had been done previously, but never to such an outrageous extent."

As a result of this violent incursion, king Stephen of England ceded Cumberland, Westmoreland and part of Northumberland to Scotland.

Gisburn

The village of Gisburn played a major role within the development of our area, in the parish of Gisburn lived a number of influential families who owned vast tracts of land and, therefore, controlled the lives of a great number of people. Langdale's *Topographical Dictionary of Yorkshire* gives the following information on the area as it stood in 1822:

"The (Gisburn) township is in Clitheroe district with some 2,028 acres, the parish contains the townships of Middop, Rimington, Horton, Newsholme, Paythorne, and Gisburn Forest in the Clitheroe district, and the townships of Swinden and Nappa in Settle district."

"Gisburn was an Ancient Parish in the counties of Yorkshire (Ancient), Lancashire (Poor Law Registration) and West Riding (Administrative), in England. It was part of Clitheroe Registration District; West Riding; In the western Staincliffe and Ewcross Wapentake; In the Clitheroe Rural Sanitary District and the Bowland Rural District."

Langdale's places within Gisburn Parish:

Cowgill - Nappa - Nappa Flatts - Newby - Newsholme - Owlshaw - Paa - Painley - Paradise - Paythorne - Rimington - Stirk House - Swinden - Todber - Tosside - Westby Hall - Wilcross Brow - Cracoe Hill - Ellenthorpe - Forest Becks - Gazegill - Gisburn Cotes - Gisburn Forest - Goosener Height - Grunsagill - Horton - Houghton Chapel - Howgill - Little Middop - Martin Top - Middop

The somewhat convoluted area of administration within which Gisburn fell illustrates its strategic importance at the crossing of ancient trade routes through our Pennine region, the topographical situation allowed for control of the Ribble and the through-routes between a series of kingdoms. The fact that two castle defences were thought to be necessary here speaks volumes. Both of these castle sites are extremely well placed, high above the Ribble, and on opposite banks of the river at a prominent S-bend - this would ensure that all movement up and down the river could have been effectively controlled. Not only was Gisburn placed on a highway route but the river would have provided a fast means of travel in the shallow-draught boats in use at the time; it is only too easy to underestimate today just how important the rivers were to our forebears. The obvious danger to the Saxons manning the Gisburn defences would have been water-borne Scandinavian invaders, heading north-east from the Ribble estuary, and their Danish counterparts heading south-west from the higher dales.

The Abbey at nearby Sawley was founded by William Percy II, son of Alan Percy the Great, on the sixth of January 1147-8, when Abbot Benedict with twelve monks and ten conversi came from

Newminster. In the foundation charter for Sawley Abbey William de Percy states that:

"He has given to God and the church of St. Mary, and to Benedict the abbot and the monks of the abbey of Mount St. Andrew, which he had built, Sawley and Dudelant and Helwinesthorp (Dudland and Ellenthorpe, both in Gisburn) and all their appurtenances, as well as a carucate of land in Rimington."

Forty years later a question arose as to whether the monks would have to abandon Sawley, owing to their inability to obtain the necessary sustenance from the land, *"the climate being so cloudy and wet that the crops rotted on the stalk."* William Percy, who according to the Account of Sawley was the great-grandson of the founder, granted his manor of Gisburn in Craven to the abbot and convent for the maintenance of six monks, who were to be priests in the abbey, and in 1313 his son Henry de Percy, considering their poverty, gave to the abbot and convent the church of St. Andrew of Gargrave. Its value had been fifty marks, but owing to the Scottish wars was, in 1320, only thirty marks.

In 1242 a *"deed of Kinge Henrye sonne of Kinge John"* granted:

"to the Abbot and Convent of Salley of the manor of Gisburn in Craven, which manor they had of the gift of William de Percy son of Henry de Percy - - - - witnesses were: William, Archbishop of York; Walter, Bishop of Carlisle; Peter, Bishop of Hereford; William of Cantilup, John son of Geoffrey, Bartram of Carlisle, Robert of Mustegros, Nicholas of Bosevill, Drogone [Drew] of Barent and Geoffrey of Langley."

In 1243 this was confirmed:
"Confirm to the Abbot and Convent of Salley (Sawley) the manor of Gisburn in Craven, with all men belonging, their services and other appurtenances, which manor they had by gift of William de Percy son of Henry de Percy"

Another deed, dated 1338, shows the Archbishop of York appropriating the parish church of Gisburn to the use of the Prioress and convent of the monastery of Stainfield in Lincloln. Because the monastery had suffered from flooding the patronage of Gisburn was to be granted to the nuns with revenues to be made available for the maintenance of the church. The Prioress and nuns were to provide books and vestments and were to pay the sum of two marks per annum to the Archbishop of York and one mark annually to the Dean. A 1404 lease relates to the rectory of Gisburn and lands there, part of the now-dissolved priory of Stainfield, which had passed from Thomas Lister (the younger) to Sir Arthur Darcy. Part of the agreement was that the Abbot and Convent of Sawley leased from the Prioress and Convent of Stainfield, for eighty-two years, the church of Gisburn and the lodging house of Rayhead in Gisburn Forest.

Gisburn Records

The mining of ores and coal was an important part of any estate and the rights were jealously guarded.

In 1745 Thomas Lister of Gisburn Park and Edward Marton of Lancaster leased to John Williams, a miner of Haslehaw in the parish of Mask, Yorkshire, and Richard Paul of Malham in the parish of Kirkby Malhamdale, miner:

"All mines and pits of lead and copper in Ewe Moor, Pikedale and Grazedales in the manor of West Mallham for twenty-one years, paying twenty shillings for every ton of copper mined, and also every tenth piece or pigg of lead mined."

An agreement was drawn up in 1753 between Thomas Lister of Gisburn Park, Danson Roundell of Marton, William Bulcock of Barcroft in Lancashire and John Cockshutt of Barnoldswick for the digging and smelting of lead ore and coal on their Barnoldswick properties.

The Clitheroe geological records mention that there was a lead mine at Todber, near to Westby Hall, and the above record suggests that there was at least one working lead mine in Barnoldswick. There are early records of silver mining at Twiston and the Skelhorn silver and lead mine at Rimington was worked commercially, possibly from Roman times until quite recently. In 1664 Thomas Airton contracted Christopher Brown of Gisburn to deliver thirteen hundredweight of lead from the Earl of Cork's smelting mill at Grassington.

The mining of coal at Gisburn is illustrated by records dated 1709 relating the landowner's intention *"to build a wall in Brogden from the quarry in the Coalpit Flat down to the River Ribble"* and the presence of Coal Pit Lane running through the area. The Lister family also owned a calamine mine in Malham, the product from this mine was ground to a powder and mixed with oil to form putty, or mastic, for the building trade.

Another record, from the manorial court at Gisburn, dates from 1342 and shows that Walter de Pathorn, Sir John de Clyderhou (chaplain) and William Balde granted out two messuages with buildings and gardens in the vill of Gisburn-in-Craven. This property was held of the prioress of Stainfield by the service of one pound of cumin per annum, eleven acres of cultivated land and four acres of meadow land in the hamlet of Westby *"lying in a cultivated place called Galeghebergh"*, which the grantor held of the Lord de Percy by the service of eighteen pence per annum, and as much *forinsec* service as was reasonable for such a tenement. In this case a dozen carucates of land constituted a knight's fee whereby the tenant paid in goods and service to the lord instead of being obligated to carry out military duty. The document was witnessed by Sir John Tempest, knight, John de Mydhopp, Alan de Horton, Henry de Boulton, Thomas del Grene, Antony de Mydhopp and Walter Mahaud.

The Lister Family

A name that is synonymous with the Gisburn area is that of Lister – the family was first mentioned at Gisburn in 1312 and eventually the title of Lord Ribblesdale applied to this branch of the family, a name that has long been connected with the village through the extensive Ribblesdale estates and Gisburn Park. A potted history of the family is that, in the early fourteenth century, a John Lister of West Derby married Isabel de Bolton who was the widow of Roger de Clitheroe. Isabel was the daughter and co-heiress of John de Bolton, of Bolton-by-Bowland and Middop, bowbearer of the Forest of Bowland and was descended from Leofric, king of Mercia and his wife, Lady Godiva of Coventry, who also had two sons, the youngest of whom was Hereward the Wake. The eldest son was Algar who succeeded Leofric to the throne. Clitheroe was part of Mercia at that time. Hereward became general of the English forces after 1066 and held out on the Isle of Ely.

The Listers of Gisburn, therefore, hold a direct kinship with the Mercian royal family and the coronet on top of their coat of arms is the heraldic emblem of this connection - this can be seen in

the Ribblesdale chapel in Gisburn parish church. The marriage of Isabel de Bolton and John Lister brought the areas of Middop, Rimington, Gisburn and Clitheroe into the Lister family. Adelaide Lister, sister of the fourth Baron Ribblesdale, was the last of the Gisburn Listers and died in 1943.

The seat of the Listers was originally at the fortified manor house of Arnoldsbiggin on the edge of Gisburn village but in 1520 Thomas Lister married Effamia de Westbye, of neighbouring Westby Hall, and this brought Westby into Lister hands. Arnoldsbiggin was demolished in the 1730s to provide stone for the refurbishment of the Lower Hall (Gisburn Park), this being the property to which the Lister family moved in the seventeenth century. The name of Arnoldsbiggin can be seen in the OE *aern* = *house* and *halden/es* = *to watch/tend* (cattle) and *bigging* = *cultivation* hence *Aernhaldenbiggin* simply means *a farm*. The third name element of *bigging* also came to have the colloquial meaning of building as can be seen in *Th' icker Biggin's* (The Higher Buildings) at Lane Bottom, Briercliffe.

JAC

Westby Hall in the 1730s when Arnoldsbiggin (left) was undergoing demolition

On the site of the present Gisburn Vicarage, to the east of the parish church, once stood a fine Jacobean house belonging to Henry Marsden, one-time Member of Parliament for Clitheroe. In the seventeenth century the Listers had become sufficiently wealthy to be able to buy the lordship of the Manor of Gisburn from the Marsdens. They went on to buy the Rectory of the Church and the house which, unfortunately, they demolished.

On the subject of the Lister family, mention must be made of their part in the Pendle Witch Trials of 1612. In the year 1607 Thomas Lister of Westby Hall died and according to Anne Robinson, an eye-witness to the death-bed scene:

"he cried out to them that stood about him; that Jennet Preston was in the house, look where she is, take holde of her; for God's sake shut the doors, and take her, shee cannot escape away. Look about for her and lay hold of her, for shee is in the house; and so cried very often in great paines."

This testimony was used as evidence for the prosecution at the Assize Court in York during the 1612 trial of Jennet Preston for the supposed killing of Thomas Lister by means of witchcraft. Jennet Preston was said to have been *'of Gisborne in Craven in the Countie of Yorke'* and it is likely that she was born as Jennet Balderston as, in 1587, a woman of this name married William Preston at Gisburn Parish Church. The church records show that she would have been aged thirty-eight years when Thomas Lister died in 1607.

Jonathan Lumby, in his *Lancashire Witch Craze* (1995), makes a strong case for Thomas Lister and Jennet Preston having grown up together in the Gisburn area and they were possibly life-long friends. Far from being an accusation against Jennet, Lister's death-bed statements could well have been an expression of his wish to have his friend (mistress?) Jennet at his bedside. Lumby shows that Thomas Lister probably collapsed during the marriage of his sixteen year-old son, Thomas junior, at Bracewell Church. Thomas senior cried out for Jennet in front of the assembled wedding guests and this would be embarrassing for his wife, Jane (formerly Jane Greenacres of Worston), and son, Thomas junior. The latter married Jane Heber, daughter of Thomas Heber of Marton. Having earlier tried and failed to have Jennet Preston prosecuted for the killing of a child of the Dodgeson family (probably from the Gisburn locality) Lister junior eventually found an unlikely ally in James Devise (Davies), grandson of Old Demdike of Malkin Tower.

Jennet Preston was said to have taken against Lister following his failed attempt to prosecute her and James Devise stated that she had attended a meeting of witches on Good Friday, 10th April 1612 – this was four days following her acquittal at York for supposedly bewitching a child named Dodgson. One of the purposes of this 'diabolical' meeting was, according to James, for Jennet Preston to enlist the aid of her neighbours in Pendle to bring about *'the utter ruin and overthrow of the name and the blood of this gentleman.'* In other words, according to the evidence of the young Devise, Jennet planned to murder Thomas Lister junior.

Having his excuse, Lister enlisted the aid of his father-in-law, magistrate Thomas Heber, and had Jennet indicted at the July 1612 assizes at York where Jennet was summarily convicted and executed on the Knavesmire (where York racecourse now stands).

Many friends, family and neighbours of Jennet vociferously protested her innocence, probably because they knew the real story of her good relationship with Thomas Lister and the jealous acts of his young son following his father's death. This incidence of witchcraft took place in Craven and was actually a precursor to the larger Pendle Witch Trials and executions that would soon take place over the county border. Jennet was first accused of witchcraft in 1607 and this would create a mind-set of suspicion amongst the local gentry which would simmer until coming to a head in Pendle. The pattern of the magisterial approach within witchcraft trials had been set and this culminated at the 1612 Lancaster Witch Trials under the auspices of Judges Altham and Bromley who ensured that the majority of the accused were executed.

In 1597 a lease records a nice example of the boon work (work carried out in lieu of rent) owing to the lord of the manor by a tenant when Thomas Lister, son and heir of Thomas Lister esquire, of Westby-in-Craven, leases to William Monkes, husbandman, a messuage and land within the rectory of Gisburn at an annual rent of nineteen shillings and six pence plus boon rents of:

'One day ploughing, one day mowing, one day shearing of corn in harvest, two hens at Christmas and four horse loads of coal to be supplied to Westby Hall.'

Also included in the lease are the provisions that George Harrison was to be allowed space within his garden so that he could thatch his new house in Gisburn as required, no ash or elm trees were to be felled and all grain was to be ground at the Lister's mill in the lordship of Newsholme.

A sixteenth century lease shows the hamlet of Admergill being granted to John Lister who never actually took up ownership of the area.

'Lease to John Lister of a tenement in Barnoldswick called Hadmargill now in the tenure of Alexander Hartley, Nicholas Blakey, and Christopher Hunson, and another tenement now or late in the tenure of Christopher Mitchell with the woods and underwoods at a rent of £4. 0. 8 (for the former 64s. and for the latter 16s. 8d).'

Accounts of 1761-1773 show rents due for the estates of the late Thomas Lister at: Grange Meer, Sawley, Gisburn, Bracewell and Barnoldswick, Hellifield, Swinden, Nappa, Newsholme, Horton, Malham, Grindleton, Bolton and Paythorne; with moduses in lieu of tithe; Rimington, Twiston, Clitheroe, Pendleton, Oldham, Denton, Middleton, Brinnington and Romeley, etc. A list of the estates belonging to Thomas Lister dated 1785 shows that he owned property at Gisburn, Grangemeare, Rimington, Horton, Newsholme, Swinden, Paythorne, Twiston, Bracewell, Barnoldswick, Bolton, Grindleton; Also properties at Malham Water House ie, East Malham, West Malham, Kirkby Malham; At Clitheroe, Pendleton, Chatburne and also at Whalley rectory, Oldham and Werneth along with a house in George Street in Hanover Square, London. Nineteenth century records showed the local estate tenants in Gisburn, Newsholme, Horton, Paythorne, Gisburn Forest, Rimington, Middop Mitton, Clitheroe, Sawley, Whalley, Colne, Bolton, Slaidburn, Burnsall, Bracewell, Barnoldswick, Long Preston, Thornton and Burnley.

The Lister family were also prominent at Thornton-in-Craven following the purchase of the manor there by one William Lister, son of Christopher, in 1556. The extent of the manor at that time was thought to include the manor house, some sixty cottages, a watermill and lands at Hague-in-Craven, Kelbrook and Earby along with the Thornton church advowson.

The Listers of Thornton supported Parliament during the Civil War, Sir William Lister fought for this cause at the Battle of Marston Moor in 1644 and the next year saw him commanding the Yorkshire troops. Sir William's eldest son, Captain William Lister, was killed at the Battle of Tadcaster whilst fighting for General Fairfax in 1642.

Chapter Eleven

Craven and Pendle

To continue our journey around the 'enclosed' area within West Craven, the line of *ber* sites continues eastwards from the Ribble at Gisburn. The site of the tumulus here falls between the Hellifield road and the Ribble just to the north of the village. This is the area known as Little Painley, the *leah* element has the meaning of *clearing* but the first element is difficult and has many possibilities, a few of which are: *paean* = Latin *deliverance*: *paian* = related to the god Apollo and has the connotation *to strike*: *Peine* = Old French *punishment*, penalty: *panne* = OE Mercian word for *shallow, pan, dich*: *pane* = OF *section of wall*: *peon/pehon* = OF *foot soldier*: *paiier* OF = *pacify: paienime* = *heathen lands*: *Payne, Paine, Payen, Payne, Payan* from OF *Paien a given name* - from Latin *paganus* = *outlying village*: *pen, pen, penne* = OE *enclosure*: *pinn* = OE *bolted gate*: *paa* (an area of Gisburn) = Scandinavian dialect for *upon (the river?)*.

An early mention of Painley is a record in 1226 of Hugh of Pathenhale, in 1633 Thomas Danser leases lands at Paithnoll and an eighteenth century estate record mentions Paithnol or Painley Pastures, many other references are made to Paithnoll. The meaning of the name here could not be clearer, OE *paithe* means *track* or *causeway* and OE *cnoll* means *small rounded hill,* an exact description of the ancient trackway, running over the tumulus at Painley and on past the mound of Castle Haugh.

In 1732 Lady Catherine Petre swapped lands called Paithknowle Pasture (being part of Paithknowle Farm within the manor of Paythorne) for the tithes of corn, hay, wool and lamb (payable out of the township of Paythorne) belonging to Thomas Lister of Arnoldsbiggin. Pathnowe became a family name in the area within the later Medieval period. The village of Paythorn could well have the same place-name root in *path by the thorns,* as we have seen, the trackway from Gisburn traversed the Castle Haugh site, dropped into the river valley and crossed the Ribble, the way then parted in Paythorn, north-westward into Gisburn Forest and north-east to the river crossing at Arnford (*arn* = OE *iernan* meaning *rapid, flowing*) near to Long Preston.

There is another example of a site beginning with Pa where we have the unusual name of Paa Farm at Paythorne, besides the *paa* etymology given above this could also originate in a shortening of the OE *pare-roc* which eventually became *parrock* and meant *fenced off area of land.*

Bracewell and Broughton

The township of Bracewell is located roughly mid-way between Gisburn and Barnoldswick and can be seen to be a cluster of properties around the church of Saint Michael's. This was a private chapel for the Tempest family and dates from around 1100; in 1135 there are references to priests at Bracewell and the Fountains Abbey records show that there was a chapel here prior to 1147. The name of Bracewell is somewhat uncertain but the OE word *braec,* meaning *strip of unploughed land,* shows a viable Saxon root.

As the Lister family were to Gisburn so the Tempest family were to the manors of Bracewell and nearby Broughton. This family can trace their roots to the twelfth century priory of Bolton. Two major branches of the family were created by Sir Piers Tempest who was born sometime during the 1390s and was knighted for his services to king Henry V at the Battle of Agincourt (1415). His eldest sons were Sir John Tempest, knight of Bracewell and the high sheriff of Yorkshire (died in

1464) and Roger Tempest (died before 1469) who married Catherine, heiress of Piers Gillot, the lord of Broughton manor. Sir Richard Tempest fought at the Battle of Towton in 1461 when the Duke of York defeated the Lancastrian armies in a heavy snow storm. Richard was buried at Giggleswick church in 1489 with the head of his horse beside him, his grandson fought at Flodden and is reputed to have built Bracewell House.

Besides creating a junior branch of the family at Tong Hall, the Tempests were to found another junior branch at Broughton, Roger and Catherine's great-grandson, Roger Tempest, married Ann Carr and had eight offspring, a son of his first marriage was Henry Tempest who extended the family landholding at Broughton. Henry married into the Percy family, who were earls of Northumberland, in 1544, and their son Stephen built the Broughton manor house in 1597, Henry was knighted by James 1st and went on to have seventeen children by two wives. The estate passed through the line of the eldest surviving son of his second wife, Stephen, who managed to lose the estates by backing the wrong side in the Civil War.

Eventually the Broughton properties were regained and they passed to Stephen's nephew, another Stephen (born 1654) in 1670 - this Stephen Tempest was responsible for extending the Broughton manor and landscaping the site with new bridges and lakes before he died in 1742.

The Bracewell branch of the Tempest family moved across to France during the flight of James 2nd, this was to be the beginning of the end of the family's connection with the village. The manor passed through various hands (including Earl Grey) until eventually a Blackburn cotton magnate replaced the Norman manor house with a somewhat rambling new mansion in the Scottish Baronial style (see lithograph). I am indebted to Stanley Graham for providing the sale deed of 1875 for the Bracewell Hall Estate, an extract of which follows:-

BRACEWELL ESTATE SALE; The estate consists altogether of rich old pastures, well watered and covering an area of 1,596 acres divided into eleven compact farms with good homesteads in the occupation of a highly respectable class of tenants at moderate rents, amounting, with the small estimated rental of the mansion, sporting, and lands in hand to upwards of £3,720 per annum. Free from all outgoings except £6-7s 4d per annum. Together with the manor of Bracewell and the advowson and next presentation to the vicarage of Bracewell.

Bracewell Hall in the 19th century

THE ESTATE is of a boldly undulating character and is pleasingly interspersed with small woods and plantations containing young and thriving timber and well-placed for the preservation of game. There is also a fine trout stream intersecting the property and a large, well-stocked fish pond. The estate affords excellent sporting and there is also the right of grouse shooting over Weets Common in Barnoldswick, containing about two-hundred and thirty acres, in respect of two-and-a-half cattle gates attached to Hesketh Farm. The West Craven Hounds hunt the district and Mr Starkey's hounds also meet in the neighbourhood.

THE LANDS consist altogether of rich old pastures and cover an area of about 1,596 acres divided into eleven compact farms, all well watered and having good stone-built and slated houses and homesteads in a good state of repair and in the occupation of a highly respectable tenantry at moderate rents amounting, with the small estimated rental of the mansion (sporting and lands in hand) to upwards of £3,720 per annum free from all outgoings except £6-7-4 per annum. The estate abounds in limestone and there is a kiln in field no. 37.

An abridged account of the estate farms of Bracewell Hall shows:

- **Hopwood Arms Farm:-** 202 acres, occupied by the exors of the late Luke Hartley. Rent £490 per annum.

- **New House Farm:-** 227 acres, occupied by Mr Robert Blakey. Rent £500 per annum.

- **Hesketh Farm:-** 171 acres, plus two-and-a-half gates on Weets Common, occupied by Mr Henry Grime, rent is £280 per annum.

- **Willcross Farm:-** 150 acres, occupied by Mr William Lambert at a rent of £330 per annum.

- **Gutteridge Farm:-** 115 acres, occupied by Mr John Hepple at a rent of £260 per annum.

- **Hargreaves Farm:-** 73 acres, occupied by Mr John Haythornthwaite at a rent of £195 per annum.

- **Stock House Farm:-** 122 acres, occupied by Mr Thomas Ayrton Jnr. At a rent of £241 per annum.
- **Turf Pit Gate Farm:-** 81 acres, occupied by Mr Richard Fell at a rent of £180 per annum.

- **Croft House Gate Farm:-** 89 acres, occupied by Mrs Elizabeth Mawdsley and Son at the rent of £200 per annum.

- **Stock Green Farm:-** 161 acres, occupied by Mr Christopher Waite at a rent of £365 per annum.

- **Crook Carr Farm:-** 118 acres occupied by Mr James Simpson at a rent of £280 per annum.

Field names at Bracewell show the same high incidence of *ber* names as do those of Gisburn, examples being: Narrowber, Lingber, Arnsbur Doles, Thistleber, Audber, Crookber, Hayber and Great Cockber.

Stock Village

 Within the township of Bracewell was the village of Stock, now the site of some half-dozen scattered farmsteads the area is marked on the map as *The deserted Medieval village of Stock*. We have seen that the *stoc* name element commonly denoted the site of an outlying hamlet, farm or small estate, a smaller but integral part of a larger administrative region.

 The earthworks at Stock are the finest example of their kind within the whole of post-1974 Lancashire. Figure 15 shows the main village layout although the land system extends north and

west from Stock Green (*green* usually denotes the common area within a settlement). It can be said that Stock was a rare example of a nucleated village within our area, the (lost) manor house would have been situated away from the through route from Barnoldswick to Horton and close to the best plough land and infields whilst the farmsteads of the estate workers were situated so as to take advantage of the more outlying areas of land; these were gradually brought into cultivation, such is the case with the area of *Aynhams* to the north and west of the village, the name *aynhams* is descriptive of newly enclosed land. The Domesday Book records that: '*In Braisuelle (Bracewell) Ulchil and Archil had six carucates of land to be taxed and in the manor of Stoche (Stock) Archil had four carucates to be taxed (twelve-hundred acres).*'

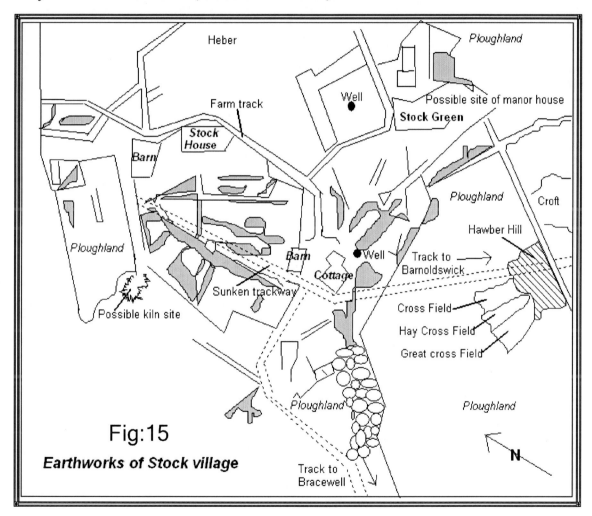

Fig:15

Earthworks of Stock village

Stock village was abandoned although this occurred somewhat later than is the case with many of the other examples of deserted villages, there are records showing people working at Stock as late as the nineteenth and twentieth centuries. No single reason is apparent for the gradual decline and final desertion of the village, in reality a number of reasons can be proposed. The continued

population expansion of the twelfth and thirteenth centuries ground to a halt in the fourteenth century. In that century the Black Death, amongst other things, was responsible for an estimated decline in the population as a whole, in some areas this was as much as 30-50% although this may not have been as severe within our under-populated area, famine could have been the major factor in the high death-rates of the fourteenth century here.

As the population contracted it is thought that the more productive settlements would become available and the more outlying farmsteads were often abandoned. The Lancashire part of the former West Riding of Yorkshire has a cluster of known deserted Medieval sites, these include Battersby, Easington and Stock. There is also the consideration that Elfwynthorp, a known vill of the Barnoldswick area, was another deserted settlement that has (to date) not been identified. The deserted sites within our area tend to be of the larger, village scale rather than individual farmsteads. The establishment of vaccaries by the Norman lords in the fourteenth century could explain this, upland farms were an important part of the central vaccary and could have enjoyed relative security and this would help to ensure continuous tenure through to the present day. The abandonment of whole settlements could be seen as being the result of a gradual shift in population rather than the sudden extinction of the inhabitants by a single factor.

Along with the effects of disease and famine there was another reason for the desertion of particular areas, the religious houses had the habit (if you will pardon the pun) of wanting large areas of fertile land for themselves. To this end they often evicted the inhabitants within areas of ecclesiastical control and set up their own central farm in the form of a grange, this occurred on an increasingly regular basis following the Norman Conquest. Areas such as Accrington, Higham and Barnoldswick (Brogden) felt the effects of this at one time or another. The state of play regarding the power held by monastic houses within the Bracewell area is somewhat vague, it is not known when the church at Bracewell was originally created, it is entirely possible that there was a chapel here well before the arrival of the Normans.

It is interesting to note that in certain cases the *stoc* name element can have a more specific meaning than just an outlying part of an estate, it can have the further *place* inference of *'cell.'* If this were to be the case at Stock then it raises the possibility that a small group of monks were settled there. It is interesting to note that three adjacent fields around the western side of Hawber Hill are shown on an eighteenth century estate map as Cross Field, Hay Cross Field and Great Cross Field. Hawber Hill itself has been enclosed and to the north of Stock is Monk Bridge.

There is no evidence here that the village of Stock was adapted as a grange and the people summarily evicted; it is reasonable, however, to consider the possibility of there having been a strong church presence at the site, even if this took the form of temporary quarters for the monks who established nearby Bracewell church, or perhaps the new church being created at Barnoldswick in the twelfth century. In 1150 Adam Tempest and his wife Matilda (daughter of Fulcher) made a gift of twelve pence per annum from their alms in Heton (held by Godwin) to the Brothers Hospitallers of Jerusalem. Witnesses to the document were: *"Brother Swein, Brother Helta, Brother Robert de Leicester, Brother Reginald, Richard the clerk, Henry the parson of Braizwell, Alexander Tempest and Walter the clerk of Stoc.'"*

In 1340, under William, the eighteenth Abbot of Kirkstall Abbey, Richard Tempest (son of Roger) released all his rights to the advowson of the church at Bracewell. This meant that all the glebe lands belonging to the church, and all other possessions, became the property of the Abbot and Convent of Kirkstall. Following this, in 1347, the church itself was appropriated to the Abbey by William de la Zouche, Archbishop of York, who *"ordained a vicarage therein."* Thus, Bracewell and Stock came under the same ecclesiastical hegemony as the grange of Barnoldswick.

A deed of 1614 shows that: *"Ambrose Barcrofte of Fowleridge, gent, surrendered to Thomas Ellis,*

husbandman of Stocke, a close of land called Lathebutts and Lathebutts Ynge, also a north part of Pykelayfield and a moiety of close called The Street in Stocke and Bracewell, County Yorkes."

In 1641 John Jackson of Foulridge held the tenancy of a farm in Stock and the tenancy of a farm and oxgang of land in Horton-in-Craven which he relinquished to Thomas Barcroft of Foulridge and Peter Ormerod, of Ormerod (both yeomen) upon his marriage to Jenet, the daughter of Ambrose Barcroft of Foulridge.

To a certain extent the demise of Stock as a village became a case of 'The last one to leave please turn out the lights.' The last few inhabitants had much the same reason for leaving as did many of the people of earlier centuries, the bright lights of the nearby eighteenth and nineteenth century cotton boom-towns of Barnoldswick and Colne would prove irresistible. The wages of a weaver, compared to an agricultural labourer, were considered to be worth the move from country to town, fresh air did not feed the family!

Barnoldswick

'Barlick,' as the town is known to its inhabitants, was mentioned in the Domesday Book:

"In (the manor of) Bernulfesuuic Gamal had twelve carucates to be taxed. Berenger de Todeni held it but now it is in the castellate of Roger de Poictou."

Other names mentioned in relation to the village were: *Alcolm; Almund; Arnbrandr; Arnketil; Berengar de Tosny; Bo; Clibert; Earl Tosti; Earnwine; Earnwine the priest; Erneis de Buron; Fech; Gamal; Gamal Barn; Gillemicel; Gluniairnn; Gospatric; Karli; Ketil; Machel; Machern; Orm; Roger de Poitou; Sten; Svartkollr; Thorfinnr; Uhtraed; Ulf; Ulfkil and William de Percy.*

The mention of the castellate could be a reference to Roger de Poitou's lands within Clitheroe but other places within Yorkshire have the same description, there is a suggestion that the castellate may have been somewhere in the Leeds/Pontefract area. Around the time of the Norman Conquest the village of Barnoldswick was the largest within the area (one third larger than Bracewell). Gamel, the owner of Barnoldswick at the time of the Domesday Survey, also owned lands in nearby Marton and Thornton and as far as Bradford. Warner, in his *History of Barnoldswick* says:

"Bernulf must have been some predecessor of Earl Gamel, who probably first built here a little simple manor house and attendant cottages or hovels, with a palisade round them, at the foot of Weets. A certain Beornwulf, king of the Mercians, fought at Ellandun against Egbert, king of the West Saxons, in the year 823 AD, and Egbert got the victory, so the Anglo- Saxon Chronicle informs us; but it would be hazardous to identify this Beornwulf as the founder of Barnoldswick. Beornwulf was a not uncommon Saxon name, perhaps reminiscent of encounters with the bears and wolves that roamed the forests of old England when Edward the Confessor was king in England. Bernulf's 'wick' had descended, as we have seen, either by inheritance or by some other right, to earl Gamel. In Domesday Book, the Conqueror's great survey of the lands of his new kingdom, the following is the record given of Bernulfeswick:- In Bernulfeswic Gamel XII carr ad gtd. Berengr de Todeni tenuit sz m e in castellatu Rogr Pictuaensio."*

* The name of Ellandun translates as Ellen Hill – we have the castle motte of Ellenthorpe at Gisburn, and the lost vill of Elfwynthorpe in Barnoldswick. Beornwulf is mentioned in Domesday

in relation to both Gisburn and Ellenthorpe, the obvious question is whether the Battle of Ellendun took place at a local site?

*"From which we gather that Earl Gamel, who with his retainers from Barnoldswick and elsewhere, had probably fought side by side with Harold in the Battle of Senlac Hill, was for this crime, or even only for the crime of being a Saxon, dispossessed of his lands, which were handed over by the Conqueror to Berenger de Todeni, a nobleman from Normandy. Berenger, it appears, did not hold it long, and it became part of the extensive possessions of Roger of Poitou, alias Roger the Poitevin. This Roger was a man of note and a favourite of the Conqueror's, from whom he received large gifts of lands in Yorkshire and Lancashire. Whitaker, in his "History of Craven" tells us that he is sure that there was a Church here then, though no mention is made of it in Domesday Book. His reason is that Serlo the Monk, of whom we shall hear anon, tells us that in 1147 the Church in Barnoldswick was already an ancient structure. If there was a church, it would, no doubt, have been a very simple building indeed, of wood or wattle, plastered with mud and roofed with thatch, little grander than the poor huts of the people. But where there was a church there would be a priest, and we may believe that he would not have been molested by the Norman Christians, as his predecessors might have been when the heathen Saxons drove out British Christianity and for a time replaced Christian churches by the temples of Odin and Thor. He could and no doubt would minister the comfort of God to the stricken members of his flock. This ancient Church of Barnoldswick** stood probably at or near the spot where Calf Hall Shed stands now, or else on the site of the present market-place. It was certainly close to the field now known as Monkroyd."*

"We find the monks engaged in a struggle not only with the stubborn inhabitants, but also with a yet more stubborn climate and soil which would not suffer hard labours at their crops to bring them their due reward. Their neighbours at Sawley were undergoing the same hardships. One of their patrons, Matilda, Countess of Warwick, describes the situation of that Abbey as being in a land "nebulosa et pluviosa" ("full of rains and vapours"), and a still nobler patron, Edward I himself, in writing to the Pope describes it as lying close to the Irish Sea, astonishingly wooded and mountainous, and visited by wild tempests. The vapours of the Irish Sea sweeping over Pendle descend upon Barnoldswick also in showers which may be refreshing and cleansing, and good for cotton manufacturing, but are not conducive to good harvests. So we can enter with sympathetic understanding into the feelings of the colony of monks whose historian, Serlo, in a fine vigorous phrase, complains of the 'importunity of the rains' (importunitas imbrium) which would not allow the crops to rejoice in the ripening rays of the sun. Nor was this all; for in addition to outraged and therefore unhelpful villagers, and to Irish Sea vapours, the monks had to endure the depredations of pillaging Scots, whose thieving bands carried off cattle and sheep and greater spoil."

"The monks of Sawley may have been made of sterner stuff, for they refused to be driven from their solitudes by Irish vapours or Scotch robbers. But neither did they have an Abbot Alexander at their head as the Barnoldswick monks had. This adventurous and ambitious man kept his eyes open for a 'better 'ole,' if one may be allowed to use this now classic phrase. He found it, too, in Kirkstall; and if any of my readers would like to know the negotiations and strategies by which he obtained possession of it, and built there the noble pile of the great Abbey and Church, he will find it set out in full in the Chronicles of Kirkstall and its Chartulary, or in the pages of Dugdale and Whitaker, and lesser historians who have followed in their wake. Barnoldswick people may reflect with pride that in a sense their town is the mother of the great Abbey whose

noble ruins still look across the waters of Aire and which in its turn has become a possession of pride to one of the greatest of the great manufacturing and industrial cities of the North. We may venture to hope that Leeds people will not be wholly forgetful nor neglectful of the bonds which unite them to this homely old mother of theirs amongst the hills and moors."

** In his *History of Craven* Whitaker states that:

"Barnoldswick 1147....... a church stood on the margin of a brook immediately to the west of the village where tiles, lead pipes etc, have been dug up in Monkroyd Field within memory and the channel for the mill stream on the north-east is still very conspicuous."

Here we have, in short, a description of the earliest known history of Barnoldswick, the pre-Norman church at Calf Hall has never yet been discovered but it is highly likely that it is in the vicinity of Lower Calf Hall, there is an elongated ridge here known as Monkroyd Hill and aerial photographs show marks on the landscape that may of value in locating the lost buildings. A parcel of land here (possibly Monkroyd Hill) was known as Stanridge, this suggests a stone-covered ridge, possibly a reference to the remains of buildings on the site at an early period.

The later post-Norman minister church came to be built because the overlord of the time, Henry de Lacy, fulfilled his vow that if he were to recover from a dangerous illness he would invite Alexandre, the Prior of Fountains Abbey, to found a monastery at Barnoldswick. Thus twelve monks, along with ten 'Conversi' (lay brethren) descended on the area to set up office and lodgings in preparation. The newly settled monks found that the original inhabitants of the area were somewhat rowdy in their services at the established chapel and so the Abbot ordered his men to pull the older chapel down.

As can be seen above, the monks eventually tired of Barnoldswick and its adverse weather and, on June 14th 1153, they wandered off to found the new Abbey at Kirkstall, near Leeds. A few years after this the parish church of St. Mary-le-Ghyll was built at Ghyll, near to the boundary with Thornton-in-Craven, although this was at a distance of one and a half miles from the original Calf Hall site. This new site was possibly for the convenience of the inhabitants of Marton and Thornton although Marton and Bracewell later separated from the parish of Barnoldswick.

It is believed that the manor of Thornton, which included the villages of Earby and Kelbrook, was once a part of Barnoldswick, the church at Thornton is thought to date roughly to the same period as those at Marton and Bracewell. Barnoldswick became a grange, the area of Brogden was depopulated and a building at Admergill housed the monks in that area.

On the boundary of Gisburn and Sawley is the site of Gisburn Cotes Farm and Hall, and within the bounds of modern Barnoldswick (although removed from the original settlement site), is an area of land, once attached to Sawley Abbey, known as Coates, the origin of the name would probably have been *cote* and signified an outlying farm of the larger abbey estate.

What's in a name?

The name of Barnoldswick is commonly accepted to have originated in *Bernulf's-wick,* Warner stated that the first element would have been *beorn = bear,* the second element was *ulf = wolf* and the last was the standard *wick*. There is a striking similarity, however, between the name of Arnoldsbiggin (at nearby Gisburn) and Barnoldswick whereby we have B (*arnolds*) wick and (*Arnolds*) biggin. Earlier we saw the possible origin of the latter in that the OE *aern = house* and *halden = to watch/tend* (cattle). It seems to me that the OE word of *halden* (sometimes *haldes*) is

a more comfortable root for the word *olds* than is the word *ulf*. If this were to be the case then the remaining question is where did the B in *B-aernhaldeswick* originate? Possibly the answer lies in the OE word *be* = *near* giving *Be-aern-haldes-wick* and so the meaning of Barnoldswick would be *'near the farm'* as opposed to the accepted meaning of *Bernulf's Farm*. Interestingly, another permutation of place-names is possible here in that Warner postulates that *beorn* meant *bear* whereas, in actual fact, the OE word *beorn* meant 'of a man': ie *noble, chief, prince* or *warrior*. This might give us *Beornhaldeswick* with the meaning of *'the chief or warrior who oversees (protects) the wick.'*

Further to this, one of the oldest parts of the town of Barnoldswick is that of the area known as Wapping, this is adjacent to the area of Calf Hall. The name of Wapping here can be seen to share the OE word *vapn* with that of the division of certain English counties known as *wæpengetæc* or *weapon take*. Wapping, therefore, can be taken as *'the weapon carriers'* or *'place of the weapons.'* Possibly it was originally an military muster-site or else an assembly where consent was expressed by brandishing swords and spears. The context of a gathering, or settlement of warriors, is interesting when coupled with the possible warrior connotation of *Beornhaldeswick*. As a final stab at the puzzle, the OE word *bèarn* means *'offspring'* or *'young'* and therefore *Bearnhaldeswick* would have the connotation of *a farm, or place for the rearing of young animals* or *a stock breeding establishment*.

North and East

Carrying on northwards from Barnoldswick, along the boundary of the West Craven 'enclosed area,' we come to the village of Thornton-in-Craven. The *thorn* element of the name suggests a boundary marker and the *-in-Craven* delineates the site of the village within Cravenshire, as opposed to neighbours who were within the West Riding of Yorkshire but outside of West Craven. The Domesday Book mentions the manor of Thornton as *"In Torentune Alcolm had three carucates to be taxed."*

Whitaker's *History of Craven* says:-
"In this parish are the manors of Thornton, Eureby, and Kelbrook, which have never been separated from the earliest times, but have passed together, and in succession, through the families of Percy, Kyme, Muncey, Roos, Pilkington, Manners, Lister, and Kaye. In 28th Edward I Walter de Muncey, obtained a charter of free warren in Thornton, Enreby, and Kelbrook, together with a fair and market at Thornton, viz. a market every Thursday, and a fair there for five days, viz., on the eve, day, and morrow of St. Thomas the Martyr, and two following days. In 1556, 3 and 4 Philip and Mary, the manor and advowson were alienated by Henry, second earl of Northumberland, to William Lister; through which family they have descended to the present proprietor. Thornton appears to have had some share of the troubles in the time of Charles I for we find, that the Manor House of Sir William Lister was taken by a party of Royalists, in July, 1643, sent by Sir John Mallory, from Skipton, which was some time afterwards burnt, and never rebuilt. Several years since, on digging into the rubbish, an apartment was discovered on the ground floor, with the old furniture undisturbed."

Heading on to Marton there are the two hamlets, West Marton and East Marton, the latter being situated at a picturesque spot where the Clitheroe to Skipton highway crosses the Leeds and Liverpool Canal. The old name for the hamlets was Marton Both, East Marton was known also as Church Marton. West Marton was long the seat of the Heber family and within the 'townships both' stands Gledstone Hall, a country house and formal gardens, designed by Edwin Lutyens in

the 1920s, with planting scheme supplied by Gertrude Jekyll for the owner, cotton manufacturer Amos Nelson.

Also within the township, on what was once the through road from Stainton to East Marton, is situated the interesting building of Ingthorp Grange whose name was variously shown as Ingthorne Grange, Inthorne, Ingthorp, Uncthorp and Ungthorp. There has been a suggestion that Ingthorp is actually the lost village of Elfwynthorp, there is little to recommend this on etymological grounds alone. Having said that, the remains of a lost village were said to have been discovered here in the nineteenth century and, the village being separate from Marton, would have been accepted as an individual part of Barnoldswick. There is a local tradition that this lost village was destroyed, and the inhabitants slaughtered by one of the many violent incursions by the Picts and Scots.

Eventually the Grange at Ingthorp was held by Bolton Abbey, the Canons here regularly paid a pension to the Abbot and monks at Kirkstall – this was possibly in relation to Ingthorp lands having once belonged to the Kirkstall Abbey.

Whitaker mentions that:

"Ingthorpe, now Ingthorpe Grange, was a Grange to Bolton Priory, and having been granted to the first Earl of Cumberland, in 1542, was sold by his grandson to the Baldwyns, in which family it still continues. Here the Canons seem to have had a small Cell and Chapel; for a Basso Relievo, in white marble, was found here some years ago; the subject of which seems to have been the apprehension of Christ, and Peter drawing his sword."

The next port of call along the apparent *ber* boundary is the area of Ingber in the township of Gargrave which sits quietly on the infant River Aire, the river springs into life at Aire Head in the nearby Malham area. The village of Gargrave is situated on an important route through the Aire Valley and has long been a settlement, in 1381 records show that tithes for the area were due to be paid to Sawley Abbey on:- 41½ quarters of tithe-wheat, 62 quarters of tithe-barley, 5½ quarters and 3 bushels of beans, 208 quarters of oats and 40 stones of wool. Remains of carved Saxon stone crosses have been found in the river, near to the church, and a Roman site exists at nearby Kirk Sink. This latter was excavated (badly) in the early nineteenth century when a large amount of tesseri paving was uncovered. When the site was excavated later the churned-up deposits were found to be too badly out of context to be of much value. The lost building foundations had been robbed out, possibly to build the church at Gargrave, but the excavators did manage to ascertain that the overall dimensions would have been some one-hundred and eighty feet long and eighty feet wide.

From Gargrave we reach the north-western corner of the enclosed area at Eshton, the 'manor house' of Eshton Hall, was originally built in the eighteenth century and remodelled in the Elizabethan Revival style between 1825 and 1827. On the Eshton to Winterburn road, near to the bridge over Eshton Beck, can be found an ancient holy well dedicated to Saint Helen. Until recently the bottom of the well was lined with stones carved with distinctive heads but these now appear to have been stolen, the ancient custom of well-dressing still takes place here.

At Scarnber the apparent *ber* boundary turns eastward at Mickleber and on past Bonber, Wenningber and Lingber to the terminal village of our north-western corner at Hellifield. The pele tower at Hellifield is a large fifteenth century crenellated tower house, said to have been built by Lawrence Hammerton in 1440-41. Records show that Richard Hammerton was a knight in 1428 and he gave to Thomas, the Prior of the monastery of the Blessed Mary at Bolton-in-Craven, the property of one toft and one piece of land in the vill of *Helnfield* (Hellifield) *in Craven*. In 1542

lands within Hellifield were in the possession of the Hospital of St. John of Jerusalem in England and were shown to have formerly been the possession of the preceptory of Newland.

Hellifield Pele Tower

Nappa is situated a short distance along the road from Painley towards Long Preston and we have already seen that the name possibly originates in the fishing rights on the Ribble. Hayber Farm here was once an inn called The Craven Heifer, in 1842 the inn was advertised to let along with one-hundred acres of land. Along with Hayber Farm the other surviving residences within the old settlement of Nappa are Stansfield Farm, Nappa Manor Farm and Fish Hole Cottage. It is thought that a number of Roman roads converged on the river crossing here. In 1086 William de Percy held two carucates of land at *Nappey* and twenty six inhabitants were recorded. In 1316 Thomas del Grene, Master of the Hospital of Saint Leonard at York, was Lord of the manor of Nappey, the hospital held the manor until the Dissolution of the Monasteries in 1537-8. A field in the area was known as both Spittle Myre and Bell Field and could well have been either a part of the hospital grant or related to the rectory within Gisburn village.

Conclusion

This brings us full-circle to our starting point of Gisburn, a former stronghold on the banks of the Ribble at the south-western corner of our subject area. It is interesting to note that the four corners of the enclosed area have associated defensive sites and also, in the centre of the area, is a hill known as Flambers Hill. The first connotation to leap to mind here is that the name derives from the Old French word *flambe* meaning *flame* or the later French meaning of *blaze,* this would appear to relate to the hill having been a beacon site whereby early-warning fires would be lit as a reaction to an enemy threat. There is also a possibility that the name of Flambers originated in the OE *fleam* meaning put to flight or the OE word *flan* meaning *arrow*.

Both of these have an obvious relation to defence, the *ber* element suggests a fortified hill. Most, if not all of the manor hamlets within the area were situated beneath, or close to, one of the pronounced hills that litter this part of West Craven, it is probable that these would have been the defensive *ber* sites for the protection of the settlement.

The outline of the area (Fig:16) contains within it a number of small estates, or manors, none of which were large enough, or important enough, to have developed much beyond the status of a group of farmsteads or hamlets. It is possible that, as was the case with Stock Village, the small vills and townships were larger than at present and socio-economic pressures saw the depopulation of the sites towards the fourteenth century. We have seen that a number of these townships and manors were situated to take advantage of some natural resource or other, chiefly well-drained land, stone, timber and lead. Situated on the corners of the area are the four larger

townships of Gisburn, Barnoldswick, Gargrave and Hellifield all of which are associated with defences and related ancient sites.

It is, perhaps, significant that much of the topography along the postulated boundaries is dominated by the ice-age formation of large numbers of rounded hills or drumlins. These would have afforded excellent, ready-made encampments and defensive sites and so it may be seen that there is no coincidence in the fact that there is a large concentration of *ber* place-names here.

Flambers Hill (centre left of photograph)

Ingleborough can be seen on the far horizon illustrating the far-reaching connection between beacon sites

The postulation of this area having been a possible British tribal region, later becoming a Saxon estate group and then a collection of scattered manors under the Normans, may prove incorrect, should this indeed be the case I hope that at least the illustation has served to show how certain areas prospered whilst others either shrank or became deserted. Barnoldswick would lose its townships of Thornton, Earby and Kelbrook but the coming of the Leeds and Liverpool Canal, followed by the railway, ensured that the village not only grew into a small town but managed to sustain that growth to the present day.

Gargrave also had the benefit of the canal but, unlike Barnoldswick, the railway went elsewhere. Being related to its larger neighbour of Skipton the village grew to a certain extent, certainly it became larger than the hamlets within the enclosed area. This can also be said for Hellifield, the railway did reach here and a station within the village meant that it saw an enlargement of its former hamlet status. Gisburn had only a small, isolated railway stop and so the village reached an optimum size whereby the farmsteads and worker's dwellings were sufficient in number to serve the manor.

The extent to which the Anglo-Saxons settled this area of Yorkshire is not only evident in the *ber* sites covered here but also in the number of *tun* place-names relating to the *bers* in their distribution pattern. An example of this is the ring of *tun* names around the boundary of the 'enclosed area' (Fig:16), these are not merely minor field, or farm names, but relate to villages and towns.

Having taken this small patch of West Yorkshire as an example it is clear from the place-name distribution alone that the Saxons held sway here. The fact that this area fell within the area of the Danelaw appears to have counted for little other than certain administrative factors, such as weights and measures, these often differed in Lancashire and Yorkshire from other parts of the country. There is a consideration, as in other parts of the north-west, that there would have been a

larger Scandinavian population than is apparent in our surviving place-names, in certain cases the newcomers would have had no reason to change an existing name already familiar in their language and would have retained the English names. If, however, there had been any significant population here, other than the English, we could possibly expect to see a somewhat larger incidence of Norse names. The fact is that within the defined enclosed area Norse test words, such as *brekka, skali, slakki* and *gill* and the elements of *thorpe, holmr* and *by,* rarely occur in comparison to those of English origin.

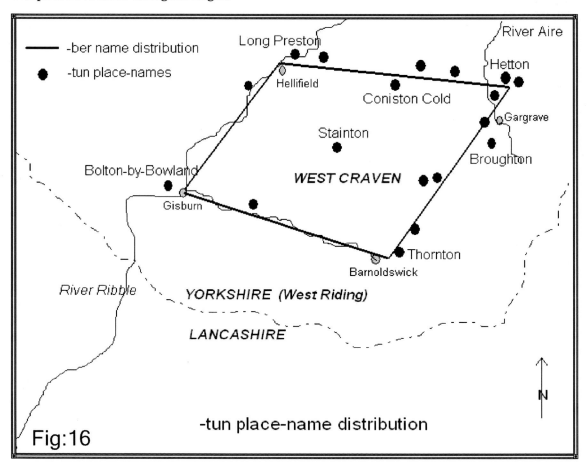

Fig:16

-tun place-name distribution

It is often difficult to ascribe the name of *gill* to a particular society as it has much the same meaning in both the Scandinavian (*gill*) and the OE (*gil/e*). The former is the most widely used of the Norse names in the subject area but even here there are doubts as to it having been applied directly by Scandinavian settlers, in the post-Conquest centuries people who could be said to have Scandinavian influence spread through the area from other parts and brought their particular names with them. In other words, the site of *Gill* at Barnoldswick might very well have been named in the thirteenth or fourteenth centuries.

Another example here is that of an area of woodland near to the hamlet of West Marton. The name of the wood is Skelda Wood, the can be seen to originate in the Norse word *skálda*, whose roots are within the Old High German word *sealla* meaning *pole* or *staff,* a likely name for

woodland once managed as coppice to provide poles for fencing and the erection of timber dwellings and palisades. Again, the isolation of this Norse word within a predominately English region of settlement does not suggest that any great number of Norwegians, or Danes settled here.

To the north and west of this former area of West Craven we begin to find a heavy concentration of Danish names within the Yorkshire Dales, this suggests that the area of south-west Craven seen above would have born a stronger relationship with its largely Saxon neighbour of Pendle than it might have done with that of deepest Northumbria to the north and east.

The Pendle area shows a lack of Scandinavian place-names, the ones that can be shown to be of genuine Norse settlement are distributed on an east-west line, from south Yorkshire, through the northern highlands of the Trough-of-Bowland and onwards to the area around the Fylde Coast.

The place-name pattern here, then, might be seen as illustration of the argument propounded by Professor Ekwall where he used dialectical evidence to conclude that the English settlement of Lancashire south of the Ribble was the product of penetration from Mercia, with a somewhat smaller element coming from Northumbria (we saw earlier that the word *caster* takes on the form of *Chester* in more southerly parts of Lancashire). Both these intrusions probably dated from the later seventh century although there is no proof that the English were not settled here in small numbers at an earlier time.

In 675 Bishop Wilfred made a speech at Ripon in which he included the region *iuxta Rippel* among the areas *"which the British clergy have deserted, fleeing the hostile swords in the hands of our people"*. It has been suggested that this reference to a Northumbrian route of the English, near to the Ribble, applied to the area of Amounderness, others have made a case for the incursion having been within our area (south of the Ribble) whilst yet another suggestion is that the area was that of the upper reaches of the Ribble.

The naming patterns shown imply a Northumbrian expansion towards our area although the western extent of this might possibly be seen within the northern bounds of the proposed 'enclosed area' in Fig:16, the largely English/Mercian nomenclature far outweighs the scattered names of Northumbrian influence.

Chapter Twelve

Scandinavian Settlement

In a previous chapter we saw that the Danes were knocking at the door of Egbert's Anglo-Saxon kingdom, this appears to have started in 787 when an Annal within the Anglo-Saxon Chronicle says that three ships arrived and the occupants killed a reeve who tried to force them to visit the royal manor. The Annal describes these visitors as *"The first ships of the Danes to come to England."* The following decades would see a growing influx of these unwelcome visitors, fleets of them began to overwhelm the native inhabitants and the hitherto minor skirmishes turned into a full-scale invasion - the Vikings were here!

In the initial stages of the Scandinavian incursions, the colonization fell into two parts:- firstly, the Danes arrived towards the end of the ninth century and their coming was followed by the arrival of the Norwegians during the early decades of the tenth century. In contrast to that of the Danes the Norwegian settlement appears to have been relatively peaceful. Within a few years of their arrival the Danes were in control of the majority of Eastern England. The West Saxons, under the leadership of King Alfred, checked further Danish incursions into other areas and, under the Treaty of Wedmore (878 AD), the Danes agreed to remain east of a line running roughly diagonally across the country between Chester and London. Because this area was subject to Danish Law it became known as the *Danelaw,* a later invasion in the latter part of the tenth century resulted in the seizure of the English throne and a Danish monarchy which lasted for twenty five years.

Although the West Saxons eventually recovered the north and the east of England, they found themselves having to use the weapons of diplomacy, rather than the sword to maintain their rule.

Archaeological and textual references, though useful, provide no more than a vague indication of the general areas in which the Scandinavians settled although a source of clarification comes from the *Anglo Saxon Chronicle,* this notes the movement of Scandinavian invaders toward the north and east and the English struggle against them. However, the record refers to actual settlement by the Scandinavian army three times only:-

- 876... *and in this year Halfdan (a chieftain) shared out the lands of Northumbria, and they were engaged in ploughing and in making a living themselves.*

- 877... *and then in autumn the host departed into Mercia, and some of it they shared out.*

- 880... *and this year the host went from Cirencester into East Anglia, and occupied that land, and shared it out.*

Yorkshire was exposed to Scandinavian colonization and rule between the years AD 867 to 954. At the end of the eleventh century, from the record of Yorkshire place-names in the Domesday Book, 69% of the locations in the West Riding were of Anglian origin with the remainder being Scandinavian. In the East Riding there was more of an even balance with only slightly less than 50% of the place-names being Scandinavian. In the North Riding 46% of the settlements were attributable to the Danes. It is necessary to distinguish here between the types of Scandinavian invaders; whilst the Danes were settling the eastern regions of England our area of the north-west was relatively quiet. It would not be until the early years of the tenth century that we would

experience any degree of Scandinavian presence and this would be in the form of the Norwegians.

The new wave of Norse people arrived here in the west (Fig:17) in small separate companies having sailed not directly from their homeland but from the Gaelic speaking Scandinavian colonies of Ireland, the Isle of Man and Strathclyde. The newcomers appeared along the coast which stretches from the Dee to beyond the Solway and, generally speaking, they were in search of lands to cultivate rather than monasteries to plunder.

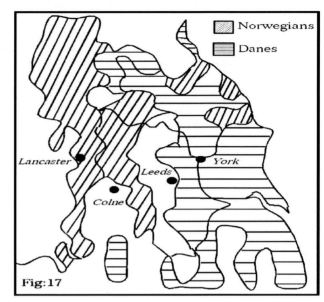

There is a lack of evidence for the Norwegians having taken the areas west of our Pennine area by force; there would have been a limit to their intentions of simply being peaceful farmers, however, as they must have been prepared to meet violence with violence to some extent (otherwise their settlement would have been very short-lived). The English chroniclers had nothing to say about large scale battles, mass slaughter or pillaging by the newcomers at this time.

Taking certain Scandinavian place-names as evidence it is apparent that a definite relationship existed between the established English and the new Scandinavian cultures. A large number of hybrid names, and place-names modified by Scandinavian speech influence, exist throughout the north and east, names such as Hurst Gill show both the OE *hyrst* and the Norse *gill* where the latter has been appended to the earlier name. The fact that so many of these types of name existed, and survived suggests that the two communities must (eventually at least) have lived in peace and harmony. Even within the more unstable early years of the Danelaw it appears that within Yorkshire, there was no significant displacement of the indigenous English, in common with their Norwegian neighbours in the east the Danes would eventually come to live by supplementation, rather than replacement of the existing population.

In a Paper entitled *The Scandinavians in Lancashire,* published in 1948, F. T. Wainright stated that:

"It is unlikely that, under the conditions which existed, they (the Norwegians) *would deliberately stimulate resistance against themselves, and although local skirmishes may well have occurred there is no reason to imagine here military operations such as preceded the Danish settlement. On the other hand the Norsemen definitely brought confusion to an area where conditions were already confused. Their presence alone would greatly aggravate the social and political insecurity of northern England and in particular of the area now known as Lancashire. It is equally clear that they exercised an appreciable influence on the course of the Anglo-Scandinavian struggle for the possession of England, the chief historical theme of these years."*

"Their influence did not end with the tenth century: they have permanently changed the racial and social structure of the area and they have left a mark on the development of Lancashire which persists even to-day. In short the Irish-Norse settlements in the north-west are no less

155

significant than the Danish settlements in the east, and for Lancashire no other event is of greater historical importance. The date of the Norse immigration is a question which has often been discussed. Ferguson ('Northmen in Cumberland and Westmorland') believed that the Norwegian settlements in Cumberland took place between 945 and 1,000 A. D. Lindkvist ('Middle English Place-names of Scandinavian Origin') saw the movement as a gradual process covering the greater part of the tenth century and extending into the eleventh. Ekwall ('Place Names of Lancashire') concluded that it took place in a fairly late period of the Viking Age, very likely from about 900, a view to which most scholars would now subscribe."

"We know from Irish chronicles, and in particular from the trustworthy Annals of Ulster, *that in 902 there arose a crisis which involved the expulsion of great numbers of Norsemen from Ireland. It seems likely that this crisis lies behind the whole Scandinavian colonization of north-western England. Secondly, Ingimund's settlement in Wirral, the only literary parallel to the Norse settlements in Lancashire, is explicitly linked with the crisis of 902. Thus the literary evidence, such as it is, points to the first decade of the tenth century."*

Prior to Ekwall's early tenth century date for Norse colonization of western Lancashire it is likely that raiding parties from Ireland had been landing in the north-west for many years. It is thought that these colonists were involved with the Hiberno-Norwegian-Danish control of York, they could well have established a base at the mouth of the Ribble in order to provide a safe haven for the Norse fleet in exile. The Dublin to York trade route was of great importance to the Scandinavian traders and the Ribble, along with the trackways through our area, played no small part in this.

The finding of a forty kilogram hoard of silver at Cuerdale in 1840 serves to illustrate the importance of the lower reaches of the Ribble. The Cuerdale Hoard was uncovered near to the former Roman base at Walton, one of the lowest crossing points of the river. It is thought that the large amount of coins, brooches and rings within the hoard, although of earlier collective date, would have been buried sometime around 905 and suggests that the Norsemen did not leave Ireland empty handed. The high number of Continental coins contained in the hoard again emphasises the importance of the Baltic trade route, from Dublin via York. As we saw in an earlier chapter, the linking of the Scandinavians from coast-to-coast provided reason for the southern House of Wessex to stem the Norse tide, this they did by creating their system of *burhs* and taking the north into Mercian hands, firstly up to an area bounded the Mersey and eventually further north to the new Northumbrian frontier of the Ribble.

The Local Frontier

That the effects of the Scandinavian incursions would have been felt within Pendle and West Craven there can be little doubt. The area fell within Danish control during the Danelaw and, whatever the level of Norse supplication here, the native inhabitants would certainly be aware of their overlords. We have the placement of a number of apparently fortified sites and it is clear that the area was at least prepared for invasion by land at various stages of its history.

Our problem here is in the definition of exactly which period a particular earthwork defence might have been created and employed. There is a line of camps, castles and beacon sites running east-west on our southern border which begins at Skipton and includes the earthworks at Carlton, Pinhaw and Bleara Lowe, the heights of Noyna, Castle-on-the-Nor to the north of Colne, Castercliffe hill fort, Burwains Camp at Thursden, Twist Castle at Extwistle and on to the beacon site on the heights of Deerplay Moor above Burnley. These are commonly assigned to the British peoples of the Bronze and Iron Ages although it is certain that some of these sites would have been

employed by following cultures - the Romans and later the Saxons were not slow to adopt pre-existing defences.

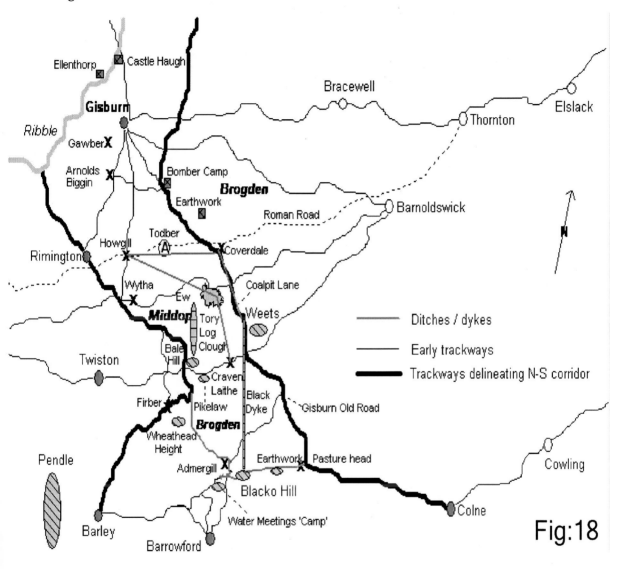

Fig:18

When assigning particular defences, however, early British and Saxon field boundaries can be easily confused with the dykes constructed for other purposes. A wider picture of an area must be obtained in order to differentiate between domestic and military earthworks. When the topography of the area is taken into account the valley leading from the Ribble to the lower slopes of Pendle Hill shows a number of features that can only bear the description of 'defence.' The valley incorporates the parishes of Gisburn, Rimington, Middop and Brogden Detached (in which Admergill lies).

As illustrated in Fig:18 this 'corridor' is formed within ancient trackways and would have provided an ideal route for an easy Pennine crossing, both from the north and east and from the

south and west. The valley runs down to the Ribble and this would have afforded any invader a fast entry through the strategic valley area and on into the Pendle region.

At the lower end of the valley, around the Ribble, we have the castles at Ellenthorpe and Castle Haugh along with the village of Gisburn. Climbing out of the village the area of Gawber is reached, this has the OE name connotation of *'to look'* and may well have related to a look- out, or early warning site. Slightly further up the valley stood the fortified manor house of Arnoldsbiggin and this estate would have been placed so as to command the passage through the valley.

Not far to the east of this site we have an area known as Coverdale, this translates as *'the angry valley'* and it is here that a large dyke system becomes evident. This runs from Coal Pit Lane at Coverdale and heads up the Middop Valley towards the defensive earthwork adjoining Middop Hall (Fig:18).

For a good distance this track runs straight until it meets with the track down to Great Todber Farm (now known as Fox Fields) where it takes a sharp turn northwards to meet with the main Gisburn to Blacko highway, it is known as Howgill Lane from this point. The construction of the lane is interesting, it is flanked by a main ditch on its northern edge, the waste from this having been used to form a banking. A secondary ditch on the Weets side creates a raised the roadway that is the present lane, there is every likelihood, however, that the ditch was not originally designed to be a trackway, rather a defensive feature protecting the northern flanks of Weets Hill.

At this point, where the track from Great Todber Farm once crossed this lane, a footpath crosses the ditch into the adjacent field, it is clear that this was actually the ancient track as two sunken roads can be seen to diverge in this field, one heads towards Weets whilst the other makes for the head of the valley near to the Greystones Moor. Where the track diverges an amount of disturbed land, on a levelled area, can be clearly seen and it is a possibility that there was a settlement of sorts here (marked **A** in Fig:18).

To reinforce this suggestion, the site has a well, two footpaths converge in its centre and an ancient, disused track (see photograph) runs straight into the area of disturbed ground.

We know that the Parish of Brogden was depopulated within the Medieval period and it has crossed my mind that this site on the Middop boundary may have been one of these lost settlements, this is pure speculation, however, without excavation the site remains a series of unexplained lumps and bumps in the earth.

Howgill Lane heads down the valley side from the Gisburn highway and once formed part of the Roman Road that ran through Barnoldswick, past Coverdale, through Todber and onwards through to Downham. The hamlet of Howgill, with its manor house and former mill, straddles the lane which then heads for Stopper Lane at Rimington. In the area between Coverdale and Howgill we have Great and Little Todber, this open part of the valley would have provided an excellent defensive system of hills as these are in a position to dominate the whole of this area. The element of *tod* in Todber was often a given-name applied to a person who managed an estate for the absent landowner, the *great* prefix probably shows that Great Todber was the local centre of farming operations for the estate 'manor farm.'

Near to the Todber area we have the Cross Hill, seen in an earlier chapter to align with Bronze Age and Iron Age sites in neighbouring Pendle and Burnley. Climbing the valley a short distance brings us to Stocks Lane, another example, as we have seen, of the name *stoc* which commonly signified an outlying area of an estate or Manor. The lane actually does relate to a manor as it runs past the property of Middop Manor Farm.

From the earthwork here a prominent dyke feature connects along the valley with Craven Laithe and the ridge of the Pikelaw hill, an ideal hill on which to dominate the through traffic from north to south. It is no coincidence that the Burnley to Gisburn turnpike crosses the ridge at this point, this is the lowest, and therefore easiest route by far. From here we pass the former

Greystones Inn and descend into the Admergill Valley at the southern end of which is the boundary stream now known as Claude's Clough. This feature connects the Pikelaw (Jackson Slack Hill) with Admergill and then heads over the ridge of Blacko Hill and on to Pasture Head. Here we have the deep hollow of Haynslack and in a field nearby is an earthwork of interest (see photograph below). Measuring some five metres square this feature takes the form of a pronounced platform of earth around three-hundred centimetres in height. The site has an excellent panoramic view and any building here would have been ideally placed as a look-out. There is added interest in this feature as it is in the area of Malkin Tower Farm within whose environs the fabled (and now lost) Malkin Tower probably stood. Could the square feature have been the foundation of the lost Tower? One thing is sure, without professional excavation this site is no more than the possible remains of a derelict hen-hut!

Earthwork on Blacko Hill

The stretch of dyke, over the ridge-top of Blacko Hillside and through Haynslack, once formed the Lancashire and Yorkshire boundary and would have been an important boundary in ancient times. It is from this ditch over Blacko Hill that the Black Dyke runs at a tangent and takes itself off up the hillside towards Weets. On a sixteenth century map the Black Dyke is described as *"the dyke which divideth Admergill from the Whitmoor."* On its southern end the dyke can be seen to have descended Blacko Hill past Blacko Hillside Farm, down to the cross- roads at the Cross Gates Inn and onwards down into the Colne Water valley before climbing once again to reach the heady heights of Castercliffe. To this end it is apparent that the dyke was anciently used as a trackway whilst later drainage work of White Moor saw it become a stream taking water down to the water mill at what is now Burnt House Farm.

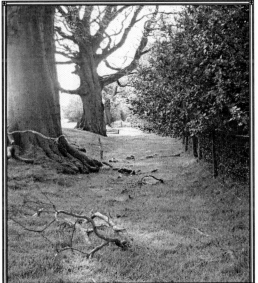

*Disused lane at Todber: marked **A** on Fig:18*

Near to the mouth of Haynslack, above Malkin Tower Farm, is another interesting feature in the shape of a raised hillock on the southern bank of the ancient boundary ditch (see photograph on page 160). This feature may be a drumlin from the glacial action that formed the area but its structure strongly suggests that it could have had a defensive purpose. The mound is circular in plan and elongated in profile; the top of the feature is level and has ample room on which to site a building so as to dominate the surrounding area. For no apparent reason an old track from Malkin

approaches the mound and forks at that point, one route carried on to Pasture head whilst the other one passed through the centre of the mound and over the boundary ditch by means of a bridge, with a little difficulty the foundations for this can still be made out.

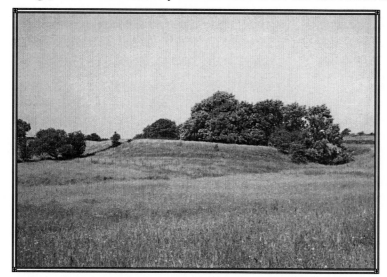

Earthwork feature at Haynslack on Blacko Hillside

Whilst on the subject of the area around Malkin it might be worth mentioning a piece of folklore collected by the Victorian author, Harrison Ainsworth, who wrote the romantic novel *The Lancashire Witches*. Published in the later nineteenth century Ainsworth's book was based on the story of the 1612 witch trials, the local knowledge he required was collected on a number of trips to the area from his home in Manchester. Ainsworth stayed at Bridge Cottage in Whalley, then a Young Lady's Seminary belonging to one of his relatives, and it was from this base that he travelled the surrounding countryside speaking to the local people. It must be remembered that the novel was nothing other than fiction based upon the realities of the people who were involved in the Pendle Witch Trials and, therefore, much of the content should be taken as it was intended by the author - as a vaguely historical romantic piece.

That is not to say, however, that Ainsworth did not pick up scraps of valuable oral history in his research for his novel. It is difficult now to distinguish truth from rumour in many folk tales but there is often at least a grain of truth within them, Ainsworth was interviewing people who had been born around the turn of the eighteenth century and they had first-hand accounts of the stories related by their older relatives. This placed the time of the witch trials at a distance of only a few generations and it is not unreasonable to expect that some truth may have been lodged deep within the stories. One of these stories is related by Ainsworth when he describes *The Legend of Malkin Tower:-*

"On the brow of a high hill forming part of the range of Pendle, and commanding an extensive view over the forest, and the wild and mountainous region around it, stands a stern solitary tower. Old as the Anglo-Saxons, and built as a stronghold by Wulstan, a Northumbrian thane, in the time of Edmund or Edred, it is circular in form and very lofty, and serves as a landmark to the country round. Placed high up in the building the door was formerly reached by a steep flight of stone steps, but these were removed some fifty or sixty years ago by Mother Demdike, and a ladder capable of being raised or let down at pleasure substituted for them, affording the only apparent means of entrance. The tower is otherwise inaccessible, the walls being of immense thickness, with no window lower than five-and-twenty feet from the ground."

"On the Norman invasion, Malkin Tower was held by Ughtred, a descendant of Wulstan, who kept possession of Pendle Forest and the hills around it, and successfully resisted the aggressions of the conquerors. His enemies affirmed he was assisted by a demon, whom he had propitiated by some fearful sacrifice made in the tower, and the notion seemed borne out by the success uniformly attending his conflicts. Ughtred's prowess was stained by cruelty and rapine. Merciless in the treatment of his captives, putting them to death by horrible tortures, or immuring them in the dark and noisome dungeon of his tower, he would hold his revels over their heads, and deride their groans. Heaps of treasure, obtained by pillage, were secured by him in the tower. From his frequent acts of treachery, and the many foul murders he perpetrated, Ughtred was styled the 'Scourge of the Normans.' For a long period he enjoyed complete immunity from punishment; but after the siege of York, and the defeat of the insurgents, his destruction was vowed by Ilbert de Lacy, lord of Blackburnshire, and this fierce chieftain set fire to part of the forest in which the Saxon thane and his followers were concealed; drove them to Malkin Tower; took it after an obstinate and prolonged defence, and considerable loss to himself, and put them all to the sword, except the leader, whom he hanged from the top of his own fortress."

Elsewhere in his book Ainsworth mentioned a story related to him by local people that another tower also existed near to Craven Laithe and Firber on Rimington Moor. To finish off this look at the defensive nature of the Gisburn/Pendle 'corridor' there are a few more place-names to add, some of these have meanings with an apparently direct relation to conflict although it must be remembered here that areas of cultivation were often named after the hardship encountered by the early farmers of the place. A site named as 'hostile' might be carrying a description of the difficulty encountered in the cultivation of the land by the early farmers.

All these minor place-names originate in the Old English unless otherwise stated:-

* **What Close** = *hwaete* = wheat, corn:
* **Hard Acre** = *heard* = harsh:
* **Cudber** = *cubyre* = cow byre:
* **Gaze Gill** = *gaesne* = barren, sterile:
* **Cring Lands** = *cring* = downfall, slaughter:
* **Aitken Wood** = *aetiecan* = add to
* **Widow Hill** = *wudo* = tree, forest, grove, wooden rood cross:
* **Bomber** = *beom* = black hornbeam or *bon* = *ban* = limb bone:
* **Sullside** = *sul* = to plough:
* **Wedacre** = *wedd* = land given by agreement or dowry:
* **Flass** = (N) *flas* = treachery, hostile:
* **Rough Hill** = *ruh* = uncultivated:
* **Raygill** = *ray* = possibly relating to fish:
* **Martin Top** = *metan* = poor, small or *maest-ing* = site of pig breeding:
* **Brogden** = the past participle of *bregden* = to move quickly/draw a sword - this suggests that the valley may have been a through-route for armed warriors - also *braegden* = crafty
* **Craven Laithe** = the outermost barn of the Craven district or the tithe barn in that part.

Conclusion

Other sites of an apparently defensive nature, such as that at the Water Meetings below Blacko, can be seen to have been part of a system of earthworks that 'blocked the funnel' of the Middop Valley route. There is no doubt that our history furnishes us with an ongoing cycle of invasion, settlement and a need to defend that settlement. For millennia our forebears have had the communal need to group together in order to defend what was perceived as being theirs by right. It is difficult for us now to appreciate the possible extent of this, even during times of protracted peace there would have been the threat from neighbours, let alone foreign invaders.

To this end I suspect that we know very little of the defences employed within our area, it is one thing to point at Castle Haugh and state the obvious fact that it was a defensive site but how many sites are we completely unaware of? How many sites have weathered away over the past three thousand years, or indeed, three hundred years? Conversely, of course, it is all too easy to over-egg the pudding in assuming that everyone was constantly at loggerheads, as the various invasions took root in settlement then times became gradually more peaceful, at least until the next drama appeared over the hills!

The valley 'corridor' would have acted as a two-way valve in as much as we know that limited numbers of Danes penetrated from the east into Blackburnshire and the Norsemen from the west found their way into Cravenshire, this is not to say, however, that anything other than local skirmishes might have taken place amongst the local population.

There must be a case for assuming that a massive ditch, with no other obvious purpose than that of the wish to control population movement (Offa's Dyke on the Welsh borders being an excellent example), was not constructed merely as a field boundary. Massive earthwork camps were built for a serious purpose but why were they located at any one particular spot? Within our area we are aware of the border between Mercia and Northumbria, no dyke was required here as the Ribble was more than a sufficient delineation between the two. What, though, of other kingdoms and principalities, how many major or minor tribal areas were there in our locality and exactly where were their boundaries? To what extent were early British settlements and later Saxon estates defended? Hopefully, if enough extant defensive features can be found within our landscape, and accurately mapped, we might eventually gain at least some answers to these questions.

I hope that I have been able to show that our landscape contains within it a larger number of features that reflect our often troubled past than might be immediately apparent. Our rich legacy of mounds, dykes, ditches, castles, battle-stones and earthwork camps are surviving testimony to this.

Chapter Thirteen

Full many a stalwart warrior lay
Upon the field of death that day,
By swarthy kite devoured, and torn
By raven with its beak of horn

And lordly eagle, plumaged white,
And hawk that follows still the fight,
And the grey wolf, whom evening brings
From forest depths to feed on kings

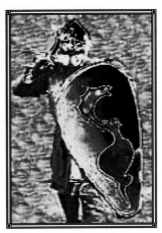

Brunanburh - The Great Battle

Amongst all of the known battles within our pre-Norman history the Battle of Brunanburh holds a special place within the collective psyche of English historians, the battle can be seen as a decisive point within our journey towards the Britain we know and love. Following his great victory at Brunanburh king Athelstan was hailed as *"Lord of warriors and ring-giver to men."* The total route of the northern armies by the Anglo-Saxons helped to cement their dominion by creating a single kingdom where there had previously been seven. The Celtic peoples were placed firmly in the western fringes of the country and the Anglo-Saxon roots of *Ængla Land* were firmly established on that fateful day in the year 937.

Alfred The Great had been the scourge of the Vikings, his system of *burhs* had enabled him to expand his kingdom of Wessex and form a base for his descendants to build upon. This they did and his son, Edward the Elder, and his grandsons, Athelstan, Edmund 1st and Eadred continued the stout resistance against the Scandinavians. Gradually the Viking kingdoms and lordships were vanquished until, in 920, Edward was finally declared to be the overlord of the British Angles, Scots and Scandinavians. However, this was by no means the end of the matter as the Northumbrians were not easily subdued, their long history as a separate kingship was a great source of pride to them. The Scots were even more inclined towards their independence from the spreading southern kingdom of Wessex and this was the cause of trouble - each time a southern king died the north reasserted itself in a declaration of independence. Things came to a head in our part of the world when the Mercian and West Saxon armies combined against the northern confederacy at the Battle of Brunanburh.

Three years before the Battle of Brunanburh Athelstan had marched north to subdue king Constantine of Scotland and his fellow northern British kings, having accepted their homage he returned home carrying the mantle of overlord of the British and Danish sub-kings and earls. Constantine had been overwhelmed by the southern show of power but he was not about to accept his fate quietly, the southern authorities were hundreds of miles away and this allowed for plans to be forged whereby he would organise an alliance of Athelstan's many enemies. Chief amongst these (Constantine's troops aside) were the Anglo-Scandinavians of Northumbria who were led by anti-Wessex rebels such as earl Orm and Archbishop Wulfstan of York. Also invited to the party were the Norsemen in Ireland under Olaf Guthfrithson, of Dublin, the northern Welsh armies under the leadership of Idwal and the Celtic king, Owein of Strathclyde.

The strength of feeling against Athelstan held by these northerners cannot be understated, the leaders of the various regions were comparative to the nobility of the Medieval and Modern periods whereby most of the ruling families were related to each other. Not only did each leader wish to consolidate and expand their own authority, they were also highly sensitive to wrongs done (or perceived to have been done) to their kinsmen in other regions. An example of this can be seen in the Irish kingdoms where the Scandinavians arrived in serious numbers within the ninth century and added fuel to the already blazing fires of inter-tribal wars there. By the year 877 the Annals of Ulster record that things had settled somewhat, there being no fresh Norse invasions for the next forty years. In 916 Dublin was captured by the Norsemen under the leadership of Sigtrygg and between 920 and 970 Scandinavian power in Ireland reached its peak, the country was plundered by foreigners and natives alike. In the year 920 Sitric (Sigtrygg) was driven out of Dublin by his brother, Godfred, and he retired to York where he became the king of the northern province of Deira.

Around the year 927 Sitric died and Athelstan took the opportunity to annex Deira to the south, Sitric's sons, Olaf Sihtricson and Godfred, were expelled from England and settled in Scotland and Ireland. Olaf took part at Brunanburh where he was one of the leaders of the confederacy. Confusingly, this Olaf's cousin was also called Olaf (Guthfrithson) but was usually given the name of Anlaf. Anlaf (died 941) was the son of Godfred (Guthfrith), king of Dublin, and attained the title himself in 934, in this capacity he led the Hiberno-Norse factions in the uprising of 937. This, at least, is the general version of events, some accounts of the two Olaf's intermix their lives to such an extent that it becomes difficult to distinguish between them.

The location of the Battle of Brunanburh is scantly described in written texts although the battle itself is relatively well documented for the Dark Age period; the twelfth century historian of the early English, William of Malmesbury (c.1080/1095 - c.1143) was a monkish scholar at the Abbey of Malmesbury and left an account of the battle. It was at Malmesbury Abbey that Athelstan was buried in the year 941. To this day, the "commoners" of this place enjoy certain lands which the king bestowed upon the townsmen for services that they rendered unto him in his wars. A description of the battle is also found in four manuscripts of the Anglo Saxon Chronicles as *The Athelstan:- "937... this year Aethelstan and Edward his brother led a force to Brunanburgh and there fought against Olaf and Christ helping him had the victory and there they slew five kings and seven earls."*

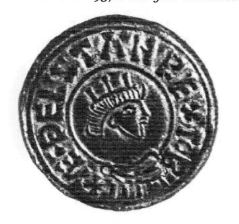

An Athelstan silver penny bearing the inscription REX TOTIUS BRITANNIAE *whereby Athelstan was declaring himself as 'Ruler of All Britain'*

The early English chronicler, Ethelward of Wessex, was a descendant of king Alfred's brother, Ethelred, and wrote accounts of the battle largely based upon the Anglo-Saxon Chronicles. Although the common spelling of the name is now Brunanbur(g)h early writers on the subject had numerous variations. For example, Ethelward had *Brunandune,* Simeon gives *Wendune on Brunanburh,* Malmesbury and Tugulf have *Brunanburh* and *Bruford,* Florence of Worcester said *"near Brunanburh,* Henry of Huntingdon had *Brunesburh,* Gaimer said *Brunswerc,* the Annales Cambriae styled the name *Bellum Brun (Battles of the Brun),* Fordum had it as *Brounyngfeld,* Groses Antiquities has it as *Brinkburn* and in

similar fashion Camden named it *Brincaburh*. All of these variations refer to roughly the same meaning of the *'Fortification on the Brown Ber/Hill'* - one account of the battle, by Simeon, stated that it took place at the fortified site of *Brunanburh* on the hill known as *Weondun* or *Wendune*, where there had been a pagan temple. The description of a *'holy hill'* matches the name in as much as the OE *wen = wynn* meaning *joyous*, this has a connotation of worship, the OE *wén* has a different meaning as it described a site upon a bend or twist (presumably in a river or valley).

The Anglo-Saxon Chronicles describe the savagery of the battle as does the Annals of Ulster which states that the battle was *"Immense, ahorrible.....desperately fought"*. There is a caveat in the Chronicles, however, as the political nature of the contemporary English account in extolling the virtues of the Anglo-Saxon bravery and skill must be taken into account. Having said that, there is no doubt that the English soundly beat the northern alliance, largely because they were a better organised, well armed force. The rebels were routed and pursued by the English until darkness fell, the account of the Chronicle stated that the survivors were chased back to their ships; when they eventually arrived home the tattered remnant of the Irish force made a pitiful sight.

The northern alliance had been destroyed in the battle, amongst their losses were *"five kings and seven princes"* including king Owein, seven of Olaf's earls and one of Constantine's sons. The battle account of the Chronicles was described by one modern Anglo-Saxon scholar:- *"The poem lacks the epic perception and direct power of the folk-song as well as invention. The patriotic enthusiasm, however, upon which it is borne, the lyrical strain which pervades it, yield their true effect. The rich resources derived from the national epos are here happily utilised, and the pure versification and brilliant style of the whole stir our admiration."*

The following is one of many translated versions of the Chronicles, experts tell us that it is unclear whether the poem was actually written for the Chronicle or absorbed into it at a later date:

The Battle of Brunanburh

"937.... In this year King Athelstan, Lord of warriors, ring-giver to men, and his brother also, Prince Eadmund, won eternal glory in battle with sword edges around Brunanburh ~ They split the shield-wall, they hewed battle shields with the remnants of hammers ~ The sons of Eadweard, it was only befitting their noble descent from their ancestors that they should often defend their land in battle against each hostile people, horde and home ~ The enemy perished, Scots men and seamen, fated they fell ~ The field flowed with blood of warriors, from sun up in the morning, when the glorious star glided over the earth, God's bright candle, eternal lord, till that noble creation sank to its seat ~ There lay many a warrior by spears destroyed; Northern men shot over shield, likewise Scottish as well, weary, war sated ~ The West-Saxons pushed onward all day; in troops they pursued the hostile people ~ They hewed the fugitive grievously from behind with swords sharp from the grinding ~ The Mercians did not refuse hard hand-play to any warrior who came with Anlaf (Olaf) over the sea-surge in the bosom of a ship, those who sought land, fated to fight ~ Five lay dead on the battle-field, young kings, put to sleep by swords, likewise also seven of Anlaf's earls, countless of the army, sailors and Scots ~ There the North- men's chief was put to flight, by need constrained to the prow of a ship with little company: he pressed the ship afloat, the king went out on the dusky flood-tide, he saved his life ~ Likewise, there also the old campaigner through flight came to his own region in the north - Constantine - hoary warrior ~ He had no reason to exult the great meeting; he was of his kinsmen bereft, friends fell on the battle-field, killed at strife: even his son, young in battle, he left in the place of slaughter, ground to pieces with wounds ~ That grizzle-haired warrior had no

reason to boast of sword-slaughter, old deceitful one, no more did Anlaf; with their remnant of an army they had no reason to laugh that they were better in deed of wars battle-field - collision of banners, encounter of spears, encounter of men, trading of blows - when they played against the sons of Eadweard on the battle field ~ Departed then the Northmen in nailed ships ~ The dejected survivors of the battle, sought Dublin over the deep water, leaving Dinges mere to return to Ireland, ashamed in spirit ~ Likewise the brothers, both together, King and Prince, sought their home, West-Saxon land, exultant from battle ~ They left behind them, to enjoy the corpses, the dark coated one, the dark horny-beaked raven and the dusky-coated one, the eagle white from behind, to partake of carrion, greedy war- hawk, and that gray animal the wolf in the forest ~ Never was there more slaughter on this island, never yet as many people killed before this with sword's edge: never according to those who tell us from books, old wisemen, since from the east Angles and Saxons came up over the broad sea ~ Britain they sought, proud war-smiths who overcame the Welsh, glorious warriors they took hold of the land."

Preparation for The Battle

Some schools of thought believe that the northern alliance planned to consolidate their forces at York and ravage the lands from the Humber southwards. Things did not proceed as quickly as the Scottish king, Constantine, would have wished as later in the year Anlaf had not even set sail from Ireland for the mainland. The Dublin contingent had been occupied in gathering, mainly by force, a private fleet to carry them to the muster, they were still in Ireland in early August but eventually they arrived in England. Some historians say that the Irish fleet sailed around to the Humber via the north of Scotland, this is not generally accepted, however, as this hazardous route was to be avoided unless absolutely necessary. It is more likely that the landing would have been on the east coast in either the Ribble estuary or the Mersey from where they could march inland to meet with their allies.

Whilst the north was mustering Athelstan appeared to be quiet, he was fully aware of the threat but was not about to be rushed into a hurried march north. Steadily through the year he exercised his rights to raise troops by the levy system in Wessex, Sussex and Hampshire along with Mercia in the Midlands. In the autumn of the year Athelstan moved northwards as he had done three years earlier when he subdued Constantine, this meant that he knew the land and the routes; previously he had marched by way of the surviving Roman roads through Derby, York, Chester-le-Street, Edinburgh and Perth. It is not known which route Athelstan chose in 937, he would be aware that the northerners knew of his previous way and would expect him to use it again, therefore the rebels would have the advantage. Taking this in to account it is possible that the southern armies would have taken an alternative route, all we do know is that Athelstan, his brother Edmund and their allies, arrived in the north and set about their enemies at Brunanburh.

The Saxons were not the only forces involved in the momentous battle, small mercenary armies from other parts of the country, and from the Continent, also played a part. In fact, as will be seen, two Norwegian brothers, with their three-hundred strong force, were to be essential allies to Athelstan when the battle began. It is also suggested in some accounts that the first recorded English cavalry charge was carried out at Brunanburh, a tactic so successfully employed by the Persian armies against the Romans one thousand years previously. The *Anglo Saxon Chronicle* account of the events in 937 were written at a later date.

Another account of the battle is provided in the family history of one Egil Skalagrimmson and can be seen as more of a contemporary account, the subject having actually fought at the battle. Care must be taken, however, the story is no different to any other saga in that the subject tended

to be vested with almost supernatural powers, a natural quirk of human nature when recounting the adventures of family heroes. Nevertheless, the history of Egil is of value and worthy of repeat: the following is a translation of this history (abbreviated) by Rev. W. C. Green, published in 1893:-

The Story of Egil Skalagrimmson

☐ Alfred the Great ruled England, being of his family the first supreme king over England. That was in the days of Harold Fairhair, king of Norway. After Alfred, Edward his son was king in England. He was father of Athelstan the Victorious, who was foster-father of Hacon the Good. It was at this time of our story that Athelstan took the kingdom after his father. There were several brothers, sons of Edward.

But when Athelstan had taken the kingdom, then those chieftains who had lost their powers to his forefathers rose in rebellion; now they thought was the easiest time to claim back their own, when a young king ruled the realm. These were Britons, Scots and Irish. King Athelstan therefore gathered him an army, and gave pay to all such as wished to enrich themselves, both foreigners and natives.

The brothers Thorolf and Egil were standing southwards along Saxony and Flanders when they heard that the king of England wanted men and that there was in his service hope of much gain. So they resolved to take their force thither. And they went on that autumn till they came to king Athelstan. He received them well; he saw plainly that such followers would be of great help. Full soon did the English king decide to ask them to join him, to take pay there, and become defenders of his land. They so agreed between them that they became Athelstan's men.

England was thoroughly Christian in faith, and had long been so when these things happened. King Athelstan was a good Christian; he was called Athelstan the Faithful. The king asked Thorolf and his brother to consent to take the first signing with the cross, for this was then a common custom both with merchants and those who took soldiers' pay in Christian armies, since those who were 'prime-signed' (as 'twas termed) could hold all intercourse with Christians and heathens alike, while retaining the faith which was most to their mind. Thorolf and Egil did this at the king's request, and both let themselves be prime-signed. They had three hundred men with them who took the king's pay.

Of Olaf, king of Scots

Olaf the Red was the name of the king in Scotland. He was Scotch on his father's side, but Danish on his mother's side, and came of the family of Ragnar Hairy-breeks. He was a powerful prince. Scotland, as compared with England, was reckoned a third of the realm; Northumberland was reckoned a fifth part of England; it was the northernmost county, marching with Scotland on the eastern side of the island. Formerly the Danish kings had held it. Its chief town is York. It was in Athelstan's dominions; he had set over it two earls, the one named Alfgeir, the other Gudrek. They were set there as defenders of the land against the inroads of Scots, Danes, and Norsemen, who harried the land much, and though they had a strong claim on the land there, because in Northumberland nearly all the inhabitants were Danish by the father's or mother's side, and many by both.

Bretland was governed by two brothers, Bring and Adils; they were tributaries under king Athelstan, and withal had this right, that when they were with the king in the field, they and their force should be in the van of the battle before the royal standard. These brothers were right good warriors, but not young men.

Alfred the Great had deprived all tributary kings of name and power; they were now called earls, who had before been kings or princes. This was maintained throughout his lifetime and his son Edward's. But Athelstan came young to the kingdom, and of him they stood less in awe. Wherefore many now were disloyal who had before been faithful subjects.

Of the Gathering of the Host

Olaf king of Scots, drew together a mighty host, and marched upon England. When he came to Northumberland, he advanced with shield of war. On learning this, the earls who ruled there mustered their force and went against the king. And when they met there was a great battle, whereof the issue was that king Olaf won the victory, but earl Gudrek fell, and Alfgeir fled away, as did the greater part of the force that had followed them and escaped from the field.

And now king Olaf found no further resistance, but subdued all of Northumberland. Alfgeir went to king Athelstan, and told him of his defeat. But as soon as king Athelstan heard that so mighty a host was come into his land, he despatched men and summoned forces, sending word to his earls and other nobles. And with such force as he had he at once turned him and marched against the Scots. But when it was bruited about that Olaf king of Scots had won a victory and subdued under him a large part of England, he soon had a much larger army than Athelstan, for many nobles joined him. And on learning this, Bring and Adils, who had gathered much people, turned to swell king Olaf's army. Thus their numbers became exceeding great.

All this when Athelstan learned, he summoned to conference his captains and his counsellors; he inquired of them what were best to do; he told the whole council point by point what he had ascertained about the doings of the Scots' king and his numbers. All present were agreed on this, that Alfgeir was most to blame, and thought it were but his due to lose his earldom. But the plan resolved on was this, that king Athelstan should go back to the south of England, and then for himself hold a levy of troops, coming northwards through the whole land; for they saw that the only way for the needful numbers to be levied in time was for the king himself to gather the force. As for the army already assembled, the king set over it as commanders Thorolf and Egil.

They were also to lead that force which the freebooters had brought to the king. But Alfgeir still held command over his own troops. Further, the king appointed such captains of companies as he thought fit. When Egil returned from the council to his fellows, they asked him what tidings he could tell them of the Scots' king. He sang:

"Olaf one earl by furious onslaught in flight hath driven ~ The other slain; a sovereign stubborn in fight is he ~ Upon the field fared Gudrek false path to his undoing ~ He holds, this foe of England, Northumbria's humbled soil"

After this they sent messengers to king Olaf, giving out this as their errand, that king Athelstan would fain enhazel him a field and offer battle on Vin-heath by Vin-wood; meanwhile he would have them forbear to harry his land; but of the twain he should rule England who should conquer

in the battle. He appointed a week hence for the conflict, and whichever first came on the ground should wait a week for the other. Now this was then the custom, that so soon as a king had enhazelled a field, it was a shameful act to harry before the battle was ended. Accordingly king Olaf halted and harried not, but waited till the appointed day, when he moved his army to Vinheath.

North of the heath stood a town. There in the town king Olaf quartered him, and there he had the greatest part of his force, because there was a wide district around which seemed to him convenient for the bringing in of such provisions as the army needed. But he sent men of his own up to the heath where the battlefield was appointed; these were to take camping-ground, and make all ready before the army came. But when the men came to the place where the field was enhazelled, there were all the hazel poles set up to mark the ground where the battle should be. The place ought to be chosen level, and whereon a large host might be set in array. And such was this; for in the place where the battle was to be the heath was level, with a river flowing on one side, on the other a large wood.

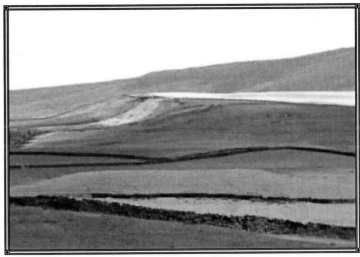

Deerstone Moor with Boulsworth Hill in the background.

Was this level site part of the battlefield?

But where the distance between the wood and the river was least (though this was a good long stretch), there king Athelstan's men had pitched, and their tents quite filled the space between wood and river. They had so pitched that in every third tent there were no men at all, and in one of every three but few. Yet when king Olafs men came to them, they had then numbers swarming before all the tents, and the others could not get to go inside. Athelstan's men said that their tents were all full, so full that their people had not nearly enough room. But the front line of tents stood so high that it could not be seen over them whether they stood many or few in depth. Olafs men imagined a vast host must be there.

King Olafs men pitched north of the hazel-poles, toward which side the ground sloped a little. From day to day Athelstan's men said that the king would come, or was come, to the town that lay south of the heath. Meanwhile forces flocked to them both day and night. But when the appointed time had expired, then Athelstan's men sent envoys to king Olaf with these words: 'king Athelstan is ready for battle, and has a mighty host. But he sends to king Olaf these words, that he would fain they should not cause so much bloodshed as now looks likely; he begs Olaf rather to go home to Scotland, and Athelstan will give him as a friendly gift of one shilling of silver from every plough through all his realm, and he wishes that they should become friends. When the messengers came to Olaf he was just beginning to make ready his army, and purposing to attack. But on the messengers declaring their errand, he forebore to advance for that day. Then he and his

captains sate in council. Wherein opinions were much divided. Some strongly desired that these terms should be taken; they said that this journey had already won them great honour, if they should go home after receiving so much money from Athelstan. But some were against it, saying that Athelstan would offer much more the second time, were this refused. And this latter counsel prevailed. Then the messengers begged king Olaf to give them time to go back to king Athelstan, and try if he would pay yet more money to ensure peace. They asked a truce of one day for their journey home, another for deliberation, a third to return to Olaf. The king granted them this.

The messengers went home, and came back on the third day according to promise; they now said to king Olaf that Athelstan would give all that he offered before, and over and above, for distribution among king Olaf's soldiers, a shilling to every freeborn man, a silver mark to every officer of a company of twelve men or more, a gold mark to every captain of the king's guard, and five gold marks to every earl. Then the king laid this offer before his forces. It was again as before; some opposed this, some desired it. In the end the king gave a decision: he said he would accept these terms, if this too were added, that king Athelstan let him have all Northumberland with the tributes and dues thereto belonging. Again the messengers ask armistice of three days, with this further, that king Olaf should send his men to hear Athelstan's answer, whether he would take these terms or no; they say that to their thinking Athelstan will hardly refuse anything to ensure peace. King Olaf agreed to this and sent his men to king Athelstan.

Then the messengers ride all together, and find king Athelstan in the town that was close to the heath on the south. King Olafs messengers declare before Athelstan their errand and the proposals for peace. King Athelstan's men told also with what offers they had gone to king Olaf, adding that this had been the counsel of wise men, thus to delay the battle so long as the king had not come. But king Athelstan made a quick decision on this matter, and thus bespake the messengers: "Bear ye these my words to king Olaf, that I win give him leave for this, to go home to Scotland with his forces; only let him restore all the property that he has wrongfully taken here in the land. Then make we peace between our lands, neither harrying the other. Further be it provided that king Olaf shall become my vassal, and hold Scotland for me, and be my under- king. Go now back," said he, "and tell him this."

At once that same evening the messengers turned back on their way, and came to king Olaf about midnight; they then waked up the king, and told him straightway the words of king Athelstan. The king instantly summoned his earls and other captains; he then caused the messengers to come and declare the issue of their errand and the words of Athelstan. But when this was made known before the soldiers, all with one mouth said that this was now before them, to prepare for battle. The messengers said this too, that Athelstan had a numerous force, but he had come into the town on that same day when the messengers came there.

Then spoke earl Adils, "Now, methinks, that has come to pass, Oh king, which I said, that ye would find tricksters in the English. We have sat here long time and waited while they have gathered to them all their forces, whereas their king can have been nowhere near when we came here. They will have been assembling a multitude while we were sitting still. Now this is my counsel, Oh king, that we two brothers ride at once forward this very night with our troop. It may be they will have no fear for themselves, now they know that their king is near with a large army. So we shall make a dash upon them. But if they turn and fly, they will lose some of their men, and be less bold afterwards for conflict with us." The king thought this good counsel. "We will here make ready our army," said he, "as soon as it is light, and move to support you." This plan they fixed upon council.

Of the Fight

Earl Hring and Adils his brother made ready their army, and at once in the night moved southwards for the heath. But when day dawned, Thorolf's sentries saw the army approaching. Then was a war-blast blown, and men donned their arms selects spirited and that they began to draw up the force, and they had two divisions. Earl Alfgeir commanded one division, and the standard was borne before him. In that division were his own followers, and also what force had been gathered from the countryside. It was a much larger force than that which followed Thorolf and Egil. Thorolf was thus armed; He had a shield ample and stout, a right strong helmet on his head; he was girded with the sword that he called Long, a weapon large and good. In his hand he had a halberd, whereof the feather-formed blade was two ells long *(around six-feet)*, ending in a four-edged spike; the blade was broad above, the socket both long and thick. The shaft stood just high enough for the hand to grasp the socket, and was remarkably thick. The socket fitted with an iron prong on the shaft, which was also wound round with iron. Such weapons were called 'mail-piercers.'

Egil was armed in the same way as Thorolf He was girded with the sword that he called Adder; this he had gotten in Courland; it was a right good weapon. Neither of the two had shirt of mail. They set up their standard, which was borne by Thofid the Strong. All their men had Norwegian shields and Norwegian armour in every point; and in their division were all the Norsemen who were present. Thorolf's force was drawn up near the wood, Alfgeir's moved along the river. Earl Adils and his brother saw that they would not come upon Thorolf unawares, so they began to draw up their force. They also made two divisions, and had two standards. Adils was opposed to earl Alfgeir, Hring to the freebooters. The battle now began; both charged with spirit. Earl Adils pressed on hard and fast till Alfgeir gave ground; then Adils' men pressed on twice as boldly. Nor was it long before Alfgeir fled. And this is to be told of him, that he rode away south over the heath, and a company of men with him. He rode till he came near the town, where sate the king. Then spake the earl: "I deem it not safe for us to enter the town. We got sharp words of late when we came to the king after defeat by king Olaf; and he will not think our case bettered by this coming. No need to expect honour where he is." Then he rode to the south country, and of his travel 'tis to be told that he rode night and day till he and his came westwards to Earls-ness. Then the earl got a ship to take him southwards over the sea; and he came to France, where half of his kin were. He never after returned to England.

Adils at first pursued the flying foe, but not far; then he turned back to where the battle was, and made an onset there. This when Thorolf saw, he said that Egil should turn and encounter him, and bade the standard be borne that way; his men he bade hold well together and stand close. "Move we to the wood," said he, "and let it cover our back, so that they may not come at us from all sides." They did so; they followed along the wood. Fierce was the battle there. Egil charged against Adils, and they had a hard fight of it. More of Adil's men fell than of Egil's.
Then Thorolf became so furious that he cast his shield on his back, and, grasping his halberd with both hands, bounded forward dealing cut and thrust on either side. Men sprang away from him both ways, but he slew many. Thus he cleared the way forward to earl Hring's standard, and then nothing could stop him. He slew the man who bore the earl's standard, and cut down the standard-pole. After that he lunged with his halberd at the earl's breast, driving it right through mail-coat and body, so that it came out at the shoulders; and he lifted him up on the halberd over his head, and planted the butt-end in the ground. There on the weapon the earl breathed out his

life in sight of all, both friends and foes. Then Thorolf drew his sword and dealt blows on either side, his men also charging. Many Britons and Scots fell, but some turned and fled. But earl Adils seeing his brother's fall, and the slaughter of many of his force, and the flight of some, while himself was in hard stress, turned to fly, and ran to the wood. Into the wood fled he and his company; and then all the force that had followed the earl took to flight. Thorolf and Egil pursued the flying foe. Great was then the slaughter; the fugitives were scattered far and wide over the heath. Earl Adils had lowered his standard; so none could know his company from others. And soon the darkness of night began to close in. Thorolf and Egil returned to their camp; and just then king Athelstan came up with the main army, and they pitched their tents and made their arrangements. A little after came king Olaf with his army; they, too, encamped and made their arrangements where their men had before placed their tents. Then it was told king Olaf that both his earls Hring and Adils were fallen, and a multitude of his men likewise.

The Fall of Thorolf

King Athelstan had passed the night before in the town whereof mention was made above, and there he heard rumour that there had been fighting on the heath. At once he and all the host made ready and marched northwards to the heath. There they learnt all the tidings clearly, how that battle had gone. Then the brothers Thorolf and Egil came to meet the king. He thanked them much for their brave advance, and the victory they had won; he promised them his hearty friendship. They all remained together for the night. No sooner did day dawn than Athelstan waked up his army. He held conference with his captains, and told them how his forces should be arranged. His own division he first arranged, and in the van thereof he set those companies that were the smartest. Then he said that Egil should command these: "But Thorolf," said he, "shall be with his own men and such others as I add thereto. This force shall be opposed to that part of the enemy which is loose and not in set array, for the Scots are ever loose in array; they run to and fro, and dash forward here and there. Often they prove dangerous if men be not wary, but they are unsteady in the field if boldly faced." Egil answered the king: "I will not that I and Thorolf be parted in the battle; rather to me it seems well that we two be placed there where is like to be most need and hardest fighting." Thorolf said, "Leave we the king to rule where he will place us, serve we him as he likes best. I will, if you wish it, change places with you." Egil said, "Brother, you will have your way; but this separation I shall often rue."

After this they formed in the divisions as the king had arranged, and the standards were raised. The king's division stood on the plain towards the river; Thorolf's division moved on the higher ground beside the wood. King Olaf drew up his forces when he saw king Athelstan had done so. He also made two divisions; and his own standard, and the division that himself commanded, he opposed to king Athelstan and his division. Either had a large army, there was no difference on the score of numbers. But king Olaf's second division moved near the wood against the force under Thorolf. The commanders thereof were Scotch earls, the men mostly Scots; and it was a great multitude. And now the armies closed, and soon the battle waxed fierce. Thorolf pressed eagerly forward, causing his standard to be borne onwards along the woodside; he thought to go so far forward as to turn upon the Scotch king's division behind their shields. His own men held their shields before them; they trusted to the wood which was on their right to cover that side. So far in advance went Thorolf that few of his men were before him. But just when he was least on his guard, out leapt from the wood earl Adils and his followers. They thrust at Thorolf at once with many halberds, and there by the wood he fell. But Thorfid, who bore the standard, drew back to

172

where the men stood thicker. Adils now attacked them, and a fierce contest was there. The Scots shouted a shout of victory, as having slain the enemy's chieftain. This shout when Egil heard, and saw Thorolf's standard going back, he felt sure that Thorolf himself would not be with it.

So he bounded thither over the space between the two divisions. Full soon learnt he the tidings of what was done, when he came to his men. Then did he keenly spur them on to the charge, himself foremost in the van. He had in his hand his sword Adder. Forward Egil pressed, and hewed on either hand of him, felling many men. Thorfid bore the standard close after him, behind the standard followed the rest. Right sharp was the conflict there. Egil went forward till he met earl Adils. Few blows did they exchange ere earl Adils fell, and many men around him. But after the earl's death his followers fled. Egil and his force pursued, and slew all whom they overtook; no need there to beg quarter.

Nor stood those Scotch earls long, when they saw the others their fellows fly; but at once they took to their heels. Whereupon Egil and his men made for where king Olaf's division was, and coming on them behind their shields soon wrought great havoc. The division wavered, and broke up. Many of king Olaf's men then fled, and the Norsemen shouted a shout of victory. But when king Athelstan perceived king Olaf's division beginning to break, he then spurred on his force, and bade his standard advance. A fierce onset was made, so that king Olaf's force recoiled, and there was a great slaughter. King Olaf fell there, and the greater part of the force which he had had, for of those who turned to fly all those overtaken were slain. Thus king Athelstan gained a signal victory.

Egil Buries Thorolf

While his men still pursued the fugitives, king Athelstan left the battle-field, and rode back to the town, nor stayed he for the night before he came thither. But Egil pursued the flying foe, and followed them far, slaying every man whom he overtook. At length, sated with pursuit, he with his followers turned back, and came where the battle had been, and found there the dead body of his brother Thorolf. He took it up, washed it, and performed such other offices as were the wont of the time. They dug a grave there, and laid Thorolf therein with all his weapons and raiment. Then Egil clasped a gold bracelet on either wrist before he parted from him; this done they heaped on stones and cast in mould.

Egil was large-featured, broad of forehead, with large eyebrows, a nose not long but very thick, lips wide and long, chin exceeding broad, as was all about the jaws; thick-necked was he, and big-shouldered beyond other men, hard featured, and grim when angry. He was well-made, more than commonly tall, had hair wolf-gray and thick, but became early bald. He was black-eyed and brown-skinned.

Then those men were healed whose wounds left hope of life. Egil abode with king Athelstan for the next winter after Thorolf's death, and had very great honour from the king. With Egil was then all that force which had followed the two brothers, and come alive out of the battle. Then gave Athelstan further to Egil as poet's meed two gold rings, each weighing a mark, and therewith a costly cloak that the king himself had formerly worn. But when spring came Egil signified to the king this, that he purposed to go away in the summer to Norway, and to learn "how matters stand with Asgerdr, my late brother Thorolf's wife. A large property is there in all; but I know not whether there be children of theirs living. I am bound to look after them, if they live; but I am heir to all, if Thorolf died childless."

The king answered, "This will be, Egil, for you to arrange, to go away hence, if you think you have an errand of duty; but I think 'twere the best way that you should settle down here with me on such terms as you like to ask." Egil thanked the king for his words. "I will," he said, "now first go, as I am in duty bound to do; but it is likely that I shall return hither to see after this promise so soon as I can." The king bade him do so. Whereupon Egil made him ready to depart with his men; but of these many remained behind with the king. Egil had one large war-ship, and on board thereof a hundred men or thereabouts. And when he was ready for his voyage, and a fair wind blew, he put out to sea. He and king Athelstan parted with great friendship: the king begged Egil to return as soon as possible. This Egil promised to do. Then Egil stood for Norway, and when he came to land sailed with all speed into the Firths. He heard these tidings, that lord Thorir was dead, and Arinbjorn had taken inheritance after him, and was made a baron. Egil went to Arinbjorn and got there a good welcome. Arinbjorn asked him to stay there. Egil accepted this, had his ship set up, and his crew lodged. But Arinbjorn received Egil and twelve men; they stayed with him through the winter□

A Saxon burial cairn

Another part of the story, from a different source to the Egil Saga, relates to the death of Athelstan's bishop, Wersthan:

"While the armies lay encamped over against each other, Anlaf, seeking to know what Athelstan proposed to do, disguised himself as a minstrel, and so made his way into the tent of the king. There he played and sang, while Athelstan and his nobles sat at their meal, and while he seemed to be resting from his playing and singing, he listened to their talk. The meal ended, the king gave him a silver piece. This he buried in the earth, disdaining to keep that which had been given him as hire for service. But one who had been a soldier under him in former times, saw the prince while he was burying the money, and knew him again. The man kept silence till Anlaf had gone back to his own camp, then he told the English king what he had seen. "Why did you delay?" said the King. "Had you been quicker, we had caught him." The man made answer "Sire, the same oath that I have sworn to you, I swore once to Anlaf. If I had betrayed him, you might have looked for me to betray you. But now, if you will listen to my advice, change the place of your tent." The king changed it, and it was well that he did so, for the camp was attacked that night, and a certain bishop, who, being newly come thither, pitched his tent in the place where the King's had been, was slain."

The Battle Site

*"Here, King Athelstan, leader of warriors,
ring-giver of men, and also his brother,
the aetheling Edmund, struck life-long glory in strife around Brunanburh"*

174

Many locations for the battle have been proposed, sites ranging from the north-east to Doncaster to Lockerbie being put in the frame. One of the strongest claims to fame has long been that of Bromborough, on the Wirrall. Recently a claim was made that a local historian had finally discovered the scene of the battle and that it had taken place on what is now the Brackenwood Golf Course , in the Storeton Woods area of Bebington on the Wirral. The bulk of the evidence put forward for this centres on a few mounds and a local road known as Battle Lane. There appears, however, to be scant evidence here to prove that the area was the battle site - the Wirral is not a place known for its hills and the battle was described as having taken place on high ground, also there are few tumuli and cairn sites, the northern confederacy would have found themselves with their backs to the sea and William of Malmesbury reported the battle as *"having been far into England."*

In his search for a site, the local historian is hindered by the fact that local legend tends to be interwoven with fact, wishful-thinking clouds the objective eye. On the other hand, he does have the advantage of local experience. Realistically, it is not unreasonable to propose that the battle site would be somewhere along a line drawn across the country from the Ribble to the Humber. Assuming that the most likely landing point for the Irish would have been the Ribble (this would afford the quickest route to York) then they would follow the river closely for much of its length. The north-bound Welsh army of Owein might have struck out through Northwich, along the old Roman road through Manchester, Castleshaw, Slack and directly onwards towards York, somewhere along this route they would have expected to meet with the armies of their allies.

Alternatively it would have made sense militarily for any (relatively small) Welsh contingent to have joined forces with their Celtic brothers as soon as was practicable. Any intended meeting would have taken place somewhere to the south of the Ribble, the obvious Pennine crossing point having been the Aire Gap. If this were indeed the case then the planned route would have taken the Welsh invaders along the other west-coast Roman *iter* running from Chester to Wilderspool at the mouth of the Mersey, on through Wigan to Walton-le-Dale on the Ribble (where a muster with the Irish and Strathclyde troops could take place) and then inland along the Ribble to meet with the larger Northumbrian and Scottish armies. They might equally have taken the shorter west-bound route by leaving the Ribble at Mitton and headed south of Pendle Hill along the Calder, using the ancient trading roads through Blackburnshire.

This would put the Irish-Norse armies of Anlaf, along with the Welsh army of Idwal and some of Owein's Strathclyde faction, on a line from Preston to York and, knowing this, Athelstan might very well have seen his chance to cut them off before they met up with their compatriots who were mustered to the east. To this end Athelstan could have veered westwards from his route north so as to outflank the threat from the east whilst the bulk of the northern armies would counter this move by heading west from their Yorkshire base.

Assuming that Athelstan would take the quickest route north, along what is now the A1 road corridor, he would roughly follow his earlier way except that he may well have struck out to the west around Doncaster, instead of taking the expected road straight to York, where he would wheel round to the rear of any forces along the Humber. Moving westwards from Doncaster, Athelstan could have headed straight for the east-bound Irish invaders via Halifax and on towards the Ribble. This would have meant that the southern armies would have travelled along the ancient trackway, known as the Long Causeway, running along the higher ground of Upper Calderdale towards Burnley. An old poem relates the journey along the Long Causeway:

Brunley for ready money,
Mereclough ne'er trust,
tha teks a peep at Stiperden,
but call at Kebs tha must.

Blackshaw Yed for travellers,
an' Heptonstall for trust,
Hepton Brig for landladies,
an' Midgley in't moor.

Luddenden's a waarm shop,
Roylehead's reight cold,
an' if tha gets to Halifax,
tha mun bi middlin' bold!

A road was called a causeway if it was of sufficient importance to be paved with stones, at this time a paved road would have been a relatively rare luxury to the long-distance traveller. As the Long Causeway reaches the outskirts of Burnley it delivers its travellers into the region of mounds, dens, earthworks, battle-stones and castles that covers the high ground between Mereclough, Worsthorne Moor, Boulsworth and Emmott Moor.

Egil's description of the battle fits with others in that the battle was not one singular bout of intense fighting, on the contrary there had been a savage interaction between the northern and southern forces on the day previous to the main battle. The vanguard of both sides had arrived on the prepared battlefield and fighting commenced before Athelstan had reached the area. The northern armies were fooled into delaying their attack until the southern king eventually arrived. The main battle itself, whilst centred originally on the *Brunen-burh,* consisted of many smaller clashes and skirmishes which eventually spread over a wide area. The fight was undertaken in regular battle-order and therefore a large tract of open land was required, there would have been encampments of troops and their supplies on all suitable sites around the intended field of conflict.

Chapter Fourteen

The Battles of Burnley and Hastings

On the 4th December, 1856, Thomas Turner Wilkinson (1815-1875), a master at Burnley Grammar School and local historian, submitted a paper to the Lancashire and Cheshire Antiquarian Society (Transactions Volume 1X). In this tract Wilkinson made a strong case for the Battle of Brunanburh having been a local event; amongst his evidence for this was:

"Bishop's Leap and Bishop's House were in the immediate vicinity of Godley Lane and St. Peter's church and attest to the visit of Paulinus who baptised the local people in the River Brun. The church would have been one of the first be erected by the Saxons and a burh for its protection would no doubt have been erected on the steep cliffs of the Brun, by which the church is overlooked on the west. Winewall means 'the place of contention' or 'protected enclosure' or 'white enclosure' and nearby Emmott was the site of Eamot at which Athelstan had earlier been declared king of all England."

"Many of the stone cairns and circles from the Burnley moors have been carted off to build roads to the new quarries. Tradition in the Worsthorne area had it that the Danes constructed many defences in the area and the tumulus at nearby Ringstones Camp contained one or more of the opposing chieftains, also a chest of gold had long been hidden somewhere on Worsthorne Moor. The name of the village of Worsthorne could originate from Werstan's-thorn, the name of Athestan's bishop who was killed in the area. At Saxifield House a great quantity of human bones had been discovered whilst excavating for the cellars and nearby many small tumuli in a field had been levelled by farm improvements, the name of the field was The Graves."

"Old charters show the name of Burnley as Brumley and Burnwest (Burwains?), whilst one account of the battle gives the site at Wendune (Swinden?). The transition from Brunford to Brumley to Brunley to Brunanley to Brunanburh appears so natural in form that there can be little doubt that they indicate the same locality."

Wilkinson also co-wrote a book entitled *Memories of Hurstwood* in which he stated that: "The River Brun flows by Hurstwood and washes the base of a hill in a field at the top of which is erected a huge block of hard rock which is traditionally called The Battle Stone and the dead of this battle are buried in the valley to the north of the stone. The Sharples family farmed hard by the site of the stone for some five or six hundred years and they always held with this tradition." (Quoting Baine's History) - "That Athelstan once fought in Lancashire is preserved within the family history of the Lancashire family of Elston (anciently Ethelstan, Cf. Harl. MSS., 2042, date 1613) where Mr. Elston writes as follows: 'It was once told to me by Mr. Alexander Elston, who was uncle to my father, and sonne to Ralph Elston, my great grandfather, that the saide Ralph had a deede, or copie of a deede, in the Saxon tongue, wherein it did appeare that the king Ethelstan, lying in campe in this Countie upon occassion of warres, gave the land of Ethelstan (or Ethelston) unto one to whome himselfe was Belsyre.'"

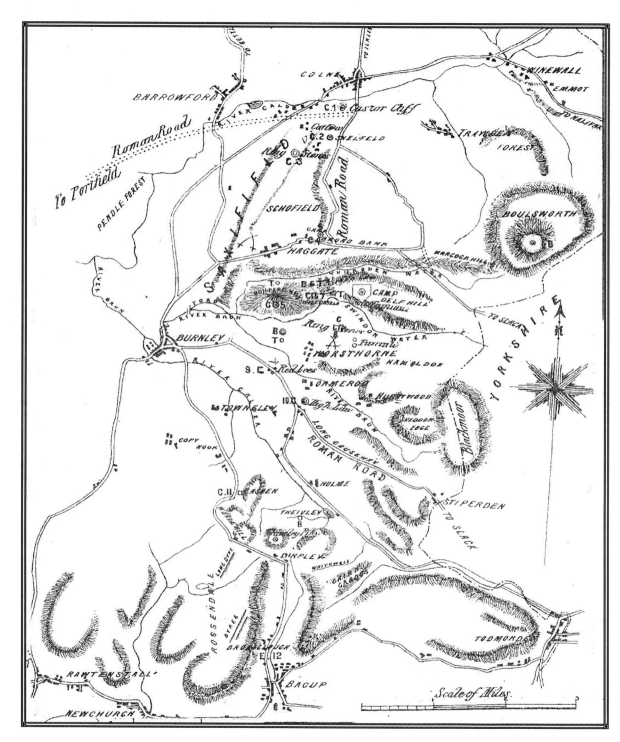

T. T. Wilkinson's map of the battle site (c.1856)

178

Further to Wilkinson's paper the Colne and Barrowford historian, James T Marquis, expounded the proposal for the battle having been in the Burnley area when he published his own account based on the premise that:

"There is overwhelming testimony in favour of the site of the Battle of Brunanburh having taken place on the Lancashire Brun. The original site of the Godley Lane Cross would have been at Brunford (the area of St. Peter's church) from which the town took its name of Brun- ley. The ancient road ran on the east side of the valley from Brunford via Haggate and Shelfield to Castercliffe, Colne and Emmott. Dr. Whittaker stated that in his day 'in the field behind Red Lees are many strange inequalities in the ground, something like the obscure appearances of foundations or perhaps entrenchments.' Below Walshaw is a dyke stretching across from Scrogg Wood to Dark Wood, a walshaw would have been a 'wall of wood.' Such was the Brun- burh, this burh at Red Lees with mounds and ditches in a half circle on each side of the causeway."

"The line of burhs ran from Thelwall, Manchester, Bacup, Broad Dyke, Long Dyke, Easden Fort, Copy Nook, Castle Hill (Towneley) Watch Gate, Brunburh, Broadbank, Castercliffe, Shelfield, Winewall and Emmott. Our area being the one place where, in the Saxon king's dominions, hostile hosts could meet for an attack. We have Brownedge, Brownside, Bishop's Leap, S'winless Lane, Saxifield, Saxifield Dyke, Ruh-ley, Red Lees (across from which is a traditional battlefield in which is a battle stone), High Law Hill, Hore Law Pasture and numbers of cairns and tumuli, all of which can be said to be near to the hillfort Brunanburh."

"Near Stirpenden is Warcock Hill and on the north side, at Thursden, is another Warcock Hill. Between these two hills would stretch Anlaf's army in its first position. From the north end of this position a road runs north to Shelfield and Castercliffe, by means of which he would be joined by the Welsh from the Ribble via Portfield and also his Strathclyde and Cumbrian allies from the north. From this end of the position runs a road west to Broadbank where there is the site of a small camp at Haggate. From here Anlaf would send the Welsh, under the command of Adalis, and his shipmen, under Hryngri, for a night attack on the advancing Saxons as they crossed from Brunford. They fell on the enemy somewhere in the Bishop's House estate area but were beaten back across the estates known as Saxifield. Two days later both sides prepared for the main battle near to the burh, Anlaf advanced to his left and took possession of High Law Hill (now called Round Hill) near to Mereclough, the pastures are still called Battlefield with a Battlestone at their centre. Constantine and his Scots were in charge of this hill with the Picts and Orkney men behind. He pushed his centre between Brown Edge and Worsthorne where his right flank touched Swinden Water under Adalis with the Welsh."

"Athelstan changed his position and put Wersthan, Bishop of Sherbourne, in charge of his old position and he was killed, possibly at Bishop's Leap. Adalis had done this in the night attack, probably coming by Walshaw and Darkwood. Alfgier took up command with Thorolf and Eglis in support in front of the wood. Alfgier was assaulted by the Welsh, driven from the field and eventually left the country. Thorolf was assaulted by Hryngr the Dane and soon afterwards by Adalis, Thorolf was aided by Eglis and was the hero of this day near to Netherwood on Thursden Water. He fought his way to Hryngr's standard and slew him, Adalis retreated back over Saxifield to the Causeway Camp at Broadbank."

"The enemy left the Saxifield area entirely and the decisive battle took place at the other end of the Brunburh. Walking up Swinden, by Swinden Water, the right-hand side, between that river and

the River Brun, is called on old maps Roo-ley (Rowley) and old manuscripts show it as Ruhlie - in the time of Wilkinson the place was marked by a cairn and a tumulus. Some distance further is Heckenhurst. Roads running down from the burh area pass through Rooley, Brownside and Red Lees by the Long Causeway leading to Mereclough."

"Athelstan placed Thorolf on the left flank of his army at Rooley to oppose the Welsh and the irregular Irish under Adalis. In front of Brownside was Eglis and on his right, opposite Worsthorne, was Athelstan and the Saxons. Across the Long Causeway on Red Lees, with the burh entrenchments at his back, was Turketul the Chancellor, with warriors from Mercia and London standing opposite Round Hill and Mereclough. Thorolf was killed beside Hackenhurst Wood, at Rooley, whilst trying to turn the enemies right flank. Eglis destroyed the Welsh prince, Adalis, and drove his troops from the wood, the memorial of this fight was the cairn and tumulus by Rooley."

"Athelstan and Anlaf fought in the centre for the possession of Worsthorne and both were equally matched until Turketful, with hand-picked men (including the Worcester men under Sinfin), made a flank attack at Mereclough and broke through the Pict and Orkney men and reached the Back O'th Hill. He penetrated through to Constantine's position and was nearly killed but Sinfin slew Constantine's son and therefore ended the fight."

"On Round Hill, until about AD 1800, stood a cairn called High Law, the stones were used to mend the local road and a skeleton was found underneath. At Back O'th Hill a blind road leads through what an old map, and tradition, call Battlefield; following this road the Chancellor would find himself at Brown End near to Brown Edge. At the other end of the position Eglis, having won the wood, would be near to Hell Clough, ready to charge at the same time as Turketful upon the rear of Anlaf's army. Athelstan pushed back the centre of the opposition and it was then that the carnage began, the memorials of which can still be seen on Brown Edge, Hamilton Pasture, Swindene, Twist Hill, Bonfire Hill and beyond. In the flight of the northern army those who could get through the hills at Widdop would do so, others would take their hoards from the camps at Warcock Hill and other places and bury their treasures as they went along. They would pass in front of Boulsworth Hill and over the moor through Trawden Forest between Emmott and Wycollar."

"If the Saxon description of the battle in Turner's 'History of the Anglo-Saxons be read and compared with modern Ordnance Survey maps the reader will see that there is no place in England which can show the same circumstantial evidence nor any place, having that evidence, be other than the place sought for."

"T. T. Wilkinson stated that Danes House is now a deserted mansion situate about a half-mile to the north of Burnley on the Colne Road. It has been conjectured that there was a residence here AD 937. Tradition has it that here Anlaf rested on his way to the battlefield. Daneshouse has long been pulled down. Broadclough (Bacup) Dyke is a mighty entrenchment over 600 yards long and 400 yards of the line is 18 yards wide at the bottom. The *History of Rossendale* says that If Saxon Field near Burnley was the scene of the battle then it is in the highest degree probable that one or other of the rival armies, most likely that of the Saxon king, forced a passage through the Irwell Valley and there they were encountered by the confederate hosts entrenched behind the vast earthwork at Broadclough that commanded the line of their march. Whether this was taken on the north flank, or rear, by the Saxons, or whether it succeeded in arresting their progress it is impossible to determine. The dyke was constructed for weighty strategical purposes under the belief that it was of the last importance.' "

Conclusion

The foregoing account is somewhat fanciful in as much as the battle scenes are described with a certainty that can at best, be described as being based on best- guess principles. With no concrete evidence to back up the claims for any particular place having been the battle site, any proposal must be viewed as being circumspect. Having said that, the case for Burnley having hosted what would, a hundred years after the event, be called *"The Great Battle,"* is as good as any and far better than most.

With this in mind the following is an attempt to further illustrate the case outlined by Marquis:- The moorland, stretching from Coombe Hill, over Boulsworth to Widdup and Worsthorne, is an outstanding example of our wild upland heritage. The main changes that have occurred on these sweeping oceans of sedge grass, in the past few thousand years, are a loss of the birch woodlands, a deepening of the peat blanket and the appearance of modern stone enclosure- walls. As is the case within most regions, the minor names of the moor are largely English with a smattering of Celtic and Scandinavian influences.

Firstly, the name of the battle itself is worthy of a closer look: we have seen the variations upon the theme of Brunanburh and that the name is commonly accepted as meaning '*the brown fortification.*' This is based largely on the translation of the OE *brún* as simply meaning *brown* or *burn,* however, the word essentially translates as *dark* or *dusky* whilst another meaning can be that of *translucent* or *shining.* The OE *brunna* = *burna* and this has the meaning of *brook* whilst the nearest meaning to *brunanburh* appears to be the Germanic word *brunnen* which translates as *burn,* also meaning *brook* or *stream.* Here we have other meanings of the accepted name of the battle site; accepting the word *burh* as a fortified site we have examples in *The Burh by the Brown - The Burh by the Stream - The Burh by the Dark* and *The Burh on the Edge* (Brinks?). The first mentioned could well relate to any 'brown' site of which our area has a number ie, Brown Hill Moor above Trawden, Brownside, Brownhill and Brown Edge near Worsthorne and Brunshaw, also Brownwood at Burnley.

A '*burh by the Stream*' is relatively meaningless in locating the site as the moors are marbled with brooks and streams draining the sponge-like land into the Calder – meaningless that is unless we take the alternative description of the site in *Brunford.* This would provide us with an apt description for the crossing of the River Brun, near to St. Peter's in Burnley. Furthermore an early document dating from 1469 makes mention of *The Brig of Brown* which probably relates to a bridge built to replace the Brun Ford. If there was (as suggested by Marquis) indeed a *burh* at this site then it can also be taken literally as '*The Burh by the Stream*' or Brunanburh.

The village of Burnley was probably founded around the later eighth century and would, at the time of the battle, still have been a small collection of timber cottages and scattered farmsteads around the area of the Brunford (later Brig of Brown) at the bottom of Ormerod Road. There would also have been hamlets, or farmsteads at Healey, Towneley, Westgate, Coalclough and Fulledge, all of these hamlets collectively formed a *tun.* The Egil saga mentions that Athelstan was quartered at a tun just to the south of the battlefield and the area of present-day 'Top O'th Town' (the St. Peter's/Brunford area of Burnley) might fit this description. As a matter of interest the *tun-lee* (Towneley), as opposed to the nearby, but separate, settlement of the *brun-lee,* had its own *burh* in the form of the hill that would later be known as Castle Hill. Taking the element of *lee* as the OE word for *woodland clearing* it is possible to picture Burnley at the time of the battle as still retaining much of its original woodland and scrub. Bennett has this to say on the subject:

"Apparently the land on either side of the River Brun was well covered with trees and brushwood. Hag Wood and the few trees around Queen's Park and Thompson Park may well be

the last remaining relics to mark the site of an ancient but more extensive wood. Possibly the clearance from which Burnley derives part of its name lay on either side of the present Ormerod Road, stretching towards The Ridge and Brunshaw. Other place names, some of much later origin than the eighth and ninth centuries, show the same woodland or rough character of the ground; Brunshaw, Burnley Wood, Timber Hill speak for themselves, Reedley Hallows, Ridehalgh and the Holmes portray marshy meadows, Rowley emphasises the rough, stony nature of the soil, Fulledge speaks of a slow, muddy stream with wide marshland, Whincroke (a stream in Clifton) tells of a winding, twisting stream flowing through gorse covered land whilst Ightenhill, in the same vicinity, perhaps derives its name from the same moorland shrub."

Another account of the extent of the woodlands in the area was given in a letter to the Burnley Express at the turn of the twentieth century:- *"Towards the end of the 1700s Burnley was little more than a village in the woods. An old chap I knew, who died around 1860 aged over eighty, told me that his father had taken him as a child to visit his uncle in Mereclough. The uncle took them to the top of a nearby hill and told them that times had changed as within living memory as far as the eye could see (towards Burnley) had been unbroken forest."*

On the periphery of the *tun* were the common wastes at Saxifield (this ranged from Harle Syke to Brunford), Broadhead Moor (from Gambleside in Rossendale to Padiham Road), Thornhill Moor (including Lowerhouse), Turf Moor, The Ridge and Whittlefield. To the east of the *tun* were the open moorlands of the proposed site of the extended battle.

Across The Moors

The area to the south of Trawden carries a number of *'Brinks'* name elements such as Pot Brinks Moor, Brink Ends Moor and Brink Ends. It is interesting to note that two early writers had the name of the battle site as *Brinkburn* and *Brincaburh*, another example of the name can be found to the south-west of Extwistle Moor in the high ground overlooking Widdop reservoir known as The Brinks.

Taking the battle area outlined by Marquis, working east to west, a look at the various place-names of the region might very well compound the case for the *'Battle of Burnley.'* The road from Emmott, running over the moors to Haworth, traverses the Forest of Trawden and, in its day, was an important part of the trans-Pennine route system. A trackway from this road, at Coombe Hill Cross, ran south-west across Brink Ends Moor, skirting to the north of Boulsworth Hill, over Bedding Hill Moor, Antley Gate and on to the Thursden road at Coldwell. This through route, known for much of its length as Will O' Moor, would have facilitated the movement of troops within the battle area. On the summit of Boulsworth Hill are the rock formations known locally as *'The Slaughter Stones'* and a short distance below, on the higher northern slopes are the Abbot Stone and The Battle Stone. It has been suggested that the former commemorates Abbot Wersthan, Athelstan's priest who fell in the battle. Around the same distance to the south of the summit we find Warcock Hill whose name might be surmised in the OE words *wearr = callosity* and *ceace = cheek* (side of) giving *'the lump on the hillside'* or a pronounced hillock on the otherwise plain slopes of the hill. However, the historian, Titus Thornber, said that: *"The standard of the Vikings was a black raven known as a 'Warcock' and where this was planted over their war camps it was remembered by all future generations as the Warcock Hill."*

Some two and a half miles north-west of Boulsworth, and still on the moorland plain, is the site of Knave Hill and Shelfield, we have already seen that this area abounds with mounds and stones. My wife's father lived at Slitterforth Farm, Shelfield, during the 1920s and he related that the old

182

farmer there often said that a *'great battle'* was fought on the site around Walton's Spire and the warriors were buried in a mound by Knave Hill Farm. It is also known locally that, prior to the opencast mining operations that took place following WWII around Shelfield Farm, traces of a large defensive ditch could be seen on the north-west side of Knave Hill. Viewed from the western area of Haggate, Knave Hill upon which the monolith of Walton's Spire stands, can be clearly seen to have been levelled for some purpose and, along with the nearby Castercliffe hill fort, could well have been a part of the local Saxon *burh* system.

Moving eastward along the ridge top, above the former Marsden Hall estate (now the Municipal Golf Course), through Higher Southfield and Catlow, we arrive at Lane Bottom. There were two major routes leading through Lane Bottom at the time of the battle, one ran directly west from Burnley and Saxifield via Harle Syke and the other ran from the ridgeway at Laund (Wheatley Lane), crossed Pendle Water at the Mont Ford (also called Pendle Waterside and Quaker Bridge). From here this route passed through Little Marsden and the now lost large wayside mark stone at Marsden Cross (known as the Dowle Stone) and then over the hill of Marsden Heights by means of the King's Causeway.

This ancient trackway is of interest because it appears to have traversed an area that was once held to be of some importance - the presence of the St. Helen's Well, and the former ancient cross which stood at the entrance to Nelson Golf Club, bear testimony to this. Furthermore, the name itself suggests an important connection. Taking into account that we also have the high, flat defensible plateau of King's Cliffe on this same route as it passed through Lane Bottom it is tempting to link the two sites. It would not be impossible for the sites to have played a part in the *'Great Battle'* when it is realised that this route led directly from the Ribble and then in to the higher lands or our proposed battle-site. The causeway led straight across Finsley, on Black Hill, down into Lane Bottom and then began its long, steady climb towards Boulsworth and the Thursden Valley.

Crossing the Roman road, near to which the now-lost Annot's Cross once stood, the road progresses for a further one and a half miles before it reaches a point where it forks. This spot, known as Broadbank, is on the lower slopes of Boulsworth Hill and also has an excellent view over the steep-sided valley of Thursden Water far below. Here we find the camp, or fortification, of Burwains, the strategic importance of this dominant site is illustrated by the fact that the Ministry Of Defence saw fit to place a WWII pillbox here. From this point the road heads south-east into the river valley and then struggles over the craggy heights of Extwistle Moor towards Widdop Moor, alternatively, the opposite fork can be taken along the base of Boulsworth, past Coldwell and on up to Knave Hill. A third option was available to our forebears whereby the ancient, and now long-disused sunken roadway called the Scotch Road was the natural extension of the road from Lane Bottom – this headed straight up onto Warcock Hill from where it traversed the lonely pinnacle of Boulsworth Hill.

Having touched on the subject of this forgotten route in an earlier chapter, where I stated that I thought it had its name-origin within the word *'scutch'* (banked) it might be worth mentioning that, in the context of the subject of the Battle of Brunanburh, the name of Scotch Road might actually be a reference to the northern troops of Constantine and the lesser Scots king, Olaf.

Accounts of the events leading up to the battle describe the encampments of the adversaries and the battle site. Athelstan's army was said to have encamped close to the scene of battle, between a river and a wood, whilst his enemies were near a town a 'day's ride' to the north. The battle site itself was described as being on high ground, fairly level, with a far reaching view in all directions, this is indicative of moorland which is enforced by the naming of the site (in Egil's account) as Vin-heath by Vin-wood. The name element of *vin* might have been applied to the scene of battle in the later accounts by the conquerors, rather than it having been the traditional name of the area when

the protagonists arrived. This would provide us with the ON *vinne* = *win* or *gain,* the Danish *vinde* = *to win,* N *vincere* = *to overcome* and the Latin derivation in *vincens* = *conquering.*

Red Spa Moor with the lower slopes of Boulsworth Hill to the right. Was this the Vin Heath?

Alternatively, if the region had long held the description of Vin Heath then the meaning of this was common to many languages, having originated in the Roman international trading of wine where *vin* is the *Latin vinus/vinum.* That is not to suggest, however, that the English people were cultivating vineyards on the upper reaches of Boulsworth, it is more likely that the name was being applied as a description of the colour of the land ie, red or reddish brown. This, in fact, is the very colour of many of the iron-carrying streams in the area and moreover, the name of the region into which the Scotch Road penetrated is known as Red Spa Moor. An alternative to this is that the OE *wine* meant *friend* or *protector* whilst the OE *wén* stood for *bend* or *twist,* relating to this we have the fortification of Twist Castle in Extwistle.

There is also the consideration that Simeon's account of the battle has the site *"upon the hill called Weondun or Wendune"* – taking the element of *dune* as the OE for *hill* it can be seen that the prefix *wen/weon* could well have translated as *vin,* thus giving us *Vin Hill.* The second element in the name is *heath* and this is rather more straightforward, the ON *heidr* = *heather field* and the OE *head* = *track of waste land,* both of which provide us with our modern idea of a heath. We also have to consider that Wilkinson stated that Winewall, near to Emmott, had the meaning of *'place*

184

of contention' – further to this we have in this name the only incidence of the actual word *wine* in the whole area.

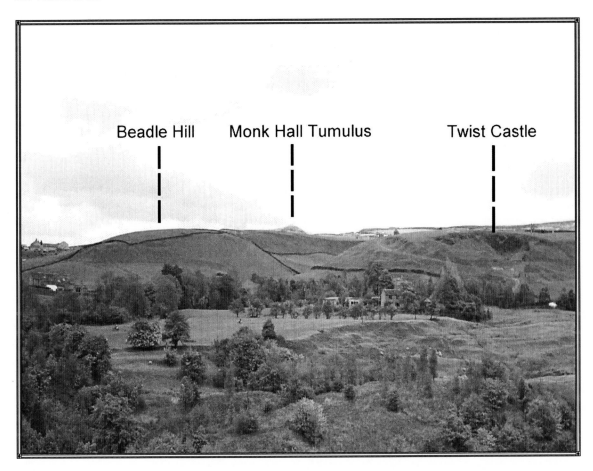

Looking over Swinden Clough at Roggerham towards Briercliffe and Extwistle

A short distance to the south, across the Thursden Water valley from Burwains Camp, is the large tumulus above Monk Hall. This is the location of the concentration of mounds, cairns, camps, stone circles and tumuli in the area ordering the two townships of Briercliffe and Extwistle. We have in this fascinating area a cluster of sites carrying names such as Twist Castle whose name can originate in either the OE *twisla* meaning *a junction between two manors* (an exact description of this spot between Briercliffe and Extwistle) or alternatively the OE *twisehtan* means *to disagree*. The castle is roughly fifty yards square with an extension to one side measuring some twenty metres by twenty metres, an entrance to the larger enclosure can still be made out. Other structures of a very similar nature to this are at nearby Beadle Hill, from the OE *beado = beadu = battle*, and Ringstones Hill in nearby Worsthorne. It is thought that these fortifications were erected in Roman times when the local Brigantes revolted against the invaders in 155 to 158 AD and 196 to 197 AD. These uprisings saw the Roman fort at Ribchester being damaged and, as the purpose of this fort was to guard the Ribble crossing there, the Romans required a further system

of defence whilst their fortress was being repaired. It is possible that sites such as Beadle Hill, Twist Castle, Ringstones and Castercliffe (along with a chain of others across the Pennines) were brought into service at this time.

Also in the Extwistle area, between the ruined Extwistle Hall and the village of Worsthorne, we find the steep cliff known as Hell Clough, where the OE *hell = burial*. The similarly named Ell Clough runs from the northern slopes of Delph Hill, with its pronounced cairn circle, down into the depths of the Thursden Valley, the OE *ele* prefix signifies the place of *strangers* or *foreigners*. It was here that en excellently preserved burial was unearthed. There were also burial grounds near to the now-ruinous Jerusalem Farm where three apparently ancient structures can be found; one takes the form of an earthen circle some eight metres in diameter and the other two are circles each of which contains seven stones.

Slightly to the south we come to the moors surrounding Worsthorne, here are the neighbouring features of the Ringstones, the stone circle upon Slipper Hill (*sleopar = to slip away/escape*) and the tumulus and cairn circle on Wasnop Edge whose name-origin can be seen in the OE *wase = mire/marsh* and *norp = northern*. Close by, to the east, the area known as Ben Edge has another distinct flavour of battle, the OE *benn = wound* or *mortal injury*. Further along to the east we pass over Hameldon Moor and Standing Stone Height before reaching another *brinks* site in The Brinks on the edge of Widdop Reservoir, this area abounds in moorland stones, most of which carry names. South of this area are the Shedden and Cant Cloughs with the nearby Hazel Edge, the obvious reason for this latter place to carry the name is that hazel trees grew there. I cannot help wondering, however, if this could have any relationship to the *enhazelling* of battlefields, could this actually be the edge of our battlefield, where the level moor gave way to a steep sided clough? This is the Worsthorne Moor and on the southern side is the Long Causeway, turning west along here brings us to Mereclough and the Round Hill, upon which was the High Law burial cairn and the Battle Stone. Here we also have the area known as Red Lees (another *'red'* or perhaps *'vin'* site) within which stands the Brown Hill. There has long been a tradition amongst the people of the Worsthorne area that something mysterious was buried on their moors, be it *'five kings'* or *'a horde of treasure.'*

About a mile to the west of Mereclough is the Towneley family seat of Towneley Hall with its attendant knoll known as Castle Hill. Directly north from here is one of the old timber supply sites for the *tun* of Burnley in Burnley Wood, then we cross Fulledge and Pike Hill to the ancient site of Rowley Hall (Rooley in Marquis' description). This area contains the sites of Brownside, Heckenhurst Wood and Netherwood, where Marquis has the downfall of Thorolf taking place. The River Brun runs by Rowley and following the waterway slightly to the west we arrive at Heasandford - there is within this name the curious fact that the OE word *heascan* means to *jeer at, deride* or *taunt*. Is it possible that this river ford marked the boundary of the battlefield and that anyone who crossed it became the object of derision for having been seen to flee the hostilities? To balance this, the name is more likely to have originated in OE *hey = fence* or *boundary* and *sandy ford,* the area was variously shown as Feasandford in 1496, Haysandforth in 1500 and Fezandforthe in 1596 and, in 1400, there was a Sand Hall Green in the area.

Keeping on to the north we pass Bend Hill and Mustyhalgh before reaching the area of Walshaw. We saw in an earlier chapter that Walshaw (*wealas = Welsh/foreigner*) sites commonly refer to places where the English forced the native Celtic speakers into enclaves within remote areas. There is also the consideration, in the context of a place of this name on a proposed battle site, that the OE *wael* means *battle* or *slaughter*. This could also apply to the place known as Walshaw Dean on the moors to the east of Boulsworth Hill.

Having reached Harle Syke (the *ditch of Herle or Harle*) we are in the Saxifield estate which ran from Haggate, through Harle Syke and down into the *tun* of Burnley proper. It is commonly

accepted that the name of Saxifield represents *The Saxon Fields*, which it may well do. There is, as usual, an alternative here in that the OE *seax*, a word with the meaning of *knife, sword* or *dagger*, has the definite connotation of battle.

One more piece of circumstantial evidence springs to mind; Athelstan met with his northern opponents, in the year 920, *"at a place called Eamot"* where he was accepted as *"ruler of all England."* There is no reason to suggest that the *Eamot* site was not the Emmott on the eastern boundary of our subject area. The fact that Athelstan knew this place, and would no doubt have held it in high esteem, at least sets a precedent for the area within the mindset of the king; in need of a northern site for the forthcoming battle he would have a particular target area on which to concentrate the many different factions within his armies.

The Second World War pillbox on the site of Burwains 'Fort' (Broadbank) overlooks the Thursden Valley. This is a nice illustration of the importance of strategic military sites to successive generations. It is likely that this particular spot has been valued for its defensive nature by every culture to have graced our shores since the Neolithic period. Conflict and wars abide and over the wide span of history things do not change!

Of the accounts of our distinguished local historians I will leave the final word to Thomas Booth who was a doyen of Victorian Burnley Society; amongst other things he was involved in the founding of the Mechanic's Institute and a popular writer on the subject of local history in the Burnley Express. In this capacity he wrote: *"I have carefully read all the papers on the subject of the Battle of Brunanburh and the most conclusive evidence yet brought to bear upon the matter seems to strongly corroborate the claim of Burnley."*

Having circumnavigated the region of the battle fields, as proposed by T. T. Wilkinson and J. Marquis (amongst others) it remains only to state the obvious - that there does not appear to be any sound reason why Burnley could not have hosted the Great Battle. On the positive side of the argument we have seen a number of possible, and a number of definite 'battle' sites within the area; this suggests that the region as a whole has certainly seen action within its history. The one abiding drama within our national psyche can be seen to be the Battle of Hastings when the French so rudely gate-crashed our party - however, if a single event were to be chosen to represent the creation of our Anglo-Saxon nation then it would have to be the big one: The Battle of Brunanburh!

Another Battle Site?

To finish this look at local battle sites it is worth giving some thought to another possible area of conflict in the region (Fig:19), this may, or may not, have been related to Brunanburh. Many local skirmishes and raids took place here over a long period of time and the fact that a site carries a battle-related name does not necessarily brand it as being part of a major offensive. Nevertheless, it is both interesting and worthwhile to speculate on the nature of related areas within a landscape, in this way at least a few new lessons may be learned. We have already seen that a probable defensive site exists at the Barrowford Water Meetings, where the slopes of Blacko Hillside sweep into Pendle Water, this spot would have controlled the river valleys through to Colne and Burnley from Pendle Valley and the Ribble via Middop and Admergill. Domination of the ancient high ridgeway route from Ribchester and on to Gisburn would also have been afforded by the position of the 'camp.'

Taken from Blacko Hillside looking south; the east-west ridgeway runs from right to left in the photograph. The Hameldon Hills are on the horizon and Utherstone Woods are at the end of the ridgeway (centre left). The treeless top of the Water Meetings camp can be seen to the left and above the row of houses (centre).

The trees within Utherstone Wood hide the old trackway into the river valley and the top of the Utherstone escarpment would have made an excellent defended settlement area, being level land surrounded on three sides by steep, ridged banks. In an earlier chapter I postulated that the name of Utherstone was related to huddart (keeper of animals in the wood) but another possibility raises its head when exploring the possibility of this area having been a major part of the region's defences – could Utherstone (colloquially Utherstan) derive from Athelstan? Also of interest in the battle context is that the fact that the OE *uthere* means *foreign army*. Further to this the historian, Camden, wrote in his '*Britannia*' of 1586 "*the term 'stan' was a superlative termination ie, Athelstan was the most noble.*" Taking the word *stan* as having the above meaning, instead of the more common assignation of *stone,* we would have the description of '*the great/mighty foreign army.*'

The Water Meetings 'camp' also has steep, ridged defences on three sides and an ancient trackway passing through it. Returning to the argument for the name Brunenburh having the meaning within the first element *brunen* of *burn* (stream) we have a perfect example of a stream/fortification, the Water Meetings feature is washed on two sides by the rivers of Pendle Water to the west and Blacko Water to the east, the steep, high banks of both waterways actually form part of the earthwork. As a point of interest, the Water Meeting is referred in sixteenth century documents as *Watter Gate* which, on the face of it, means '*going of the water,*' there is the strong possibility, however, that the name is the OE *wattergaet* meaning *water spider*, a nice description of a spot where a number of rivers meet and divide in a 'spidery' fashion. It would also illustrate the continued use of pure Saxon language in our local area.

The ridge of Blacko Hill (centre right), looking from Stang Top:

The Admergill Valley is to the left of the hill:

Lanefield 'enclosure' and Bell Wood lie within the trees (centre foreground)

Following northwards from the Water Meetings camp the ancient trackway crosses Blacko Water at Blacko Foot and clings to the river side. This area is Bell Wood and is another example of a steep, high bank where the narrow river plain was once heavily wooded. Where the track meets the road from Blacko Bar is an area of woodland, described by a local writer, in the 1940s, as "*the modern plantation,*" the track here once forded the stream where the 1914 bridge now stands and immediately crossed the old boundary of Claudes Clough by means of a clapper bridge (this is still in situ, beneath a new wooden bridge). This area, at the very bottom of the valley, where Wheathead Lane descends from Blacko and then rises steeply towards Wheathead Height, is

known as The Hole. Claudes Clough is a major boundary, it formerly separated the Yorkshire parish of Brogden (detached) from Lancashire. On early maps the name is given as Clouds Clough and the origin of this could well be in the vegetation of the area. The dwarf-mulberry (Chamaemorus) was commonly known as clowdes-berry and this probably accounts for the name in Clouds /Clauds Clough. Interestingly, there is a piece of local folklore that the clowdes-berry was originally known as cnout-berry or knout-berry, this was because king Cnut was once stranded on the moors hereabouts and survived by eating these berries.

Another local tradition relates that a battle once took place in Bell Wood although it is impossible to say whether this might have related to some ancient conflict or to one of the many local skirmishes of the Civil War. From Bell Wood, an ancient track took the traveller along the stream to the hamlet of Admergill whilst another branch led westwards from the wood, up the hill to Lower Wheat Head Farm. This property is situated at the western tip of an apparent enclosure in the Lanefield area, this feature takes the form of an oval area of land roughly twelve acres in extent, determined by a ring of ancient hedges and trees.

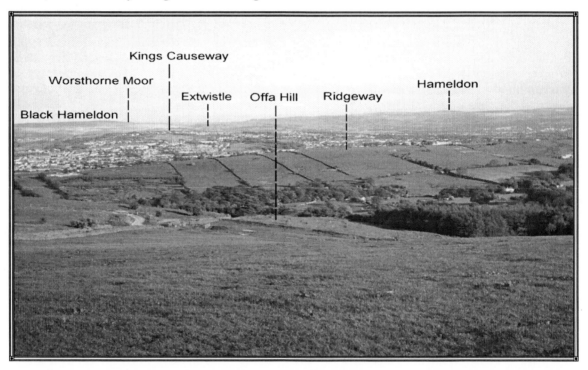

Taken from Stang Top, with Offa Hill below, this photograph shows the topographical position of the present subject area in relation to the proposed Burnley field of the Battle of Brunaburh. Offa has the appearance of a raised 'camp' feature and a connecting dyke, or trackway, from Stang can just be made out in the right foreground

Wheathead Lane, on its way from Blacko to Downham, makes a distinct detour around to the north of this site whilst the old route from Bell Wood skirts around its boundary to the west, this is indicative of there having been some kind of feature within the landscape here when the trackways were formed. Significantly, the stream of Caster Clough washes the edge of the site; as with

Castercliffe, we can take the name of *caster* as meaning an ancient *camp* or *fortified place*. This raises the question as to whether this enclosed area was the camp referred to when the Clough was named, there is one small caveat to be considered here as the stream is shown on some maps as Castor Clough, *castor* being the British word for *beaver*. In etymological terms, however, the likelihood is that this was a cartographer's mistake as the term *caster* was much more prevalent within our former area of northern Mercia.

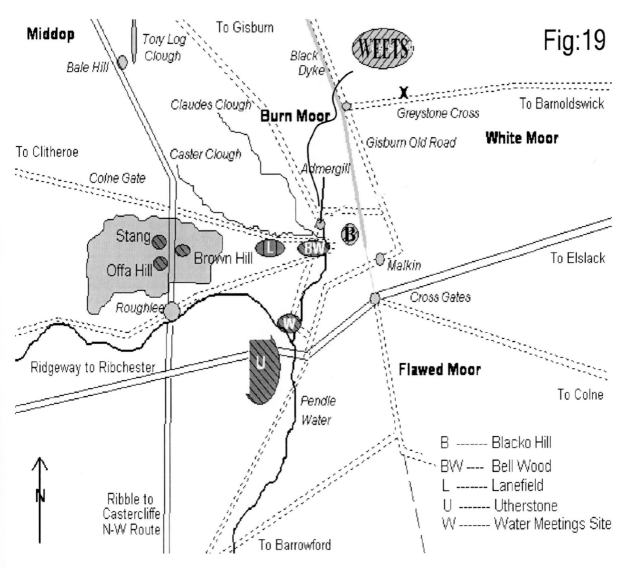

Fig:19 *Map showing the ancient routes and camps/defended areas through the area of Middop, Roughlee and Blacko*

Leaving Lower Wheat Head (the scene of an altercation between Old Demdike and her daughter when Baldwin the miller turned them off his land) we climb for a short distance above Bank End

Wood and Hollin to reach Brown Hill. This has the *brun/brown* element and it is not beyond the realms of possibility that this bare, rounded hill could also have been employed as a burh for the protection of the postulated settlement at Lanefield below.

A spit-and-a-stride to the west, across the narrow road, is Stang Top Moor, the summit of which is hard by the road upon a small, false hillock. Despite the fact that Stang is not the highest of the hills in this region it still affords an excellent three-hundred and sixty degree panorama of the distant mountains and moors. Stang Top is an area of flax-covered heath stretching into the distance towards Pendle, the lower slopes of the higher Wheathead Height and down into the valley at Whitehough. A more fitting site for a battle than this broad and level expanse of moorland cannot be imagined. Further to this, the narrow road bisecting Brown Hill and Stang was the main north-south ancient arterial route from the Ribble at Gisburn, via Middop, through to Castercliffe and beyond. Also of relevance is the fact that the word *stang* is Danish and means *pole (hazel), stake, spear,* this a possible reference to the enhazelling of a battle-field.

A short way down the road towards Roughlee is the site known as Offa Hill, the road here now deviates around the area whereas it once carried on straight down to the waterfall in Roughlee and then up the opposite side of the valley to join the ridgeway. Offa has the obvious personal name element as in king Offa (Offa's Dyke), in this context, however, we also have to consider the fact that the OE word *offor* meant *intercept/attack*. The situation of the Offa site, nestling below its close neighbours of Brown Hill and Stang, is such that anyone heading down the road from the north would have been vulnerable to a surprise attack, or ambush, as would anyone who would be attempting to flee any battle upon the nearby higher ground.

We have already seen that the Middop Valley has a number of defensive positions, if an enemy were to enter the Pendle area from the north then they would, by necessity, either pass through Middop, Rimington Moor and Admergill or through the Twiston area and across the moors to Stang. The latter site would have full control on the higher of these crossings, the Middop route in particular, via Rimington Moor and Firber, would channel any invader along the track passing between Stang and Brown Hill. Defences within the locality would be called into play, the Black Dyke would have controlled any attempt at invasion from the Weets and White Moor area, the Water Meetings camp would have dominated the Pendle Water valley whilst Stang, Brown Hill, Wheathead Height and Offa would possibly have been the first site of the main confrontation between invader and defender.

This group of sites, therefore, represent a linked system of possible defences within our landscape; they may have played a part in the Great Battle, indeed they may have acted as the front line in the conflict. Whatever the case may be, we have at least seen that the picturesque rolling hills we are so fortunate to be surrounded by have a hidden history beyond the obvious pastoral scene of today.

Into a New Millennium

The system of *burhs*, begun by Alfred and continued by his descendants, had served their purpose in the subjugation of the northern confederacy - following the success of Brunanburh things settled down for some twenty years. The *burhs* developed into new administrative centres which became prosperous centres of population and trade, they also became the hub of new shires, modelled upon the system already in place in Wessex where the shire unit was divided into hundreds. As the tenth century wore on the young king Eadwig, who was somewhat of a waster, alienated many of his northern subjects and the upshot was that Mercia and Northumbria transferred their allegiance to his brother, Edgar, and Eadwig found himself with limited powers.

Edgar had possibly been crowned as king of the Mercians at an earlier date but in the year 973

192

he was crowned king of the English at Bath. Within two years Edgar had died and trouble surrounded the appointment of his successor; eventually his eldest son, Edward, was crowned in 975 at Kingston but his reign was to be short-lived as, in March 978, he was killed by his half-brother's men in Dorset, Aethelred then succeeded to the crown. He went on to reign for a long period and became known as Aethelred the Unready. Under him, in the late tenth century, England prospered, many new churches were built and the systems of government and law were reformed.

The *witan* council took on the form of a modern government with the royal court at its head but the aristocratic leaders of the council fell into a spiral of back-biting, greed and intrigue and the government of the country suffered as a consequence. Taxes rose rapidly and the people were becoming restless, the country could be seen to be lacking sound leadership and this did not go unnoticed - yet again the ravens of the Viking standard began to circle.

The Norsemen returned to England in the 990s, stronger and more determined than ever; in 991 they attacked Ipswich and then landed in force at Maldon in Essex. The resulting battle saw the English mount a stout defence but they were to be overwhelmed in the fight, as a result the archbishop of Canterbury advised the king to pay off the Vikings in a tribute known as the Danegeld. This turned out to be a big mistake, the invaders knew a good thing when they saw it and kept coming back for more - by the year 1002 the English were paying out a sum of £24,000 and by 1007 this had risen to £30,000. The Vikings began to take the Mickey and in a campaign of 1006-7 they paraded their ill-gotten spoils past the gates of Winchester, striking through the old Saxon heartland of Wessex; whilst this was going on Aethelred was skulking far away in Shropshire!

The year 1009 saw a shambolic end to the British fleet, assembled to attack the Vikings and, again, signals were sent out to Denmark that England was ripe for the plucking. In 1013 the Danish king, Swein Forkbeard, invaded the north and quickly subjugated it, shortly afterwards London surrendered and Aethelred legged it to Normandy. Swein did not enjoy his spoils for long, however, he died the following year and this brought about an unexpected turn of events, the Danes wanted Swein's younger son, Cnut, to succeed him but the English sent to France with an offer of conditional return to Aethelred. A form of contract between the king and his people was drawn up, a virtual forerunner of the Magna Carta, and the king agreed to abide by these rules. This set a precedent that can be seen to descend through later declarations of right down to the present day.

Having had a kick up the proverbial the returned king decided to address the Viking problem and forced them to leave England's shores. In a further twist of the story, the king's son Edmund (Ironsides) rebelled against his father and seized the former area of the Danelaw following which the Vikings returned and took Mercia and Wessex. Aethelred died in April 1016 and this saw a split in proposed succession between Edgar's supporters and a candidate chosen by the Danes. Taking the bull by the horns Edmund attacked the Vikings and succeeded in forcing the invaders to agree a north-south boundary along the Thames, Edmund held the regions south of the line and the Danes held the north. Edmund died in 1016, and the chosen leader of the Danes, Cnut, was recognised as 'king of all England.'

Cnut turned out to be a relatively successful king, he used the wealth of the English treasury to reward his followers from the homeland and, as an act of political astuteness he married Emma, the widow of former king Aethelred. In 1018 Cnut signed an agreement with the English people and paid off the Danish forces, at land and at sea, with a Danegeld tribute of some £72,000. Unlike Aethelred's attempts to pay off the invaders, Cnut's actions worked a treat and all but forty Danish ships sailed home. As time passed Cnut found that, by necessity, he was spending an increasing amount of time abroad, to address this problem he appointed close allies to run things in his

absence. He partitioned England into four main parts, Wessex, East Anglia, Mercia and Northumbria – he kept Wessex for himself and appointed ealdormen, or earls, to rule over the other three. One of these earls was an Englishman called Godwin whom Cnut appointed as earl of Wessex, Godwin married Cnut's sister-in-law (or possibly his sister) and created for himself huge estates.

Cnut died in November 1035 and again the succession was disputed, on the one side was Harold Harefoot, who was Cnut's son by Aelfgifu, and on the other was Emma's son, Harthacnut. The solution to this problem was for both men to rule in a joint regency, a protracted period of political intrigue followed, mainly instigated by Emma, but earl Godwin finally had his way and, in 1037, Harold Harefoot was generally accepted as sole king of England.

Harefoot died in March 1040 and the absent Harthacnut, along with his mother Emma, arrived back in England with a great fleet and took over what they had always considered their rights of kingship. Unfortunately the line of Harthacnut was programmed genetically to live a short life and Emma, realising this, brought Edward, a son by her earlier marriage to Aethelred, to England to rule with Harthacnut in joint kingship. To prove Emma right Harthacnut duly died in June 1042.

Edward was crowned king and one of his first steps was to strip his formerly powerful mother of her estates because she "*had been formerly very hard on him,*" although they were to be partially reconciled later the good times for Emma were over and she died at Winchester in 1052. In 1045 Edward married Edith, the domineering daughter of earl Godwin, Edith had two elder brothers who had already risen to the ranks of earldom, Swein of Wessex and Mercia and Harold of East Anglia.

Gradually king Edward came to despise the powerful house of Godwin and things eventually came to a head with a military stand-off, the eventual consequence of which was that Godwin and his family were outlawed and fled to Flanders. In the meantime Edward had been cultivating his contacts in France, where he had lived for so long in exile. As a result of this he invited his nephew, William, Duke of Normandy, to England and it is possible that on this visit Edward made a rash political gesture and promised William the succession to the English crown.

The people of England, however, were not best pleased at this apparent move to give England to the French, the aristocracy began to show their allegiance to the exiled Godwin and he was not slow to take advantage. He returned to England with his son, Harold, and eventually effected a pardon before the *witan* council, the fact that Edward had no option but to co-exist with his enemy appears to have played upon Edward's mind and he went into a sulk. He turned his back on the perceived ingrates of the English people and threw himself into his religious project of the Westminster Abbey foundation. In April 1053 Godwin died and gradually Edward became closer to Godwin's sons, Tostig and Harold, in fact Harold became the king's confidante and Tostig became earl of Northumbria in 1055; two of his other brothers, Gyrth and Leofwin (the husband of Lady Godiva) were also given earldoms. In 1063 Harold and Tostig attacked Wales for the king and sent him the severed head of one Gruffud ap Llwelyn as a trophy.

The later period of Edward's reign was relatively successful, things bumped along as they had a tendency to do but trouble arose in 1065 when earl Tostig alienated the Northumbrians. As a southerner his ways were somewhat alien to the northerners who accused him of false taxation, perversion of the law and robbing of churches. The Northumbrian leaders moved against Tostig and stripped him of his power and marched south, eventually Harold, acting as mediator, persuaded Edward to accept the northerners' choice of leader, Morkere, as earl of Northumbria. The Domesday Book refers to much of the area of Pennine Lancashire as *'wastes'* and it has been suggested that this might have been as a result of the northern uprising.

Edward was sixty years of age at this time and it would appear that the northern uprising affected him badly, by late December 1065 he had taken to his deathbed. Surrounded by his close

court, Edward, in one of his more lucid moments, said to Harold *"I commend this woman* (his wife, Edith) *and all the kingdom to your protection."* This was taken to be a formal declaration of the succession of Harold on Edward's part, he died on the 5th January, 1066. Harold was duly crowned king and was soon at loggerheads with his brother, Tostig, who attacked the coast from his base in the Isle of Wight and progressed to Lincolnshire. Harold, with a massive show of force, booted Tostig out of England causing him to flee into exile in Scotland, Harold then positioned his forces along the south coast in readiness to combat the expected threat from duke William in France.

During much of Edward's reign the old Viking enemy were too busy fighting amongst themselves to trouble England but this was to end when King Harold Hardrada of Norway brought an armada of some three-hundred ships and landed in the Tyne where Tostig joined forces with him, despite a valiant defence by the earls Edwin and Morkere, the invaders took York. Harold arrived on the scene, having marched his southern-based troops north, and both Tostig and Hardrada were slain at the ensuing Battle of Stamford Bridge - the English all but annihilated the Vikings.

Meanwhile, William had been amassing his troops in France and now only required favourable weather to mount his campaign to capture the English throne to which, as far as he was concerned, he had a God-given right. By a cruel stroke of fate the wind turned in William's favour immediately following Harold's victory at Stamford bridge, the Norman invasion of England was now well and truly on!

On hearing the unwelcome news Harold started straight for the south, he consolidated in London for around a week and then set out, possibly before he was fully prepared, to meet the newly-arrived William. Harold's hoped for element of surprise did not materialise as the Normans had advanced notice of their coming and were prepared.

The ensuing Battle of Hastings commenced on the 14th October, the English foot soldiers, facing mounted French knights, fought bravely but the odds were stacked against them. Harold's brothers Leofwin and Gyrth were killed before the tide of the battle had become apparent, it appeared to the English that a number of the Norman army were attempting to flee the field - it is thought that the English broke ranks to pursue them and were cut down by the troops of William's half-brother, Bishop Odo. The constant volleys of arrows began to take their toll upon the English positions and eventually Harold's close entourage were slain, the king himself was disabled by an arrow (traditionally to the eye) and then killed by a heavy sword blow to the upper leg. The English, seeing their leader had fallen, fled into history.

* * * * * * *

We have now reached the end of the long and dark millennium spanning the era from the Romans to the Normans, an era where both established and fledgling powers flexed their muscles and jostled their neighbours in search of lands and wealth.

William of Normandy, not-so-fondly known as William the Bastard, brought with him a hegemony that was to change the face of the nation. No longer would rich and poor share a common language and no longer would the poor man or woman enjoy the relatively even-handed Saxon laws. The

diverse former Saxon estates of Lancashire would become the single lordship of William's favourites. It would not be long before the powerful new religious orders would appear on the scene and the lord's hunting forests of Pendle, Trawden, Rossendale and Bowland would be created.

Ironically, the plagues that would scythe down the working classes in the coming centuries would also provide a catalyst for an improvement in their living conditions. Shortage of manpower saw the gradual dilution of the feudal system, workers were able to move from area to area and wages slowly increased. The lord's hunting forests became untenable and these areas gradually gave way to new farming operations, new lands were enclosed, farming methods gradually improved and our proud counties of Lancashire and Yorkshire flourished.

The rest, as they say, is history!

Bibliography

Chapter l :

Bentley, J 1975: Portrait of Wycoller
Carr, J 1878: Annals and Stories of Colne
Gardner, W: Ancient Earthworks: Lancashire South of the Sands
Hale, R 1971: Exploring Prehistoric England
Lancashire University Archaeological Unit - The Archaeology of Lancashire: 1996
Marsden, B 1974: The Early Barrow Diggers
Rigby, V 1997: Britain and the Celtic Iron Age
Underwood, G 1970: The Pattern of the Past
Whittaker, G 1980: Roughlee Hall - Fact and Fiction

Chapter ll :

Bannister, F: The Annals of Trawden Forest
Bennet, W 1946: The History of Burnley - Vols 1 and 2
Brown, P 1976: Megaliths, Myths and Men
Carr, J 1878: Annals and Stories of Colne
Ekwall (Prof.): The Place Names of Lancashire
Farrar, W 1912: Clitheroe Court Rolls - Vols 1 / 2 / 3
Gardner, W: Ancient Earthworks: Lancashire South of the Sands
Harrison, D) 1988: The History of Colne (Pendle Heritage)
Kenyon, D 1991: The Origins of Lancashire
Mills, D 1976: The Place Names of Lancashire
Transactions of the Lancashire and Cheshire History Society 1982

Chapter lll :

Carr, J 1878: Annals and Stories of Colne
Ekwall (Prof.): The Place Names of Lancashire
Farrar, W 1912: Clitheroe Court Rolls - Vols 1 / 2 / 3
Harrison, D 1988: The History of Colne (Pendle Heritage Centre)
Mills, D 1976: Place Names of Lancashire
Millward, R: The making of the English Landscape - Lancashire
Whitaker, T 1881: The History of Whalley

Chapter lV :

Bagley &
Hodgkiss 1985: A History of the County Palatine in Early Maps
Bannister, F: The Annals of Trawden Forest
Bennet, W 1946: The History of Burnley - Vols 1 and 2
Ekwall (Prof.): The Place Names of Lancashire
Mills, D 1976: The Place Names of Lancashire
Rigby, V 1997: Britain and the Celtic Iron Age

ChapterV :

Carr- Gomm, P 1991: The Druid Tradition
Frost, R 1982: A Lancashire Township
Kenyon, D 1991: The Origins of Lancashire

Chapter Vl :

Brown, P 1976: Megaliths, Myths and Men
Hale, R 1971: Exploring Prehistoric England
Screeton, P 1974: Quicksilver Heritage
Watkins, A 1925: The Old Straight Track

Chapter Vll :

Bennett, W 1957 The History of Marsden and Nelson
Farrar, W 1912: Clitheroe Court Rolls - Vols 1 / 2 / 3
Screeton, P 1974: Quicksilver Heritage
Whitaker, T 1881: The History of Whalley

Chapter Vlll :

Arnold, E 1894: The Story of Lancashire
Bennet, W 1946: The History of Burnley - Vols 1 and 2
Bennett, W 1957 The History of Marsden and Nelson
Carr, J 1878: Annals and Stories of Colne
Ekwall (Prof.): The Place Names of Lancashire
Farrar, W 1912: Clitheroe Court Rolls

Frost, R 1982: A Lancashire Township
Harrison, D 1988: The History of Colne (Pendle Heritage Centre)
Mills, D 1976: The Place Names of Lancashire
Millward, R: The making of the English Landscape - Lancashire
Pearson, S 1985: Rural Houses of the Lancashire Pennines
Welch, M 1992: Anglo Saxon England
Whitaker, T 1881: The History of Whalley

Chapter lX :

Bennet, W 1946: The History of Burnley - Vols 1 and 2
Ekwall (Prof.): The Place Names of Lancashire
Farrar, W 1912: Clitheroe Court Rolls - Vols 1 / 2 / 3
Kenyon, D 1991: The Origins of Lancashire
Mills, D 1976: The Place Names of Lancashire
Whitaker, T 1881: The History of Whalley
Whitaker, T 1885: The History of Craven

Chapter X :

Arnold, E 1894: The Story of Lancashire
Kenyon, D 1991: The Origins of Lancashire
King, D 1983: Castellarium Anglicanum
Lumby, J 1995: The Lancashire Witch Craze
Partington, S 1909: The Danes in Lancashire
Smith, R 1961: Blackburnshire (Paper)
Wainwright, F 1948: The Scandinavians in Lancashire
Welch, M 1992: Anglo Saxon England (English Heritage)
Whitaker, T 1885: The History of Craven

Chapter Xl :

Ekwall (Prof.): The Place Names of Lancashire
Farrar, W 1912: Clitheroe Court Rolls - Vols 1 / 2 / 3
Lancashire University Archaeological Unit - The Archaeology of Lancashire: 1996
Mills, D 1976: The Place Names of Lancashire
Savage, J: A history of Barnoldswick
Whitaker, T 1885: The History of Craven
Warner: The History of Barnoldswick

Chapter Xll :

Ainsworth, W 1854: The Lancashire Witches
Ekwall (Prof.): The Place Names of Lancashire
Mills, D 1976: Place Names of Lancashire
Wainwright, F 1948: The Scandinavians in Lancashire

Chapter Xlll :

Ekwall (Prof.): The Place Names of Lancashire
Green, W (Rev.) 1893: The Egil Skalagrimmson Saga (translation)
Mills, D 1976: The Place Names of Lancashire
Partington, S 1909: The Danes in Lancashire

Chapter XlV :

Bennet, W 1946: The History of Burnley - Vols 1 and 2
Camden, W 1586 (1695 reprint): Britannia
Ekwall (Prof.): The Place Names of Lancashire
Marquis, J 1908/09: The Battle of Brunanburh (Paper)
Mills, D 1976: The Place Names of Lancashire
Partington, S 1909: The Danes in Lancashire
Starkey, D 2004: The Monarchy of England - Vol 1
Thornber, T: Cliviger (history)
Walton, J 1950s: Pendle Forest Folk
Wightman, P 1963: Whalley to Wycoller
Wilkinson, T 1856: The Battle of Brunanburh (Paper)
Wilkinson, T (Co- author): Memories of Hurstwood
Williams, E 1951: Walks and Talks with Fellman

Nelson, Colne, Burnley, Clitheroe and Barnoldswick Libraries - Various unpublished papers

Crowther, Doreen - Local library stock ~ numerous transcriptions of deeds etc, held at Preston Records Office

Preston Records Office - Various published records

Copies of deeds and land/property surrenders held by the author

Introduction (p2): Millward, R: The making of the English Landscape ~ Lancashire

Index

www.barrowfordpress.co.uk

All photographs and illustrations by the author unless otherwise stated

Maps and diagrams are for illustrative purposes only and are not intended for any other use